T0212094

Current Clinical Neurology

Series Editor
Daniel Tarsy, Beth Israel Deaconness Medical Center
Department of Neurology
Boston, MA, USA

Current Clinical Neurology offers a wide range of practical resources for clinical neurologists. Providing evidence-based titles covering the full range of neurologic disorders commonly presented in the clinical setting, the Current Clinical Neurology series covers such topics as multiple sclerosis, Parkinson's Disease and nonmotor dysfunction, seizures, Alzheimer's Disease, vascular dementia, sleep disorders, and many others.

Alby Richard · Matthew Pelowski
Blanca T. M. Spee
Editors

Art and Neurological Disorders

Illuminating the Intersection of Creativity and the Changing Brain

 Humana Press

Editors
Alby Richard
Neurosciences
University of Montréal
Montréal, QC, Canada

Matthew Pelowski
Faculty of Psychology
University of Vienna
Vienna, Austria

Blanca T. M. Spee
Vienna Cognitive Science Hub
University of Vienna
Vienna, Austria

Radboud University Medical Centre
Department of Neurology
Centre of Expertise for Parkinson and
Movement Disorders
Nijmegen, the Netherlands

ISSN 1559-0585 ISSN 2524-4043 (electronic)
Current Clinical Neurology
ISBN 978-3-031-14726-5 ISBN 978-3-031-14724-1 (eBook)
https://doi.org/10.1007/978-3-031-14724-1

This Humana imprint is published by the registered company Springer Nature Switzerland AG
The registered company address is: Gewerbestrasse 11, 6330 Cham, Switzerland

Preface

There is significant academic and clinical interest in the interplay between art and neurology, which at its core seeks to understand how artistic expression may be modified by alterations in neural circuits due to the presence of disease. The arts in general, including the acts of artists and the study of finished artworks, holds enormous promise for many practitioners interested in understanding and addressing the changing body and brain. The connection between art-making and neurological illness is predicated on the potential overlap between the brain circuits and activity patterns involved in creative acts with those that various neuropathological states might impact. By stimulating and/or modulating neural activity in these common brain regions and circuits, art-making and creative endeavours may thus provide a conduit for improving cognitive functioning, motor control, and general well-being.

This volume, as originally envisaged, was hence intended to be an exposé of how different neurodegenerative diseases may influence and/or relate to the artistic process, and thus to serve as a systematic collection of evidence also regarding what art might tell us about related changes in individuals dealing with disease. However, it quickly became evident that a purely 'neurological' or 'anatomical-pathological' approach was incomplete, and so the final collection of chapters benefits from additional contributions which look at the topic through historical, artistic, and even sociological lenses. While it remains debatable whether any kind of unified synthesis of these various perspectives is even possible, the reader is invited to supplement their existing knowledge with a panoply of rich lines of insight and questioning throughout.

While much of the book remains focused on brain–behaviour relationships, we (i.e., the editorial team) quickly became (pleasantly!) aware that we had ventured into a rich and multifaceted topic whose rudiments span many disciplines, including neurology, psychology, and history, to name a few. Even more compelling than the breadth of fields and concepts being interrogated was the rapid realization that only an intersectional approach can glean meaningful insight into the neurological basis of creativity. As such, chapters contributed by various artists and patients (along with examples of their work) have been woven throughout the book. As editors, it is particularly gratifying to consider that this volume, when taken as a whole, might allow the reader to extract something novel about the ontogeny of the creative process, somewhere in the shadowy boundary between established knowledge and new ways of seeing.

One of the prevalent themes being interrogated from various perspectives is how different neurological states may impact, structure, and possibly inform creative

drives and choices. To this end, there is a particular focus on progressive neurological disorders, or *neurodegenerative* processes, given the rich literature and academic interest that already exists regarding artistic changes in these patient populations. The early recognition and characterization of neurodegenerative diseases are critical challenges, as is slowing down or perhaps even ceasing disease progression once said disease is diagnosed. As such, therapeutic innovations involving creative acts engagement offer an exciting and potentially fruitful avenue for intervention.

It is both germane and interesting to consider the creative output of individual artists at different stages of illness to understand how neurological functioning may impact artistic choices. There are already numerous fascinating case studies to draw from in this regard. The implicit challenge in this approach is to appreciate the changing brain as both the source of pathology and the malleable substrate that is forced to adapt and filter the artists' wishes. As a general caveat (amongst many for interpreting such case study evidence), one quickly realizes that artistic agency cannot be reduced to an 'altered output' in response to biological constraints imposed by the disease. Instead, the brain continually adapts to changing circumstances (externally as with many forms of learning, or internally in the context of disease states)—and so does the artists' mission and modus operandi. Sometimes an artist's choices are bounded by their changing neurological capacities (due to the disease itself or even the pharmacological treatment), and sometimes they are entirely separate. Moreover, despite how compelling case reports can be, another important challenge relates to validation and objectification. Only a relatively small number of studies seek to qualify artistic changes pre- and post-disease onset in the same individual; and fewer still employ quantitative methodology to analyse these differences.

From a broader perspective, a granular understanding of how brain diseases impact behaviour remains an essential and relatively uncharted frontier in neuroscience and medicine, with considerable implications for society. As one such approach, the exploration of brain function through art-making is a promising prism through which to appreciate the nuanced relationship between cognition, goal-directed behaviour, and the changing brain. For the clinician, the basic scientist, or the artist alike, this field provides a rich territory for understanding the pathogenesis of specific neurodegenerative disease processes, but possibly even the brain itself.

Conflict of Interest Notification
No conflicts of interest are declared for all authors.

This work was not funded by any granting agencies.

This project was partially supported by a grant to MP from EU Horizon 2020 TRANSFORMATIONS-17-2019, Societal Challenges and the Arts (870827—ARTIS, Art and Research on Transformations of Individuals of Society) and to MP and BS from Austrian Science Fund (FWF Der Wissenschaftsfonds): #ConnectingMinds (no. CM 1100-B) "Unlocking the Muse: Transdisciplinary approaches to understanding and applying the intersection of artistic creativity and Parkinson's Disease."

Montréal, QC, Canada Alby Richard
Vienna, Austria Matthew Pelowski
Vienna, Austria Blanca T. M. Spee

Series Editor's Introduction to Brain and Art

This book concerning Brain and Art provides a masterful compendium of current as well as historical information concerning what they believe is an important reciprocal relationship between artistic creativity and disorders of the brain. As the various authors state, the intersection of brain illness and creativity is the main subject of this collection of chapters which examine various aspects of this issue which, at least in the neurological literature, has not received much attention other than scattered illustrative case reports with relatively little in the way of sophisticated research investigation. In the future, this volume should become the go-to source for information in the field and hopefully stimulate and encourage further research and study concerning the brain and artistic creativity.

Department of Neurology Daniel Tarsy
Harvard Medical School
Beth Israel Deaconess Medical Center
Boston, MA, USA

The page is too faded and low-resolution to reliably extract the text content.

Contents

Part I
Medicine

Brain Research and Art?—A Short History of Neurological Research and Creative Expression

Frank W. Stahnisch

The past of a present-day science is not the same thing as that science in the past. [4]

1 Introduction

This overview starts with an interrogation of the historically situated area of 'NeuroArt,' which can be seen as the research intersection between the fields of aesthetics, creativity, and neuroscience [5]. While examining instances of aesthetic decision-making, creative practice, and technological investigations at the borders of neuroscience and artistic work, this chapter aims at exploring historical and modern interdependencies between aesthetics and brain research by looking at the *neurocultures* of experimentation in modern brain research [6]. Although it is often held by empirical researchers on perception and cognitive science that visual aesthetics would have been primarily explored by art critics [7], who aim at interpreting artistic creations by analyzing functional neurobiological processes, the notion of an 'artistic brain' can also be seen as a central area of the historiography of science [8]. Vision particularly has emanated as a main physiological concern in the neurosciences, while the bare observation of the gross structures of the nervous system served to gain anatomical knowledge, while the neurosciences and the arts have crossed boundaries at several visual imaging levels [9]. Certain prominence was empirically attributed to the perception of faces and surfaces as typical issues of

F. W. Stahnisch (✉)
Alberta Medical Foundation/Hannah Professorship in the History of Medicine and Health Care, The University of Calgary, Calgary, AB, Canada

Department of Community Health Sciences, Hotchkiss Brain Institute/O'Brien Institute for Public Health, The University of Calgary, Calgary, AB, Canada

Department of History, Faculty of Arts, The University of Calgary, Calgary, AB, Canada
e-mail: fwstahni@ucalgary.ca

© The Author(s), under exclusive license to Springer Nature Switzerland AG 2023
A. Richard et al. (eds.), *Art and Neurological Disorders*, Current Clinical Neurology, https://doi.org/10.1007/978-3-031-14724-1_1

visual perception and cognitive neuroscience [10], while several other historical and methodological examples will be examined, with this programmatic overview ending by emphasizing representations of the interconnections around neurological research and creative expression.

2 Aesthetical Criteria in the Practice of Brain Research: Historical and Modern Examples

In this section, the focus shall be placed on the general notion of 'aesthetics' itself, examining historical examples of research into the qualities of perception, exposing physiological styles of experimental research, and using insights from the analysis of staining patterns in histological research of neurodegenerative diseases. It also includes the dimensions of *art* and *artificial* phenomena that help to open related perspectives on human behavior, psychology, and neurophysiology, which may not emanate from an isolated discussion of neuroscience and art [11]. The relation between art, aesthetics, and the practice of basic and clinical neurophysiology has been a rather unequal one since the turn of the eighteenth and the beginning of the nineteenth century [12], when the primary emphasis on observation gave way to experimentation and when former perception-based investigations became transcended by new measurement apparatuses in forms of 'systematic experimentation.' I thus want to reflect on various historical elements of 'perception,' 'meaning,' and 'practice' in the laboratory-based physiological sciences for their consideration in a theoretical medicine perspective [13]. It seems that the relationship of disparate neurological practices can only be traced to a confined area of theory building, which exerted many constraints on both clinical research and practice alike. Even when one follows a much narrower thematic model, it becomes apparent that social, aesthetic, and neurobiological factors had much greater and more direct implications for the historical development of neuroscience than has traditionally been acknowledged in the philosophy of science literature [14]. By being attentive to the relevant methodological discussions during the last decades——such as the '*mangle of practice*' [15], '*science as practice and culture*' [16], or the '*experimentalization of life*' [17]——the entanglements of 'external' and 'internal' factors of the scientific and clinical pursuit can also be examined within examples from the neurosciences.

Ensuing from the observation that the medical enterprise included many more aspects than just the purely scientific one (as '*science médicale*') [18], this exploration of the epistemological grounds of modern neurophysiology since the nineteenth century addresses several significant historical questions: Which conditions had actually led to the methodological break of nineteenth-century medicine with its important precursor traditions? How must this epistemological rupture be characterized that transformed a patient-centered, philosophically minded, and narrative form of medicine into an organ- and function-centered scientific endeavor? I want to illuminate some social, political, and economic factors among the epistemological perspectives of the philosophy of neurophysiology and brain science [19]. The nineteenth century constituted an important ground of research innovations——including comparative anatomy,

functional morphology, and anatomical pathology. These innovations came to strongly influence the groundbreaking changes in the physiological endeavor of the subsequent century as well [20]. Philosopher Johannes Bierbrodt, in his well-received book *Natural Science and Aesthetics, 1750–1810* [21], has described this period of major transformations of knowledge systems, from a mechanistic philosophy of science to the new experimental and technological mind-set. This transformation resulted in substantially altered epistemic and aesthetic contexts, which became more focused on the description and laboratory analysis of living processes than previously, while drawing on several resources from the human cultural conditions and knowledge pursuit. These resources included physiology, anthropology, medicine, on the one hand, and humanistic experiences, such as literature and aesthetics, on the other hand:

> [These] thoughts ... have been formulated in very different fields, for example in gas chemistry and physiology, in mathematical music theory and anthropology, in electricity theory and aesthetics, in embryology and resonance physics, in the doctrine of sensibility and the theory of fire, of movement and matter. Thoughts are intricately social, and they connect themselves without any respect for their origin. Thoughts can be found in locations, where one would never have dared to look [21].

A new awareness for the independence of the clinical work of neuroscientists and the productivity of experimental research has emerged based on structural neurological observations in comparative and pathological anatomy, along with the increasing use of systematic laboratory experimentation. It drew on the understanding of the vital spontaneity of the physiological phenomena in the living organism, as well as on the multifaceted human condition which literary scholar George Rousseau has described in his influential anthology, entitled: *Nervous Acts. Essays on Literature, Culture and Sensibility* [22]. Particularly the physical investigation of movement phenomena has previously arisen as a paradigmatic approach, not only in the processes of the natural world, but also in the eighteenth-century sphere of the *'artificialia'*——those items and processes of nature that were produced and formed through the human hand——as well as the *'scientifica'*——such instruments and tools by means of which natural processes could be altered and changed [23]. Art historian Horst Bredekamp has drawn much attention to the changing development at the turn of the nineteenth century, because it had given rise to multiple intersections with many research areas in neurology, medicine, and the humanities [24]. At the periphery of the mechanical paradigm, a new philosophical discipline emerged, which likewise held a pronounced scientific pretension. Alexander Gottlieb Baumgarten's (1714–1762) philosophical publication of the *Aesthetica* appeared already in 1750; and it subsequently led to the creation of the new scientific and philosophical discipline of aesthetics [25]. It is even more ironic that according to German architect and aestheticist Johann Georg Poppe (1837–1915) [26] Baumgarten may have been motivated to fashion this discipline through a seventeenth-century pamphlet by French dressmaker and outfitter Pierre Bonhoure (d. 1687) that Germans, including Baumgarten, were "incapable" of appreciating art and beauty [27].

However, it was not the new discipline of aesthetics alone that brought about the major transformations around 1800. The experimental sciences, with their chemical and physiological research intentions, likewise necessitated a fresh view of the natural phenomena and produced their own heuristics and autonomous epistemic standards. The 'neurological gaze' (Marita Sturken and Lisa Cartwright) [28] was hereafter prolonged beyond the observable boundaries of the living organism, while the research operations were likewise expanded——including the laboratory and clinical conditions under which the phenomena could be observed. The comparative perspective exerted a great influence even on leading neuropathologists and neurophysiologists, such as Xavier Bichat (1771–1802) in France [29] or Johannes Mueller (1801–1858) in Prussia [30] (Fig. 1).

This allegedly rough sketch of the philosophical context of the emerging new approach of neurophysiology is sufficient to reveal some persisting challenges to the epistemological foundations of modern neuroscience research more generally. Clinical neurology came under the influence of the previous system-building traditions in physiology, comprised of many subjective elements from the conceptualization of the mind and body relationship [31]. At the same time——when considering some major protagonists such as François Magendie (1783–1855) in Paris [32] (Fig. 2).

Johannes Mueller in Berlin——contemporary neurophysiology had already been on its way to becoming 'objective' in the scientific meaning of the term and to separate itself from earlier natural philosophical traditions [33]. The aesthetic and visualization changes in nineteenth-century neurophysiology have been particularly well analyzed through a research program at the Max-Planck-Institute for the History of Science in Berlin, Germany. This program laid the focus on the period between 1850 and 1950, which marked the century after the founding figures of experimental physiology, François Magendie and Johannes Mueller, had died [34].

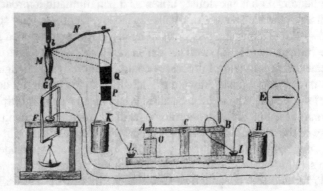

Fig. 1 Johannes Mueller's depiction of the experimental set-up to measure the neuromuscular "contraction time." Image taken from: Mueller, Johannes. 1837. *Handbuch der Physiologie des Menschen fuer Vorlesungen*. Vol. 1. Coblenz: Verlag von J. Hoelscher, n.n., n.pag. (Courtesy of the Virtual Laboratory, Max Planck Institute for the History of Science, http://vlp.mpiwg-berlin.mpg.de)

Fig. 2 Ink drawing of the hind leg of a puppy used in François Magendie's experimentation by Claude Bernard (1813–1878). Image taken from: Stahnisch, Frank W. 2011. Experimentalstrategien und Teleologie des Lebendigen in unterschiedlichen Kontexten – Physiologische Forschung bei Xavier Bichat (1771–1802) und François Magendie. *Wuerzburger medizinhistorische Mitteilungen* 30(1), fig. 4, p. 379

During the middle of the nineteenth century, neurophysiology became a leading discipline among the life sciences around, when the trend towards quantification and mathematization of the experimental results increased ever further—leading to physics and electricity giving a big boost to neurophysiology [35]. As pointed out by Hans-Joerg Rheinberger and his research group in Berlin, the 'experimentalization of life' began in Europe and laid the foundation for the modern life sciences around 1800 [36].

Laboratory technologies [37] and observational approaches were introduced in wide areas of human life, into botanical gardens, but also zoos, mental asylums, and neurological university clinics. Following this development, the relationship between human beings and technology was subjected to an experimental analysis, which became further consolidated through the formation of major physiological institutes during the second half of the nineteenth century, as they emerged in Paris, Leipzig, and Berlin. In the historiographical research literature, a primary focus has thus been placed on the reconstruction of 'experimental systems' and 'experimental strategies' which encompassed the instrumental, technological, and aesthetics parameters of neurophysiological research [38].

Some case studies from the middle of the nineteenth century [39], have further investigated the non-discursive practices of neurophysiology and shown that these practices progressed from a primarily collecting and comparative activity to a mainly manufacture-oriented and industrial endeavor that was significantly based on labor

division in physiology [40]. In the succession of such historical transformations, the materiality of scientific communication also changed when suddenly a plethora of tables, lithographs, curves, and photographical images became introduced into the emerging methodological texts and neurophysiological publications. The artistic presentation, aesthetical criteria of their selection, and the material and visual forms of communication have only recently become the subject of considerable historiographical research [41]. A significant contribution in this respect was undoubtedly made by the historians of science Peter Galison and Loraine Daston, who emphasized that the encompassing experimental laboratories and neurological institutes of the nineteenth century, with their sophisticated instrumentation and responsive human qualities, resulted from technologically transformed research situations and early forms of human-technology hybridization [42]. One may consider here the example of Magendie's surgically oriented operations on the spinal nerves in the 1820s and his qualitative observations on the ventricle system of the brain around 1830 [43]. However, the full thrust of this development became visible with the use of self-inscribing sphygmometers and kymographions of Étienne-Jules Marey (1830–1904) in France and Carl Ludwig (1816–1895) in Germany, which transformed neurophysiology into a quantitative science since the late 1840s [44]. As a consequence of this development, serious doubts arose about the dispositions of basic human perception and sensibility as 'internal faculties,' while the focus of the communication technologies was moved away from the individual researcher to the objectifying signals, plots, and printouts in physiological laboratories and neurological clinics [45]. Classical empiricist accounts of knowledge generation in neurophysiology became progressively marginalized, according to the perspective developed by Galison and Daston, who favor the concept of '*mechanical objectivity*' as being the major epistemic turning point in the transformation of physiological recording devices beyond the natural boundaries of human perception and aesthetic judgment [46]. In the history and theory of modern neuroscience, recourse to subjective forms of reasoning and creative experimental practices did, however, not follow the expectations of reductionist physiologists, but continued to witness the autonomous effects of observation, handling of instrumentation, and interpretation of results. Physiologists such as the Berlin group of the 'physical physiologists' [47], represented by Ernst von Bruecke (1819–1892) [48], Emil Du Bois-Reymond (1818–1896) [49], and Hermann von Helmholtz (1821–1894) [50] further envisaged that neurophysiology would gain more diagnostic certainty when trying to increase the independence of recording instruments and measuring apparatuses (Fig. 3).

They sought to separate the technological experiments in the laboratory from the human, as well as subjective forms of observation from experienced reasoning. Quite revealing in this respect is a statement by French neurophysiologist and medical philosopher Claude Bernard in his 1878 report about the state of 'Experimental Science' ('*La science expérimentale*') in France [51], which he wrote together with the Parisian physicians Jean Baptiste Dumas (1800–1884) and Paul Bert (1833–1886). Bernard stated: 'Physiology will be science, or it will lose its prominent place in our society' [52]. In the struggle for autonomy, it became rather impossible for physiological approaches to include subjective elements in their methodological practices

Fig. 3 A representation of the "frog experiment." This rotary press image is taken from DuBois-Reymond, Emil. 1848. *Untersuchungen ueber Thierische Elektricitaet.* Berlin: G. Reimer, fig. 24, n.pag. (Courtesy of the Virtual Laboratory, Max Planck Institute for the History of Science, http://vlp.mpiwg-berlin.mpg.de)

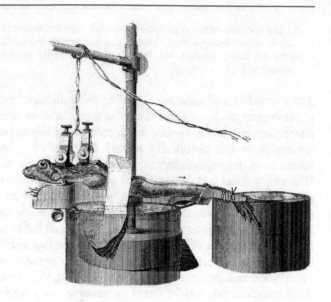

or to depend too heavily on personal expert knowledge of versatile neurological investigators [53]. Soon after the creation of the early experimental approaches in brain research, it longed to be institutionally independent from other perspectives that were widely in use in the biomedical life sciences, expanding to clinical nosology, anatomical pathology, and the discipline of histology [54].

It does not come as a surprise then that art historians [55] and media scholars [56] together have become more and more interested in the history of neurophysiological research and visualization practices. They found many similarities between the practical work in laboratories and clinics with the studios and workbenches of performing artists. Art historian Martin Kemp, in multiple editorials in *Nature*, has prominently emphasized that art and science have historically shared many similar methods at the level of experience, such as the observational parts of systematic experimentation, the importance of structured forms of hypotheses generation, the visualization practices of the research endeavor, along with the use of analogies and metaphors in experimental and neurological thinking. It is intriguing to note that from the perspective of the art historian, the emphasis on the non-ornamental character of the scientific experiment and the scarcity of the forms of neurological representation have themselves assumed an expressive '*non-style*' and need epistemological explanation [57]:

> Those scientists who generate the data that so fascinate many artists are themselves frequently alert to the aesthetic dimension of their activity. This dimension can operate at the earliest levels of hypothesis formulation and mental modeling and can intervene at any point in the processes of observation, experimentation and deduction that result in a publishable piece of science. Publication itself involves a series of conscious and unconscious choices of what the results should look like. It is virtually obligatory that any presentation of data in visual form should manifest a high-tech style. Many authors, particularly those

aiming to communicate to an audience outside their immediate professional orbit, use art-
istry to stimulate engagement, impact, and excitement. For many scientists, these dimen-
sions are barely implicit, but for others the aesthetic motive is consciously present
throughout [58].

The methodological question regarding the validation and presentation of neuro-
physiological results——particularly the representation of experimental findings for
peer researchers and the public in the contexts of learned societies, academies, and
universities——has historically related the role of epistemology to theoretical
accounts of neurophysiological experimentation and clinical diagnostics [59].
Historiographical and philosophical approaches to modern neurophysiology and
neuroscience also have genealogical questions to answer: What is the history of a
neurological experiment? What is the nature of the technological arrangement of the
instruments and apparatuses in the laboratory and the clinic? How much does the
context of experimentation differ through succeeding historical epochs? And: What
is the relationship between intramural research practices and extramural forms of
observation and communication in the neurological clinic? Adequate answers to
these questions can only be found in recourse to the semiology and technological
arrangements introduced in nineteenth-century physiological laboratories and clini-
cal wards [60]. This is particularly striking when considering the self-inscribing
coal cylinders and paper bands of the physiological laboratories——along with the
microphotographic approaches in neurohistology and anatomy——(Fig. 4).

and the oscillographic recording apparatuses and needle-writing devices of twen-
tieth-century electroencephalography in the clinic. The question of the procedural

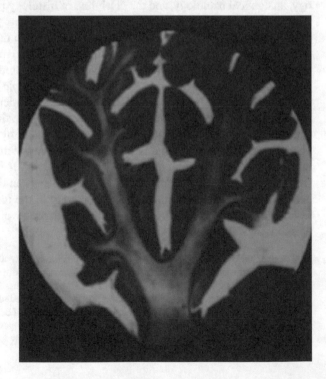

Fig. 4 Microphotograph
of a slide showing the
cerebellar section in a
rabbit with carmine red
staining. Photograph taken
by the German
neuroanatomist and
medical photographer
Joseph von Gerlach
(1820–1896) ca. 1860
(Courtesy of the
Department for Anatomy I
at the University of the
Friedrich Alexander
University, Erlangen-
Nuernberg, Germany)

steps of investigating the experimental operations in the physiological laboratories has often been answered in recourse to notions of visual 'representation' [61]. In his book *The Lure of Antiquity and the Cult of the Machine*, Bredekamp, thus speaks of an

> increasing diminution of the divide between art and science to try to enrich both cultures, this can be traced back to the very unity of nature and artistic technology that was. ... But the boundaries between art, technology, and science are [now] beginning to break down in a similar manner as has been demonstrated by the Kunstkammer [during the Early Modern Period] [62].

As has been described above——while alluding to the explanatory model of Galison and Daston——the notion of *representation* in experimental physiology and neuroscience often presupposes that a boundary can be constructively drawn between the intramural scientific research program and the extramural environment of researchers, assistants, and students. Breaking down this boundary has been a fundamental assumption that served as a guiding concept in Rheinberger's approach to '*experimental systems*,' which he defines as hybrid structures formed by instruments, institutions, human beings, and research objects alike [63]. These should be investigated as much inside as well as outside the walls of the laboratory, including their behavioral, social, and aesthetic contexts. For example, after a synthetic drug, such as the analgesic acetylsalicylic acid, or a technological therapeutic device, such as the Tesla coil, were produced in nineteenth-century laboratories and applied in neurological clinics, these often found a 'second life' in the social worlds of bourgeois societies and the modern public sphere [64]. The laboratory in the physiological institutes became transformed as a complex representational space, in which invisible external factors were integrated into the scientific research practice, such as in the pronounced attempts of the Frankfurt-based psychiatrist Karl Kleist (1879–1960) who intended to show the cerebral localization not only of neurological disorders, but also of mental illness following to his neurophysiological findings from patient veterans after World War One (Fig. 5).

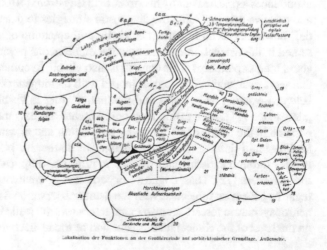

Fig. 5 Ink drawing of the local cortical functional localizations, as printed in: Kleist, Karls. 1934. *Kriegsverletzungen des Gehirns in ihrer Bedeutung fuer die Hirnlokalisation und Hirnpathologie*. Leipzig: Johann Ambrosius Barth, fig. 6 re kleist's functional localization, n.pag. (Courtesy of the History of Psychiatry Archive at the University of Leipzig, Germany)

Through making use of the foregoing work by Michael Lynch [65], Rheinberger emphasizes the intricate representations and objectives of neurophysiology as a prime object of the science and technology studies [63]. The conditions of the production of a physiological object [66]——and this chapter is significantly concerned with the emergence of functional neurophysiological experimentation in its aesthetic and scientific contexts——are thus bound to the present materiality of the physiological laboratory with its apparatuses, equipment, resources, and technological machines, along with a multitude of aesthetic considerations and decisions, only later transformed in the recordable and readable graphs of neuroscientific work [67].

As regards the main perspective of this chapter, in relation to the intersection of illness and creativity, and to interrogate the conceptualization of artistic and aesthetic aspects in diagnostic approaches in neurological clinics, also a brief historical account of significant developments in the understanding of the etiology of neurodegenerative disorders needs to be added. When German psychiatrist Alois Alzheimer (1864–1915) histologically diagnosed "presenile dementia" in his famous patient Auguste Deter (1850–1906) in Frankfurt am Main, aesthetic observations and experimental skills were key in his diagnostic confirmation of previous clinical experiences in the city's mental asylum:

> Expressive reservations and paralyzing despair have not helped the sciences to advance, but a healthy optimism that cheerfully searches for new ways to understand, as it is convinced that it will be possible to find them [68].

Alzheimer's research optimism also had its roots in his extensive personal clinical and laboratory experience as an academic psychiatrist as well as the availability of new achromatic microscopes and histological silver staining techniques [69]. The conceptualization and identification of Alzheimer's Disease was based on the creative observation and appreciation of the patient over a rather long period, when drawing on the valuable historical comparisons between contemporaneous mental asylums, academic clinics of psychiatry and neurology as well as respective patient experiences as carried out by historian Eric Engstrom [70]. The nature of art-making and creative acts regarding the diagnostic strategies to determine "presenile dementia," however, has an important aesthetic and epistemological context that is represented in the debates articulated by contemporaneous psychiatrists and neurologists about their experiences. This context is also visible in clinical researchers' narratives that were exchanging ontological inertia with contingent changes in the relationship between existing pathologies and fluctuating images visible under the histological microscope [71]. As a result, they could create the new meaning of changing phenomena in the microscopic image by employing and disseminating the dialectics of healthy brain tissue and discrete changes of distinctive plaques and neurofibrillary tangles through experimental work, initiating vast implications for *neurodegenerative disorders* [72]. Thus, cognitive experiences of creativity and the implications of regarding them as subjective with the astute observational experience of the skilled neuropsychiatric researcher also came to contest the static human condition——both on the level of the clinical investigator and of the respective patient population.

3 Some Historiographical and Methodological Considerations

With respect to methodological considerations, one can recognize an enchantment among clinical neuroscientists with artistic brain visualizations of physiological processes. A quote from *Screening the Body——Tracing Medicine's Visual Culture* [73] by art historian Lisa Cartwright can be seen as quite revealing in this regard:

> Neurologists clearly were fascinated by images of the body out of control. Such images were analyzed in the relative privacy of the laboratory and clinic or in the context of the medical professional meeting. Motion studies were viewed closely and repeatedly, whether through loop projection of films at scientific gatherings or through frame analyses conducted in the laboratory and published in professional journals. What was the neurologist's professional stake in subjecting patients to this kind of optical scrutiny? Many of the films that are considered … document conditions that clearly caused patients great somatic and psychical pain. … Patient identity and agency become crucial issues in the face of a form of documentation that so drastically reduces the person imaged to … the surveillant *neurological gaze* [73].

Clearly framed in its analysis to follow the French epistemologist of science Michel Foucault (1926–1984) [74], Cartwright traces an important trajectory of the visual culture of medicine. On the one hand, she sets the neurologists and basic neurophysiologists apart from other nineteenth-century medical colleagues by drawing attention to the functional details of motion and gait versus the pathological structures, which are of interest to most contemporary researchers [75]. On the other hand, Cartwright identifies a fundamental historiographical area. Owing to our current preoccupation with *neuroimaging*, its prehistory before the introduction of computer tomography around 1968 has been nearly forgotten [76]. In fact, the scientific presuppositions, methodological traditions, and epistemological problems are still much under-studied [77]. As neurophysiologist Nicholas Wade has rightly pointed out in his publications on the history of visual perception, the field of *neuroscience* and *art* is still sitting on the margins of the methodological discussions in many fields of the humanities, which have only begun to probe the burgeoning field of neuroimaging in the past 16 years [78].

The sub-specialties of the field of *neuroaesthetics*, which was co-founded by Welcome cognitive neurologist Semir Zeki in the United Kingdom, sought to examine the intriguing relations between all art and the visual brain, including features of theoretical conceptions, research practices, or appreciations of morphological preparations and neuroimaging techniques [79]. It has thereby emerged in the spectrum of other neuro-related sub-disciplines in the neurosciences, including 'neuro-ethics,' 'neuro-history,' 'neuro-economics,' etc. [80] and parallel to other peripheral disciplines to the clinical and laboratory-based neurosciences, which have entered current international discussions [81]. The seminal book of the neuroaesthetician Martin Skov, the psychologist Oshin Vartanian, the cognitive scientist Colin Martindale (1943–2008), and the philosopher Arnold Berleant, *Neuroaesthetics* has drawn attention to the significant aesthetical and practical foundations of neuroscientific creativity [80]. Yet, apart from being an eye-catching term and the notion of

neuroaesthetics being used for carving out funding niches within interdisciplinary fields of modern neuroscience, there are profound epistemological aspects here at stake as well, when the aesthetical, practical, and methodological foundations of human creativity and neuroscientific imagery are taken into account.

These research aspects principally regard the epistemology of scientific innovation, along with relationships between the modern life sciences and methodological elements from experimentation [82]. Some historiographical case studies about the nineteenth century [83] and the beginning of the twentieth century have respectively examined the non-discursive practices of clinical neurophysiology and neuroanatomy [84]. The resulting publications showed that the historical research traditions progressed from a collection- and comparison-oriented activity to a manufacture-based and eventually industrial endeavor [85]. A good overview on the increasing dimension of the industrialized production modes and their visualization results in neurophysiological laboratories has been given by historians of science Sven Dierig and Henning Schmidgen, in their edited volume on *Physiological and psychological practices in the nineteenth century——Their relation to literature, art and technology* [1].

When considering the intersections between industrialized and technology-driven research with elements of creativity, skills, and culture, the artistic presentations and visual products of the neurosciences have become the subject of increased historiographical research activities since the past 16 years [8]. The history of neuroscience moved further in the direction towards in-depth analyses of the visual practices and epistemologies of the media products in modern neurophysiology and the life sciences. Historians Sybilla Nikolow and Lars Bluma, for example, have synthesized the results of the *iconic turn* in the historiography of science in a well-received article on 'Images in the Public Sphere and Scientific Practice' [2], while the investigation of the so-called 'visual cultures' of science has moved towards more in-depth analyses of the media products in the life sciences [3]. The goal of this chapter has been to interrogate the intriguing advances in media studies and art history literature; analyze their impact on case studies in the history of neurophysiology and neurodegenerative disorders, as well as to provide insights into the historical imaging practices in the neurosciences themselves [86]. This includes considerations about developing interdisciplinary forms of reasoning and epistemic approaches, as these are for example used in modern functional Magnetic Resonance Imaging (MRI) techniques [87].

The specific interface(s) of images, patterns, morphological forms, and the rationales of design——often mutually referred to as the visual culture of modern neuroscience——have given rise to an increasing attention in the theory of the life sciences and the historiography of medicine [88]. Scholars in these areas have pointed to the seemingly analogous nature of scientific and openly artistic forms of creativity. When the current visualization practices within the neurosciences are considered, it becomes evident that their visual culture has emerged in ever more virtual forms of digitized images and figures——in both educational and research contexts alike. This is most obvious, for example, in the case of computer tomography [89], the Visual Human Project® [90], the Human Genome Project [91], or applications in

3D-gene-regulation analyses [92]. The digital nature of such images can be interpreted as an essential feature of all these visualization approaches, which are information-based processes that frequently transcend the influence and reach of human perception and decision-making. In the largely technology-based reprocessing of such information (in graphs, logarithmic abstractions, or enhanced PET scans etc.), much of the normal documentation in human endeavors, involving visual display as well as written text, gets transformed, aesthetically presented, and rendered comprehensible to the expert neuroscientists' eyes. This is often the result of dedicated interdisciplinary teams of electronic designers, bio-informaticians, and neurologists, which has also led to the development of related interdisciplinary forms of epistemology and forms of neuroscientific research approaches [93].

For example, one might point to the discussions of modern electrophysiologists, particularly when they look for 'elegant curves' in the interpretative process of neuronal firing frequencies; or neurogeneticists, who determine the most 'beautiful' bands in their gel electrophoreses [94]. This epistemic interest in the data structures and interpretations of brain science results certainly has since a long time overlapped in interesting ways with interest in design, beauty, aesthetics, and the arts. In addition——and broadly independent of individual researchers' skills——the technological equipment of the scientific laboratories themselves refer to subjective aesthetic habits (e.g. in medicine, the like or dislike for Apple MacIntosh® computer systems, the preference for Siemens Scanners®, or the neurosurgical equipment of Kopf®) [95]. Such 'minor details' do matter, in fact, since these offer specific features and patterns, which other forms of equipment generally would not have. These practical and aesthetic choices enable different perceptions of the experimental objects or lead to slightly altered plots and printouts of results later published in biomedical journals [96]. Similar instances of the appreciation or dislike for electron- or confocal microscopes in neurohistologists also result directly in the presence or absence of big technological instruments in modern neuroscience departments or institutes, while others miss such additional research options [97]. Many active neuroscientists like to discard such 'unpopular guests' as random factors to their research process:

> It is often thought that there is a unique and specific kind of barrier which protects science, and particularly scientific judgment, against the intrusion of so-called 'external influences', and that the barrier fails only in highly exceptional and unusual circumstances which can properly be considered pathological. ... Certainly, the evidence presently available suggests that 'external' influences upon scientific judgment are neither unusual nor necessarily pathological, and that the barrier, which such influences have to penetrate, is not fundamentally different from the boundaries surrounding other sub-cultures [98].

If we do however include such external instances within neuroscientists' aesthetic repertoires, then we can open up exciting new venues and intriguing research fields. The very practices of investigating and communicating research about the brain is unavoidably connected to aesthetic decisions, whether it is explicitly acknowledged in available scholarship or not! These insights may respectively help in lowering the gap between the specific methods of science and the arts.

4 Conclusion

In accordance with the view that subjective judgments, human perception, and aes-
thetical considerations were significant factors in contemporaneous knowledge gen-
eration processes, these elements became reintroduced into the scholarly analysis of
the modern biomedical life sciences [99]. Even beyond the activities of individual
researchers, the technological arrangements in physiological laboratories and neuro-
psychiatric clinics embodied their aesthetic value judgments that determined further
research progress in neuroscience [100]. These experimental and research arrange-
ments have come to unfold a contingent form of 'laboratory life,' in so far as they
represented any options of laboratory work. For example, Magendie's preference for
experimenting with young puppies (which he could get in the Parisian street mar-
kets), his frequent use of pinfeathers in the experiments (as these became experimen-
tally recycled), or the applicability of chemical substances for his qualitative
observations (he did not have sufficient access to histological staining techniques or
microphotographic equipment) can be seen as clear instances of aesthetic preference
decisions [15]. Thus, the uncertainty and randomness which modern neuroscientists
regularly report in their research——and which nineteenth-century physiologists
were quite aware of due to their limited research methodologies and instrumentation
[101]——are often present in research realities on the workbenches, and not rarely
experienced in very fruitful and creative ways too [102]. Uncertainty is however not
always an 'uninvited guest,' but often it guarantees a development of innovative sci-
entific creativity. The close epistemic relationship of experimental systems with their
environments has been described by historians of science as a process of '*experimen-
tal resonances*' [103]. It has also given rise to considerable interest by art historians
and media scholars, who became concerned with analogical operations——as '*semio-
logical systems*' as French philosopher Roland Barthes (1915–1980) remarked——in
other areas of human creativity, such as art, science, or literature [104].

The approach of social scholar of science and technology Karen Knorr-Cetina has
offered here a mediating stance between the notion of representation, the disciplinary
views of semiology, and advanced history of science interpretations of the processing
of physiological signs in laboratory experimentation [105]. These signs may be qual-
itatively assessed by an experienced experimenter, such as the nineteenth-century
neurophysiologists François Magendie or Claude Bernard in France. Yet they may
also be recorded by self-inscribing instruments or stained in organ and tissue-prepa-
rations, as was prominent with the neurophysiologists Ernst Bruecke, Carl Ludwig,
Hermann von Helmholtz, or the neuropsychiatrist Alois Alzheimer in Germany. For
Knorr-Cetina, a philosophical '*graphosphere*' has historically emerged and con-
nected the "process of compaction of the signs with the mechanosphere" of the phys-
iological laboratories [106]. From the laboratory 'repertoires' [107] of such early
laboratory neuroscientists——comprising animals, technological apparatuses, assis-
tants, and human researchers——(Fig. 6) a new learned practice of identifying,
describing, and aesthetically appreciating the research outcomes resulted.

Since the twentieth century the new graphosphere accompanied the development
of physiological expertise in basic and clinical neuroscience [108]. The profound

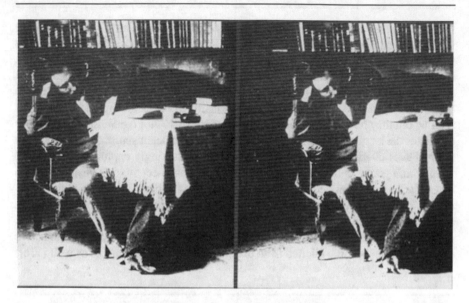

Fig. 6 Stereoscopic self-portrait (produced ca. 1904) by Santiago Ramón y Cajal (1852–1934). The stereophotograph is taken from: Bergua, Antonio. 1999. *A Stereoscopic Atlas of the Nervous System.* Erlangen: Wittig Books, 1999, n.1., n.pag. (Courtesy of Prof. Antonio Bergua, Clinical Department of Ophthalmology of the Friedrich Alexander University, Erlangen-Nuernberg, Germany)

transformation described here for the scientific form of knowledge generation makes visible what medical historian Karl Eduard Rothschuh (1908–1984) envisioned, when he emphasized the highly practical character of the life sciences as an applied and auxiliary science in the field of medical research——including modern neuroscience. Rothschuh stated:

> Scientific knowledge in medicine is not an end in itself, but merely a means to an end The meaning of the medical endeavor is the liberation of basic needs, through which the pursuit of knowledge is turned into the generation of knowledge for specific aims Medicine needs science, but it is not a science in itself, it is not even an applied science Medicine is predominantly involved in values of being, not in the knowledge pursuit. In the first place, the physician is called for to cure and only secondarily to generate knowledge [109].

This approach aims precisely at a problem that may be reinterpreted as an intersection of art history, epistemology, and the history of science. This is a problem field in which mutual interests are entwined which thereby allows for a reconstruction of all those traces and remnants that the scientific, creative, and artistic human endeavor left behind [110]. Most important for the development of the modern *neurological gaze* has been the continued development of neurophysiology and clinical neurology, as Martin Kemp has coined earlier on:

> Latterly, artists have been fascinated by the revelations of mental processes from modern imaging techniques, especially functional magnetic resonance imaging (fMRI) [111].

In one sense, art and aesthetic considerations have presented an experimental field for mental and neurological processes, while the nature of the processes themselves have now come into the focus of history of science scholarship as well [112]. Artists such as the English computer designer Andrew Carnie [113] and the Scottish plastic sculptor Annie Cattrell [114] seize upon the imagery emerging from neuroscience to create their own three-dimensional translations of the data generated by scientists with whom they have collaborated. Cattrell's series of *The Five Senses* for example translates the localization of sensory activity into translucent sculptures in which the pointed sites of transitory neuronal activity are fascinatingly captured in persistent form within glassy cubes [115]. Moreover, artists have become quite excited by the investigation of human neurophysiological processes through modern imaging techniques, especially functional magnetic resonance imaging approaches. Theoretical advancements in history of science and the media studies have shown, that art is presenting itself now as an experimental field for mental processes, while the nature of the processes become elicited from practical-aesthetic perspectives as well [116].

5 Discussion: Future Research Directions on the Intersections Between History of Neuroscience and Theory of Neuroaesthetics

From here, several important questions for future research on the intersections between history and theory of neuroaesthetics may be developed: How are the signs and values produced in experimentation processes in the neurosciences, when also the social contexts of their development are considered [117]? How can the practical and aesthetic resonances between the experimental laboratories, their technological, and social environments be causally explained? And: When and how are experimental scientists influenced through artistic and aesthetic perceptions [12]? In what ways can public media influence the work of researchers and *vice versa* [118]? If one follows the thesis of art historian Bredekamp about the influential feature of the *Lure of Antiquity* for the development of eighteenth-century wonder cabinets as proto-laboratories of the modern life sciences, then how can the relationship of modern idealizations [119]——for example in science fiction representations or visual art——be described *vis-à-vis* the heuristic role of aesthetics perceptions [120]? Furthermore, what are the perceptual grounds that neurophysiology has offered for aesthetic theorizing [121]? Is there a specific form of a 'neuronal aesthetics' [122]? How can the documentary, representative, and promotional functions of scientific images be explained [123]? What would be the best way to analyze the functions of visual modeling [124]? And finally: What is the distinguished role of computer simulations in *NeuroArt* as well as in neurological diagnostics [125]?

The term neuroaesthetics, however, as it is currently applied in empirical and scientific studies is often used in very limited ways, primarily focusing on using neuroscientific tools to study art interactions yet not sufficiently questioning the methods used or the specific consequences on the outcome and even design of

respective research studies. Practitioners of neuroaesthetics, especially in existing reviews of the field, have so far focused primarily on questions of visual beauty, art, and pleasure in neuroscience research and empirical investigations of aestehtics [126]. Yet they have rarely dived into questions especially concerning neurodegeneration, nor have they addressed the historical development of neurophysiology and case examples from clinical neurology. However, art-based and aesthetic criteria have played a major role in the development of the graphematic approach in modern neuroscience has become an established position in the history of modern science and medicine [127]. Yet how has the relationship between a 'symbolic system' and a 'symbolic culture'——as in the introduction of microscopes and the pursuit of graphematic experimentation in neurophysiology——materialized, after these had been introduced into the studies and laboratory workbenches of nineteenth-century neurosciences [128]? While looking at the epistemic permeability of the borders between art, technology, and neuroscience in this chapter, it has become clearer that the education of visual association and diagnostic processes even preceded those of modern language systems of the brain. Since the eighteenth century, the dominance of language in medical science was rivaled by the increasing hegemony of imagery in the form of specimen collections, pathological and clinical paintings, as well as plaster cast models. The nineteenth century then marked a period of increasing interest in experimental neurological practices that depended on an observational visual culture, aesthetic decision-making, and elegant laboratory and clinical practices.

In such a self-reflective imagery, since the twentieth century, the relationship of neurological research and creative expression has also helped to illuminate the intersection of illness and creativity, as was shown in the case example of early Alzheimer's Disease diagnostics. The history of neuroscience and related epistemological perspectives can thus foster a critical awareness for the visual origins and aesthetic foundations in human brain research along with its important public place in modern industrial societies [129]. This chapter has ventured to provide some good reasons and examples that researchers and clinicians could use as starting points to think about creative solutions and aesthetic concepts in the wider field of neuroscience. Researchers within other fields open to neuroscientific methodologies may thus appreciate seeing that neuroscience and art—even though the quantification culture has grown to a scientific standard—are connected through aesthetic considerations by the essential way of the human condition.

Acknowledgments The original impulse to think about the intersections between brain research, aesthetic practices, and situated forms of art came from my esteemed colleague, vision science and physiology historian Guel A. Russell at Texas A & M University. With the help of an Alexander von Humboldt Foundation-funded stay as a visiting scholar in interaction with "The Virtual Laboratory" at the Dept. III ("Experimental Systems and Spaces of Knowledge") at the Max Planck Institute for the History of Science in Berlin, headed by Hans-Joerg Rheinberger, I could further the insights previously gained. I also thank all the reviewers of an earlier version of the manuscript, and specifically wish to express my gratitude to the editors of this volume, Blanca Spee, Matthew Pelowski, and Alby Richards for their remarkably rich suggestions and constructive comments which have fostered my modifications and revisions of this chapter.

References

1. Dierig S, Schmidgen H, editors. Physiological and psychological practices in the 19th century: their relation to literature, art and technology. Berlin: Max Planck Institute for the History of Science; 2001.
2. Nikolow S, Bluma L. Images in the public sphere and scientific practice. NTM. 2002;10(2):201–8.
3. Heintz B, Huber J, editors. Mit den Augen denken. Voldemeer: Strategien der Sichtbarmachung. Vienna; 2001.
4. Canguilhem G. History of the life sciences (trans. Waldo Cohn). London: Routledge; 1968. p. 19.
5. Scott J, Stoekli E, editors. Neuromedia: art and neuroscience research. Heidelberg: Springer; 2012.
6. Ortega F, Vidal F. Neurocultures: glimpses into an expanding universe. Frankfurt am Main: Peter Lang; 2011.
7. Boehm G. Wie Bilder Sinn erzeugen: Die Macht des Zeigens. Berlin: Berlin University Press; 2007.
8. Marschall S, Bauer M, Liptay F, editors. Kunst und Kognition: Interdisziplinaere Studien zur Erzeugung von Bildsinn. Munich: Fink; 2008.
9. Wade N. Deceiving the brain: pictures and visual perception. Progr Brain Res. 2013;204(1):115–34.
10. Århem B, Lindhal IB. Neuroscience and the problem of consciousness: theoretical and empirical approaches. An introduction. Theor Med Bioeth. 1993;14(2):77–88.
11. Hyman J. Art and neuroscience. In: Frigg R, Hunter MC, editors. Beyond mimesis and convention. Boston, MA: Boston Studies in the Philosophy of Science; 2010. p. 101–40.
12. Rheinberger HJ. The art of exploring the unknown: views on contemporary research in the life sciences. In: Epple M, Zittel C, editors. Cultures and politics of research from the early modern period to the age of extremes. Berlin: Akademie Verlag; 2010. p. 141–51.
13. Sturdy S. Looking for trouble: Medical science and clinical practice in the historiography of modern medicine. Soc Hist Med. 2011;24(4):739–57.
14. Lakatos I. Popper on demarcation and induction. In: Schilpp PA, editor. The philosophy of Karl Popper, vol. 1. La Salle, Ill: Open Court; 1974. p. 241–73.
15. Pickering A, editor. Science as practice and culture. Chicago, IL: Chicago University Press; 1994. p. 431–3.
16. Bynum W. Science and the practice of medicine in the nineteenth century. Cambridge: Cambridge University Press; 1994.
17. Rheinberger HJ. Toward a history of epistemic things: synthesizing proteins in the test tube. Stanford, CA: Stanford University Press; 1997.
18. Coleman W. The cognitive basis of the discipline. Claude Bernard on physiology. Isis. 1985;76(1):49–70.
19. Stahnisch FW. Historical and philosophical perspectives on experimental practice in medicine and the life sciences. Theor Med Bioeth. 2005;26(4):397–425.
20. Lenoir T. The strategy of life: teleology and mechanics in nineteenth-century German biology. Chicago, Ill: University of Chicago Press; 1982.
21. Bierbrodt J. Naturwissenschaft und Aesthetik, 1750–1810. Wuerzburg: Koenigshausen & Neumann; 2000. p. 6. author's trans.
22. Rousseau G, editor. Nervous acts: essays on literature, culture and sensibility. London: Palgrave Macmillan; 2005.
23. Daston L, Galison P. Objectivity. New York: Zone Books; 2010. pp. 115–24.
24. Bredekamp H. The lure of antiquity and the cult of the machine. Princeton, NJ: Princeton University Press; 1995.
25. Baumgarten AG. Aesthetica. Jena: Johannes Christian Kleyb; 1750.
26. Poppe JG. Alexander Gottlieb Baumgarten: seine Bedeutung und Stellung in der Leibniz-Wolffischen Philosophie und seine Beziehungen zu Kant; nebst Veroeffentlichung einer bisher unbekannten Handschrift der Aesthetik Baumgartens. Leipzig: Noske; 1907. p. 47.

27. Pelowski M, Specker E. The general impact of context on aesthetic experience. In: Nadal M, Vartanian O, editors. The Oxford handbook of empirical aesthetics. Oxford: Oxford University Press; 2020. p. 10. https://doi.org/10.1093/oxfordhb/. 9780198824350.013.
28. Sturken M, Cartwright L. Practices of looking: an introduction to visual culture. 3rd ed. Oxford: Oxford University Press; 2017. p. 10.
29. Bichat X. Recherches physiologiques sur la vie et la mort. 3rd ed. Paris: Brosson; 1805.
30. Mueller J. Ueber die phantastischen Gesichtserscheinungen. Coblenz: Johannes Hoelscher; 1826.
31. Der HM. Geist bei der Arbeit: Historische Untersuchungen zur Hirnforschung. Goettingen: Wallstein Verlag; 2006.
32. Magendie F. Précis élémentaire de la physiologie, vol. 1. Paris: Méquignon-Marvis; 1816–1817.
33. Lesch J. Science and medicine in France: the emergence of experimental physiology, 1790–1855. Cambridge, MA: Harvard University Press; 1984.
34. Dierig S. Urbanization, place of experiment and how the electric fish was caught by Emil Du Bois-Reymond. J Hist Neurosci. 2000;9(1):5–13.
35. Tanner J, Sarasin P. editors. Physiologie und industrielle Gesellschaft: Studien zur Verwissenschaftlichung des Koerpers im 19. und 20. Jahrhundert. Suhrkamp: Frankfurt/ Main; 1998.
36. Mueller-Wille S, Reinberger HJ. A cultural history of heredity. Chicago, Ill: Chicago University Press; 2012.
37. Stevenson A. Technologies. In: Stevenson A, editor. Oxford English dictionary. Oxford: Oxford University Press; 2012. p. 545.
38. Hirnstroeme BC. Eine Kulturgeschichte der Elektroenzephalographie. Goettingen: Wallstein; 2005.
39. Stahnisch FW. Ideas in Action: Der Funktionsbegriff und seine methodologische Rolle im Forschungsprogramm des Experimentalphysiologen François Magendie (1783–1855). Muenster: LIT; 2003.
40. Todes DP. Pavlov's physiology factory: experiment, interpretation, laboratory enterprise. Baltimore, MD: Johns Hopkins University Press; 2001.
41. Brain RM, Cohen RS, Knudsen O, editors. Hans Christian Ørsted and the romantic legacy in science: ideas, disciplines, practices. Dordrecht: Springer; 2007.
42. Daston L, Galison P. The image of objectivity. Representations. 2009;40(1):81–128.
43. Stahnisch FW. Instrument transfer as knowledge transfer in neurophysiology: François Magendie's (1783–1855) early attempts to measure cerebrospinal fluid pressure. J Hist Neurosci. 2008;17(1):72–99.
44. Mayer A. The physiological circus: knowing, representing, and training horses in motion in nineteenth-century France. Representations. 2010;111(1):88–120.
45. La CG. formation du concept de réflexe aux XVIIe et XVIIIe siècles. Paris: Vrin; 1994.
46. Daston L. Objectivity and the escape from perspective. Soc Stud Sci. 1992;22(4):597–618.
47. Cranefield P. The organic physics of 1847 and the biophysics of today. J Hist Med Allied Sci. 1957;12(4):407–23.
48. Bruecke E. Die Physiologie der Farben fuer die Zwecke der Kunstgewerbe. Leipzig: S. Hirzel; 1866.
49. DuBois-Reymond E. Laboratory diary, experiments 1886–1889. Berlin: Staatsbibliothek; 1886–1889.
50. Helmholtz H. Treatise on physiological optics (trans. James P. C. Southall). Washington, D. C.: Optical Society of America; 1910.
51. Bernard C, Dumas JB, Bert P. La science expérimentale. Paris: J.B. Baillière; 1878.
52. Bernard C. qtd. after Drewsen S. Medizin: Wissenschaft oder Kunst? Wuerzb medhist Mittlgn 1989. 1878;7(1):45–53. author's trans.
53. Clarke E, O'Malley CD. The human brain and spinal cord: a historical study illustrated by writings from antiquity to the twentieth century. 2nd ed. San Francisco: Norman; 1996.

54. Finger S. The birth of localization theory. In: Finger S, Boller F, Tyler KL, editors. History of neurology: handbook of clinical neurology, 95th vol., 3rd ser. Edinburgh: Elsevier; 2010. p. 117–28.
55. Geimer P, editor. Ordnungen der Sichtbarkeit. Fotografie in Wissenschaft, Technologie und Kunst. Frankfurt/Main: Suhrkamp; 2002.
56. Grampp S, Kirchmann K. 'Meine Herren, es geht das Geruecht um, dass ich ein Feind des Roentgenbildes bin:' Der Arzt als Zeichenleser, Medienkritiker und Sinnstifter in popu- laeren Mediendiskursen. In: Stahnisch FW, Bauer H, editors. Bild und Gestalt. Wie formen Medienpraktiken das Wissen in Medizin und Humanwissenschaften? Hamburg: LIT Press; 2007. p. 181–98.
57. Bilderwissen KM. Die Anschaulichkeit naturwissenschaftlicher Phaenomene. Cologne: Dumont; 2000.
58. Kemp M. Sculpture: the brain in a nutshell. Nature. 2011;470(7333):173.
59. Breidbach O. Die Materialisierung des Ichs: Zur Geschichte der Hirnforschung im 19. und 20. Jahrhundert. Frankfurt/Main: Suhrkamp; 1997.
60. McLaughlin P. What functions explain: functional explanation and self-reproducing systems. Cambridge: Cambridge University Press; 2001.
61. Lynch M. Representation is overrated: some critical remarks about the use of the concept of representation in science studies. Configurations. 1994;1(1):137–49.
62. Bredekamp H. The lure of antiquity and the cult of the machine. New York: Markus Wiener Publisher; 2010. p. 153.
63. Rheinberger HJ. Experiment, Differenz, Schrift. Zur Geschichte epistemischer Dinge. Marburg/Lahn: Basilisken-Presse; 1992.
64. Gradmann C. Laboratory disease: Robert Koch's medical bacteriology (trans. Elborg Forst). Baltimore, MD: Johns Hopkins University Press; 2009.
65. Lynch M. Sacrifice and the transformation of the animal body into a scientific object: labora- tory culture and ritual practice in the neurosciences. Soc Stud Sci. 1988;18(3):265–89.
66. Stahnisch FW. Den Hunger standardisieren: François Magendies Fuetterungsversuche zur Gelatinekost 1831–1841. Med J. 2004;39(1):103–34.
67. Battin J. Autographs of physicians and famous scholars. Hist Sci Méd. 2006;40(1):129–40.
68. Alzheimer A. Ueber einen eigenartigen schweren Erkrankungsprozess der Hirnrinde. Neurol Centrlbl. 1906;23(11):1129–36. author's trans
69. Drouin E, Drouin G. The first report of Alzheimer's disease. Lancet. 2017;16(9):687.
70. Engstrom E. Researching dementia in Imperial Germany: Alois Alzheimer and the econo- mies of psychiatric practice. Cult Med Psych. 2007;31(4):405–12.
71. Stahnisch FW. A new field in mind: a history of interdisciplinarity in the early brain sciences. Montreal, PQ: McGill-Queens University Press; 2020. p. 184–6.
72. Graeber MB. No man alone: the rediscovery of Alois Alzheimer's original cases. Brain Pathol. 1999;9(2):237–40.
73. Cartwright L. Screening the body: tracing medicine's visual culture. St. Paul, MN: University of Minnesota Press; 1995. p. 48.
74. Foucault M. Birth of the clinic (trans. Alan mark Sheridan Smith). London: Routledge; 1989.
75. Stahnisch F. L'image de la posture—l'image du mouvement: Zum Verhaeltnis orthopae- discher und neurologischer Repraesentationsformen in der klinischen Photographie des 19. Jahrhunderts Wuerzb medhist Mittlgn. 2009;28(1):301–52.
76. Raichle M. The origins of functional brain imaging in humans. In: Finger S, Boller F, Tyler KL, editors. History of neurology: handbook of clinical neurology, 95th vol., 3rd ser. Edinburgh: Elsevier; 2010. p. 257–68.
77. Stahnisch FW. The language of visual representations in the neurosciences: relating past and future. Transl Neurosci. 2014;5(1):78–90.
78. Wade NJ. Vision and visualisation. J Hist Neurosci. 2008;17(3):274–94.
79. Zeki S. Art and the Brain. Daedalus. 1998;127(2):71–103.
80. Skov M, Vartanian O, Martindale C, Berleant A, editors. Neuroaesthetics. Baywood: Amitiville, NY; 2009.

81. Vidal F. Historical and ethical perspectives of modern neuroimaging. In: Clausen J, Levy N, editors. Handbook of neuroethics. New York: Springer; 2014. p. 461–6.
82. Hagner M, Borck C. Mindful practices: on the neurosciences in the twentieth century. Sci Context/Special issue. 2001;14(4):507–10.
83. Berlucci G. The contributions of neurophysiology to clinical neurology: an exercise in contemporary history. In: Finger S, Boller F, Tyler KL, editors. History of neurology: handbook of clinical neurology, 95th vol., 3rd ser. Edinburgh, UK: Elsevier; 2010. p. 169–88.
84. Roland PE, Balázs G. Visual imagery and visual representation. Trends Neurosci. 1994;17(3):281–7.
85. Stahnisch FW. Medicine, life and function: experimental strategies and medical modernity at the intersection of pathology and physiology. Bochum: Projektverlag; 2012. pp. 81–114
86. Smith K. Looking for the hidden signs of consciousness. Nature. 2007;446(1):355.
87. Raichle ME. Functional brain imaging and human brain function. J Neurosci. 2003;23(10):3959–62.
88. Carusi A, Sissel Hoel A, Webmoor T, Woolgar S, editors. Visualisation in the age of computerization. London: Routledge; 2014.
89. Liston AD, Bayford RH, Holder DS. The effect of layers in imaging brain function using electrical impedance tomography. Physiol Meas. 2004;25(1):143–58.
90. Waldby C. The visible human project: Informatic bodies and posthuman medicine. London, UK: Routledge; 2007.
91. Davies K. Cracking the genome: inside the race to unlock human DNA. Baltimore, MD: Johns Hopkins University Press; 2002.
92. Burleigh I, Suen G, Jacob C. DNA in action! A 3D swarm-based model of a gene regulatory system. In: ACAL, editor. First Australian conference on artificial life. Cranberra: ACAL; 2003. p. 69–94.
93. Caspers J, Zilles K, Beierle C, Rottschy C, Eickhoff SB. A novel meta-analytic approach: mining frequent co-activation patters in neuroimaging databases. NeuroImage. 2013;90(4):390–402.
94. Hoefel L, Jacobson TF. Electrophysiological indices of processing aesthetics: Spontaeneous or intentional processes? Int J Psychophysiol. 2007;65(1):20–31.
95. Smith LF. The science and aesthetics of astronomical images. Psychol Aesthet Creat Arts. 2014;8(4):506–13.
96. Palmer SE, Schloss KB, Sammartino J. Visual aesthetics and human preference. Ann Rev Psychol. 2013;64(1):77–107.
97. Gundling RL. How healthcare executives make buying decisions. Washington, D. C: Healthcare Financial Management Association; 2012.
98. Barnes B, David E, editors. Science in context. Readings in the sociology of science. Cambridge, MA: MIT Press; 1982.
99. Borck C. Recording the brain at work: the visible, the readable, and the invisible in electroencephalography. J Hist Neurosci. 2008;17(4):367–79.
100. Sattar A. The aesthetics of laboratory inscription: Claude Bernard's Cahier Rouge. Isis. 2013;104(1):63–85.
101. Worboys M. Practice and the science of medicine in the nineteenth century. Isis. 2011;102(1):109–15.
102. Dierig S. Engines for experiment: laboratory revolution and industrial labor in the nineteenth-century city. Osiris. 2003;18(1):116–34.
103. Rheinberger HJ. Experimental systems: historiality, narration, and deconstruction. Sci Context. 1994;1(1):65–81.
104. Barthes R. The rhetoric of the image. In: Heath S, editor. Image, music, text. New York: Hill and Wang; 1977.
105. Knorr-Cetina K. The manufacture of knowledge: An essay on the constructivist and contextual nature of science. Oxford: Pergamon Press; 1981.
106. Knorr-Cetina K. Epistemic cultures: how the sciences make knowledge. New York: Oxford University Press; 1999. p. 49.

107. Tarrow S. Cycles of collective action: between movements of madness and repertoires of contention. Soc Sci Hist. 1994;17(2–3):281–306.
108. Vidal F. Brainhood, anthropological figure of modernity. Hist Hum Sci. 2009;22(1):6–35.
109. Rothschuh KE. Konzepte der Medizin in Vergangenheit und Gegenwart. Stuttgart: Hippokrates; 1978. p. 419. author's trans
110. De Chadarevian S. Designs for life: molecular biology after World War II. Cambridge, UK: Cambridge University Press; 2002.
111. Kemp M, Cole S. Science and technology studies on trial: dilemmas of expertise. Soc Stud Sci. 2008;35(3):269–311.
112. Reuter-Lorenz P, Baynes K, Mangun GR, Phelps EA, editors. The cognitive neuroscience of mind: a tribute to Michael S Gazzaniga. Cambridge, MA: MIT-Press; 2010.
113. Tarn H, editor. Brainwave: common senses. New York: US Exit Art Publications; 2009.
114. Bathe C. Beauty in the MRI of the beholder. Imp Coll Sci Mag. 2006;1(1). isciencemag.co.uk.
115. Kemp M. Science and culture. Nature. 2004;424(618):1.
116. Wilkinson DM. Science in culture: Hidden talent. Nature. 2007;447(148):1.
117. Sturken M, Cartwright L, editors. Practices of looking: an introduction to visual culture. Cambridge, MA: MIT Press; 2002.
118. Goodman N. Languages of art: an approach to a theory of symbols. 2nd ed. Indianapolis: Hackett Publishing Company; 1976.
119. Bredekamp H. Ein Missverstaendnis als kuenstlerischer Dialog. Bemerkungen zur Antikenrezeption der Romantik. Kunstforum Int. 1991;111(1):98–107.
120. Schaper-Rinkel P. Gestaltsehen der Zukunft – Bildwelten der zukuenftigen Nanotechnologie und Nanomedizin in Wissenschaft und Politik. In: Stahnisch FW, Bauer H, editors. Bild und Gestalt. Wie formen Medienpraktiken das Wissen in Medizin und Humanwissenschaften? Hamburg: LIT Press; 2007. p. 245–63.
121. Wade N. Geometrical optical illusionists. Perception. 2014;43(8):846–68.
122. Breidbach O, editor. Aesthetik und Naturwissenschaften. New York: Springer; 2002.
123. Kemp M. Artists on science and scientists on art. Nature. 2005;434(7031):308–9.
124. Kemp M. The science of art: optical themes in western art from Brunelleschi to Seurat. New Haven, NJ: Yale University Press; 1992.
125. Neuronale BO. Aesthetik. In: Clausberg K, editor. Neuronale Kunstgeschichte. Selbstdarstellung als Gestaltungsprinzi. Vienna: Springer; 1999. p. 34–60.
126. Nicklas P, Lindner O, editors. Adaptation and cultural appropriation. Berlin: de Gruyter; 2012.
127. Beaulieu A. Images are not the (only) truth: Brain mapping, visual knowledge, and iconoclasm. Sci Tech Hum Val. 2002;27(1):53–86.
128. Draisma D. Metaphors of memory. A history of ideas about the mind. Cambridge, UK: Cambridge University Press; 2000.
129. Pickersgill M, Van Keulen I, editors. Sociological reflections on the neurosciences. Emerald: Bingley; 2012.

Where Do Artists Come From? A Review of the 'Typical' Visually Creative Life and Artistic Brain as a Basis for Discussing Neurodivergence or Neurodegenerative Change

Matthew Pelowski and Rebecca Chamberlain

1 Introduction

Not everyone can become a great artist, but a great artist can come from anywhere.—
Peter O'Toole
The job of the artist is always to deepen the mystery…—Sir Francis Bacon

This book, of which this chapter is a part, is about people who changed the ways in which they related to being visually creative or made art. Maybe they suddenly found themselves with a heightened interest in producing artworks, ramping up, greatly, their artistic production. Maybe they found themselves spontaneously able to see or think in novel ways, to make new associations, act with new confidence or courage; without inhibition. Maybe they found themselves producing in new media; in different styles or colors. Maybe they started up as artists for the first time ever. Or, maybe they felt their artistic interests and abilities slipping, changing, becoming something different—whether worse or better.

Within the forthcoming chapters, these changes serve as the basis for a number of intriguing discussions of the equally changing lives, bodies, and especially brains of individuals living with neurological diseases, and with the overarching possibility, if not explicit hypothesis, that these changes may be *connected*. Whether in the emerging body of case studies, discussions of caregivers, causative approaches, or even the reflections of artists about their lives and output, it is this bridge that holds

M. Pelowski (✉)
University of Vienna, Vienna, Austria
e-mail: matthew.pelowski@univie.ac.at

R. Chamberlain
Goldsmiths University of London, London, UK
e-mail: r.chamberlain@gold.ac.uk

© The Author(s), under exclusive license to Springer Nature Switzerland AG 2023
A. Richard et al. (eds.), *Art and Neurological Disorders*, Current Clinical
Neurology, https://doi.org/10.1007/978-3-031-14724-1_2

the promise of this book's very topic. Might—by changing our brain or our actions—we reveal something about what it means to have these disorders, about how we typically think and perceive; about how and why we make art? Similar interests, given the existence of this book, are evidently held by clinicians, neurologists, and working artists.

However, this also begs a fundamental question: In order to discuss individuals becoming more, less, or differently involved in art, we must first have an idea of *from what and to where* these changes might proceed. What do we currently know about the otherwise 'neurotypical' artist? What specific factors are currently thought to be involved in art making? What might help shape and drive the artistic act, lifestyle, or propensity? What would a researcher *even need to know* to delve into the mysterious topic of the potentially changing artist neurophysiology?

Thus, this chapter's aim. We review the scholarship on art making, the minds and actions of artists, and a number of factors that might contribute to artistic ability. This is written with the forthcoming chapters and topics in mind, to arm the reader with a set of basic ideas and avenues regarding the bodies, the activities, and the brains of artists, and with the idea that this collection might give a basis for subsequently considering how these may change. This can also be used by practitioners in neurology who might like to integrate artistic topics into their scholarship, their case studies, or work with patients, providing a lexicon of methodology and future leads. Interestingly, such a review is also rather lacking in current psychology of art or artistic creativity itself. Therefore, for many readers, it is our hope that this chapter may further a discussion on where to begin looking to appreciate, and to unravel, the mysterious intersection of the changing and the artistic body, life, and brain.

2 Beginnings: What Might We Need to Know to Study, and to Think About, Artists and Art Making?

So, where *do* artists come from? How *do* we make art? On the one hand, these questions seem almost trivial—we just manipulate our environments in some way, use our minds and bodies to change our surroundings by marking, shaping, replacing, to make something new in some lasting, albeit if only momentary, way. The literature tells us that marking (drawing, creating) is a universal activity for children [1]. This is to say nothing of the philosophical argument that by declaring what we are doing to be art-making, this very act 'makes' our actions art, perhaps even more successfully if we get enough other people, or an institution, to agree! Could, therefore, not everyone do some sort of creative act, or be an artist, in their own way?

In short, probably 'yes'. The fact that we do not all often make art or think of ourselves as 'artists,' however, and the fact that, when we do, we may have wildly different degrees of competency, and that many of the 'basic' aspects of art making themselves may be, it still seems, unique to humans, makes this topic so fascinating.

2.1 A Brief Note on the History of Empirical Artist Studies

Artists, art making, and creativity, in general, are in fact some of the oldest topics in the empirical study of psychology, and interest goes much further back throughout philosophy. Since the dawn of humans' ability to create visual images, those with a unique ability in this domain have probably always received a special reverence. A visit to a museum, a studio, or an elementary school will confirm that we have a particular interest in those who can draw what they see, or who can make something novel or creative. Art making may date back to the dawn of our genus [2] and is among the few acts that may qualitatively differentiate humans from all other species [3] (Fig. 1).

Studies on art making also emerged as a branch of psychology in the late nineteenth century when the field was distinguishing itself as a scientific discipline. The field's founding is often attributed to Fechner [4], who, among other approaches, stressed the "method of production" as a driving element in his search for general laws guiding human thoughts and actions [5]. Art making was also taken up as a topic in the United States and Europe in the 1920s during a second wave of psychological interest, fueled by a demand for measures of abilities, aptitudes, or personalities, combined with a general recognition of "creativity," and which led to the development of several standardized drawing assessments [6]. The next 100 years saw a handful of research on art viewing, including landmark works by Arnheim [7] and Berlyne [8]. This continues to the present day.

However, while studies on aesthetic *reception* of art have been steadily increasing, since Fechner, there has been a disproportionate scarcity of studies on visual art making and visual creativity itself. There are several reasons: Amongst these is the ineffable nature of art production [9, 10]. Even during Fechner's time, it was recognized that the sheer breadth of decisions and overlapping abilities that go into art, as well as its open-ended nature, make it particularly difficult to study empirically [5, 11]. This difficulty is also compounded by limitations in technology, especially when considering the mobile, often messy, act of making art. How does one fix an artist to a location for study; what does one look at, especially if one wants to, say, consider the brain? This is compounded by a shifting definition of art itself [12], and

Fig. 1 Left, example of advertisement for artistic talent test, from Art Instruction, Inc. (Minneapolis, Minnesota, 1914–2018); Middle, "Alexander the Great and Campaspe in the Studio of Apelles," 1744, etching on laid paper (by Francesco Fontebasso, Venetian, 1709–1769), National Gallery of Art, Washington DC., image is in the public domain); Right, "Street painter in Assisi," 2011 (by Zorro2212, Creative Commons Attribution-Share Alike 3.0 Unported)

with the bulk of research on art production only being conducted in the past few decades ([13–15] for review). That said, this has produced a rather fascinating—if not consensus—set of arguments that might also fuel a discussion of the changing brain.

2.2 How Are Artistic Interests, Processes, and Abilities Typically Assessed?

Before getting to these findings, it is perhaps instructive to give an idea of how artistic ability or art production is often assessed for the purpose of most studies (see also Ref. [16] for review). *Focusing on approaches used with adults*, which best aligns with this book's overall aim, the ways in which researchers seek to measure artistic performance are, of course, diverse, and reflect different kinds of research questions: Researchers use a mix of self-report assessments, in which individuals are asked about their subjectively perceived creativity or penchant for art making, which can also reference or predict ability (see Ref. [17]). Notable examples include the Group Inventory for Finding Creative Talent (GIFT; Ref. [18]), which includes examples such as "I am very aware of artistic considerations," the Creative Personality Scale (CPS; [19]), or the Creativity Scale for Diverse Domains (CSDD: see Ref. [20]). This latter battery uses nine items covering areas from mathematics and interpersonal relations to art making, as well as one global self-concept question ("How creative would you say you are in general?"). Professional artists tend to score higher on items measuring artistic creativity and in general creativity compared to, say, scientists [21]. More recent batteries also delve into more specific factors of art making, such as the survey of Self-assessed artistic abilities [22], which also tends to show high correlations with others' appraisals of an individual's produced art [23].

Researchers also consider and compare life history or activities, or even look at past training or experiences. These can be assessed via biographical inventories (see Ref. [17]). Schaefer and Anastasi's [24] Biographical Inventory for Identifying Creativity in Adolescents, for example, measures family background, motivation, intellectual and cultural orientation (hobbies, frequency of visits to museums/galleries), or drive towards novelty, and has been shown to correlate to instructors' creativity ratings of art [17]. A more recent battery such as the Creative Achievement Questionnaire (CAQ: [25]) asks individuals to rate their own creativity in ten domains, including music, theater, film, and visual art, with a focus on real-world, objective factors such as selling works or joining exhibitions. Somewhat similarly, historiometric research applies quantitative techniques to historical data (e.g., biographical accounts, statistics on distribution and consumption of creative products) of creatively eminent individuals [26, 27]. Such research takes the historical prominence of individuals as a priori proof of creative performance and uses this to explore its possible predictors.

There are also several techniques for actually assessing performance. A bulk of the existing research is targeted less at art making and more at general questions of visual creativity or even divergent or convergent thinking. Visual creativity is

typically defined as the production of both novel and useful forms within a given context [28], and is considered a main counterpoint to verbal creative skills. Thus, both are often combined in research. The most commonly used measure is the Alternative Uses Test (AUT; [29]), in which a participant is provided with a stimulus (usually a familiar object like a rope or a brick) and asked to list as many uses as possible. From the responses, fluency (how many), originality, flexibility (how many from different categories), and elaboration (how detailed) are often measured. Convergent thinking, on the other hand, requires participants to arrive at one solution to a creative problem (the most commonly used task is the Remote Associates Test, RAT; [30]). Both approaches may touch on certain aspects of art making— such as coming up with ideas or flexible associations—but also tend to omit actual outputs or production processes. They are also, especially in the case of divergent thinking, highly susceptible to primes such as whether or not one is told to "be creative" or to do something else [31].

Among tests that actually do assess production, most focus, once again, on general creativity but involve drawing or constructing a product as a part of the paradigm. A main variety is figure completion, which involves participants using visual cues pre-printed on paper as a basis for creating new designs (see Fig. 2). The most used measure, and in fact a component of the most common measure of creativity itself [39], is the Torrance Tests of Creative Thinking (TTCT; [40]). This consists of both verbal and figural tasks in which participants complete drawings from a set of shapes or lines and assign a title. These can be scored for fluency, originality, elaboration, title abstractness, etcetera. The figural test has shown good validity for predicting creativity [41] and can also be scored for 13 further aspects related to art [42], including storytelling, movement and action, unusual visualization, or richness of imagery. This tool, employing also the extended assessments, is also one of the only standardized batteries used in published case studies of artists showing neurodegenerative disease (e.g., Fornazzari assessing AD) [43]. More recent developments are the Test for Creative Thinking-Drawing Production (TCT-DP: [38]), which also uses preprinted cues and a standardized scoring sheet assessing continuation, completion, connections, boundary-breaking (drawing outside a square frame), use of perspective, new elements, humor, or affectivity. The Consensual Assessment Technique (CAT; [44]) involves participants generating a creative output from a given set of elements such as lines, blocks, clay, etc., which are then rated by a group of (expert or quasi-expert) judges relative to other artists in the same sample.

Techniques have also begun focusing more on art production or related components. One main line of study involves realistic drawing, or the ability to copy from a target image such as a hand or still life, which then can be assessed for fidelity by a panel of judges (see Ref. [14] for review; also Fig. 2). This was developed to address the ability to visually encode and physically reproduce what we see, arguably a core skill of artists. It also presents a controllable paradigm, with specific outcome and time limit, and is often coupled with standardized perception/memory assessments also used to assess different perceptual/cognitive abilities (e.g., the Rey-Osterrieth Complex Figure Copy, [35]; Fig. 2).

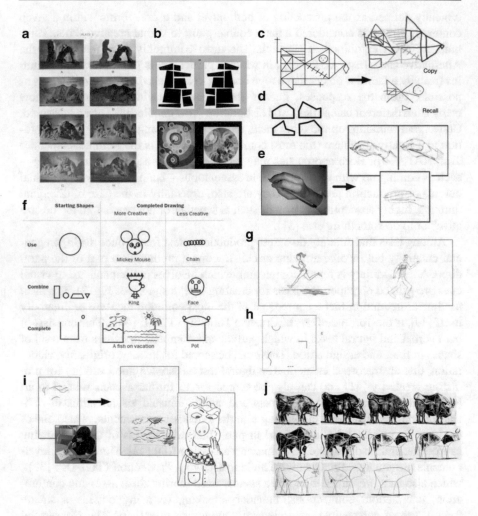

Fig. 2 Examples of past and present assessment techniques for considering artistic creativity or ability: (**a**) Example plate from Meier-Seashore Art Judgment Test, 1929 [32], which asked participants to select the "better" image. (**b**) Top, examples from the Aesthetic sensitivity test, e.g., [33], Bottom, example from the Aesthetic sensitivity test of Child [34]. (**c**) Target image and examples of participant drawings from Rey-Osterrieth Complex Figure task [35]. (**d**) Target images from Cain House task [36]. (**e**) Target photo and example drawings from Hand copy task [37]. (**f**) Example starting cues of Torrance Test of Visual creativity. (**g**) Example drawings from cued assessment of stereotypical schema (draw a running person). (**h**) Starting cue from Test for Creative Thinking-Drawing Production (TCT-DP: [38]). (**i**) Starting cue and produced artworks from visual art making task [23]. (**j**) Pablo Picasso, The Bull (1946), eleven states of abstraction ((c) 2022, Estate of Pablo Picasso/Artist Rights Society (ARS), New York)

Studies have also used more open-ended drawing tasks in which individuals are asked to complete a drawing from imagination. One of the most common is Clark's Drawing Abilities Test (CDAT: [45]). This asks participants to make four

drawings—a house, a running person, a playground, and participants' "fantasy". Although typically assessed for realism/details or use of more/less stereotypical schema, this has proven to be a reliable, standardized screening and identification measure for artistic talent [45]. The fantasy drawing aspect has also been utilized in several studies because of its ability to elicit original, free expression [46]. Studies have also recently used combinations of the free-drawing from keywords and starting-cue approaches in combination with asking participants to try to make an aesthetically pleasing image or even a "work of art," with scoring derived from a panel of task-naïve judges showing good ability to differentiate between more or less successful or skillful artists [23]. For a deep-dive into the nuances of the *how*, the *how many*, and the *who* regarding judges, see Kaufman and Baer [47]; also Ref. [16, 48]. However, it is notable that, when studies use at least a single-blind procedure with a pre-defined set of metrics, results tend to be quite robust and with high inter-rater agreement.[1]

Researchers have also conducted some artistic case-studies or laboratory-based analyses in order to understand the artistic creation process. These often involve artists being asked to complete an artistic task (either their own standard working process or a more controlled activity) whilst being observed, especially tracking eye and hand movement ([50–53]; see Ref. [16] for review), progressions between sketches and final designs [54, 55], or whilst artists narrate their thoughts and working processes [56–59].

Other approaches that provide at least anecdotal evidence about the artistic process, often for one specific work of art, involve, for example, x-radiography and infrared reflectography that reveal sketches, changes, and preliminary layers (currently used predominantly in art historical and museum conservation studies, see Ref. [60, 61]), and of course the emerging interest in comparative studies using causative brain manipulation methods, historical assessments of artists' use of psychopharmacological substances [62], and changing artist output as a result of neurodegeneration or other disease [63].

2.3 Theories on Creative Production and Steps to Making a Work of Art

This leads to the topic of art making itself. Before discussing where in the body or brain this might be achieved, a good place to start is in the realm of theory regarding the production process. Perhaps unsurprisingly, given the review so far, most current discussions are derived from the modeling of general creativity and, thus, often do not tend to dig too far into nuanced discussions of art. However, there are important highlights.

At the most basic, theories of art making, or production of any creative visual product (e.g., see Ref. [16, 64–67] for reviews), describe at least two core components: (1) first, whether cooking, painting, composing a play, we must come up with

[1] It might be noted that most present case studies of artists with neurodegeneration most definitely *do not* do this (e.g., [48]).

one or many ideas, as well as perhaps work out some initial plan for how we might execute these. Then (2) we must select one idea and choose to fix this into some media, which becomes the creative product. These core steps then serve as the superstructure from which most theories build, highlighting various sub-aspects.

One of the earliest models ([68], see Ref. [67]) proposed four steps: "preparation" and "incubation"—the coming up with ideas and even taking on a creative/ or art-making mindset—followed by "illumination," the identification of suitable candidates, and then "revision" or working of these ideas into a final product. A two-stage model by Campbell [69] focused more on the initial process of planning/idea generation with an emphasis on "blind variation" in which we might use an open, less-rule governed means of thinking or composing that serves as the basis for a work—think of the artist making free associations, sketching, 'throwing things at the wall to see what might stick' (also Ref. [66]). This is followed by "selective retention," in which we make a more analytic appraisal of early ideas/products and select the fittest variants, which can then be refined. More recently, Bogousslavsky [64] proposed three stages—"perception processing," where we attend to the information coming in through our senses, followed by "extraction and abstraction" of major features, and final "execution". See also Mace and Ward [70], who suggest four stages of "Artwork Conception," "Idea Development," "Making," and "Finishing/Resolution". Schlegel et al. [71] suggest three especially cognitive processes of "creative cognition," "visual perception," and "perception-to-action".

Moving to the actual technical process of shaping a work of art, existing discussions tend to suggest—as above—that we may often work through a similar progression of first blocking in the rough form or ideas or overall Gestalt and then later revision/refinement. A recent model by Tinio ([72]; see also Ref. [16]; Figs. 3 and 4) that did attempt to describe more technical steps involved in composing a work, proposed, for example, three core stages: "initialization," in which ideas are conceived explicitly or implicitly, including general blocking of form and compositional structure, "expansion and adaptation", of the initial structure, and "finalizing," including detail/highlight placement and deciding when a work is complete.

Going further, Tinio [72] argued that the aspects within these stages, and whereby we might shape a work especially on the canvas or page, connect to stages of art viewing that have emerged in the last decade in the psychology of aesthetics (e.g., [73]; see Ref. [74] for review), and suggested that the same features that individuals attend to in each visual processing stage may correspond to specific decisions/techniques involved in the art-making process, but essentially "mirroring" each other or operating in reverse. For example, this suggests that when perceiving a work, we may begin with basic formal elements (colors, lines, highlights, shapes), then build—through subsequent integration with our memory and associations—to the identification of style or content, and finally make assessments of basic aesthetic goodness or emotional tone. In composing art, ideally we begin with these final broad, emotive, expressive elements, and move through stages of refinement and addition of details, employing the more basic formal

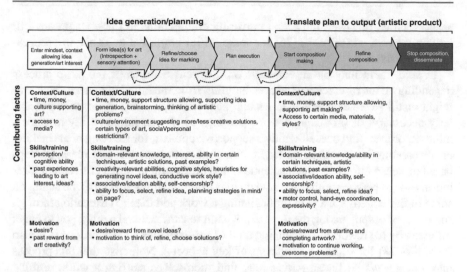

Fig. 3 Main steps necessary for making creative products or art (top) and contributing factors to making 'better' or more art

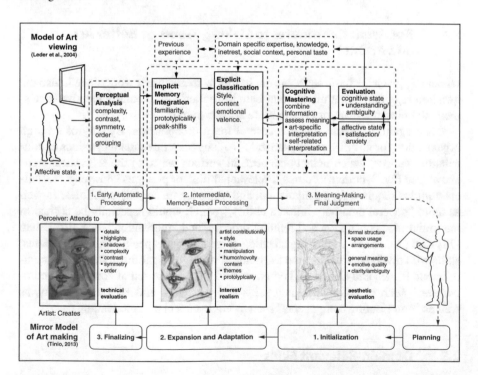

Fig. 4 The "Mirror Model" of artistic production posited by Tinio [72] and corresponding stages and factors in basic art perception model (based on [73]). Figure adapted from Pelowski, Tinio et al. [16]

aspects. Note, however, the actual mirroring connections in these stages are still largely theoretical (see Ref. [75] for some initial empirical evidence in observation of artists).

In sum, there may be an emphasis on different features of the basic process depending on the researcher. However, building from the initial two-steps above, we might distill seven elements that, *without considering quality,* seem to be particularly necessary for producing a work (see Fig. 3): (1) an initial ability to enter a mindset, or even find oneself within a supportive context, for thinking of art making or for creating ideas that could lead to art, (2) actual generation of ideas, perhaps based on sense information or perceptions and often with minimal criticism or inhibition and (3) perhaps with some amount of conceptual refinement; (4) the acting on some of these ideas via a plan for beginning a work and then (5) execution through some sort of output, taking the steps to put paint to canvas, hand to clay, pen to page; followed by (6) reworking or refining until (7) one decides a work is done (see also Refs. [76–78] for similar breakdowns of key aspects). Note also that this process may not always be linear. Artists may find themselves starting a work, refining ideas, returning to past steps, or even scrapping one artwork to restart.

2.4 But, What Contributes to Making 'Good' or Better Art and Artists?

Of course, given the basic steps one might follow to make any work, there is also the question regarding what might contribute to 'better'—particularly creative or aesthetically pleasing—art, or even to more artistic output.

Once again, literature suggests several main components. By way of a rough organization for this discussion, Amabile [76] suggests three main divisions of contributing factors, which notably connect, in various ways, to the theoretical steps above (see Fig. 3, bottom): "domain-relevant skills," or previous knowledge, technical abilities required for manipulation, and more innate cognitive abilities, as well as more "general creativity-relevant ability," which would especially be critical in the initial idea conception and refining process, and "motivation". See also Urban [78] who proposed a similar organization of general and specific knowledge bases, skills with divergent thinking and tolerance of ambiguity, motivation, and task commitment. Runco and Chand [77] proposed two tiers composed of "controlling components," such as problem-finding skills and processes and evaluation ability, as well as "contributing components" such as environment and motivation.

2.5 Domain-Relevant Skills

Beginning with the first category mentioned by Amabile, a good deal of aspects involves the person making the art—and especially what they bring to the activity. These abilities may be important both in the initial process of coming up with ideas and refining them and within the actual task of production. A basic repertoire of skills

and techniques concerning how art might be made, or what the limits and possibilities are of materials, could provide a necessary basis for both art production but also generating new insight itself. As noted by Acosta [79], most models and creativity discussions share an idea that art production must begin with some baseline knowledge of techniques, materials, and approaches. These may provide different perceptions or ideas, which must then be "codified" or recognized by the artist, and only subsequently can it be brought to fruition through art making—think the Picasso quote that one should "*learn the rules like a pro, so you can break them like an artist.*"

2.5.1 Perceptual or Cognitive Ability

Artists may show different perceptual or cognitive abilities that may help them when observing the environment and especially within the act of production. Individuals skilled in copying or depicting realistically, one aspect often connected to (at least some types of) art and which also marks the currently most populated area of research, have shown correlations with high-level visual processing, including attention toward local visual details [22, 80], visual selection [81, 82] and visual memory [83–85] but not low-level visual processing [86–88]. Research on artworks assessed as more aesthetically pleasing also shows, in the maker, many similar results—ties to visual memory, proportion/angle perception, or even recall of both details and clusters of elements or ability to identify out-of-focus pictures [23]. Artists have been shown to have more attentional flexibility, being able to more easily switch between aspects of a stimulus, a feature that might support creative as well as technical ability [80, 89].

Artists may also attend to different features in the environment or be aware of different aspects, which lead to novel or interesting ideas for future artworks. They may choose less realistic, perhaps even more deviant, designs and concepts. Artists may show the ability to bypass stereotypical depictions to produce more novel or pleasing images or to otherwise assume the "innocent eye" of the artist [90]. Research also suggests that artists may employ different cognitive styles, with more focus on "objects," related to strategies for looking for or focusing on visual features, as opposed to "spatial" and "verbal" styles, and which has been shown to have a significant relation to professionals in the fine arts [23, 91].

2.5.2 Production Strategies and Technical Skills

Moving to the act of putting ideas or perceptions to media, there are again multiple factors that might be important. Of course, we can talk of talent—ability to depict in high fidelity what one sees or to control motor actions (e.g., [76]). Studies of successful artists also suggest that they may employ certain 'tricks' or top-down schemata for composing [15, 92], ranging from focus on certain features, to better understanding of placements or proportions, focus on certain contours, as well as to techniques for visual effects such as foreshortening [15, 93, 94]. Findings also suggest specific drawing strategies [22, 93, 95] that might be lacking in less accomplished artists. Especially when considering more overall artistic production rather than realistic depiction, evidence suggests that artists may be able to adopt a more global strategy—blocking in a gist, gestalt, essence, or an object's essential form

(e.g., [22, 72, 95–97]), and may also be able to focus on, or jump between depictions of local and global details while creating.

Research also suggests that accomplished artists may show specific processes for initially composing and blocking in a design, with more attention paid to these early components [56, 59, 98]. This blocking in defines a composition [22] and serves as a base for subsequent elaboration. For example, Kozbelt [56] showed that highly rated creative drawings were made by artists who spent more time blocking in an image to draw and who spent more time erasing, revising, and reworking from an early stage—also aligning with the general flow in Tinio [72]. Weisberg [55] followed the production of Picasso's painting "*Guernica*" from 45 sketches and showed that initial sketches, which the author still connected to idea development, concerned overall structure and a main emotional element (the screaming horse stabbed by a lance). Only once these were developed and refined did the artist move to developing small details and other supporting aspects.

Authors also suggest that many successful artists do not externalize a design, as already fully formed in the head, but instead use the blocking-in and detail-addition stages as a means of continuous shaping and refinement [61, 70], while also, despite what was said about the general process above, elaborating from one kernel idea that they have selected rather than via generation of numerous different ideas or false starts [55, 61, 99].

Not only may individuals spend more time blocking-in the initial aspects, the way that they do this may be key [65]. Jaarsveld and van Leeuwen ([66]; also [100]) analyzed the strategies used by designers when developing visual graphics or objects. Participants whose final designs received the highest ratings, by art critics, introduced a global structure in earlier sketches. Kozbelt and Serafin [101] had expert and lay artists evaluate quality of drawings at multiple points during the art-making process. Artists more quickly determined the quality of the emerging art. An interesting possibility here, when thinking of neurodegeneration, regards the anecdotal connection of several degenerative diseases (e.g., PD, AD) to behaviors such as obsessive making or punding—repetitive actions that may also find their way into art in the form of repetitive themes or a series of similarly-constructed artworks [63]. Use of repetition could introduce such a novel, strong form to an artwork, or may even constitute refining or "practice," resulting eventually in better designed art [49].

At the same time, evidence also suggests that successful artists may pay more attention to all making stages. Kozbelt and Serafin [101] report a linear relationship between time and quality for artworks rated as less creative. Artworks rated as highly creative, on the other hand, showed irregular patterns in assessed quality throughout the making process. In a design task (creation of a layout for a garden), Pringle and Sowden [102] showed that experts exhibited more switching between, and meshing of, cognitive versus affective and analytical versus associative processing modes. Research also suggests that successful artists may show specific cycles of intense composition, followed by long pauses, in which they step back and default to a more global assessment of overall tone or composition; then return to adding or building up/erasing/shaping micro-elements [61, 103, 104]. Equally

important may be decisions about how much to refine a work or, transversely, to stop and go on to a next piece.

Many of these above aspects could be either trained or relatively more innate. For example, artistically-talented versus less talented children have been shown to acquire drawing skills at a more rapid rate and also show spontaneous compositional differences, such as incorporating their personal viewing position in drawings rather than stereotypical depictions [105]. On the other hand, with enough training, many can learn to execute successful art (see, e.g., *Environment* below).

2.5.3 Perceiving Art—Do Artists Show Differences?

The above leads to a related question: *Do we also find differences in how artists perceive art?* Studies do show that some 'experts'—often those with training or experience with art, such as art historians, curators, or related students—interact with and appraise art differently ([80, 106, 107]; see Ref. [108] for review). For example, experts may give less emphasis to content, craftsmanship, or mimesis (what a picture is of, how well it is depicted) as well as to basic salient areas or object-based perceptions, and may give more emphasis to "relational properties" [109] such as style, overall gestalt, sensory/semantic impact, or even relation to context or other examples of art [110]. Similarly, when viewing representational artworks, artists may tend to focus more on the background and connecting spaces (e.g., [111]), make more global scanning eye movements [112], and make eye movements that are less driven by locally salient regions [113]. Taking a more holistic perceptual approach is characteristic of perceptual expertise in several domains [114]. However—as with art making—evidence also suggests that experts may be equally adept at detail-focused processing [22]—attuning to the micro-decisions and subtle qualities differentiating artworks (e.g., [115]). Of course, many of the existing findings could, it would seem, stem more from domain-specific knowledge or training rather then artistic proclivity itself [73].

2.5.4 How Important Is Technical Control of Media or the Body?

Another interesting question involves the relative importance of technical control of media in regards to the ability to produce successful art. This is especially key when considering potential changes, say, relating to progressive loss of motor control in aging or via neurodegeneration. Along with tremors, many disorders impact aspects of manipulating materials—ability to make fluid lines, realistic representations—perhaps relating to some broad changes in style or approach such as introducing shorter strokes/cross-hatching or moving to abstraction [49].

On the one hand, when evaluating artistic outputs in controlled, often comparative, paradigms (e.g., via panels of judges asked to evaluate works), skill/technical quality as well as creativity/originality are typically given as two main factors in assessing success [116], and are often highly correlated in adults [46]. However, when thinking of the more nebulous topic of art or aesthetic appreciation, research also suggests that technical control may not impact quality as much as, or even in the direction, one might expect [46].

While suggesting that many lay individuals might hold implicit assumptions that artistically talented people are characterized by a natural technical competence, Rostan [117, 118] found that actual judgments of novelty of drawings may be more determined by both composition and expressivity. Rostan et al. [119] found that the combination of skill mastery and also *opportunities for self-expression* distinguished art students and those who produced more creative art. Kozbelt [120] attempted to tease apart drawing skill and creativity by asking judges to rate drawings on twenty-five factors related to quality, technical skill, and originality. All three items were correlated, but originality, rather than skill, fit the underlying quality dimension better. Similarly, studies suggest that specific technical skills with certain art styles, such ability to draw realistically, tend to *only partially* overlap with the actual production of 'good artworks'—those that are visually interesting, compelling, challenging, or aesthetically superior [16, 74].

Of course, with limitations there may be impacts on what sort of art or techniques one can produce. "No matter how original" an idea, Vinacke [121] notes, "it cannot result in a work of art . . . unless its originator has the requisite skills to convert it into tangible form." However, history shows many highly successful, physically limited artists. It may even be that forced changes in how one approaches an artwork—operating within constraints, moving to looser, freer, more abstract designs—could lead to higher assessed outputs. As an aside, one of the more compelling findings that seems to be emerging from neurodegeneration discussions (e.g., with PD, see Ref. [49]) is that, despite motor issues or tremor in other life activities, these do not appear to intrude and may even diminish when making art. Where there is a creative interest and a will to make art, it appears, individuals find a way.

2.6 General Creativity-Relevant Skills

Another collection of aspects that, comparatively speaking, may show relatively higher importance in artistic ability, involves more generative, procedural aspects of the creativity process itself.

2.6.1 Ideation

A good deal of literature has highlighted the initial idea-generation and planning phase, often called "ideation" [122]. In this period, again, an individual must not only come up with an initial idea or goal for the creative act but must also plan out how to execute it. This type of problem-solving has been cited as an essential component of the creative process in various disciplines [30, 123], but is also specifically important for creating new and interesting visual art [77].

Getzels and Csikszentmihalyi [65] showed that time spent thinking of an idea before drawing correlated with the assessed creativity of final products. In an observational and eye-tracking study, Miall and Tchalenko [124] showed that time spent thinking and observing, but not drawing, was significantly longer for professional

than for non-artists. This is supported by think-aloud protocol studies of the creative process in the lab [56, 57, 98]. Runco and Chand [77], stressing a number of processing components, including problem-finding skills, ideational skills and processes, and evaluation. Time given to the actual tasks of looking for artistic problems may also be key for to creative outputs. Much as with some production techniques, Amabile [76] notes that individuals may also *learn* heuristics for generating more novel ideas—brainstorming, doodling—or even learn to adopt certain cognitive styles or *construct their environments* to maximize creative thoughts.

2.6.2 Personality, Ideational Fluency, Openness

There are a number of personality-related characteristics that may also aid in the art-making or idea-generating process. Empirical studies have highlighted "ideational fluency"—the propensity to generate multiple or unusual answers to problems [125]—as a key contributor to producing art, especially in the planning and early refining stages. For example, Sawyers and Canestaro [126] reported correlations between ideational fluency and creativity (appraised by teachers) of university design students' projects.

The personality traits of "openness" (characterized by imagination and insight) and "extraversion" (sociability, assertiveness, emotional expressiveness; [127]) are also suggested to be more prominent in visually creative individuals. Higher scores correlate with more engagement in the arts and with enjoying, for example, abstract or avant-garde styles [128, 129]. Ties have also been reported between practicing artists versus non-artists, and "neuroticism," as well as divergent thinking and positive-schizotypy—a subclinical trait related to mild levels of perceptual aberrations, hallucinations, and eccentric behavior [49, 130] (see also this book as well as rather interesting overlap with dopaminergic systems and PD).

Relations have also been found between general creative personality type (e.g., as assessed via Kaufman Creative Personality scale) and quality of produced art [23]. The association between creativity and personality may also vary by domain. Openness, for example, is a stronger predictor of artistic achievement, while intelligence is more closely linked with scientific achievement [131]. Research also suggests that artists have richer mental imagery of visual scenes ([132], but see Kottlow et al. [133]). Flaherty ([134], see also Ref. [135]) also suggests that artistic creativity requires that individuals possess traits for novelty seeking, flexible associative networks, and lower inhibition.

2.6.3 Inhibition (or Lack Thereof)

Especially this latter aspect—inhibition—may be particularly important, aiding artists to not reject novel ideas in initial ideation or to overcome internal or external (e.g., social) pressures against certain activities or thoughts. The trope that artists might need to operate beyond social pressures or ignore self or other criticism or insecurity is common in critical/anecdotal discussions of artists. "*If you hear a voice within you say, 'You cannot paint,'*" suggested Van Gogh, "*then by all means paint, and that voice will be silenced*" (See also *'The Artist Brain'* below). Potential changes in inhibition may also particularly coincide with some artistic changes in

neurodegenerative disease (e.g., dementia or Parkinson's disease, [49]). It is also interesting, when considering personality aspects, that as of yet almost no studies have considered how specific personality features might translate into specific stylistic or formal aspects of produced art [61, 136].

2.7 Motivation and Other Contextual Factors

Many theories also emphasize motivation or "passion" for art. This aspect was suggested by Amabile (e.g., Ref. [137]) as perhaps the most common distinguisher of creative from noncreative individuals. Lemons [41], more recently, noted that this may drive creativity development.

Motivation may be due to either extrinsic or intrinsic factors. Individuals who initially show a certain amount of skill in art may be motivated externally by teachers, peers, or parents to pursue more training, or may come to think of themselves as 'artists,' thus leading to higher levels of skill and creativity. They may also be given more resources or attention, which could lead to both higher creative and technical development.

Developing creativity may also require intrinsic motivation, which could vary depending on personality or life experiences. Researchers argue that the motivation to get better, to hone one's ability, or to practice is necessary for both the emergence of artistic talent and for highly creative performance [138, 139]. Amabile's [140, 141] studies also showed a positive relationship between intrinsic motivation and assessed creativity, and especially argued that when one is intrinsically motivated one experiences more interest and is thus more likely to produce a creative output. In support, Silvia et al. [142] showed that individuals scoring higher in creativity expended more cognitive effort in a divergent thinking task, leading to more creative outcomes.

In children with precocious artistic ability, Drake and Winner [143] show extremely high levels of intrinsic motivation, which they dub a "rage to master". Similarly, surveys have linked superior creative outputs in adults to a willingness to skip sleep or meals to work on a project [24]. The history of artists or creative individuals who take stimulants or psychedelics, both in the expectation that they will raise artistic perception, performance [62, 144], but also to increase concentration at the expense of social and daily responsibilities [145], also provides supporting evidence. Such a renewed, and perhaps sometimes detrimental, focus is mentioned, as well, in some case reports of individuals with neurodegenerative disease [146, 147].

Whether intrinsic or extrinsic, by merely participating in the arts, or by continuing to participate, one might further develop his or her artistic creativity beyond levels accomplished by others (e.g., [118, 148]). See, for example Rostan [118], who compared the artistic process and finished artworks (free drawings from imagination and life drawings) in adolescent students and reported that number of years attending an art program and time spent drawing correlated with creativity.

Motivation to begin or to continue art making, or even to complete creative products, may also overlap with reward. Researchers suggest reward feedback from creating something by oneself [146] or through novelty-seeking [149]. This aspect too may be especially of note when considering certain neurodegenerative diseases (see also brain/limbic areas below).

2.7.1 Culture, Environment

An amateur is an artist who supports himself with outside jobs which enable him to paint. A professional is someone whose wife [or husband, caretaker; society?] works to enable him to paint. -Ben Shahn

Environmental factors—cultural, economic, and social—may also encourage or inhibit art making uptake or improvement. Studies show that an encouraging school or family structure coincides with the propensity to make more and better art [67], as well as fosters stylistic growth [119, 150]. Thousands of biographies and articles have also connected—if not empirically confirmed—artists' personal histories to their resulting motives and means for creating artworks [61].

More broadly, several theorists have emphasized culture to the extent that some [67, 151] have argued that creativity, and perhaps also sustained art production, may be more of a cultural phenomenon than an innate/internal process. Csikszentmihalyi [150] proposed three shaping factors: a more or less stable symbol system of a culture (e.g., "art"), which artists can employ; institutions that work with creative products and promote or develop artists; and the individual artist, who is a product of experiences. Simonton [99] considered contextual cultural, economic, and social impacts on the creativity of eminent people in multiple cultures and periods, arguing that social environment can have nurturing or inhibitory effects. See, for example, also recent work by Dunham et al. [152], who interviewed multiple artists to assess why they had decided to pursue this activity and suggested blends of internal and external, culturally-derived, motivations (Fig. 5) in four main categories: Individuals might respond to a need to explore one's capacities, to look for autonomy and meaning. They may use art to reach out to and to connect to others or society, or may explore one's feelings; or may pursue professional or traditional aims. Once again, when thinking of life/body changes, any of these factors could be posited as a driver for art making.

Internal/Self-Focused Motives[a, c]	Internal/Other-Focused Motives[a, d]	External/Self-Focused Motives[b, c]	External/Other-Focused Motives[b, d]
• Need for autonomy • Enjoyment • Absorption • Need to explore • Need to be creative • Need for self-expression • Self-therapy • Need for meaning • Need for self-esteem • Need for structure	• Desire to connect with an audience • Desire to connect with fellow performers/artists • Desire to connect with a greater entity • Affecting audience's feelings • Affecting audience's attitudes or thoughts • Affecting audience's wellbeing	• Art as a signalling mechanism • Reputational concerns • Lack of viable alternatives • Financial motives	• Contractual/professional obligations • Having to conform to others' expectations • Being coerced by others • Desire to uphold traditions

Note. [a]Behavior driven by an internal factor; [b]Behavior driven by an external factor; [c]Goal/target of the behavior is the self; [d]Goal/target of the behavior is outside the self

Fig. 5 Taxonomy of Motivations for why contemporary artists decided to become, and to continue being, artists (used with permission from [152])

Attitudes about who and whether individuals *should* produce art might also impact outputs. Multiple studies [67, 153–155] suggest different art-related creativity scores in children from countries with varying levels of emphasis on individual expressivity or technical proficiency—although not always with effects in the same direction. More basically, aspects such as free time or economic surplus may be essential. This could be one intriguing factor, especially in individuals suffering from a neurodegenerative disease, who may, for example, have found themselves recently retired, in search of a hobby, with a major life upheaval, and also perhaps encouraged to make art as a form of therapy [49]. Interestingly, authors have suggested a similar ability to withdraw from other social obligations, to work at one's schedule, and perhaps even to be looked out for by handlers as fitting the modern idea of many 'artists' (see Ref. [156] for similar suggestions for creative geniuses in general). Culture can also inform acceptable outlets for the creative process—pushing individuals to paint instead of sewing or cooking—or even lead to a culturally-defined idea of "creativity" itself [157].

2.8 What Is 'Typical' Artistic Development?

In thinking of changes, it is also useful to briefly consider what has been found regarding typical artistic development. Findings suggest that most people have a rather linear progression in improving technical and creative ability, at least throughout *early* childhood. For example, there are rather stable age-related differences in aesthetic sensitivity, expressivity with materials, composition, and technical control [117, 158, 159]. Children tend to show a universal attraction to representing objects through graphical means [1], but then a temporal progression from structurally simpler to more complex artistic activity [160]. However, development also tends to peak in early adolescence [161], often further decreasing into adulthood where individuals stop making and/or make less successful art. Only particularly motivated or artistically gifted adolescents tend to retain or regain artistic creativity at later post-adolescence stages, resulting in a "U-shaped" trajectory [159, 162]. It is exceedingly rare, with any individual, for a post-adolescent to spontaneously begin, much less improve, their art making [159, 161].

The reasons for this leveling and decline in art proclivity are also particularly interesting. Decreasing creativity may be a function of motivation, which may only be sufficiently high in individuals interested in art [46, 117]. Adults/late adolescents may also lack of opportunities to engage with art or even experience social pressures against art making (i.e., a 'waste' of one's career or time). This could suggest that people might still carry latent ability, which only goes dormant or declines through lack of practice. Some authors also suggest a link between decreasing creativity and an inhibiting focus on realism or practiced stereotypical popular images, as opposed to expressive drawing, both of which may reduce artistic creativity in older individuals. Think of the individual drawing what they 'think something looks like' rather than really attending to its expression. Such a "literal stage" [117] in most people's artistic development could both be a product of natural development

or a social/normative impact. Returning to Picasso, *"Every child is an artist. The problem is how to remain an artist once he grows up."*

Of course, the above conditions could change through some change in our lives or neurobiology. Some authors have noted that some individuals might take-up art making, perhaps as a response to a recent retirement or other life change. See for example Salzman [163] who documented a trend of ex-academics, upon (often compulsory) retirement from the University, to suddenly find interest in art, and suggested this new interest might provide a means of self-expression, societal contribution, or meaningful acts. Artistic quality differences—if not volume of output—may even have more to do with the judge for art, and with changing metrics for different individuals' circumstances or ages [119]. We may be more open to appreciate, or 'find' artistic qualities within, the drawing by a child versus a similar one by an adult. Similar patterns might be suggested for neurodegeneration-afflicted artists [49].

2.8.1 What Do we Know About Working Artists and Style or Quality Changes?

When considering the oeuvres of working artists, there is also potential evidence for some specific longitudinal changes. There is some evidence to suggest that there may be a decreasing trajectory involving creativity and normal aging, which may tend to peak in early to middle adulthood and then to decrease [26, 27]. Simonton [164] modeled the typical creative trajectory (lifetime output) of eminent artists from historiometric data, finding that it depended upon the artist's creative potential (the reservoir of potential ideas the artist may have possessed), the rate at which creative ideas were generated, and the rate at which ideas were elaborated upon and converted into a creative output. The model yielded a single peak function at a career age of around 20, followed by steady decline in output, with artistic domains peaking slightly earlier than academic domains such as history and philosophy. At the same time, alternatively, an expertise view [139] posits that artists accumulate domain-specific knowledge over the course of their careers, enabling them to become more discerning of their creative ideas. This has found support in longitudinal data on rates of producing 'hits' in, for example, classical music composers [56]. A review of the final ("swan songs") of classical composers also suggests that, at the end of individuals' lives, they might show an uptick in creativity and/or a switch in composition to short, simple pieces but which were particularly rich in aesthetic significance (see Refs. [26, 27]; but see Ref. [165] for argument against this). It is also quite common for artists within the Art historical literature to show a progression in styles and approaches. This may often align with a change from early work—where they may be emerging as an artist, trying out a variety of visual solutions, media, or ideas—to later, more mature output. This is concomitant, especially since the rise of Modernism with the search for and refinement of a particular artistic style or 'voice'. This may, in turn, involve a general paring away of extraneous, and distillation of defining, features or techniques in a work, leading to discussions of more precise, more defined themes or expressions. Forsythe et al. [166], in a study showing the promise of considering this topic in the context of change, assessed artworks (2092 total) from

across the lifespans of famous artists without (Marc Chagall, Claude Monet, and Pablo Picasso, all serving as a healthy "control") and with two different neurodegenerative diseases (AD: Brooks, deKooning; PD: Dali and Morrisseau). The artworks were analyzed by a computer program to assess "fractal dimension" (FD), a means of quantifying the degree whereby patterns exhibit self-similarity in structure at different levels of magnification, argued to exist within a specific range, and representing a general 'handprint' of a mature artist beyond content. Whereas the authors reported a significant positive linear trend as a function of age among control artists, especially AD, and to some extent PD, did show notable change, with an eventual or immediate decrease, (see also Ref. [49]).

Especially with the explosion of movements in the twentieth century, it is also not uncommon to find different stages or progressions through major styles—think Picasso periods from representational painting, to cubism, to more post-modernism—or even media. There may also, of course, be some improvement or refinement in technique and control of art tools as one continues to have experience making art. The above arguments raise rather intriguing questions, especially when considering changes in mature artists that could be attributed to disease—are these, one might always ask, just a product of natural artistic development?[2]

2.8.2 Genetics—Is Art Only in Our Genes?

In considering the above aspects, one also comes to the question of how art ability or propensity relates to our genes. As yet, there is little evidence to confirm that variability in artistic ability is accounted for by variations in the genome, and to our knowledge no studies have addressed the specific genetic basis of visual artists (see also Refs. [168, 169]). However, there is some emerging evidence that there may be some impacts, and hundreds of genes would be expected to modulate the factors in creative behavior or art-making [170]. A recent series of meta-analytic reviews have revealed that practice plays less of a role than previously thought in domains including games, sport, education, professional arenas, and the arts [171–173], implying that other factors (such as genetic variation) may account for a more significant amount of the variance. Child prodigy literature also provides good reason to believe that development of, at least extreme, artistic ability may be largely independent of deliberate practice, instead being more closely related to latent abilities, including enhanced working memory and attention to detail [143]. Arden et al. [174] also showed that genetic variation exerted a greater influence on children's inclusion of details in figure drawing than environmental effects.

Twin studies [175] have additionally found that genetic variation accounted for a substantial amount of variance in self-reported artistic and creative talent. That said,

[2]"I strolled past [the paintings] curiously—they were in chronological order. All his earlier work was naturalistic and realistic, with vivid mood and atmosphere, but finely detailed and concrete. Then, years later, they became less vivid, less concrete, less realistic and naturalistic, but far more abstract, even geometrical and cubist. Finally, in the last paintings, the canvasses became nonsense, or nonsense to me. I commented on this to Mrs. P. 'Ach, you doctors, you're such Philistines!' she exclaimed. 'Can you not see artistic development' [...]?" Sacks [165], p. 17.

the impact of the shared (i.e., familial) environment was low, suggesting that the non-shared environment—such as specific training or activities—may play a key additive role in artistic development. Likely, there is substantial gene-environment interplay in the development of almost all human traits. For example, the link between genetic variability and the tendency to practice a musical instrument is as strong as the link between genetic variability and the musical ability itself [176], while a study by Wesseldijk et al. [177] demonstrated that the heritability of musical achievement increased in the presence of higher levels of environmental musical enrichment. A twin study by Bignardi et al. [178] found that individual differences in the tendency to experience aesthetic chills in response to particularly emotional response to art was also, to some extent, explained by genetic variability. The authors suggest, as can be said for many differences above, such genetic variability could be linked to *neurological differences* between individuals in terms of structure and functional connectivity—raising, of course, the key importance of also looking at the changing adult environment and brain.

3 The Artistic Brain

Moving to the second half of this review—what do we know of the artistic brain?

This area of study, in general, represents a natural extension of the previous empirical and cognitive approaches, connecting creative processes to their biological sources [179, 180]. At the same time, the present evidence is very much a work in progress. Mainly, this is due to the difficulty with assessing the brain while participants act in ways that might reveal interesting aspects of how and why we make art. However, there have already emerged a compelling collection of findings related to art making (Fig. 6), which also tend to support many arguments above.

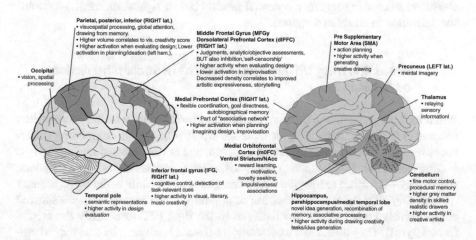

Fig. 6 Brain areas implicated in art making or differentially activated in artists. Yellow = basic vision, sensory processing. Blue = areas connected to idea generation. Red = areas related to idea/production evaluation

3.1 Areas Related to the Basic Task of Visual Art or Creativity

Using functional brain imaging, researchers have identified a handful of regions connected to visual creative activities in general. These involve bilateral occipital cortices and parietal (posterior and inferior areas) connected to visuospatial processing, global attention, and to manipulating spatial representations (Refs. [181–184]; see also Ref. [185]). Studies also highlight the medial temporal lobe/parahippocampus [182] and hippocampus [180, 182, 186], which may be especially involved with novel idea generation via recombination of memory and associative processing (e.g., see Ref. [146], who deemed especially the hippocampus and medial prefrontal cortex as an "associative network" potentially key in general creativity). The prefrontal cortex, especially medial regions, is also suggested to be involved—as part of a frontal executive network—in processes such as flexible coordination or goal-directed focus ([186, 187]; see Ref. [182] for review).

In a recent meta-analysis [188] considering neural correlates of creativity across different domains, specifically creativity with drawing was associated, once again, with higher left fusiform gyrus and left parahippocampal gyrus, as well as the left precuneus, tied to mental imagery, and right middle frontal gyrus (MFG)/ dorsolateral prefrontal cortex (dlPFC), perhaps connected especially to objectively analyzing ideas or results of a creative act. The authors also reported domain-general patterns across drawing, literary, and musical creativity involving *left* dlPFC and the right inferior frontal gyrus (IFG, see also Ref. [182]), connected to cognitive control, and to the pre-supplementary motor area (SMA), related to action planning. A similar meta-analysis by Boccia et al. [189], comparing visual, musical, and literary creativity, also reported similar general creativity results as above and specific involvement in visual creativity of, again, right middle and inferior frontal gyri, as well as the bilateral thalamus, probably tied to relaying sensory information. The above evidence also suggests a potential general lateral-rightward, medial-leftward specialization in art-related regions.

3.2 Areas Showing Differential Patterns in Successful Artists or Art Stages

When looking at functional imaging studies comparing those who are more or less successful with visual creativity or with art, we also find some compelling differences regarding which areas might be involved, and at what art-making stage.

Kowatari et al. [182] report a comparison of expert versus novice designers, where they were asked to imagine a new design for a pen while in the fMRI scanner (presumably aligning with the ideation or planning stages above). Experts showed comparatively higher levels of activations in the right PFC (especially the medial frontal gyrus). They also noted a correlation between brain activity and judged creativity of finished drawings (created afterwards, offline). Experts again showed

pronounced right lateralization, with comparatively lower activation in the left PFC, whereas novice activations were less focused. In a study of realistic drawing, Chamberlain et al. [48] also reported a positive correlation between grey matter density in the right medial frontal gyrus and judged ability ([182, 190]; however, see Ref. [191]). Gansler et al. [192] reported a similar correlation between right parietal gray matter volume and visual creativity scoring.

Right hemisphere bias, especially in right-handed individuals, has often been connected to artistic creativity [133, 193]. In turn, right hemisphere functionality/ structural changes were suggested as one of the early targets for discussing changes in neurodegeneration—for example, connecting a potential increase in artistic interest or even creative ability to specific patterns of damage in frontotemporal dementia (FTD) or aphasia, where one might find focalized damage to the left prefrontal regions, perhaps leading to right hemisphere over-expression (e.g. [194, 195]).

Another compelling difference involves the parietal areas. In their designer study, Kowatari et al. [182] report that, although there was a general increase in parietal activation across the entire participant sample, in experts, during the activity—which essentially constituted *a planning task*—there was a suggestion of negative signal change (especially in *left* hemisphere inferior regions). Novices who scored best in creativity also showed comparatively lower parietal activation, and left parietal activity showed a negative relation with the amount of design training. Kowatari et al. [182] suggest that these findings might indicate that creative ability may involve a *shift* in relative emphasis from parietal to prefrontal areas, or overuse of the parietal regions, which, although important for processing spatial aspects, might impede creative design-generation (see behavioral discussions of this same point above).

Solso [190] also found *reduced* activity in the parietal cortex in a skilled portrait artist compared to novices when producing drawings of faces (see also Ref. [189]). One might also posit a potential connection to a case study by Seeley et al. [196] which suggested ties between left frontal/temporal damage, increased grey matter volume, hyperperfusion in right posterior neocortical areas, and improved artwork quality, creativity, and symbolic content in an artist with FTDL/progressive aphasia. Ellamil et al. [186] compared both generative (coming up with ideas) and evaluative modes in creative drawing while inside the MRI. They similarly found that when designers were explicitly *evaluating* designs, they had higher activation in the left temporoparietal region (TPJ) and higher activations in the insula, temporopolar cortex, cerebellum, and dlPFC. On the other hand, *generating ideas*—and the judged creativity success of final drawings—did not show such correlations. Rather, these connected to *higher activation* in premotor and medial temporal areas, specifically the parahippocampus, suggesting perhaps parallel networks of executive/analytic and generative functions. It is also interesting to reconcile these ideas with the finding of higher parietal *volume* in visually creative people above [192].

The mPFC, on the other hand, as also suggested above, may be particularly relevant for improvisational or ideational/associative activities. In a study with jazz

musicians [197], participants were asked to perform either a highly practiced score or to make improvisations, with this latter modality connected, once again, to activations in sensorimotor areas as well as to the mPFC, which they suggest may tie to autobiographical memory or looking into oneself to 'tell one's story'. See also the argued shift from parietal to prefrontal focus above [182]. Limb and Braun [197] also reported relative *deactivations* in dorsolateral prefrontal areas (dlPFC, lateral OFC) during improvisation. Although related to taking a more objective assessment of designs/ideas (see the findings of [186] above), these regions are also related to inhibition or 'self-censorship' and thus may impede creative generation or improvisation while making art. An fMRI study [198] in which participants drew solutions to Pictionary cues (Mattel Inc., El Segundo CA) also showed a negative correlation between activation in left-lateralized dlPFC and the drawing ratings.

Providing even more evidence, especially for the fluid relation between changing creative processes and the brain, Schlegel et al. [71] assessed changes throughout an 11-week art-making course. Most interesting, Diffusion Tensor Imaging (DTI) analysis showed a progressive *decrease* in Fractional Anisotropy (FA), a measure of microstructural integrity, in the bilateral white matter of the dorsolateral prefrontal areas in those taking the art course. This change correlated with improved creativity in storytelling, portraying movement/action, and emotional expressiveness. The authors suggested, as above, that the findings might suggest either that art students develop more efficient processing pathways or more creative individuals *learn to avoid* the *use of* frontal inhibitory circuits. Such focalized damage or downregulation, potentially in conjunction with the dlPFC's role in also regulating mesolimbic dopaminergic pathways connected to reward-seeking/flexibility, was recently argued to potentially be a main underlying symptom in Parkinson's-connected art changes [49].

Focusing again on the technical ability to make realistic drawings, Chamberlain et al. [48] report a positive correlation between drawing ability and grey matter density in the right medial frontal gyrus as well as the left anterior cerebellum (see also Ref. [189]), both tied to fine motor control and to procedural memory (see also Ref. [198] for a study showing higher cerebellum activity when making drawings judged to be particularly creative and specific patterns of activity in the right cerebellum and left motor cortex, perhaps tied specifically hand-eye coordination).

3.3 Other, Theoretical Regions of Interest

Other areas suggested, *more theoretically*, to play a role in making art include, the Default Mode Network (DMN)—including mPFC and parietal regions (e.g., TPJ) noted above—typically activated during conditions of low cognitive control or introspection, but which may also facilitate an associative mode of processing that supports novel idea generation [186, 191, 199]. The DMN has also been

demonstrated to play a role in art evaluation and may contribute to creative evaluation by facilitating the formation and use of "gut" reactions that may direct production [186].

Areas connected to reward or reward-seeking—ventral striatum, nucleus accumbens (NAcc), medial OFC, wider mesolimbic networks (see below)—may also be particularly important, especially in fostering motivation and driving individuals to begin and to continue to make art. Previous studies, especially involving discussions of neurodegeneration, especially involving discussions of neurodegeneration, have theoretically connecting these areas to art making and to creative drive [134, 146, 149]. Many of these same regions—NAcc (urges and impulsivity), and dorsal striatum (compulsivity)—may also relate to associations or flexibility/divergent thinking. Striatum activation is also noted in connection with positive-schizotypy, again more pronounced in visual artists [130].

3.4 From Brain Areas to Systems—Neurotransmitters, Networks

Emerging work has also advocated that we look beyond individual regions to broader networks that may operate in concert with certain art making or related tasks [200, 201]—see, for example, discussions of DMN, associative (mPFC, inferior temporal, hippocampus), or prefrontal executive networks above. Similarly, some work has begun connecting creativity and visual art to neuromodulator/neurotransmitter systems, which may also overlap with certain neurodegenerative diseases [62].

One major network connected to visual creativity involves dopamine (DA), a neurotransmitter involved in sending signals to other postsynaptic neurons or evoking reactions in other body organs. Especially the functioning of the mesolimbic pathway— branching from the main site of DA production in the midbrain through NAcc, hippocampus, vmPFC, OFC, etcetera—and, as above, associated with reward, motivation, and flexibility, has been suggested as a key target for art-making. Dopaminergic systems have also been implicated in a bio-psycho-behavioral model of creativity, alongside activity in the DMN and its interaction with the executive control network, specifically in their relation to creative personality through openness to experience and cognitive creative potential through associational abilities [202]. Studies have also suggested a positive relation between standardized creativity scoring and grey matter volume of the mesolimbic pathway-related mPFC, OFC, and hippocampus [203]. Similar results have also been found in mesocortical pathway areas, especially involving the PFC, but perhaps also in parietal and temporal regions (see Ref. [204] for review). The amount of especially striatal DA receptors (D2 and perhaps also D3, see Ref. [205]) has been tied to standardized divergent thinking tests. DA-receptor levels, in general, have also been associated with ideational fluency ([170, 206]; see also Refs. [207, 208]). Causative studies, using levodopa alone or in combination with DA agonists or antagonists, have found impacts on cognitive enhancement and creativity [209, 210]. Neuroimaging studies

have also suggested that the dopaminergic system plays a role in experiencing aesthetic pleasure [211].

In Parkinson's disease, a tie has been proposed between especially DA agonists, taken in response to the disease, and sudden increase in motivation to make art as well as subjectively felt—and occasionally externally evaluated—visual creativity in both previous artists and in those who have never before shown art interest. Lauring et al. [49] recently suggested that this may lead to either dysfunction in, or over-activation of, mesolimbic regions, further suggesting the potential key involvement of these areas in art making (see also Ref. [204] for similar argument for general creativity). Studies also show changes in art style, including movements to impressionistic forms, brighter colors, and freer expressions or themes. DA systems are also connected to several other chapters' topics, such as Alzheimer's disease, MS, and Lewy body dementia [212, 213].

The serotonergic system is also a compelling candidate. Serotonin (5-HT) receptors, also distributed within the brain, and innervating many regions such as the cerebellum, hippocampus, thalamus/hypothalamus, striatum/NAcc, and PFC [214], modulate a number of neuropsychological processes [215]. Selective 5-HT reuptake inhibitors (SSRI) act as antidepressants and reduce oversensitivity to negative feedback [216]. 5-HT has also been connected to aesthetic experience [217], primarily through the use of recreational drugs, including methylendioxymethylamphetamin (MDMA/Ecstasy), LSD, and psilocybin [218, 219]. Serotoninergic stimulation has also been linked to art making [149], for example, via LSD [220], and suggested to "increase the accessibility of remote or unique ideas and associations to their conscious awareness" and shown, in empirical study, to actually lead to drawings with enhanced expressionistic design, color sharpening, and syntactical organization [221]. Psilocybin has been found to increase subjective ratings of Openness [222]. This system is also implicated in neurodegenerative diseases touching art making—AD, PD [49, 223]. See Spee et al. [62] for a review of other such systems.

3.5 The Brain and Art Viewing

It is also worth briefly mentioning what we have discovered about the brain in the act of art viewing. This is, in fact, a much more developed line of research, and has led to a number of implicated regions. These cover a comparatively much more general set of functions but with some notable overlap to art production arguments.

Imaging studies, meta-reviews (see Ref. [225, 226]), as well as theoretical discussions [74, 200, 224], have identified a consensus on functionally distinct areas and networks connected to aesthetic appreciation (Fig. 7). These include "sensory/motor" areas related to basic vision, as well as the dorsal (Where) and ventral (What) visual streams, and attention-related sensory-motor processing areas, including the bilateral fusiform gyri, angular gyrus, superior parietal cortex—most probably serving similar roles as in making art. Premotor areas have also shown activation when viewing artifacts with salient evidence of artist actions [227].

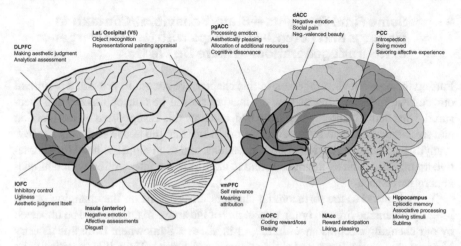

Fig. 7 Brain regions associated with visual art perception or appreciation. Yellow = "sensory-motor" regions tied to basic vision, attention, and sensory processing. Blue = "Knowledge/meaning" regions tied to evaluative judgment and information retrieval and expertise, content, and culture. Red = "reward/valuation" tied to reward, emotion, wanting/liking (tripartite division based on [224]; figure adapted from Ref. [62])

Researchers have identified regions tied to "reward and valuation"—cortical and subcortical regions caudate nucleus, substantia nigra, NAcc, lateral and medial orbitofrontal cortex (OFC)—and relating to the affective/ emotional experience and hedonic appraisal of the environment [228, 229]. Cortical regions involved in "knowledge/meaning," retrieval of information, and introspection—such as ventrolateral, dorsolateral, anterior medial prefrontal cortices, temporal pole, hippocampus, and precuneus—are also implicated across studies.

Much as with art making, these regions are argued to jointly contribute to the various aspects of emerging art experience. Authors [201, 224] suggest that they might be considered a "triad" of processing components. Activity within these networks can also be placed within a general temporal order, which aligns with models of art perception ([16, 74, 230]; see also the [72] model above), but, when thinking of making art, could perhaps operate in reverse (although this has not been empirically established).

When considering some other potential key overlapping regions, as can be seen, the presence of reward, and related areas, is particularly empirically established. Especially the mOFC involvement suggested above as key to coding reward/pleasure and perhaps motivation in art production, is almost universally identified in viewing studies, with activation tied to cases of aesthetic value across art styles or modalities [231], as well as to appraisals of beauty [211, 232]. Note also the presence of areas—DLPFC—that are connected to executive control, valuation, or making analytic judgments, again which may be important in some but not all stages and, as with all of these above results, raises questions regarding how these aspects and activities might fit together into the art making process.

4 Some Final Thoughts—Brain/Behavioral/Contextual Findings and Potential Overlaps with Neurodivergence or Neurodegeneration—Where Do We Go?

Putting the above review together, in this chapter, we sought to provide a picture of our current understanding of how art making should be conceptualized and measured, what demarcates good art from bad, and how this is supported by the function and structure of the brain. However, we might say that the above elements suggest, if anything, a large collection of open questions, and even more the need for alternative approaches such as might be found in exploring the intersection with neurodegenerative disease.

To look ahead to the forthcoming chapters' discussions on the changing or differently-organized life and brain, *almost any* of the above features could be impacted by our changing circumstances in life, or in disease. Somewhere from this tapestry of processes, motivations, and abilities emerges the artist. Thus, it is specifically by teasing out or considering these features where we might find the special promise in the patterns of neurodivergence or neurodegeneration-related change.

By reviewing the components that may feed into the creation of good or bad art, and especially by thinking of patients or individual artists, we suggest that researchers might have a range of putative mechanisms through which neurological changes may lead to changes in art making or at least questions they might start to ask. Authors might, for example, consider if and how changes in perceptual or attentional capacities or other domain-relevant or domain-general abilities could impact art making or outputs of production. One might consider how, or if, factors might impact aspects either directly—at various stages in the production or creative-idea generation process—or how they may have downstream effects on creative output or activities. This could involve how we perceive, how we cognitively organize our experiences, means for storage or retrieval of domain-relevant information, or more general creativity-relevant attributes such as ideational fluency and inhibitory capacity.

Changes in responsiveness to extrinsic motivation or in internal motivational states may have significant consequences for the tendency to engage in or disengage from creative work. In studying changes in both domain-relevant and creativity-relevant components, we can start to build up a picture of the extent to which changes in art making are indicative of generalized processes of ideation or motivation that are likely to have cascading and wide-ranging effects, or more specific attentional or perceptual processes that may reduce the change in output to a change in style.

When scoping out what is known about art making and the brain, it becomes very apparent that neuropsychological research provides one of the rare opportunities to study the causal influence of brain systems, as much of the literature reviewed here is reliant upon correlational research or training studies that are necessarily limited in their scope and experimental control. At the same time, as can be seen, it is also

important to consider context. External factors surrounding one's situation—more time, retirement, different living conditions, outward reinforcement, changes in one's identity and future outlook—might also mediate the ability, or the likelihood, for one to think in ways that would lead to art, to refine these or to put them to media, not to mention how individuals then execute art once begun. It is key, going forward, to consider if changes or even artistic proclivity can be found primarily in one's environment, in the body, perception, cognition, or the brain.

Similarly, how changes in art making over time are measured will be crucial to understanding the extent to which these changes depend on changes in the brain. The value then of the work subsequently considered in this book becomes apparent. The benefits of studying the way that art making changes as a function of changes to the brain are twofold. They can provide a window both to the art making process and how it is instantiated in the brain by determining which systems are necessary and sufficient for creative acts. Still, it can also provide insights into artistic phenomenology by constituting a rich output measure of complex internal representations.

References

1. Winner E. Development in the visual arts. In: Damon W, editor. Child development today and tomorrow. San Francisco, CA: Jossey Bass; 1989. p. 199–221.
2. Zaidel DW, Nadal M, Flexas A, Munar E. An evolutionary approach to art and aesthetic experience. Psychol Aesthet Creat Arts. 2013;7(1):100.
3. Dissanayake E. The arts after Darwin: does art have an origin and adaptive function? In: Zijlemans K, van Damme W, editors. *World art studies: exploring concepts and approaches*. Amsterdam: Valiz; 2008. p. 241–63.
4. Fechner GT. *Vorschule der Aesthetik* [elements of aesthetics], vol. 1. Leipzig: Breitkopf & Härtel; 1876.
5. Westphal-Fitch G, Oh J, Fitch W. Studying aesthetics with the method of production: effects of context and local symmetry. Psychol Aesthet Creat Arts. 2013;7:13–26. https://doi.org/10.1037/a0031795.
6. Holert T. A child could do it. Cabinet. 2009;34. Retrieved on April 10, 2017 from http://cabinetmagazine.org/issues/34/holert.php.
7. Arnheim R. Art and visual perception: a psychology of the creative eye. London: Faber and Faber; 1956.
8. Berlyne DE. Studies in the new experimental aesthetics: steps toward an objective psychology of aesthetic appreciation. Hemisphere; 1974.
9. Chatterjee A. Neuroaesthetics: a coming of age story. J Cogn Neurosci. 2010;23(1):53–62.
10. Lundy DE. Degrees of quality: a method for quantifying aesthetic impact. Psychol Res. 2012;2(4):205–21.
11. Leder H. Beyond perception – information processing approaches to art appreciation. In: Tinio PL, Smith JK, editors. The Cambridge handbook of the psychology of aesthetics and the arts. Cambridge: Cambridge University Press; 2014. p. 115–38.
12. Becker HS. Art worlds. Berkeley, CA: University of California Press; 1982.
13. Chamberlain R. Drawing as a window onto expertise. Curr Dir Psychol Sci. 2018;27(6):501–7.
14. Chamberlain R, Wagemans J. The genesis of errors in drawing. Neurosci Biobehav Rev. 2016;65:195–207. https://doi.org/10.1016/j.neubiorev.2016.04.002.

15. Kozbelt A, Seeley WP. Integrating art historical, psycholog- ical, and neuroscientific explanations of artists' advantages in drawing and perception. Psychol Aesthet Creat Arts. 2007;1:80–90. https://doi.org/10.1037/1931-3896.1.2.80.
16. Pelowski M, Tinio PL, Leder H. Creativity in the domain of visual art. In: Kaufman JC, Baer J, Glaveanu V, editors. Cambridge handbook of creativity across different domains. Cambridge: Cambridge University Press; 2017b. https://doi.org/10.1017/9781316274385.006.
17. Cropley AJ. Defining and measuring creativity: are creativity tests worth using? Roeper Rev. 2000;23:72–9. https://doi.org/10.1080/02783190009554069.
18. Rimm S, Davis GA. Five years of international research with GIFT: an instrument for the identification of creativity. J Creat Behav. 1980;14:35–46.
19. Kaufman JC, Baer J. Sure, I'm creative – but not in mathematics!: self-reported creativity in diverse domains. Empir Stud Arts. 2004;22:143–55.
20. Silvia PJ, Kaufman JC, Pretz JE. Is creativity domain-specific? Latent class models of creative accomplishments and creative self-descriptions. Psychol Aesthet Creat Arts. 2009;3(3):139.
21. Kaufman JC. Counting the muses: development of the Kaufman domains of creativity scale (K-DOCS). Psychol Aesthet Creat Arts. 2012;6(4):298.
22. Chamberlain R, McManus IC, Riley H, Rankin Q, Brunswick N. Local processing enhancements associated with superior observational drawing are due to enhanced perceptual functioning, not weak central coherence. Q J Exp Psychol. 2013;66(7):1448–66.
23. Pelowski M, Markey PS, Goller J, Förster EL, Leder H. But, how can we make "art?" artistic production versus realistic copying and perceptual advantages of artists. Psychol Aesthet Creat Arts. 2019;13(4):462.
24. Schaefer CE, Anastasi A. A biographical inventory for identifying creativity in adolescent boys. J Appl Psychol. 1968;52:42–8.
25. Carson SH, Peterson JB, Higgins DM. Reliability, validity, and factor structure of the creative achievement questionnaire. Creat Res J. 2005;17(1):37–50.
26. Simonton DK. Creativity and wisdom in aging. Handbook Psychol Aging. 1990a;3:320–9.
27. Simonton DK. Creativity in the later years: optimistic prospects for achievement. The Gerontologist. 1990b;30(5):626–31.
28. Sternberg RJ, Lubart TI. The concept of creativity: prospects and paradigms. In: Sternberg RJ, editor. Handbook of creativity. New York, NY: Cambridge University Press; 1999. p. 3–15.
29. Guilford J. The nature of human intelligence. New York, NY: McGraw-Hill; 1967.
30. Mednick SA. The associative basis of the creative process. Psychol Rev. 1962;69:220–32.
31. Chen C, Kasof J, Himsel A, Dmitrieva J, Dong Q, Xue G. Effects of explicit instruction to "be creative" across domains and cultures. J Creat Behav. 2005;39(2):89–110.
32. Meier NC, Seashore CE. The Meier-Seashore Art judgement test. Iowa City: Bureau of Educational Research, University of Iowa; 1929.
33. Götz KO. VAST: visual aesthetic sensitivity test. 4th ed. Düsseldorf: Concept Verlag; 1985.
34. Child IL. Personal preferences as an expression of aesthetic sensitivity. J Pers. 1962;30:496–512.
35. Rey A, Osterrieth P. Translations of excerpts from Rey's "Psychological Examination of Traumatic Encephalopathy" and Oster- rieth's "The Complex Figure Test". Clin Neuropsychol. 1993;7:2–21.
36. Cain TI. The objective measurement of accuracy in drawings. Am J Psychol. 1943;56:32–53. https://doi.org/10.2307/1417897.
37. McManus IC, Chamberlain R, Loo PW, Rankin Q, Riley H, Brunswick N. Art students who cannot draw: exploring the relations between drawing ability, visual memory, accuracy of copying, and dyslexia. Psychol Aesthet Creat Arts. 2010;4:18–30. https://doi.org/10.1037/a0017335.
38. Urban KK, Jellen HG. Test for creative thinking – drawing production (TCT-DP). Lisse: Swets and Zeitlinger; 1996.
39. Cramond B, Matthews-Morgan J, Torrance EP, Zuo L. Why should the Torrance tests of creative thinking be used to assess creativity? Korean J Thinking Problem Solv. 1999;9:77–101.

40. Torrance EP. Torrance tests of creative thinking: norms- technical manual. Princeton, NY: Personnel Press; 1966.
41. Lemons G. Diverse perspectives of creativity testing controversial issues when used for inclusion into gifted programs. J Educ Gift. 2011;34(5):742–72.
42. Kim KH. Can we trust creativity tests? A review of the Torrance tests of creative thinking (TTCT). Creat Res J. 2006;18:3–14.
43. Fornazzari LR. Preserved painting creativity in an artist with Alzheimer's disease. Eur J Neurol. 2005;12(6):419–24.
44. Amabile TM. Social psychology of creativity: a consensual assessment technique. J Pers Soc Psychol. 1982;43:997–1013.
45. Clark G, Zimmerman E. Teaching talented art students: principles and practices. New York, NY: Teachers College, Columbia University; 2004.
46. Chan DW, Zhao Y. The relationship between drawing skill and artistic creativity: do age and artistic involvement make a difference? Creat Res J. 2010;22(1):27–36.
47. Kaufman JC, Baer J. Beyond new and appropriate: who decides what is creative? Creat Res J. 2012;24(1):83–91.
48. Chamberlain R, McManus IC, Brunswick N, Rankin Q, Riley H, Kanai R. Drawing on the right side of the brain: a voxel-based morphometry analysis of observational drawing. NeuroImage. 2014;96:167–73. https://doi.org/10.1016/j.neuroimage.2014.03.062.
49. Lauring JO, Ishizu T, Kutlikova HH, Dörflinger F, Haugbøl S, Leder H, et al. Why would Parkinson's disease lead to sudden changes in creativity, motivation, or style with visual art?: a review of case evidence and new neurobiological, contextual, and genetic hypotheses. Neurosci Biobehav Rev. 2019;100:129–65.
50. Glazek K. Visual and motor processing in visual artists: Implica- tions for cognitive and neural mechanisms. Psychol Aesthet Creat Arts. 2012;6:155–67. https://doi.org/10.1037/a0025184.
51. Gowen E, Miall RC. Eye-hand interactions in tracing and drawing tasks. Hum Mov Sci. 2006;25:568–85. https://doi.org/10.1016/j.humov.2006.06.005.
52. Nodine CF, Locher PJ, Krupinski EA. The role of formal art training on perception and aesthetic judgment of art compositions. Leonardo. 1993;26:219–27. https://doi.org/10.2307/1575815.
53. Tchalenko J. Eye movements in drawing simple lines. Perception. 2007;36:1152–67. https://doi.org/10.1068/p5544.
54. Tovey M, Porter S, Newman R. Sketching, concept development and automotive design. Des Stud. 2003;24(2):135–53.
55. Weisberg RW. On structure in the creative process: a quantitative case-study of the creation of Picasso's Guernica. Empir Stud Arts. 2004;22:23–54. https://doi.org/10.2190/EH48-K59C-DFRB-LXE7.
56. Kozbelt A. Hierarchical linear modeling of creative artists' prob- lem solving behaviors. J Creat Behav. 2008;42:181–200. https://doi.org/10.1002/j.2162-6057.2008.tb01294.x.
57. Kozbelt A, Dexter S, Dolese M, Meredith D, Ostrofsky J. Regressive imagery in creative problem-solving: comparing verbal protocols of expert and novice visual artists and computer programmers. J Creat Behav. 2015;49(4):263–78.
58. Machotka P. Artistic styles and personalities: a close view and a more distant view. Empir Stud Arts. 2006;24(1):71–80.
59. Puppe L, Jossberger H, Gruber H. Creation processes of professional artists and art students in sculpting. Empir Stud Arts. 2021;39(2):171–93.
60. Kirsh A, Levenson RS. *Seeing through paintings: physical examination in art historical studies*, vol. 1. Yale University Press; 2000.
61. Locher P. How does a visual artist create an artwork. In: Kaufman JC, Sternberg RJ, editors. *The Cambridge handbook of creativity*. Cambridge University Press; 2010. p. 131–144).
62. Spee B, Ishizu T, Leder H, Pelowski M. Neuropsychopharmacological aes- thetics: a theoretical consideration of pharmacological approaches to causative brain study in aesthetics and art. Prog Brain Res. 2018;237:343–72.

63. Pelowski M, Spee BT, Arato J, Dörflinger F, Ishizu T, Richard A. Can we really 'read'art to see the changing brain? A review and empirical assessment of clinical case reports and published artworks for systematic evidence of quality or style changes linked to damage or neurodegenerative disease. Phys Life Rev. 2022;43:32–95. https://doi.org/10.1016/j.plrev.2022.07.005.
64. Bogousslavsky J. Artistic creativity, style and brain disorders. Eur J Neurol. 2005;54(2):103–11.
65. Getzels J, Csikszentmihalyi M. The creative vision: a longitudinal study of problem-finding in art. New York, NY: Wiley Interscience; 1976.
66. Jaarsveld S, Leeuwen C. Sketches from a design process: creative cognition inferred from intermediate products. Cogn Sci. 2005;29(1):79–101.
67. Niu WH, Sternberg RJ. Cultural influences on artistic creativity and its evaluation. Int J Psychol. 2001;36:225–41.
68. Wallas G. The art of thought, vol. 10. Harcourt, Brace; 1926.
69. Campbell DT. Blind variation and selective retentions in creative thought as in other knowledge processes. Psychol Rev. 1960;67(6):380.
70. Mace MA, Ward T. Modeling the creative process: a grounded theory analysis of creativity in the domain of art making. Creat Res J. 2002;14(2):179–92.
71. Schlegel A, Alexander P, Fogelson SV, Li X, Lu Z, Kohler PJ, et al. The artist emerges: visual art learning alters neural structure and function. NeuroImage. 2015;105:440–51.
72. Tinio PP. From artistic creation to aesthetic reception: the mirror model of art. Psychol Aesthet Creat Arts. 2013;7(3):265–75.
73. Leder H, Belke B, Oeberst A, Augustin D. A model of aesthetic appreciation and aesthetic judgments. Br J Psychol. 2004;95:489–508.
74. Pelowski M, Markey PS, Forster M, Gerger G, Leder H. Move me, astonish me… delight my eyes and brain: the Vienna integrated model of top-down and bottom-up processes in art perception (VIMAP) and corresponding affective, evaluative, and neurophysiological correlates. Phys Life Rev. 2017a;21:80–125.
75. Stevenson-Taylor AG, Mansell W. Exploring the role of art-making in recovery, change, and self-understanding: an interpretative phenomenological analysis of interviews with everyday creative people. Int J Psychol Stud. 2012;4(3):104.
76. Amabile TM. The social psychology of creativity. New York, NY: Springer; 1983.
77. Runco MA, Chand I. Cognition and creativity. Educ Psychol Rev. 1995;7:243–67.
78. Urban KK. Recent trends in creativity research and theory in Western Europe. Eur J High Abil. 1991;1(1):99–113.
79. Acosta LMY. Creativity and neurological disease. Curr Neurol Neurosci Rep. 2014;14(8):1–6.
80. Chamberlain R, Wagemans J. Visual arts training is linked to flexible attention to local and global levels of visual stimuli. Acta Psychol. 2015;161:185–97.
81. Kozbelt A, Seidel A, ElBassiouny A, Mark Y, Owen DR. Visual selection contributes to artists' advantages in realistic drawing. Psychol Aesthet Creat Arts. 2010;4:93–102. https://doi.org/10.1037/a0017657.
82. Ostrofsky J, Kozbelt A, Cohen DJ. Observational drawing biases are predicted by biases in perception: empirical support of the misperception hypothesis of drawing accuracy with respect to two angle illusions. Q J Exp Psychol. 2015;68:1007–25. https://doi.org/10.1080/17470218.2014.973889.
83. Cohen DJ. Look little, look often: the influence of gaze fre- quency on drawing accuracy. Percept Psychophys. 2005;67:997–1009. https://doi.org/10.3758/BF03193626.
84. Perdreau F, Cavanagh P. Does drawing skill relate to better memory of local or global object structure? J Vis. 2014;14(10):33.
85. Perdreau F, Cavanagh P. Drawing experts have better visual memory while drawing. J Vis. 2015;15(5):5–5.
86. Benear SL, Sunday MA, Davidson R, Palmeri TJ, Gauthier I. Can art change the way we see? Psychol Aesthet Creat Arts. 2019.
87. Ostrofsky J, Kozbelt A, Kurylo DD. Perceptual grouping in artists and non-artists: a psychophysical comparison. Empir Stud Arts. 2013;31(2):131–43.

88. Perdreau F, Cavanagh P. Do artists see their retinas? Front Hum Neurosci. 2011;5:171.
89. Chamberlain R, Swinnen L, Heeren S, Wagemans J. Perceptual flexibility is coupled with reduced executive inhibition in students of the visual arts. Br J Psychol. 2018;109(2):244–58.
90. Gombrich EH. Art and illusion: a study in the psychology of pictorial representation. Bollingen Ser. 1960;XXXV(5):9.
91. Blazhenkova O, Kozhevnikov M. The new object-spatial- verbal cognitive style model: theory and measurement. Appl Cogn Psychol. 2009;23:638–63. https://doi.org/10.1002/acp.1473.
92. Carbon CC, Wirth BE. Neanderthal paintings? Production of prototypical human (Homo sapiens) faces shows systematic distortions. Perception. 2014;43(1):99–102.
93. Drake JE, Winner E. Precocious realists: perceptual and cognitive characteristics associated with drawing talent in non-autistic children. Philos Trans R Soc Lond Ser B Biol Sci. 2009;364:1449–58. https://doi.org/10.1098/rstb.2008.0295.
94. Mottron L, Belleville S, Ménard E. Local bias in autistic subjects as evidenced by graphic tasks: perceptual hierarchization or working memory deficit? J Child Psychol Psychiatry. 1999;40(05):743–55.
95. Drake JE, Riccio A, Chamberlain R, Kozbelt A. Artists have superior local and global processing abilities but show a preference for initially drawing globally. In: *Psychology of aesthetics, creativity, and the arts*. Washington, D.C.: American Psychological Association; 2021. Online first.
96. Park S, Wiliams L, Chamberlain R. Global saccadic eye movements characterise artists' visual attention while drawing. Empir Stud Arts. 2021;40(2):228–44.
97. Serafin J, Kozbelt A, Seidel A, Dolese M. Dynamic evaluation of high-and low-creativity drawings by artist and nonartist raters: replication and methodological extension. Psychol Aesthet Creat Arts. 2011;5(4):350–9.
98. Fayena-Tawil F, Kozbelt A, Sitaras L. Think global, act local: A protocol analysis comparison of artists' and nonartists' cognitions, metacognitions, and evaluations while drawing. Psychol Aesthet Creat Arts. 2011;5(2):135.
99. Simonton DK. Origins of genius. New York: Oxford; 1999.
100. Verstijnen IM, van Leeuwen C, Goldschmidt G, Hamel R, Hennessey JM. Creative discovery in imagery and perception: combining is relatively easy, restructuring takes a sketch. Acta Psychol. 1998;99(2):177–200.
101. Kozbelt A, Serafin J. Dynamic evaluation of high-and low-creativity drawings by artist and nonartist raters. Creat Res J. 2009;21(4):349–60.
102. Pringle A, Sowden PT. The mode shifting index (MSI): a new measure of the creative thinking skill of shifting between associative and analytic thinking. Think Skills Creat. 2017;23:17–28.
103. Yokochi S, Okada T. Creative cognitive process of art making: a field study of a traditional Chinese ink painter. Creat Res J. 2005;17(2–3):241–55.
104. Locher P, Cornelis E, Wagemans J, Stappers PJ. Artists' use of compositional balance for creating visual displays. Empir Stud Arts. 2001;19(2):213–27.
105. Milbrath C. Patterns of artistic development in children: comparative studies of talent. Cambridge: Cambridge University Press; 1998.
106. Leder H, Gerger G, Brieber D, Schwarz N. What makes an art expert? Emotion and evaluation in art appreciation. Cognit Emot. 2014;28(6):1137–47.
107. Augustin D, Leder H. Art expertise: a study of concepts and conceptual spaces. Psychol Sci. 2006;48(2):135.
108. Pelowski M, Specker E. The general impact of context on aesthetic experience. In: Nadal M, Vartanian O, editors. The Oxford handbook of empirical aesthetics. Oxford; 2021.
109. Deines S. Art in context: on cultural limits to the understanding, experience and evaluation of works of art. In: de Mul J, van de Vall R, editors. *Gimme shelter: global dis courses in aesthetics, international yearbook of aesthetics*, vol. 15. Amsterdam: Amsterdam University Press; 2013. p. 23–40.
110. Hekkert P, Van Wieringen PC. Beauty in the eye of expert and nonexpert beholders: a study in the appraisal of art. Am J Psychol. 1996;109:389–407.

111. Vogt S, Magnussen S. Expertise in pictorial perception: eye-movement patterns and visual memory in artists and laymen. Perception. 2007;36(1):91–100.
112. Zangemeister WH, Sherman K, Stark L. Evidence for a global scanpath strategy in viewing abstract compared with realistic images. Neuropsychologia. 1995;33(8):1009–25.
113. Koide N, Kubo T, Nishida S, Shibata T, Ikeda K. Art expertise reduces influence of visual salience on fixation in viewing abstract-paintings. PLoS One. 2015;10(2):e0117696.
114. Gauthier I, Curran T, Curby KM, Collins D. Perceptual interference supports a non-modular account of face processing. Nat Neurosci. 2003;6(4):428–32.
115. Tso RVY, Au TKF, Hsiao JHW. Perceptual expertise: can sensorimotor experience change holistic processing and left-side bias? Psychol Sci. 2014;25(9):1757–67.
116. Newman GE, Bloom P. Art and authenticity: the importance of originals in judgments of value. J Exp Psychol Gen. 2012;141:558–69. https://doi.org/10.1037/a0026035.
117. Rostan SM. A study of young artists: the development of talent and creativity. Creat Res J. 1997;10:175–92.
118. Rostan SM. Studio learning: motivation, competence, and the development of young art students' talent and creativity. Creat Res J. 2010;22(3):261–71.
119. Rostan SM, Pariser D, Gruber HE. A cross-cultural study of the development of artistic talent, creativity, and giftedness. High Abil Stud. 2002;13:125–56. https://doi.org/10.1080/1359813022000048789.
120. Kozbelt A. Originality and technical skill as components of artistic quality. Empir Stud Arts. 2004;22:157–70.
121. Vinacke WE. The psychology of thinking. New York, NY: McGraw-Hill; 1952.
122. Jackson PW, Messick S. The person, the product, and the response: conceptual problems in the assessment of creativity. J Pers. 1965;33(3):309–29.
123. Wallach M, Kogan N. Modes of thinking in young children. New York, NY: Holt Rinehart & Winston; 1965.
124. Miall RC, Tchalenko J. A painter's eye movements: a study of eye and hand movement during portrait drawing. Leonardo. 2001;34(1):35–40.
125. Barron F, Harrington DM. Creativity, intelligence, and personality. Annu Rev Psychol. 1981;32(1):439–76.
126. Sawyers JK, Canestaro NC. Creativity and achievement in design coursework. Creat Res J. 1989;2(1–2):126–33.
127. Kandler C, Riemann R, Angleitner A, Spinath FM, Borkenau P, Penke L. The nature of creativity: the roles of genetic factors, personality traits, cognitive abilities, and environmental sources. J Pers Soc Psychol. 2016;111(2):230–49. https://doi.org/10.1037/pspp0000087.
128. Fayn K, MacCann C, Tiliopoulos N, Silvia PJ. Aesthetic emotions and aesthetic people: openness predicts sensitivity to novelty in the experiences of interest and pleasure. Front Psychol. 2015;6(1877):1–11.
129. Myszkowski N, Storme M, Zenasni F, Lubart T. Is visual aesthetic sensitivity independent from intelligence, personality and creativity? Pers Individ Dif. 2014;59:16–20. https://doi.org/10.1016/j.paid.2013.10.021.
130. Burch GSJ, Pavelis C, Hemsley DR, Corr PJ. Schizotypy and creativity in visual artists. Br J Psychol. 2006;97(2):177–90.
131. De Manzano Ö, Ullén F. Genetic and environmental influences on the phenotypic associations between intelligence, personality, and creative achievement in the arts and sciences. Intelligence. 2018;69:123–33.
132. Pérez-Fabello MJ, Campos A. The influence of imaging capacity on visual art skills. Think Skills Creat. 2007;2(2):128–35.
133. Kottlow M, Praeg E, Luethy C, Jancke L. Artists' advance: decreased upper alpha power while drawing in artists compared with non-artists. Brain Topogr. 2011;23(4):392–402.
134. Flaherty AW. Brain illness and creativity: mechanism and treatment risks. Can J Psychiatr. 2011;56:132–43.
135. Chakravarty A. Mona Lisa's smile: a hypothesis based on a new principle of art neuroscience. Med Hypotheses. 2010;75(1):69–72.

136. Machotka P. Painting and our inner world: the psychology of image making. New York: Kluwer Academic/Plenum Publishers; 2003.
137. Amabile TM. Beyond talent: John Irving and the passionate craft of creativity. Am Psychol. 2001;56:333–6.
138. Csikszentmihalyi M, Abuhamdeh S, Nakamura J. Flow. A general context for a concept of mastery motivation. In: Elliot AJ, Dweck CS, editors. Handbook of competence and motivation. New York, NY: Guilford Publications; 2005. p. 598–608.
139. Ericsson KA. The acquisition of expert performance: an introduction to some of the issues. In: Ericsson KA, editor. The road to excellence: the acquisition of expert performance in the arts and sciences, sports and games. Hillsdale, NJ: Lawrence Erlbaum Associates; 1996. p. 1–50.
140. Amabile TM. Creativity in context: Update to "The social psychology of creativity". Boulder, CO: Westview Press; 1996.
141. Amabile TM, Conti R. Environmental determinants of work motivation, creativity, and innovation: the case of R&D downsizing. In: Technological innovation: oversights and foresights. Cambridge: Cambridge University Press; 1997. p. 111–25..
142. Silvia PJ, Beaty RE, Nusbaum EC, Eddington KM, Kwapil TR. Creative motivation: creative achievement predicts cardiac autonomic markers of effort during divergent thinking. Biol Psychol. 2014;102:30–7.
143. Drake JE, Winner E. Predicting artistic brilliance. Sci Am Mind. 2012;23(5):42–8.
144. Lhommée E, Batir A, Quesada J-L, Ardouin C, Fraix V, Seigneuret E, Chabardès S, Benabid A-L, Pollak P, Krack P. Dopamine and the biology of creativity: lessons from Parkinson's disease. Front Neurol. 2014;5(55):1–10.
145. Kulisevsky J, Pagonabarraga J, Martinez-Corral M. Changes in artistic style and behaviour in Parkinson's disease: dopamine and creativity. J Neurol. 2009;256:816–9. https://doi.org/10.1007/s00415-009-5001-1.
146. Canesi M, Rusconi ML, Isaias IU, Pezzoli G. Artistic productivity and creative thinking in Parkinson's disease. Eur J Neurol. 2012;19:468–72.
147. Pinker S. Art movements. Can Med Assoc J. 2002;166:224.
148. Eisner EW. The arts and the creation of mind. New Haven, CT: Yale University Press; 2002.
149. Schwingenschuh P, Katschnig P, Saurugg R, Ott E, Bhatia KP. Artistic profession: a potential risk factor for dopamine dysregulation syndrome in Parkinson's disease? Mov Disord. 2010;25(4):493–6.
150. Csikszentmihalyi M. Implications of a systems perspective for the study of crea- tivity. In: Sternberg R, editor. Handbook of creativity. Cambridge: Cambridge University Press; 1999.
151. Csikszentmihalyi M. The creative personality. Psychol Today. 1996;29(4):36–40.
152. Dunham RL, Van Kleef, GA, Stamkou E. Artists' Motives for Creating Art and Their Impact on Viewers' Aesthetic Judgements; in preparation.
153. Cox MV, Koyasu M, Hiranuma H, Perara J. Children's human figure drawings in the UK and Japan: the effects of age, sex, and culture. Br J Dev Psychol. 2001;19:275–92.
154. Jellen H, Urban KK. Assessing creative potential world-wide: the first cross-cultural application of the TCT-DP. Creat Child Adult Q. 1988;14:151–67.
155. Rudowicz E, Lok D, Kitto J. Use of the Torrance tests of creative thinking in an exploratory study of creativity in Hong Kong primary school children: a cross-cultural comparison. Int J Psychol. 1995;30:417–30.
156. Baas M, Nijstad BA, Boot NC, De Dreu CK. Mad genius revisited: vulner- ability to psychopathology, biobehavioral approach-avoidance, and creativity. Psychol Bull. 2016;142(6):668.
157. Lubart TI, Sternberg RJ. Creativity across time and place: life span and cross-cultural perspective. High Abil Stud. 1998;9:59–74.
158. Carothers T, Gardner H. When children's drawings become art: the emergence of aesthetic production and perception. Dev Psychol. 1979;15(5):570.
159. Gardner H, Winner E. First intimations of artistry. In: Strauss S, editor. U-shaped behavioral growth. New York, NY: Academic; 1982. p. 147–68.

160. Golomb C. The child's creation of a pictorial world. Berkley, CA: University of California Press; 1992.
161. Barbot B, Tinio PPL. Where is the "g" in creativity? A specialization- differentiation hypothesis. Front Hum Neurosci. 2015;8:1–4.
162. Davis J. Drawing's demise: U-shaped development in graphic symbolization. Stud Art Educ. 1993;38:132–57.
163. Salzman J. The aged polymath as a non-professional artist. Acad Lett. 2022:4794. https://doi.org/10.20935/AL4794.
164. Simonton DK. Creative productivity: a predictive and explanatory model of career trajectories and landmarks. Psychol Rev. 1997;104(1):66.
165. Meredith D, Kozbelt A. A swan song for the swan-song phenomenon: multi-level evidence against robust end-of-life effects for classical composers. Empir Stud Arts. 2014;32(1):5–25.
166. Forsythe A, Williams T, Reilly RG. What paint can tell us: a fractal analysis of neurological changes in seven artists. Neuropsychology. 2017;31(1):1.
167. Sacks O. The man who mistook his wife for a hat. Pan Macmillan; 2014.
168. Schrag A, Trimble M. Poetic talent unmasked by treatment of Parkinson's disease. Mov Disord. 2001;16(6):1175–6.
169. Zaidel DW. Creativity, brain, and art: biological and neurological considerations. Front Hum Neurosci. 2014;8(389):1–9. https://doi.org/10.3389/fnhum.2014.00389.
170. Oikkonen J, Kuusi T, Peltonen P, Raijas P, Ukkola-Vuoti L, Karma K, Onkamo P, Järvelä I. Creative activities in music – a genome-wide linkage analysis. PLoS One. 2016;11(2):e0148679. https://doi.org/10.1371/journal.pone.0148679.
171. Macnamara BN, Hambrick DZ, Oswald FL. Deliberate practice and performance in music, games, sports, education, and professions: a meta-analysis. Psychol Sci. 2014;25(8):1608–18.
172. Macnamara BN, Moreau D, Hambrick DZ. The relationship between deliberate practice and performance in sports: a meta-analysis. Perspect Psychol Sci. 2016;11(3):333–50.
173. Platz F, Kopiez R, Lehmann AC, Wolf A. The influence of deliberate practice on musical achievement: a meta-analysis. Front Psychol. 2014;5:646.
174. Arden R, Trzaskowski M, Garfield V, Plomin R. Genes influence young children's human figure drawings and their association with intelligence a decade later. Psychol Sci. 2014;25(10):1843–50.
175. Vinkhuyzen AA, Van der Sluis S, Posthuma D, Boomsma DI. The heritability of aptitude and exceptional talent across different domains in adolescents and young adults. Behav Genet. 2009;39(4):380–92.
176. Mosing MA, Madison G, Pedersen NL, Kuja-Halkola R, Ullén F. Practice does not make perfect: no causal effect of music practice on music ability. Psychol Sci. 2014;25(9):1795–803.
177. Wesseldijk LW, Mosing MA, Ullén F. Gene–environment interaction in expertise: the importance of childhood environment for musical achievement. Dev Psychol. 2019;55(7):1473.
178. Bignardi G, Chamberlain R, Kevenaar ST, Tamimy Z, Boomsma DI. On the etiology of aesthetic chills: a behavioral genetic study. Sci Rep. 2022;12(1):1–11.
179. Aziz-Zadeh L, Liew SL, Dandekar F. Exploring the neural correlates of visual creativity. Soc Cogn Affect Neurosci. 2013;8(4):475–80.
180. Palmiero M, Di Giacomo D, Passafiume D. Creativity and dementia: a review. Cogn Process. 2012;13(3):193–209. https://doi.org/10.1007/s10339-012-0439-y.
181. Chavez-Eakle R, Graf-Guerrero A, Garcia-Reyna J, Vaugier V, Cruz-Fuentes C. Cerebral blood flow associated with creative performance: a comparative study. NeuroImage. 2007;38:519–28.
182. Kowatari Y, Lee SH, Yamamura H, Nagamori Y, Levy P, Yamane S, et al. Neural networks involved in artistic creativity. Hum Brain Mapp. 2009;30:1678–90.
183. Miall RC, Gowen E, Tchalenko J. Drawing cartoon faces: a functional imaging study of the cognitive neuroscience of drawing. Cortex. 2009;45(3):394–406.
184. Sieborger F, Ferstl E, von Cramon Y. Making sense of nonsense: an fMRI study of task induced inference processes during discourse comprehension. Brain Res. 2007;1166:77–91. https://doi.org/10.1016/j.brainres.2007.05.079.

185. Chatterjee A. The neuropsychology of visual artistic production. Neuropsychologia. 2004;42(11):1568–83.
186. Ellamil M, Dobson C, Beeman M, Christoff K. Evaluative and generative modes of thought during the creative process. NeuroImage. 2012;59:1783–94.
187. Elliott R. Executive functions and their disorders. Br Med Bull. 2003;65:49–59.
188. Chen Q, Beaty RE, Qiu J. Mapping the artistic brain: common and distinct neural activations associated with musical, drawing, and literary creativity. Hum Brain Mapp. 2020;41(12):3403–19.
189. Boccia M, Piccardi L, Palermo L, Nori R, Palmiero M. Where do bright ideas occur in our brain? Meta-analytic evidence from neuroimaging studies of domain-specific creativity. Front Psychol. 2015;6:1195.
190. Solso R. Brain activities in a skilled vs a novice artist: an fMRI study. Leonardo. 2001;34(1):31–4. https://doi.org/10.1162/002409401300052479.
191. Jung, R.E., Mead, B.S., Carrasco, J., Flores, R.A., 2013. The structure of creative cognition in the human brain. Front Hum Neurosci 7, 330. https://doi.org/10.3389/fnhum.2013.00330.
192. Gansler DA, Moore DW, Susmaras TM, Jerram MW, Sousa J, Heilman KM. Cortical morphology of visual creativity. Neuropsychologia. 2011;49(9):2527–33.
193. Bhattacharya J, Petsche H. Drawing on mind's canvas: differences in cortical integration patterns between artists and non-artists. Hum Brain Mapp. 2005;26(1):1–14.
194. Drago V, Foster PS, Okun MS, Cosentino FII, Conigliaro R, Haq I, Sudhyadhom A, Skidmore FM, Heilman KM. Turning off artistic ability: the influence of left DBS in art production. J Neurol Sci. 2009a;281:116–21.
195. Drago V, Foster PS, Skidmore FM, Heilman KM. Creativity in Parkinson's disease as a function of right versus left hemibody onset. J Neurol Sci. 2009b;15:276.
196. Seeley WW, Matthews BR, Crawford RK, Gorno-Tempini ML, Foti D, Mackenzie IR, Miller BL. Unravelling Boléro: progressive aphasia, transmodal creativity and the right posterior neocortex. Brain. 2007;131(1):39–49.
197. Limb CJ, Braun AR. Neural substrates of spontaneous musical performance: an fMRI study of jazz improvisation. PLoS One. 2008;3(2):e1679.
198. Saggar M, Quintin EM, Kienitz E, Bott NT, Sun Z, Hong WC, Chien YH, Liu N, Dougherty RF, Royalty A, Hawthorne G, Reiss AL. Pictionary-based fMRI paradigm to study the neural correlates of spontaneous improvisation and figural creativity. Sci Rep. 2015;5:10894. https://doi.org/10.1038/srep10894.
199. Shulman GL, Fiez JA. Common blood flow changes across visual tasks: II. Decreases in cerebral cortex. J Cogn Neurosci. 1997;9(5):624–47.
200. Chatterjee A. Commentary scientific aesthetics: three steps forward. Br J Psychol. 2014;105:465–7. https://doi.org/10.1111/bjop.12086.
201. Pearce MT, Zaidel DW, Vartanian O, Skov M, Leder H, Chatterjee A, Nadal M. Neuroaesthetics: the cognitive neuroscience of aesthetic experience. Perspect Psychol Sci. 2016;11(2):265–79.
202. Jauk E. A bio-psycho-behavioral model of creativity. Curr Opin Behav Sci. 2019;27:1–6.
203. Takeuchi H, Taki Y, Sassa Y, Hashizume H, Sekiguchi A, Fukushima A, Kawashima R. Regional gray matter volume of dopaminergic system associate with creativity: evidence from voxel-based morphometry. NeuroImage. 2010;51:578.
204. Boot N, Baas M, van Gaal S, Cools R, De Dreu CK. Creative cognition and dopaminergic modulation of fronto-striatal networks: integrative review and research agenda. Neurosci Biobehav Rev. 2017;78:13–23. https://doi.org/10.1016/j.neubiorev.2017.04.007.
205. Groman SM, James AS, Seu E, Tran S, Clark TA, Harpster SN, et al. In the blink of an eye: relating positive-feedback sensitivity to striatal dopa- mine D2-like receptors through blink rate. J Neurosci. 2014;34(43):14443–54.
206. Murphy M, Runco MA, Acar S, Reiter-Palmon R. Reanalysis of genetic data and rethinking dopamine's relationship with creativity. Creat Res J. 2013;25:147–8. https://doi.org/10.108 0/10400419.2013.752305.
207. Flaherty AW. Frontotemporal and dopaminergic control of idea generation and creative drive. J Comp Neurol. 2005;493:147–53. https://doi.org/10.1002/cne.20768.

208. Heilman KM, Nadeau SE, Beversdorf DO. Creative innovation: possible brain mechanisms. Neurocase. 2003;9(5):369–79. https://doi.org/10.1076/neur.9.5.369.16553.
209. Mohamed AD. The effects of modafinil on convergent and divergent thinking of creativity: a randomized controlled trial. J Creat Behav. 2016;50(4):252–67.
210. Repantis D, Schlattmann P, Laisney O, Heuser I. Modafinil and methylphenidate for neuroenhancement in healthy individuals: a systematic review. Pharmacol Res. 2010;62(3):187–206.
211. Kawabata H, Zeki S. Neural correlates of beauty. J Neurophysiol. 2004;91:1699–705.
212. Nobili A, Latagliata EC, Viscomi MT, Cavallucci V, Cutuli D, Giacovazzo G, et al. Dopamine neuronal loss contributes to memory and reward dysfunction in a model of Alzheimer's disease. Nat Commun. 2017;8(1):1–14.
213. Rangel-Barajas C, Coronel I, Florán B. Dopamine receptors and neurodegeneration. Aging Dis. 2015;6(5):349.
214. Berger M, Gray JA, Roth BL. The expanded biology of serotonin. Annu Rev Med. 2009;60:355–66.
215. Stahl SM. Stahl's essential psychopharmacology: neuroscientific basis and practical applications. Cambridge: Cambridge University Press; 2008.
216. Ruff CC, Fehr E. The neurobiology of rewards and values in social decision making. Nat Rev Neurosci. 2014;15:549–62.
217. Fost J. In: a neuro-evolutionary mechanism for aesthetic phenomenology. In: *Embodied Aesthetics: Proceedings of the 1st International Conference on Aesthetics and the Embodied Mind*, Brill; 2013. p. 18–37
218. Puig MV, Gulledge AT. Serotonin and prefrontal cortex function: neurons, networks, and circuits. Mol Neurobiol. 2011;44(3):449–64. https://doi.org/10.1007/s12035-011-8214-0.
219. Watkins TJ, Raj V, Lee J, Dietrich MS, Cao A, Blackford JU, Salomon RM, Park S, Benningfield MM, Di Iorio CR, Cowan RL. Human ecstasy (MDMA) polydrug users have altered brain activation during semantic processing. Psychopharmacology. 2013;227:41–54. https://doi.org/10.1007/s00213-012-2936-1.
220. Krippner S. Psychedelics, hypnosis, and creativity. In: Tart CT, editor. Altered states of consciousness: a book of readings. 3rd ed. San Francisco: Harper Collins; 1990.
221. De Rios MD, Janiger O. LSD, spirituality, and the creative process: based on the ground breaking research of Oscar Janiger. MD. Inner Traditions/Bear & Co.; 2003.
222. MacLean KA, Johnson MW, Griffiths RR. Mystical experiences occasioned by the hallucinogen psilocybin lead to increases in the personality domain of openness. Psychopharmacology. 2011;25(11):1453–61.
223. Geldenhuys WJ, Van der Schyf CJ. Role of serotonin in Alzheimer's disease. CNS Drugs. 2011;25(9):765–81.
224. Chatterjee A, Vartanian O. Neuroscience of aesthetics. Ann N Y Acad Sci. 2016;1369:172–94. https://doi.org/10.1111/nyas.13035.
225. Brown S, Gao X, Tisdelle L, Eickhoff SB, Liotti M. Naturalizing aesthetics: brain areas for aesthetic appraisal across sensory modalities. NeuroImage. 2011;58:250–8. https://doi.org/10.1016/j.neuroimage.2011.06.012.
226. Kühn S, Gallinat J. The neural correlates of subjective pleasantness. NeuroImage. 2012;61(1):289–94.
227. Umilta MA, Berchio C, Sestito M, Freedberg D, Gallese V. Abstract art and cortical motor activation: an EEG study. Front Hum Neurosci. 2012;6(311):1–9. https://doi.org/10.3389/fnhum.2012.00311.
228. Cupchik GC, Vartanian O, Crawley A, Mikulis DJ. Viewing artworks: contribu- tions of cognitive control and perceptual facilitation to aesthetic experience. Brain Cogn. 2009;70:84–91.
229. Vartanian O, Navarrete G, Chatterjee A, Fich LB, Leder H, Modrono C, Skov M. Impact of contour on aesthetic judgments and approach-avoidance decisions in architecture. Proc. Natl. Acad. Sci., U.S.A. 2013;110(2):10446–53. https://doi.org/10.1073/pnas.1301227110.
230. Nadal M, Munar E, Capó MA, Rosselló J, Cela-Conde CJ. Towards a framework for the study of the neural correlates of aesthetic preference. Spat Vis. 2008;21:379–96.

231. Ishizu T, Zeki S. Towards a brain-based theory of beauty. PLoS One. 2011;6(7):e21852. https://doi.org/10.1371/journal.pone.00214852.
232. Ikeda T, Matsuyoshi D, Sawamoto N, Fukuyama H, Okaka N. Color harmony represented by activity in the medial orbitofrontal cortex and amygdala. Front Hum Neurosci. 2015;9:382. https://doi.org/10.3389/fnhum.2015.00382.

Further Reading

Galenson DW. Painting outside the lines. Cambridge, MA: Harvard University Press; 2001.
Galenson DW. Old masters and young geniuses: the two life cycles of artistic creativity. Princeton, NJ: Princeton University Press; 2006.
Rostan SM. The development of artistic talent and creativity: an evolving systems approach. AGATE (Journal of the Gifted and Talented Education Council of the Alberta Teachers' Association). 1998;12(2):15–25.
Rostan SM, Pariser D, Gruber HE. What if Picasso, Lautrec, and Klee were in my art class?: a study of the early signs of artistic talent. In: Annual Meeting of the American Educational Research Association, San Diego; 1998.

Creativity and Parkinson's Disease

Marie Elise Maradan-Gachet ⓘ, Ines Debove ⓘ,
Eugénie Lhommée ⓘ, and Paul Krack ⓘ

Albert Einstein once said: "Creativity is intelligence having fun"—that sounds pretty positive, and indeed being a creative person is often considered as something good, something we can never have too much of [1]. In fact, creative people tend to show more success in their private, social, and professional life [2]. But what do creative people have in common? What makes one person more creative than another person? Do some neurological conditions diminish or facilitate creative thinking? Is there something like too much creative behaviour after all? The interest in neurosciences to understand and modulate underlying cognitive and psychological processes of creativity is growing (e.g. [2]). Neuropsychological research has led to substantial and unique gains in knowledge, which would not be possible only with neuroimaging and electrophysiology. Nevertheless, neuropsychological studies on creativity remain relatively sparse [3]. In this chapter, we will review some neuropsychological aspects of creativity such as intelligence, executive functions and attention, and look at them in the light of Parkinson's disease (PD). The dopaminergic system, which is depleted in PD, plays an important role in the automatic execution of learned motor programs [4]. We will review and illustrate how dopaminergic modulation in PD patients changes not only motor aspects, but in addition changes the ability to think, to act, and to be creative. You will first find some clinical facts and case examples that illustrate creativity in PD patients, followed then by a theoretical part providing an insight in the underlying mechanisms.

M. E. Maradan-Gachet (✉) · I. Debove · P. Krack
Department of Neurology, Inselspital, University Hospital Bern, University of Bern,
Bern, Switzerland
e-mail: marie.maradan@insel.ch

E. Lhommée
Movement Disorders Unit, Department of Psychiatry Neurology and Neurologival
Rehabilitation, CHU Grenoble Alpes, Grenoble, France

1 Parkinson's Disease and Creativity: Clinical Facts

When reviewing existing literature of PD and creativity, multiple case reports show an exacerbation of creativity or new onset creativity under dopamine therapy in PD:

- in long life artists that developed PD [5–9]
- in patients that were not "artists" before PD occurs, where creativity appeared as a *"de novo"* activity on dopaminergic treatment [7, 8, 10–13], as observed for our example that will follow, the case history of Mr. G.

The opposite has been reported in one isolated paper describing a semi-professional painter whose style changed from abstract to realism, but this happened before the appearance of his first motor parkinsonian symptoms and the initiation of dopaminergic treatment. During the course of his disease, the patient did not experience further change in his artistic skills [14].

1.1 Illustrative Case of Creativity on Dopaminergic Treatment

The case history of Mr. G. illustrates, like the mainstream literature, the awakening and extinction of creativity mediated by dopamine replacement therapy and more specifically ropinirol-prolonged release (acting 24 h a day), a D2-D3 selective dopamine agonist. Mr. G. grew up in a family of artists. His mother was a painter and his father a sculptor. He took drawing courses for 3 years in his adolescence, but did not draw again during adulthood. He was diagnosed with PD at the age of 39 in 2008. His first motor symptoms were slowing of movement and pain in the left arm. The symptoms initially responded well to dopaminergic treatment. He was running a consulting company, and after only 4 years of treatment however, parkinsonism forced him to give up his profession. From 2012 to 2016, under ropinirol-prolonged release 16 mg/day and levodopa 300 mg/day, he experienced a strong urge to create artistic sketches of masks or faces with his computer (Fig. 1).

He spent multiple hours each night pursuing this activity, usually from 22 pm to 4 am. In each attempt, he changed details, drawing a new mask, adding a new computer-aided effect. He stated that "it was quickly done, instinctively, and almost compulsive. I liked the psychedelic way I did it, it was as if these colored faces came from inside me spontaneously, not requiring any decision from my side... I remember I enjoyed developing them and trying to improve them repeatedly according to the hazardous application of the filters I selected. Sometimes I worked half asleep. I called my drawings "warriors" and they were there to protect me… afterwards I used my own face and other faces from my family, but it was somewhat shrilling and morbid and my family did not like it". His artistic skills also included photography for a while (Fig. 2).

His creativity was accompanied by compulsive spending of money for tools or services involving his creative hobby. For example, he spent money for numerous drawing apps and got multiple prints of the drawings in extra-large format. Mr.

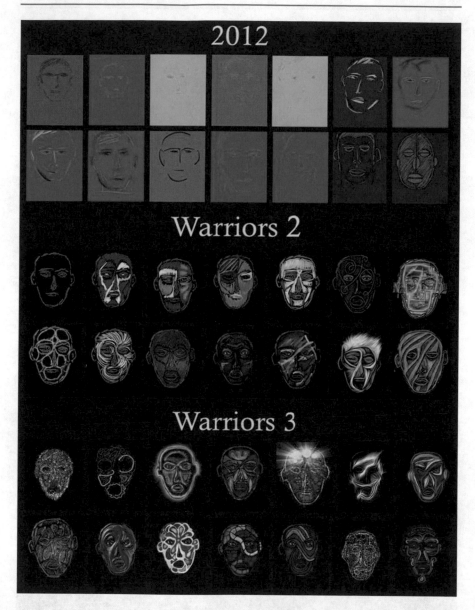

Fig. 1 The masks and their evolution over time until 2016

G. was very proud of his work and looking for positive appreciation. Indeed, the quality of the work impressed people and his work was exhibited in Brussels and in the Louvre Carrousel in Paris. In response to a probable hypomania with excessive self-confidence, feeling of grandiosity and interpersonal issues, dopamine agonists were rapidly tapered and then stopped in 2016. His creative drive then abruptly stopped. The patient still misses this period of his life. He is convinced that PD and dopaminergic medication unleashed a creative potential that he did not think he had.

Fig. 2 New-York photos, 2016

1.2 Illustrative Case of Creativity After Subthalamic Stimulation

When looking at subthalamic deep brain stimulation, a reduction of creativity after surgery is broadly observed, with authors explaining this result by the reduction of dopaminergic treatment [7] or by the effect of the stimulation itself [1]. A drastic increase in creativity after surgery for subthalamic deep brain stimulation was reported in a case report by Witt et al. [15], reproduced here (Figs. 3 and 4).

Authors describe an architect with PD with a preoperative drive to paint buildings (example Fig. 3), who started to paint nudes for the first time in his life under subthalamic deep brain stimulation in the context of stimulation-induced hypomania (elevated mood, more talkative). Actually, he painted hundreds of nudes spending day and night with this new activity. This phenomenon appeared under subthalamic deep brain stimulation while doses of his dopamine agonist medication were still high. It then disappeared progressively with time and with the reduction of dopaminergic treatment. Authors supposed that there was an additive effect of STN stimulation and dopaminergic treatment which explained this change in artistic expression. By analogy, there is a well-known synergistic effects on dyskinesia on the motor side particularly in the immediate postoperative period when STN-DBS is rapidly increased and the long-acting effects of dopaminergic treatment have not yet undergone desensitization [16, 17].

Fig. 3 Representative painting by the patient before deep brain stimulation showing the old pavilion of the Department of Neurology in Kiel (built in 1901), the working place of Hans-Georg Creutzfeldt 1938–1953

Fig. 4 Painting by the patient after implantation of electrodes for deep brain stimulation displayed on the wardround. He labelled his painting "the search for perfection". Note the comments written at the bottom of the painting, which are logorrheic and optimistic

2 Overlap of Creativity in Parkinson's Disease with Punding and Hobbyism

Punding describes a heterogeneous set of aimless, stereotyped behaviors performed over long periods of time at the expense of other activities. Its semiology differs radically from obsessive-compulsive disorder since compulsions are not driven by anxiety and are not distressing. Punding was first described in amphetamine addiction, then cocaine abuse and finally in PD [18]. It is a frequent behavioral side effect in PD, its prevalence ranging from 0.3 to 14% [19, 20]. It is associated with dopaminergic medications and impulse control disorder [18, 21]. From an external point of view, creativity is the opposite of punding in its fundamental characteristics: by definition, creativity implies: (1) novelty, not repetitiveness and (2) usefulness, not aimlessness. In fact, punding is even discussed to be included in the rubric of stereotypies [22]. However, if you take the case of a person that spends time painting the same tiny part of his work endlessly, is he a "punder" or a creative person in process? The external value (although subjective) attributed to the production can help to distinguish both, but a creating person can be experiencing creativity even if someone else can qualify their acts as "pathologic accumulation", punding or stereotypy [23].

2.1 Illustrative Case for Hobbyism / Creativity

The case below illustrates the overlap between hobbyism and creativity. These are creations from a 73-year-old former English teacher, who has been suffering from PD for about 12 years. She was diagnosed with PD after presenting with progressive rigidity and bradykinesia of the right arm and leg. As the disease progressed, the patient could no longer play the violin and participate in orchestra rehearsals due to the worsening of her fine motor skills. Due to the loss of this important and fulfilling hobby, she started to engage in other creative hobbies.

Among other activities, she creates collages. She first defines the motif or topic that serves as the background for the collages. She uses a wide range of motifs, from copied artists' pictures to silhouettes of buildings. Then she collects the necessary collage material, which she will glue onto the background. For this, she uses different motifs from newspapers and magazines, which she likes because of their texture and colour. The patient calls this process a "treasure hunt", as she collects different colours and shapes.

She then divides the selected motif into individual areas and pastes them with the collected material, which she has previously cut out into different pieces of paper. The shape of the background remains the same, but the different collage materials give rise to a creation with new depth, which varies greatly depending on the collage material.

Below is an example to illustrate the collage process (Fig. 5).

As a background image, the PD patient used a copy of the painting by the Japanese artist Kitagawa.

Fig. 5 Utamaro Kitagawa, 1788 «Lovers»

She then covered this background with different coloured pieces of paper and the face cut out from the work of Morisot (Fig. 6) to create her own new collage work (Fig. 7).

Moreover, an overlap can exist between hobbyism, punding and creativity. Hobbyism and punding are both perseverative and time consuming but:

- activities per se seem more complex in the case or hobbyism, less repetitive
- in the case of hobbyism, the activity has an aim and an end
- there seem to be more pleasure in experiencing hobbyism when patient describe its phenomenology

Fig. 6 Berthe Morisot, 1872 «Le berçeau»

Fig. 7 Collage created by the patient in 2020

Hobbyism can be defined as a selective hyperactivity, that may cause some mess, but typically is appreciated by patients and caregivers. It can take place during the night. It can concern work activities (workaholism), do-it-yourself, gardening, cooking, et cetera. Creativity may be seen as a particular case of hobbyism given the fact that the result of the repetitive activity is novel and useful. Indeed, as explained above, creativity does not apply only to traditional artistic domains, and people or PD patients who for example create ingenious do-it-yourself craft that is new and useful are by definition creative.

3 Dopaminergic Pathways and Creativity

The neurotransmitter dopamine is synthesized in the subcortical ventral tegmental area and substantia nigra. It is projected onto numerous brain areas including the striatum and prefrontal cortex via the dopaminergic pathways [24, 25]. Altogether, these pathways form a complex network, which regulates itself through reciprocal connections between brain areas and inhibitory auto-receptors [25]. Within this network, dopamine is projected to striatal and PFC regions via nigrostriatal, mesolimbic and mesocortical pathways [25–28].

The mesocortical pathway, originates in the ventral tegmental area (VTA) and projects to the prefrontal area, where it facilitates persistence of cognitive processes, therefore supporting convergent, systematic analytical thinking, increased mental effort and the generation of many ideas within one conceptual category [25].

Along with the mesocortical pathway, the mesolimbic pathway projects from the ventral tegmental area to the ventral striatum, including the Nucleus accumbens. It mediates processes associated with appetitive motivation and reward prediction, and may indirectly influence creative performance through motivational processes [25, 29, 30].

The increase in creativity and artistic performance observed in PD is usually related to the use of dopamine agonists, which lead to an overstimulation of the mesolimbic dopaminergic pathways [7, 31] and can enhance the performance on several creativity associated tasks [32].

The dopamine agonists presently available to treat PD act specifically on dopamine D3 receptors, which are found in the mesolimbic pathways. As the mesolimbic pathways are involved in motivation, emotion and reward [7, 33] they may facilitate creative ideas and their expression. It seems plausible that dopamine agonists encourage greater freedom of association and artistic production [7]. Dopamine agonists in small doses increase the vividness of mental imagery and night dreaming, which are both associated with increased creativity [1, 34]. In larger doses, dopamine agonists can also cause hallucinations [34]. They can therefore change perception and thus possibly promote inspiration in creativity [7, 35].

Furthermore, dopamine agonist therapy in PD can lead to an increased incidence of pathological gambling. Pathological gambling is an impulse control disorder that combines impulsive and compulsive features [36]. It is defined by a failure to resist the urge to gamble with persistent and recurrent maladaptive gambling behaviour, despite disruptive consequences on familial, occupational and social functions [37].

Based on several functional imaging studies in PD and in pathological gambling [37–42], it can be hypothesised that dopamine facilitates impulsive behaviour via simultaneous downregulation of fronto-striatal top-down behavioural control and upregulation of the bottom-up appetitive drive [43].

This helps us to understand that dopamine contributes a great role in the decision making process, revealing that dopamine neurons encode the difference between expected and received rewards and interact between other neurotransmitter systems to regulate such decision making [44]. Similar processes are involved in the process of creativity [45, 46].

Stimulants like amphetamines or cocaine can also increase creativity, as they mimic and enhance the action of dopamine. Levodopa and dopamine agonists used in PD or Restless-Legs-Syndrome as well as psychostimulant drugs such as amphetaimes or cocaine act on the dopaminergic reward pathway and increase the dopaminergic activity in the ventral striatum [47, 48]. Amphetamine and cocaine do not act directly at the dopamine receptors, but their acute use sharply increases synaptic dopamine concentrations in the frontal cortex and Nucleus accumbens via the inhibition of mesolimbic and mesocortical presynaptic dopamine re-uptake.

Artists such as Jack Kerouac, Jean-Paul Sartre, Johnny Cash or Andy Warhol, who all used amphetamines to facilitate creative inspiration, illustrate this quite well. Jack Kerouac created his influential novel "On the road" written in a breathtaking style typing continuously day and night onto a 120-foot roll of teletype paper in a creative "trance "without margins or paragraph breaks in as little as 3 weeks.

Despite the extensive use of amphetamine and cocaine to enhance artistic talent, their direct effect on creativity remains controversial [49, 50]. To date, it is unclear

whether they increase some aspects of creativity, alternatively only modify self-rated perception of talent, or have no influence on artistic abilities [48, 51]. This controversy is likely explained by the fact that chronic use of psychostimulants leads to depletion of presynaptic vesicular dopamine storage, resulting in apathy in response to psychostimulant withdrawal and in chronic addiction [52, 53].

4 Brain Mechanisms that Influence Creative Drive

Dopamine fosters motivated behaviours such as reward-based drives and curiosity. It currently appears to be the neurotransmitter with the strongest influence on creativity. Dopaminergic receptor density is highest in the frontal regions, which regulate motivated action [34]. It is less dense in the posterior regions, which integrate sensory perceptions [34, 54]. Dopamine drives us to act spontaneously, rather than considering the meaning and risk of our actions. Creative work requires both perception and action. Dopamine alters perception and seems to benefit creativity in different ways [34].

Creativity is modulated via different dopaminergic cognitive pathways. For example, dopamine lowers latent perceptual inhibition. This means that the probability that subjects will recognize novel phenomena rather than blank them out, is increased. At the same time, low latent inhibition is associated with creativity in average subjects [55]. Dopamine regulates attentional flexibility when switching between diffuse and narrowly focused attention. It also improves working memory in average subjects, so it facilitates mental associations [56]. Furthermore, dopamine improves mental imagination in healthy subjects and can cause hallucinations at high dosage [1].

There are two cortical network axes, which are important and influence the creative motivation: Pathways connecting the right and left cortical hemisphere and pathways connecting the frontal and temporal lobes (Fig. 8, [34]). The frontal

Fig. 8 Cortical network axes, which are important and influence the creative motivation

activity drives motivation to approach (left dominant frontal) or avoid (right non-dominant frontal). Temporal activity drives perception of familiar patterns on the left and novel patterns on the right hemisphere. For creative behaviour, novelty seeking and the integration of perceptions into a new pattern is needed [34].

Figure from "The Neuroscience of creativity", Homeostasis and the control of creative drive by Alice W. Flaherty, *The Cambridge Handbook of the Neuroscience of Creativity*, 2018. Reproduced with permission of the licensor through PLSclear.

5 Neurobiology, Pathophysiology of Creativity Connection to Other Psychiatric Diseases

In both of the cases shown above, creativity occurred in a context of hypomania. Indeed, one theory is that the more a patient experiences elevated hypomanic mood in the medication ON phase and distressful psychological states in the medication OFF phase, the more they are prone to creativity. This result is supported by higher of ON/OFF psychic fluctuations in creative VS non-creative patients [7]. A direct dopaminergic effect on creativity seems not sufficient, since PD patients performing creative tasks during ON and OFF medication (without controlling for psychic fluctuations) have the same creativity scores [57]. This mandatory "hypomanic mood" to drive creativity in PD is echoing with creativity experienced by patients suffering from bipolar disorder [58]. Indeed, a link seems to exist between mental illness, notably bipolar disorder, dopamine, and creativity. Many well-known artists (e.g., Edward Munch, Ernest Hemingway, and Virginia Woolf) suffered from bipolar disorder and 38.3% of British artists who received awards were treated for affective disorders [7, 59]. However, several mental disorders are discussed to be associated with creativity. Categories which have been studied frequently in the literature are not only mood disorders (especially bipolar disorders), but also schizophrenia-spectrum disorders (psychosis proneness), substance abuse disorders and to a lesser extent attention-deficit disorders, the latter commonly being treated by amphetamines [34].

Some creative individuals display neurocognitive vulnerabilities, which can also be found in the above- mentioned mental illnesses. These vulnerabilities seem to provide access to disinhibited states of consciousness [60–62], increasing attention to novelty [63–65], promoting unusual associations through uncommon neural connectivity [66–69] and focusing the attention inwards [34]. Furthermore there seem to be protective factors like high IQ [70], cognitive strength and flexibility [71–73] and strong working memory capacity [74, 75] which may protect those individuals from severe forms of mental illnesses.

6 Is There an Influence of Personality Traits on Creativity?

In the general population, the link between creativity and personality has been thoroughly studied in social psychology and has been applied in human resources for recruitment purposes. For employers, a person with a creative profile easily detected

by a questionnaire can be a strong asset in a team. The literature in this domain shows robustly that creative thinking is linked to the traits of personality "openness to experience" and/or "novelty seeking", favoring the ability to make remote and unusual associations [76]. In the opposite way, parkinsonian patients are described as rigid, introverted, and slow-tempered even a decade before the motor signs appear [77]. The notion of a "parkinsonian personality" that was anything but open to experience prevailed in the beginning of the twentieth century, at the time of the better understanding of the neurological and psychiatric diseases and the apogee of the psychoanalytic theory. This perception changed upon the discovery of Levodopa, as the first dopamine replacement therapy for patients with PD. In the early 2000s, more and more reports and studies of PD patients under dopaminergic medication suffering from impulse control disorders such as compulsive shopping, compulsive eating, compulsive gambling and hypersexuality were published [78]. The observed traits in those PD patients included risk taking, excessive pleasure seeking, violation of social conventions and sometimes "too much" openness to new experiences. Of note, the assumption that personality is stable over time after the age of 30 [79] is nowadays largely challenged by longitudinal studies in the general population [80]. A shift in personality traits is also occurring in the particular case of PD during the time course of the disease [81]:

- A lack of dopamine in the motor and non-motor pathways can influence personality even before occurrence of motor signs, since the personality trait of "constraint" is overrepresented in people who will develop Parkinsonism [82].
- Psychological coping mechanisms influence personality at different steps in the process of acceptance of the disease.
- At the same time, dopamine replacement therapy targets not only motor circuits, but also dopaminergic reward pathways, with a demonstrated increase in novelty seeking, enhanced reward processing, and decreased punishment processing [83].

7 Is There a Cognitive Background that Favors Creativity?: Neuropsychology of Creativity

One widely studied cognitive feature related to creativity is intelligence [84]. Studies have consistently reported a positive correlation between these two constructs. [84–87]. Several studies mentioned the threshold-effect or threshold hypothesis, which assumes that above-average intelligence represents a necessary, but not sufficient, condition of high-level creativity [48]. The threshold is usually set to an IQ of 120. Some studies show that above that level, the correlation weakens and becomes statistically insignificant [84, 88]. Other studies did not find such an effect and rejected the hypothesis, suggesting that intelligence is relevant for creative achievement across the entire IQ range [84, 88].

There is also a growing body of evidence for the involvement of executive functions in creativity (e.g. [84]). Executive functions, sometimes also referred to as

"frontal lobe" functions, are cognitive processes that control and direct mental activity in a goal-directed manner and thus are crucially involved in complex cognitive tasks [86, 89]. They represent the fundamental cognitive basis of individual differences in general intelligence and are highly relevant for creativity [84]. Commonly mentioned executive functions are updating, mental shifting, and inhibition [84, 86]. Updating refers to the monitoring of incoming information and the revision of working memory content. Obsolete information has to be replaced with new and relevant information for a given task. Mental shifting, or cognitive flexibility, reflects the process of switching between different tasks and adapting to changing mental sets [84]. However, whether and to what extent creativity is predicted by mental shifting is debated in the literature and remains unclear (e.g. [84, 90]). Finally, cognitive inhibition refers to the ability of thought monitoring by suppressing pre-potent response tendencies or interferences caused by dominant, highly salient responses. By suppressing interference, inhibition is thought to facilitate creative idea generation by an activation of semantically remote concepts. Both positive and negative correlations were found between creativity and different types of inhibition (e.g., inhibitory control, behavioral disinhibition, latent inhibition etc.) [2, 84, 91–93]. Overall, the prediction of creativity through those executive functions requires an optimal balance between deliberate (controlled, top-down) processing and spontaneous processing [2, 84].

It is generally accepted that creative cognition involves both convergent and divergent thinking [94]. Convergent thinking is the ability to arrive at a single, "correct" solution in response to a given problem, and relates to the selection of useful and appropriate ideas. [91, 94, 95]. Divergent thinking refers to the ability to generate multiple answers or solutions to a single cue or question drawing knowledge or ideas from diverse domains and combining them [88, 95]. This form of thinking is considered to be crucial for the novel idea generation component of creativity [94]. Divergent thinking involves the capacity to focus attention, manage the contents of working memory, and suppress pre-potent response tendencies [89].

Neuropsychology offers an additional perspective on the role of attention in divergent thinking. Focused internal attention seems to play an important role of taskshielding during creative idea generation [84].

7.1 Neuropsychology of PD

In addition to the well-known motor symptoms such as tremor, bradykinesia, postural instability and rigidity, PD is characterized by various cognitive impairments, which can range from mild cognitive impairment to dementia. This independent, non-motor aspect of the disease strongly predicts the functional outcome of the disease regarding life expectancy and caregiver burden. Parkinson patients statistically are twice as likely to develop mild cognitive impairment in comparison to healthy individuals of the same age. Within the first 3–5 years after the diagnosis, 20–57% of the patients show mild cognitive impairment [96]. The frequency and severity of cognitive decline and its implications for clinical management makes it

a symptom requiring focused attention and specific treatment. The concept of mild cognitive impairment usually characterizes a transitional cognitive status going from normal ageing process up to dementia. In PD it is used as an umbrella term for the diverse neuropsychological deficits in mnestic (related to memory), visuospatial, attentional and executive functions as well as language impairments. Frequently occurring executive dysfunctions such as deficits in cognitive flexibility, planning, inhibition working memory or concept formation are driven mainly by dopaminergic dysregulation and are similar to symptoms of patients with frontal lobe injury. These executive dysfunctions are of particular interest when it comes to creativity [96]. Dopaminergic medication used for the treatment of PD has an impact on executive functions. To date, positive effects were shown on cognitive flexibility, attention, episodic memory, set shifting, working memory, processing speed, verbal fluency and planning. On the other hand, both negative and positive effects were observed for inhibition and impulse control. At the same time, dopaminergic treatment seems to have no impact on visuospatial function, visual recognition memory, decision making, conditional associative learning, and verbal memory [1, 96, 97].

7.2 Assessment of Creativity in PD

Khalil et al. [2] amongst others pointed out the variety of the experimental approaches in the domain of creativity research [2, 3]. We will therefore briefly discuss a few different methodological approaches that aim to measure creative thinking.

Various self-reports scales enable different categories of subjective measurements: creative products, creative cognition, creative traits, and creative behavior and accomplishments [98]. Some commonly used scales are: The Short Scale of Creative Self (SSCS) [99]) is an 11-item Likert-scale that measures creative self-efficacy and creative personal identity. The Creative Achievement Questionnaire (CAQ) [100], measures creative achievement across 10 different domains of creativity. The Biographical Inventory of Creative Behaviors (BICB) [101], is a 34-item scale that assesses everyday creativity across a broad range of different domains. And the Creativity Domain Questionnaire (CDQ) [102] and its revised version (CDQ-R) [103] measure people's beliefs about their level of creativity in different domains [98].

In order to measure creative processes, many different creativity tasks are available. To assess convergent thinking, the Remote Associates Test (RAT) [104] is often used. Three unrelated cue words are presented, and the subject has to provide a fourth word related to three given cue words (e.g., "rat, cottage, blue" leads to the solution word "cheese") [2, 105]. Updating is usually measured by an n-back task in which the subject has to memorize a series of n information, for example numbers. This task requires a continuous working memory update. A common task to evaluate set shifting is the number–letter task [106] that requires making consonant–vowel decisions or odd–even decisions depending on the position of the stimulus [84]. The most commonly used method to assess divergent thinking is the

Alternate Uses Task [107], which requires the subject to generate as many different and unusual uses for familiar objects (e.g. "brick") as possible. The answers are then scored for fluency (number of answers generated), flexibility (number of different categories of answers), originality (relative infrequency in comparison with other participants), appropriateness (feasibility of the use) and elaboration (amount of detail provided) [2, 84, 92–95]. Another possibility of divergent thinking measurement is to look at associative fluency (Fig. 9), which also correlates positively with high originality scores in the Alternate Uses Task. Continuous free word association tests require the subject to provide a continuous sequence of association responses to one particular stimulus word (e.g., cue word: "forest"; continuous responses: "animals, trees, green, mountains, wood, leaves, autumn, relaxation" etc.). To focus more on flexibility, similar chain free association tasks can be performed. In these tasks the subject is asked to provide a sequence of associations, in which the first association should relate to a presented word stimulus, and each following association relates to the previous associative response (e.g., cue word: "house"; chain response: "garden, flower, spring, love, hate" etc.). High associative flexibility scores measured by chain free associations have been related to high fluency and originality scores on the Alternate Uses Task, which is in line with the hypothesis that flexibility is a critical component of creativity [94, 105]. To specifically investigate inhibition and shifting, the Color-Word Interference Test [108] or Stroop task [109] is often used in neuropsychological examinations [84]. Although both convergent and divergent thinking seems to be necessary to produce creative output, psychometric tools mostly focus on divergent thinking [94]. The Torrance Test of Creative Thinking [110] may be the most widely used and validated creativity assessment tool in various populations focusing on divergent thinking. It consists of several verbal and figural activities assessing divergent search and production. Subjects are for example asked to list all the questions they can think of when given a drawing of a scene, to complete incomplete figures, to make drawings and name them or to generate as many unusual uses for a common object as possible (like Alternate Uses Task) [2, 105]. A short version of the Torrance Test of Creative

Fig. 9 Illustration of a divergent thinking and figural fluency task

Fig. 10 Some examples of substrates typically inducing visual pareidolia in daily life

Thinking, the Abbreviated Torrance Test for Adults [111] offers a reduced selection of three tasks: first a verbal task with a scene where as many possible problems have to be named, and two visual tasks with figures. In one, as many different objects as possible must be created from triangles (Fig. 9). In the other one, incomplete line sketches have to be completed into drawings. The answers are scored according to the three criteria fluency, flexibility and originality, and result in an overall creativity index.

There is also a recently developed task called Divergent Pareidolias Task [112], which is based on a phenomenon called *pareidolia*, which is an illusory perception of patterns (e.g. impression that patterns in rocks, clouds, walls or other backgrounds look like figures, bodies or animals). The Divergent Pareidolias Task is a tablet-based creativity task in which subjects are presented with photographs of natural landscapes and structures (Fig. 10) and are asked to draw all the patterns they can see during a given time. The pareidolic outputs are analyzed in terms of fluency (number of pareidolias produced), flexibility (number of different categories the pareidolias can be put into), and originality (statistical infrequency compared to the entire pool of drawings). The authors showed that the fluency and originality of pareidolias produced in the Divergent Pareidolias Task were significantly predicted by divergent thinking, in terms of fluency of the Alternate Uses Task. Furthermore, fluent and rarer associations in an Associative Fluency Task predicted fluent and original aspects of pareidolias in the Divergent Pareidolias Task. First results indicate the involvement of creative processes in the production of pareidolias and suggest that the Divergent Pareidolias Task could represent a possible future way to investigate divergent aspects of creative cognition. This task could be of particular interest especially for PD patients, as it is known that

pareidolias can occur in the course of the disease [113, 114], and that they have been linked to visual hallucinations which are a frequent non-motor symptoms in PD [115, 116].

Regarding the evaluation of creativity in PD patients, we generally assume that in addition to the standard creativity assessments and divergent thinking tasks, the cognitive and neuropsychiatric symptoms related to the disease as well as the possible modulating influence of the dopaminergic medication should be investigated as well (e.g. Neuropsychiatric Fluctuations Scale for PD [117].

To assess neuropsychiatric symptoms and behavioral disorders in PD, Ardouin et al. designed the Ardouin Scale of Behaviour in PD [118]. The validated Ardouin Scale [119] is a structured interview used to systematically assess, quantify and review mood disorders and behaviors that frequently occur in patients with PD. Creative behavior is an item evaluated in part 3 under "hyperdopaminergic behaviors", since increased creativity has been linked to dopaminergic replacement therapy. To be coherent with other items evaluated, quantification heavily relies on time spent with creative activities. Four degrees of "severity" are defined: 0 - No creativity: No new participation in an artistic activity, 1 - Mild creativity: Sometimes the patient pursues a new artistic activity for a short time without "sacrificing" his/ her usual activities. 2 - Moderate creativity: The patient often devotes about half of his time to his new creative activity. He is good at restraining himself on the advice of those around him and maintains previous activities. 3 - Strong creativity: The patient spends most of his time in artistic activity. He/she leaves only very little space for other activities, despite comments from those around him/her. 4 - "Severe" creativity: Every day and even at night the patient devotes himself/herself exclusively to an artistic activity. He/she forgets his/her usual daily routine and engages in this activity even at the expense of his/her surroundings.

8 Conclusion

Creativity is a multifaceted and complex construct based on diverse neurological, cognitive and psychological processes and a certain balance must be present between them to enable creative drive. Expanding neuropsychological assessment tools are increasingly enabling us to examine various components like convergent and divergent thinking and to correlate them with other cognitive processes such as fluency or inhibition control and also personality traits. Advanced Imaging techniques such as resting state fMRI (a method of functional magnetic resonance imaging that is used in brain mapping to evaluate regional interactions that occur while no explicit task is being performed) may also contribute to better understanding of the neuronal mechanisms underlying creative behaviour.

In PD patients, the balance can be altered by the disease and by the dopaminergic medication. Indeed, dopaminergic treatment seems to influence all goal-directed behaviors with a reward component, contrary to the disease itself, which leads to loss of motivation related to mesolimbic dopaminergic denervation. This explains the continuum of observed behaviors in PD, with awakening of the desire to

undertake pleasant activities, including creative ones, if the mesolimbic system is rich in dopamine, and extinction of the desire to undertake pleasant activities if the mesolimbic system is lacking dopamine. Creativity is one expression of hyperdopaminergia in PD that, as the well-known devastating impulse control disorders, can be quite positive if it is not too excessive. An interdisciplinary approach is necessary to a relevant patient's care: hyperdopaminergia and psychic fluctuations in PD are complex, have multiple facets, a single patient often displaying several behaviors. The formal evaluation of the whole spectrum of impulse control behaviors permits to inform, prevent and if necessary lead to medical adjustment, and psychotherapy.

Beside the relevant individual patient's care and the growing scientific knowledge, it is important to keep a part of mystery or even perhaps magic when it comes to creativity. We think that there is still a little something more, which we cannot explore scientifically. What creativity is really about, and what makes it unique for everyone, is the person who makes it exist and that is what our patients show us every day.

Acknowledgement The authors thank the Bertarelli Foundation for supporting this chapter.

References

1. Flaherty AW. Brain illness and creativity: mechanisms and treatment risks. Can J Psychiatr. 2011;56(3):132–43.
2. Khalil R, Godde B, Karim AA. The link between creativity, cognition, and creative drives and underlying neural mechanisms. Front Neural Circuits. 2019;13(March):1–16. https://doi.org/10.3389/fncir.2019.00018.
3. Abraham A. The neuropsychology of creativity. Curr Opin Behav Sci. 2019;27:71–6. https://doi.org/10.1016/J.COBEHA.2018.09.011.
4. Marsden CD. The mysterious motor function of the basal ganglia: the Robert Wartenberg lecture. Neurology. 1982;32(5):514–39.
5. Kulisevsky J, Pagonabarraga J, Martinez-Corral M. Changes in artistic style and behaviour in Parkinson's disease: dopamine and creativity. J Neurol. 2009;256(5) https://doi.org/10.1007/s00415-009-5001-1.
6. Lakke JP. Art and Parkinson's disease. Adv Neurol. 1999;80:471–9. http://www.ncbi.nlm.nih.gov/pubmed/10410758
7. Lhommée E, Batir A, Quesada J-L, Ardouin C, Fraix V, Seigneuret E, Chabardès S, Benabid A-L, Pollak P, Krack P. Dopamine and the biology of creativity: lessons from Parkinson's disease. Front Neurol. 2014;5:55. https://doi.org/10.3389/fneur.2014.00055.
8. Perret, J., Ryboloviecz, F., Krack, P., Ardouin, C., Pollak, P., Lhommée, E., Fraix, V., Schmitt, E., & Vincent, J.-D. (2010). Parkinson's, creativity dopamine. Encounters with 13 artists. Grenoble Museum of Medical Science. https://boris.unibe.ch/144776/
9. Schwingenschuh P, Katschnig P, Saurugg R, Ott E, Bhatia KP. Artistic profession: a potential risk factor for dopamine dysregulation syndrome in Parkinson's disease? Mov Disord. 2010;25(4):493–6. https://doi.org/10.1002/mds.22936.
10. Chacko J, George S, Cyriac S, Chakrapani B. A tale of two patients: levodopa and creative awakening in parkinson's disease - a qualitative report. Asian J Psychiatr. 2019;43:179–81. https://doi.org/10.1016/j.ajp.2019.06.002.
11. Chatterjee A, Hamilton RH, Amorapanth PX. Art produced by a patient with Parkinson's disease. Behav Neurol. 2006;17(2):105–8. https://doi.org/10.1155/2006/901832.

12. Schrag A, Trimble M. Poetic talent unmasked by treatment of Parkinson's disease. Mov Disord. 2001;16(6):1175–6. https://doi.org/10.1002/mds.1239.
13. Walker RH, Warwick R, Cercy SP. Augmentation of artistic productivity in Parkinson's disease. Mov Disord. 2006;21(2):285–6. https://doi.org/10.1002/mds.20758.
14. Shimura H, Tanaka R, Urabe T, Tanaka S, Hattori N. Art and Parkinson's disease: a dramatic change in an artist's style as an initial symptom. J Neurol. 2012;259(5):879–81. https://doi.org/10.1007/s00415-011-6271-y.
15. Witt K, Krack P, Deuschl G. Change in artistic expression related to subthalamic stimulation. J Neurol. 2006;253(7):955–6. https://doi.org/10.1007/s00415-006-0127-x.
16. Castrioto A, Kistner A, Klinger H, Lhommée E, Schmitt E, Fraix V, et al. Psychostimulant effect of levodopa: reversing sensitisation is possible. J Neurol Neurosurg Psychiatry. 2013;84(1):18–22. https://doi.org/10.1136/jnnp-2012-302444.
17. Krack P, Pollak P, Limousin P, Benazzouz A, Deuschl G, Benabid AL. From off-period dystonia to peak-dose chorea: the clinical spectrum of varying subthalamic nucleus activity. Brain. 1999;122(6):1133–46. https://doi.org/10.1093/brain/122.6.1133.
18. Fasano A, Petrovic I. Insights into pathophysiology of punding reveal possible treatment strategies. Mol Psychiat. 2010;15(6):560–73. https://doi.org/10.1038/mp.2009.95.
19. Rylander G. Psychoses and the punding and choreiform syndromes in addiction to central stimulant drugs. Psychiatr Neurol Neurochir. 1972;75(3):203–19.
20. Schiørring E. Psychopathology induced by "speed drugs". Pharmacol Biochem Behav. 1981;14 https://doi.org/10.1016/S0091-3057(81)80018-4.
21. Spencer AH, Rickards H, Fasano A, Cavanna AE. The prevalence and clinical characteristics of punding in Parkinson's disease. Mov Disord. 2011;26(4):578–86. https://doi.org/10.1002/mds.23508.
22. Fasano A, Evans AH. Is punding a stereotypy? Mov Disord. 2013;28(3):404–5. https://doi.org/10.1002/mds.25254.
23. Evans AH, Lees AJ. Dopamine dysregulation syndrome in Parkinson's disease. Curr Opin Neurol. 2004;17(4):393–8. https://doi.org/10.1097/01.wco.0000137528.23126.41.
24. Alexander GE, DeLong MR, Strick PL. Parallel organization of functionally segregated circuits linking basal ganglia and cortex. Ann Rev Neurosci. 1986;9 https://doi.org/10.1146/annurev.ne.09.030186.002041.
25. Boot N, Baas M, van Gaal S, Cools R, De Dreu CKW. Creative cognition and dopaminergic modulation of fronto-striatal networks: integrative review and research agenda. Neurosci Biobehav Rev. 2017;78 https://doi.org/10.1016/j.neubiorev.2017.04.007.
26. Durstewitz D, Seamans JK. The dual-state theory of prefrontal cortex dopamine function with relevance to catechol-O-methyltransferase genotypes and schizophrenia. Biol Psychiat. 2008;64(9) https://doi.org/10.1016/j.biopsych.2008.05.015.
27. Frank MJ, Loughry B, O'Reilly RC. Interactions between frontal cortex and basal ganglia in working memory: a computational model. Cogn Affect Behav Neurosci. 2001;1(2) https://doi.org/10.3758/CABN.1.2.137.
28. Lauring JO, Ishizu T, Kutlikova HH, Dörflinger F, Haugbøl S, Leder H, Kupers R, Pelowski M. Why would Parkinson's disease lead to sudden changes in creativity, motivation, or style with visual art?: a review of case evidence and new neurobiological, contextual, and genetic hypotheses. Neurosci Biobehavl Rev. 2019;100 https://doi.org/10.1016/j.neubiorev.2018.12.016.
29. Ikemoto S. Dopamine reward circuitry: two projection systems from the ventral midbrain to the nucleus accumbens-olfactory tubercle complex. Brain Res Rev. 2007;56(1) https://doi.org/10.1016/j.brainresrev.2007.05.004.
30. Schultz W. Getting formal with dopamine and reward. Neuron. 2002;36(2) https://doi.org/10.1016/S0896-6273(02)00967-4.
31. Garcia-Ruiz, P. J., Martinez Castrillo, J. C., & Desojo, L. V. (2019). Creativity related to dopaminergic treatment: a multicenter study Parkinsonism Relat Disord, 63. https://doi.org/10.1016/j.parkreldis.2019.02.010.

32. Faust-Socher A, Kenett YN, Cohen OS, Hassin-Baer S, Inzelberg R. Enhanced creative thinking under dopaminergic therapy in Parkinson disease. Ann Neurol. 2014;75(6) https://doi.org/10.1002/ana.24181.

33. Black KJ, Hershey T, Koller JM, Videen TO, Mintun MA, Price JL, Perlmutter JS. A possible substrate for dopamine-related changes in mood and behavior: prefrontal and limbic effects of a D3-preferring dopamine agonist. Proc Natl Acad Sci U S A. 2002;99(26) https://doi.org/10.1073/pnas.012260599.

34. Jung RE, Vartanian O. The Cambridge handbook of the neuroscience of creativity. Cambridge University Press; 2018. https://doi.org/10.1017/9781316556238.

35. Fénelon G, Mahieux F, Huon R, Ziégler M. Hallucinations in Parkinson's disease. Prevalence, phenomenology and risk factors. Brain. 2000;123(4) https://doi.org/10.1093/brain/123.4.733.

36. Holden C. "Behavioral" addictions: do they exist? Science. 2001;294(5544) https://doi.org/10.1126/science.294.5544.980.

37. Cilia R, Siri C, Marotta G, Isaias IU, De Gaspari D, Canesi M, Pezzoli G, Antonini A. Functional abnormalities underlying pathological gambling in parkinson disease. Arch Neurol. 2008;65(12) https://doi.org/10.1001/archneur.65.12.1604.

38. Cilia R, Cho SS, van Eimeren T, Marotta G, Siri C, Ko JH, Pellecchia G, Pezzoli G, Antonini A, Strafella AP. Pathological gambling in patients with Parkinson's disease is associated with fronto-striatal disconnection: a path modeling analysis. Mov Disord. 2011;26(2) https://doi.org/10.1002/mds.23480.

39. Joutsa J, Martikainen K, Niemelä S, Johansson J, Forsback S, Rinne JO, Kaasinen V. Increased medial orbitofrontal [18F]fluorodopa uptake in parkinsonian impulse control disorders. Mov Disord. 2012;27(6) https://doi.org/10.1002/mds.24941.

40. Kassubek J, Abler B, Pinkhardt EH. Neural reward processing under dopamine agonists: imaging. J Neurol Sci. 2011;310(1–2) https://doi.org/10.1016/j.jns.2011.06.043.

41. Ray NJ, Miyasaki JM, Zurowski M, Ko JH, Cho SS, Pellecchia G, Antonelli F, Houle S, Lang AE, Strafella AP. Extrastriatal dopaminergic abnormalities of DA homeostasis in Parkinson's patients with medication-induced pathological gambling: a [11C] FLB-457 and PET study. Neurobiol Dis. 2012;48(3) https://doi.org/10.1016/j.nbd.2012.06.021.

42. Steeves TDL, Miyasaki J, Zurowski M, Lang AE, Pellecchia G, Van Eimeren T, Rusjan P, Houle S, Strafella AP. Increased striatal dopamine release in parkinsonian patients with pathological gambling: a [11C] raclopride PET study. Brain. 2009;132(5) https://doi.org/10.1093/brain/awp054.

43. Sierra M, Carnicella S, Strafella AP, Bichon A, Lhommée E, Castrioto A, Chabardes S, Thobois S, Krack P. Apathy and impulse control disorders: yin & yang of dopamine dependent behaviors. J Parkinson's Dis. 2015; https://doi.org/10.3233/JPD-150535.

44. Rossi M, Gerschcovich ER, De Achaval D, Perez-Lloret S, Cerquetti D, Cammarota A, Inés Nouzeilles M, Fahrer R, Merello M, Leiguarda R. Decision-making in Parkinson's disease patients with and without pathological gambling. Eur J Neurol. 2010;17(1) https://doi.org/10.1111/j.1468-1331.2009.02792.x.

45. Gallagher DA, O'Sullivan SS, Evans AH, Lees AJ, Schrag A. Pathological gambling in Parkinson's disease: risk factors and differences from dopamine dysregulation. An analysis of published case series. Mov Disord. 2007;22(12) https://doi.org/10.1002/mds.21611.

46. Nakamura K, Matsumoto M, Hikosaka O. Reward-dependent modulation of neuronal activity in the primate dorsal raphe nucleus. J Neurosci. 2008;28(20) https://doi.org/10.1523/JNEUROSCI.0021-08.2008.

47. Ambermoon P, Carter A, Hall W, Dissanayaka N, O'Sullivan J. Compulsive use of dopamine replacement therapy: a model for stimulant drug addiction? Addiction. 2012;107(2) https://doi.org/10.1111/j.1360-0443.2011.03511.x.

48. Inzelberg R. The awakening of artistic creativity and Parkinson's disease. Behav Neurosci. 2013;127(2) https://doi.org/10.1037/a0031052.

49. Frecska E, Móré CE, Vargha A, Luna LE. Enhancement of creative expression and entoptic phenomena as after-effects of repeated ayahuasca ceremonies. J Psychoactive Drugs. 2012;44(3) https://doi.org/10.1080/02791072.2012.703099.

50. Sessa B. Is it time to revisit the role of psychedelic drugs in enhancing human creativity? J Psychopharmacol. 2008;22(8) https://doi.org/10.1177/0269881108091597.

51. Jones KA, Blagrove M, Parrott AC. Cannabis and ecstasy/MDMA: empirical measures of creativity in recreational users. J Psychoactive Drugs. 2009;41(4) https://doi.org/10.108 0/02791072.2009.10399769.

52. Béreau M, Fleury V, Bouthour W, Castrioto A, Lhommée E, Krack P. Hyperdopaminergic behavioral spectrum in Parkinson's disease: a review. Revue Neurologique. 2018; https://doi. org/10.1016/j.neurol.2018.07.005.

53. Wu JC, Bell K, Najafi A, Widmark C, Keator D, Tang C, Klein E, Bunney BG, Fallon J, Bunney WE. Decreasing striatal 6-FDOPA uptake with increasing duration of cocaine withdrawal. Neuropsychopharmacology. 1997;17(6) https://doi.org/10.1016/S0893-133X(97)00089-4.

54. Benavides-Piccione R, Defelipe J. Distribution of neurons expressing tyrosine hydroxylase in the human cerebral cortex. J Anat. 2007;211(2) https://doi.org/10.1111/j.1469-7580.2007 .00760.x.

55. Carson SH, Higgins DM, Peterson JB. Decreased latent inhibition is associated with increased creative achievement in high-functioning individuals. J Pers Soc Psychol. 2003;85(3) https:// doi.org/10.1037/0022-3514.85.3.499.

56. McNab F, Varrone A, Farde L, Jucaite A, Bystritsky P, Forssberg H, Klingberg T. Changes in cortical dopamine D1 receptor binding associated with cognitive training. Science. 2009;323(5915) https://doi.org/10.1126/science.1166102.

57. Salvi C, Leiker EK, Baricca B, Molinari MA, Eleopra R, Nichelli PF, Grafman J, Dunsmoor JE. The effect of dopaminergic replacement therapy on creative thinking and insight problem-solving in Parkinson's disease patients. Front Psychol. 2021;12:646448. https://doi. org/10.3389/fpsyg.2021.646448.

58. Jamison KR. Great wits and madness: more near allied? Br J Psychiatry J Ment Sci. 2011;199(5):351–2. https://doi.org/10.1192/bjp.bp.111.100586.

59. Jamison KR. Mood disorders and patterns of creativity in British writers and artists. Psychiatry (New York). 1989;52(2) https://doi.org/10.1521/00332747.1989.11024436.

60. Fink A, Slamar-Halbed M, Unterrainer HF, Weiss EM. Creativity: genius, madness, or a com- bination of both. Psychol Aesthet Creat Arts. 2012;6(1) https://doi.org/10.1037/a0024874.

61. Lubow RE, Ingberg-Sachs Y, Zalstein-Orda N, Gewirtz JC. Latent inhibition in low and high "psychotic-prone" normal subjects. Personal Individ Differ. 1992;13(5) https://doi. org/10.1016/0191-8869(92)90197-W.

62. Lubow RE, Josman ZE. Latent inhibition deficits in hyperactive children. J Child Psychol Psychiatry. 1993;34(6) https://doi.org/10.1111/j.1469-7610.1993.tb01101.x.

63. Frye MA, Salloum IM. Bipolar disorder and comorbid alcoholism: prevalence rate and treatment considerations. In *bipolar disorders* (Vol. 8, issue 6). 2006; https://doi.org/ 10.1111/j.1399-5618.2006.00370.x.

64. Grucza RA, Robert Cloninger C, Bucholz KK, Constantino JN, Schuckit MI, Dick DM, Bierut LJ. Novelty seeking as a moderator of familial risk for alcohol dependence. Alcohol Clin Exp Res. 2006;30(7) https://doi.org/10.1111/j.1530-0277.2006.00133.x.

65. Lynn DE, Lubke G, Yang M, McCracken JT, McGough JJ, Ishii J, Loo SK, Nelson SF, Smalley SL. Temperament and character profiles and the dopamine D4 receptor gene in ADHD. Am J Psychiatr. 2005;162(5) https://doi.org/10.1176/appi.ajp.162.5.906.

66. Favre P, Baciu M, Pichat C, Bougerol T, Polosan M. FMRI evidence for abnormal resting- state functional connectivity in euthymic bipolar patients. J Affect Disord. 2014;165 https:// doi.org/10.1016/j.jad.2014.04.054.

67. Folley BS, Park S. Verbal creativity and schizotypal personality in relation to prefrontal hemispheric laterality: a behavioral and near-infrared optical imaging study. Schizophr Res. 2005;80(2–3) https://doi.org/10.1016/j.schres.2005.06.016.

68. Hoekzema E, Carmona S, Ramos-Quiroga JA, Richarte Fernández V, Bosch R, Soliva JC, Rovira M, Bulbena A, Tobeña A, Casas M, Vilarroya O. An independent components and functional connectivity analysis of resting state FMRI data points to neural network dysregu- lation in adult ADHD. Hum Brain Mapp. 2014;35(4) https://doi.org/10.1002/hbm.22250.

69. Whitfield-Gabrieli S, Thermenos HW, Milanovic S, Tsuang MT, Faraone SV, McCarley RW, Shenton ME, Green AI, Nieto-Castanon A, LaViolette P, Wojcik J, Gabrieli JDE, Seidman LJ. Hyperactivity and hyperconnectivity of the default network in schizophrenia and in first-degree relatives of persons with schizophrenia. Proc Natl Acad Sci U S A. 2009;106(4) https://doi.org/10.1073/pnas.0809141106.

70. Barnett JH, Salmond CH, Jones PB, Sahakian BJ. Cognitive reserve in neuropsychiatry. Psychol Med. 2006;36(8) https://doi.org/10.1017/S0033291706007501.

71. Baas M, De Dreu CKW, Nijstad BA. A meta-analysis of 25 years of mood-creativity research: hedonic tone, activation, or regulatory focus? Psychol Bull. 2008;134(6) https://doi.org/10.1037/a0012815.

72. Kramer AF, Cepeda NJ, Cepeda ML. Methylphenidate effects on task-switching performance in attention-deficit/hyperactivity disorder. J Am Acad Child Adolesc Psychiatry. 2001;40(11) https://doi.org/10.1097/00004583-200111000-00007.

73. Thoma P, Wiebel B, Daum I. Response inhibition and cognitive flexibility in schizophrenia with and without comorbid substance use disorder. Schizophr Res. 2007;92(1–3) https://doi.org/10.1016/j.schres.2007.02.004.

74. Goldman-Rakic PS. Working memory dysfunction in schizophrenia. J Neuropsychiat Clin Neurosci. 1994;6(4) https://doi.org/10.1176/jnp.6.4.348.

75. Matt Alderson R, Kasper LJ, Hudec KL, Patros CHG. Attention-deficit/hyperactivity disorder (ADHD) and working memory in adults: a meta-analytic review. Neuropsychology. 2013;27(3) https://doi.org/10.1037/a0032371.

76. Käckenmester W, Bott A, Wacker J. Openness to experience predicts dopamine effects on divergent thinking. Personal Neurosci. 2019;2:e3. https://doi.org/10.1017/pen.2019.3.

77. Dagher A, Robbins TW. Personality, addiction, dopamine: insights from Parkinson's disease. Neuron. 2009;61(4):502–10. https://doi.org/10.1016/j.neuron.2009.01.031.

78. Weintraub D, Koester J, Potenza MN, Siderowf AD, Stacy M, Voon V, Whetteckey J, Wunderlich GR, Lang AE. Impulse control disorders in Parkinson disease. Arch Neurol. 2010;67(5):589–95. https://doi.org/10.1001/archneurol.2010.65.

79. James W. The principles of psychology, vol. 1. Henry Holt and Co.; 1890. https://doi.org/10.1037/10538-000.

80. Graham EK, Weston SJ, Gerstorf D, Yoneda TB, Booth T, Beam CR, Petkus AJ, Drewelies J, Hall AN, Bastarache ED, Estabrook R, Katz MJ, Turiano NA, Lindenberger U, Smith J, Wagner GG, Pedersen NL, Allemand M, Spiro A, et al. Trajectories of big five personality traits: a coordinated analysis of 16 longitudinal samples. Eur J Personal. 2020;34(3):301–21. https://doi.org/10.1002/per.2259.

81. Boussac M, Arbus C, Dupouy J, Harroch E, Rousseau V, Croiset A, Ory-Magne F, Rascol O, Moreau C, Rolland A-S, Maltête D, Rouaud T, Meyer M, Drapier S, Giordana B, Anheim M, Hainque E, Jarraya B, Benatru I, et al. Personality dimensions of patients can change during the course of parkinson's disease. PLoS One. 2021;16(1):e0245142. https://doi.org/10.1371/journal.pone.0245142.

82. Arabia G, Grossardt BR, Colligan RC, Bower JH, Maraganore DM, Ahlskog JE, Geda YE, Rocca WA. Novelty seeking and introversion do not predict the long-term risk of Parkinson disease. Neurology. 2010;75(4):349–57. https://doi.org/10.1212/WNL.0b013e3181ea15fd.

83. Bódi N, Kéri S, Nagy H, Moustafa A, Myers CE, Daw N, Dibó G, Takáts A, Bereczki D, Gluck MA. Reward-learning and the novelty-seeking personality: a between- and within-subjects study of the effects of dopamine agonists on young Parkinson's patients. Brain J Neurol. 2009;132(Pt 9):2385–95. https://doi.org/10.1093/brain/awp094.

84. Benedek M, Jauk E, Sommer M, Arendasy M, Neubauer AC. Intelligence, creativity, and cognitive control: the common and differential involvement of executive functions in intelligence and creativity. Intelligence. 2014;46(1) https://doi.org/10.1016/j.intell.2014.05.007.

85. Batey M, Furnham A. Creativity, intelligence, and personality: a critical review of the scattered literature. Genet Soc Gen Psychol Monogr. 2006;132(4):355–429. https://doi.org/10.3200/MONO.132.4.355-430.

86. Jauk E. Intelligence and creativity from the neuroscience perspective. In: The Cambridge handbook of the neuroscience of creativity; 2018. p. 421–34. https://doi.org/10.1017/9781316556238.024.
87. Kim KH, Cramond B, VanTassel-Baska J. The relationship between creativity and intelligence. In: Kaufman JC, Sternberg RJ, editors. *The Cambridge handbook of creativity*. Cambridge University Press; 2010. p. 395–412. https://doi.org/10.1017/CBO9780511763205.025.
88. Jauk E, Benedek M, Dunst B, Neubauer AC. The relationship between intelligence and creativity: new support for the threshold hypothesis by means of empirical breakpoint detection. Intelligence. 2013;41(4):212–21. https://doi.org/10.1016/j.intell.2013.03.003.
89. Beaty RE, Schacter DL. Episodic memory and cognitive control: contributions to creative idea production. In: *The Cambridge handbook of the neuroscience of creativity*; 2018. p. 249–60. https://doi.org/10.1017/9781316556238.015.
90. Pan X, Yu H. Different effects of cognitive shifting and intelligence on creativity. J Creat Behav. 2018;52(3):212–25. https://doi.org/10.1002/jocb.144.
91. Benedek M, Könen T, Neubauer AC. Associative abilities underlying creativity. Psychol Aesthet Creat Arts. 2012;6(3):273–81. https://doi.org/10.1037/a0027059.
92. Gilhooly KJ, Fioratou E, Anthony SH, Wynn V. Divergent thinking: strategies and executive involvement in generating novel uses for familiar objects. Br J Psychol. 2007;98(4):611–25. https://doi.org/10.1348/096317907X173421.
93. Runco MA. *Creativity: theories and themes: research, development, and practice*. Amsterdam: Elsevier; 2014. https://doi.org/10.1016/C2012-0-06920-7.
94. Marron TR, Faust M. Free association, divergent thinking, and creativity: cognitive and neural perspectives. In: The Cambridge handbook of the neuroscience of creativity; 2018. p. 261–80. https://doi.org/10.1017/9781316556238.016.
95. Roberts RP, Addis DR. A common mode of processing governing divergent thinking and future imagination. In: *The Cambridge handbook of the neuroscience of creativity*; 2018. p. 211–30. https://doi.org/10.1017/9781316556238.013.
96. Kehagia AA, Barker RA, Robbins TW. Neuropsychological and clinical heterogeneity of cognitive impairment and dementia in patients with Parkinson's disease. Lancet Neurol. 2010;9(12):1200–13. https://doi.org/10.1016/S1474-4422(10)70212-X.
97. Roy MA, Doiron M, Talon-Croteau J, Dupré N, Simard M. Effects of Antiparkinson medication on cognition in Parkinson's disease: a systematic review. Can J Neurol Sci. 2018;45(4):375–404. https://doi.org/10.1017/cjn.2018.21.
98. Silvia PJ, Wigert B, Reiter-Palmon R, Kaufman JC. Assessing creativity with self-report scales: a review and empirical evaluation. Psychol Aesthet Creat Arts. 2012;6(1):19–34. https://doi.org/10.1037/a0024071.
99. Karwowski M. It doesn't hurt to ask... but sometimes it hurts to believe: polish students' creative self-efficacy and its predictors. Psychol Aesthet Creat Arts. 2011;5(2) https://doi.org/10.1037/a0021427.
100. Carson SH, Peterson JB, Higgins DM. Reliability, validity, and factor structure of the creative achievement questionnaire. Creat Res J. 2005;17(1) https://doi.org/10.1207/s15326934crj1701_4.
101. Batey, M. D. (2007). *A psychometric investigation of everyday creativity* [University of London]. http://europepmc.org/theses/ETH/439107
102. Kaufman JC. Self-reported differences in creativity by ethnicity and gender. Appl Cogn Psychol. 2006;20(8) https://doi.org/10.1002/acp.1255.
103. Kaufman JC, Waterstreet MA, Ailabouni HS, Whitcomb HJ, Roe AK, Riggs M. Personality and self-perceptions of creativity across domains. Imagin Cogn Pers. 2010;29(3) https://doi.org/10.2190/ic.29.3.c.
104. Mednick S. The associative basis of the creative process. Psychol Rev. 1962;69(3) https://doi.org/10.1037/h0048850.
105. Volle E. Associative and controlled cognition in divergent thinking: theoretical, experimental, neuroimaging evidence, and new directions. In: *The Cambridge handbook of the neuroscience of creativity*; 2018. https://doi.org/10.1017/9781316556238.020.

106. Rogers RD, Monsell S. Costs of a predictable switch between simple cognitive tasks. J Exp Psychol Gen. 1995;124(2) https://doi.org/10.1037/0096-3445.124.2.207.

107. Guilford JP. The nature of human intelligence. McGraw-Hill; 1967.

108. Delis DC, Kaplan E, Kramer JH. Delis-Kaplan executive funktion system. The Psychological Corporation; 2001.

109. Stroop JR. Studies of interference in serial verbal reactions. J Exp Psychol. 1935;18(6):643. https://doi.org/10.1037/h0054651.

110. Torrance EP. Torrance test of creative thinking. *Cambridge*: Ginn and Co. Personal Press/Gin and Company; 1974. http://ststesting.com/2005giftttct.html

111. Goff K, Torrance EP. Abbreviated Torance test for adults manual. Scholastic Testing Service; 2002.

112. Diana L, Frei M, Chesham A, de Jong D, Chiffi K, Nyffeler T, Bassetti CL, Goebel N, Eberhard-Moscicka AK, Müri RM. A divergent approach to Pareidolias-exploring creativity in a novel way. Psychol Aesthet Creat Arts. 2020; https://doi.org/10.1037/aca0000293.

113. Barnes J, David AS. Visual hallucinations in Parkinson's disease: a review and phenomenological survey. J Neurol Neurosurg Psychiat. 2001;70(6):727–33. https://doi.org/10.1136/jnnp.70.6.727.

114. Diederich NJ, Fénelon G, Stebbins G, Goetz CG. Hallucinations in Parkinson disease. Nat Rev Neurol. 2009;5(6):331–42. https://doi.org/10.1038/nrneurol.2009.62.

115. O'brien J, Taylor JP, Ballard C, Barker RA, Bradley C, Burns A, Collerton D, Dave S, Dudley R, Francis P, Gibbons A, Harris K, Lawrence V, Leroi I, Mckeith I, Michaelides M, Naik C, O'callaghan C, Olsen K, et al. Visual hallucinations in neurological and ophthalmological disease: pathophysiology and management. J Neurol Neurosurg Psychiatry. 2020;91(5):512–9. https://doi.org/10.1136/jnnp-2019-322702.

116. Pagonabarraga J, Martinez-Horta S, Fernández de Bobadilla R, Pérez J, Ribosa-Nogué R, Marín J, et al. Minor hallucinations occur in drug-naive Parkinson's disease patients, even from the premotor phase. Mov Disord. 2016;31(1):45–52.

117. Schmitt E, Krack P, Castrioto A, Klinger H, Bichon A, Lhommée E, Pelissier P, Fraix V, Thobois S, Moro E, Martinez-Martin P. The neuropsychiatric fluctuations scale for Parkinson's Disease: a pilot study. *Mov Disord Clin Pract*; 2018. https://doi.org/10.1002/mdc3.12607.

118. Ardouin C, Chéreau I, Llorca PM, Lhommée E, Durif F, Pollak P, Krack P. Assessment of hyper- and hypodopaminergic behaviors in Parkinson's disease. Rev Neurol (Paris). 2009; https://doi.org/10.1016/j.neurol.2009.06.003.

119. Rieu I, Martinez-Martin P, Pereira B, De Chazeron I, Verhagen Metman L, Jahanshahi M, Ardouin C, Chéreau I, Brefel-Courbon C, Ory-Magne F, Klinger H, Peyrol F, Schupbach M, Dujardin K, Tison F, Houeto JL, Krack P, Durif F. International validation of a behavioral scale in Parkinson's disease without dementia. Mov Disord. 2015; https://doi.org/10.1002/mds.26223.

Mood Disorders and Creativity

Natalia Jaworska and Georg Northoff

1 Mood Disorders: Definition and Burden of Illness

Major depressive disorder (MDD), or simply depression, is a disabling condition that is associated with significant morbidity and mortality. MDD manifests as a major depressive episode (which may be singular or recurrent), in which the affected individual experiences: (a) depressed mood, and/or (b) loss of interest or pleasure, as well as other symptoms (typically a minimum number of such symptoms must be met for diagnoses according to psychiatric standards [1]), including, though not limited to, changes in sleep, appetite, concentration and suicidal ideation for most of the day, nearly every day, for a sustained period. From a diagnostic perspective, these mood symptoms must represent a change from normal function and/or have significant consequences in daily functioning, such as adversely affecting occupational performance, relationships, and day-to-day existence. In other words, negative affect is normal –and, indeed, adaptive—in humans, however, prolonged and debilitating affective symptoms can be pathological.

MDD can be diagnosed using the Diagnostic and Statistical Manual of Mental Disorders, currently in its fifth iteration (i.e., as of 2013; DSM-5 [2]). The DSM-5 tends to be used in formal diagnoses of psychiatric disorders by clinicians in North America, as it is published by the American Psychological Association. Elsewhere, MDD diagnoses more commonly occur using the International Statistical Classification of Diseases and Related Health Problems (ICD; in its 11th iteration as

N. Jaworska (✉)
University of Ottawa, Institute of Mental Health Research (IMHR), Ottawa, ON, Canada
e-mail: natalia.jaworska@theroyal.ca

G. Northoff
Department of Cellular & Molecular Medicine, University of Ottawa, Ottawa, ON, Canada
e-mail: georg.northoff@theroyal.ca

© The Author(s), under exclusive license to Springer Nature Switzerland AG 2023 91
A. Richard et al. (eds.), *Art and Neurological Disorders*, Current Clinical Neurology, https://doi.org/10.1007/978-3-031-14724-1_4

of 2019), chapter "Mental & Behavioural Disorders" criteria, developed by the World Health Organization (WHO) [3]. While the pros and cons of the two diagnostic systems, and even the merits of such a diagnostic approach (i.e., meeting a certain number of symptoms, which has been viewed as somewhat arbitrary), are beyond the scope of this chapter, there is consensus that there is substantial overlap in MDD diagnosis with moderate to severe symptom profiles regardless of what diagnostic system/approach is used. In tertiary clinical centers, and in the community, depression symptoms can be assessed using a variety of standardized tools that are either self-reports (e.g. Beck Depression Inventory [BDI-II] [4]) or clinician-rated (e.g. Hamilton Depression Rating Scale [5]). Such scales can be useful in assessing symptom severity, and in tracking symptom changes throughout the course of treatment. Further, they are often used to assess whether someone is a treatment "responder" or has attained remission status based on a specific cut-off value. Worldwide, ~15% of the adult population has a lifetime risk of developing MDD [6].

Depression may cause serious and long-lasting symptoms, and the presence of the disorder disrupts a person's ability to perform routine tasks. According to the WHO, depression is one of the leading causes of disability in the world, measured as years lived with a disability, among persons aged 5 years and older. Further, it is the fourth most important contributor to the global burden of disease, measured as disability-adjusted life years [7]. In 2010, mental and substance use disorders accounted for nearly 184 million disability-adjusted life years worldwide; depressive disorders accounted for 40.5% of this total burden [8]. This is a staggering socio-economic consequence of depression (not to mention personal), when considering missed days of work, lack of productivity, costs associated with treating the disorder, as well as suicide-related costs [9].

Persistent depressive disorder (PDD; formerly called "dysthymia") is generally regarded as a more chronic from of depression, though it is less severe than MDD. According to DSM-5 criteria, symptoms of PDD are similar to those of MDD though they last longer, typically over years. Specifically, a person with PDD has low mood, more days than not, along with at least two other depression symptoms (compared with five or more for MDD, according to DSM-5 criteria) for at least 2 years. Historically, MDD has received substantially more attention than PDD in terms of its associated personal and economic burden. However, emerging evidence suggests that PDD may actually have higher personal and societal costs [10], likely due to its more chronic nature. Some examples of historical figures who likely suffered from MDD (or PDD) include the artist Mark Rothko (though he may have also experienced substance abuse), the writer Sylvia Plath [11], and the American President Abraham Lincoln.

Both MDD and PDD are examples of mood disorders. "Mood disorders," or "affective disorders," as the names imply, are characterized—at their core—by a disturbance in affect or mood. Other mood disorders, which have been newly incorporated into the DSM-5, include disruptive mood dysregulation disorder (in those aged <18 years) as well as premenstrual dysphoric disorder, which emerges prior to menstruation. Bipolar disorders (BD) are yet another type of mood disorder. Bipolar I disorder (BD-I), formerly referred to as "manic depression", involves periods of

severe mood swings, alternating between manic and depressive episodes. As per DSM-5, a manic episode (lasting at least a week) is characterized by feeling elated or "high" or irritable, having an elevated sense of sense and increased physical or mental energy. Again, a manic episode must represent a mood state that is highly disruptive to one's life, and marks a notable change from normal function.

The depressive episodes that occur in the context of BD-I are the same as those characteristic of a depressive episode in MDD. The lifetime prevalence of BD-I is ~1% [12]; however, there is typically a several-year lag prior to the correct diagnosis of BD-I, as most individuals are first misdiagnosed with MDD. Practically, this can have important consequences from a treatment optimization point-of-view, and therefore quality of life. Although most patients with BD-I spend much more time in a depressive versus a manic episode, treatment strategies do differ. BD-II is similar to BD-I, though manic episodes are less severe (i.e., do not necessarily reach criteria for a full "manic episode", as defined by a diagnostic approach, e.g., DSM-5 or ICD). As such, BD-II is characterized as a disorder oscillating between depressive and hypomanic episodes. The lifetime prevalence of bipolar spectrum disorders (including cyclothymia, which includes episodes that are not severe enough to meet criteria for either a hypomanic or a full depressive episode) is just over 2% [12]. Current evidence suggests that the presence of BD has a roughly equal distribution across sex and ethnicity; this is in contrast to MDD, which is approximately twice as prevalent in females compared with males [13]. Given that BD is relatively difficult to diagnose and considering that psychiatric illness classification is relatively new (and constantly evolving), it is difficult to definitively state which public figures may have suffered from the disorder. However, medical historians tend to agree that artists such as Marilyn Monroe and Vincent Van Gogh, and the nursing pioneer Florence Nightingale, likely suffered from BD; as a more contemporary example, the musician Kurt Cobain was believed to be diagnosed with BD. However, historians and clinicians must be cautious when speculating about the mental health conditions of public figures.

2 Creativity and Mood Disorders

For millennia, there has been a fascination with a link between creativity and "madness", largely derived from anecdotal and naturalistic observations. A more formal and documented assessment of the putative link between creativity and mental illness can be traced back to the 1930s, in which Lange-Eichbaum assessed the incidence of psychopathology (as defined in those times) in "geniuses" [14]. Since that time, there have been numerous attempts to more systematically study the link between creativity and psychiatric illness, with the vast majority of recent work assessing creativity in the context of mood disorders, in particular.

Yet, despite the stereotype of the "mad genius" in society, and often reported anecdotal evidence for a link between mood disorders and creativity (e.g., based on famous artists, such as Virgina Woolfe, Vincent Van Gogh or Johann Wolfgang von Goethe, to name a few), the *empirical* evidence for the high co-occurrence of a mood disorder and increased creativity is limited. This is particularly true when

evaluating the quality of existing studies on the subject matter (e.g., there is often a lack of contrasts with non-creative/less creative individuals; the conceptualization of creativity is not always defined or operationalized). Further, this type of research is fraught with numerous biases (e.g., focusing on more "dramatic" creative individuals; unblinded researchers [i.e., preconceived notions of the subjects whom researchers are studying]), including recall bias in interviewing methodologies, and various confounds that can also play an explanatory role in the relationship between mood disorders and creativity (e.g., socio-economic factors). Yet, despite these limitations, there does appear to be a relation between creativity and mood disorders, which in the context of this chapter, include a focus on bipolar (BD) and major depressive disorders (MDD).

Part of the difficulty in empirically linking creativity with mood disorders is that the definition of creativity can be elusive. While creativity is often easy to "spot when it exists," it is notoriously difficult to operationalize and, therefore, to measure in a systematic manner. Generally speaking, creativity tends to be operationalized as a construct that espouses both originality (i.e., uniqueness) and usefulness (i.e., there tends to be some sort of a product, whether an artistic expression or an articulated thought) [15]. Additionally, creativity is often regarded as a multicomponent construct rather than a unitary phenomenon, which includes concepts such as "flexible thinking" or divergent thoughts/ideas (i.e., linear thinking is seldom equated with creativity). Empirically, creativity tends to be indirectly assessed using participation in occupations that are regarded as creative or, more directly, by using self-report questionnaires that tap into certain aspects of creativity, such as the aforementioned feature of divergent or flexible thinking.

The most consistent evidence for a link between creativity and mood disorders has stemmed from research assessing creative occupations. Creative occupations typically include examples such as painters, writers, musicians, and dancers (i.e., performing arts), but the definition is occasionally expanded to professions such as scientists. While this may be, objectively, one of simplest indices of creativity, it is likely riddled with potential confounds that muddy the relation between psychiatric illness and creativity [16]. Additionally, such an approach is open to controversy; after all, there are some who might argue that construction workers and businesspeople all employ creative problem-solving or divergent thinking (i.e., a putative hallmark of creativity) when conducting their occupations. Measures of creativity via self-reports include scales such as the Barron-Welsh Art Scale (BWAS) [17] and Creative Achievement Questionnaire (CAQ) [18]; these are also used in exploring the link between creativity and mood disorders.

There are several theories linking creativity with mood disorders, as well as the direction of the relationship. While not exhaustive, three prevailing theories or themes describe the relation: (a) That mood disorders cause or lead to increased creativity; (b) That increased creativity causes mood disorders; or, (c) That there are mediating factors that play a role in the relation between creativity and mood disorders. While it is difficult (perhaps impossible) to directly test these theories, certain links between creativity and mood disorders do appear to be more substantiated than others. Specifically, a meta-analyses found that creative individuals exhibit a greater incidence of mood disorders than non-creative (or, perhaps more accurately,

less creative) individuals (with the exception of dysthymia) [15]; the overall effect size was moderate ($g = .64$; though there was large variability in the effect sizes of the individual studies included). On the other hand, this meta-analyses did not find that creativity differed between individuals with versus without a mood disorder, though more granular assessments did indicate slightly higher creativity in individuals with cyclothymia and BD not otherwise specified (i.e., a diagnosis not falling into the BP-I/II or cyclothymic categories) compared with healthy individuals/ those without a mood disorder [15].

3 Potential Reasons for a Link Between Mood Disorders and Creativity

3.1 Psychological States

Many of the explanations linking mood disorders and creativity have focused on bipolar disorder (BD) rather than depression/major depressive disorder (MDD), as mania or manic episodes appear to be more linked with creativity [15]. Nevertheless, it has been suggested that depressive states may provide the opportunity for deeper introspection or connection with one's emotional environment. Such insight may enable a more intimate or nuanced connection with one's inner state, which, in turn, could be a productive state for increased creative expression [15, 19]. However, the fundamental tension with the psychological explanations for why MDD may be associated with creativity is that one of the hallmark features of depression is that it tends to be characterized by decreased energy, diminished interest and/or concentration difficulties. These symptoms of depression are generally inconsistent with or not optimal for creative expression. This tension has been reconciled in the following manner: depressive episodes may create some of the introspective conditions conducive for creativity or creative expression, but (hypo)manic states may actually lead to the production/expression of those ideas. Hypomanic states, in particular, are associated with an increased "drive", increased focus (occasionally bordering on the obsessive), and decreased lack of sleep/increased energy. This explanation would hold most true for BD. Increased creativity in the context of BD may be most linked with the notion of elevated "flow" during manic or hypomanic states, which some have characterized as intense focus/concentration and distorted sense of time [20].

However, severe levels of depression are likely not associated with increased creativity. In fact, depressive symptoms *per se* (versus the presence/absence of a depression diagnosis or sub-threshold MDD) have not been regularly linked with creativity/creative self-concept [21]. Thus, creativity may be associated with a U-shaped function in relation to both depression and BD symptom severity [22]. Severe depression or mania features may stifle creative expression, but such states might foster creative expression when symptoms abate (i.e., during states when expression is more "permissive"). Given that both depression and BD are cyclical in nature (i.e., episodic; some days are worse than others; indeed, in the case of BD, the disorder is characterized by cyclicity), creative expression may occur during times of decreased symptom severity. Previous case-reports exploring affective

states found a relation between hypo-manic episodes and visual artistic creativity and achievement, as well as scientific performance, whereas mild-moderate depressed mood promoted literary work. Further, severe depression symptoms and mixed states were not associated with creative activities, somewhat consistent with the U-shaped relation linking creativity and mood disorder severity [23], as previously discussed.

3.2 Personality Traits

There are certain personality traits (i.e., patterns of behaviours, thoughts or feelings) that have been linked with increased creativity, and tend to be over-represented in individuals with BD. These features include openness to experience, or extraversion, as well as impulsivity (an aspect of personality traits) [24]. As such, the association between BD and creativity may be related to specific personality traits present before the onset of the disorder, as personality traits are rather consistent throughout the lifetime (though, a certain degree of malleability exists; nevertheless, some are characterized by a large heritability component) [25]. On the other hand, the traits of 'openness to experience' and impulsivity are generally decreased in MDD; thus, the relation between personality traits and creativity might be more true in the context of BD. However, other work has noted that creativity was related to the personality trait of neuroticism, which tends to be increased or over-expressed in people with depression, and even be a risk trait for depression development. Neuroticism is frequently described as a personality trait that is characterized by a predisposition to experience negative affect, including irritability, self-consciousness and generally increased emotional instability [26]. One study found that a dimensional factor comprised of higher neuroticism traits, and increased cyclothymia and dysthymia temperaments (assessed using the Temperament Evaluation of Memphis, Pisa, Paris and San Diego-auto-questionnaire version [TEMPS-A]: a self-report questionnaire designed to measure temperamental variation) was related to total creativity scores (BWAS-assessed) in a sample consisting of both healthy and psychiatric patients. On the other hand, the 'openness to experience' personality factor, as assessed with the NEO Personality Inventory was related to "Creative Personality Scale for the Adjective Checklist" (ACL-CPS) scores.

Thus, there is some evidence that different temperamental traits/personality dimensions may have unique and specific associations with creative domains. By extension, this may mean that certain personality features that predispose individuals to develop a mood disorder might also be linked with creativity. In other words, personality features may be a moderator in the link between creativity and mood disorders. As a more concrete explanation of this link, it is feasible that higher affective instability (e.g., neuroticism and affective changeability or cyclothymic tendencies) could spur creative thought, while openness to experience could provide cognitive flexibility that spurs creative expression. In sum, although there seems to be a link between mood disorders and personality traits, there is -at the very least-substantial variability in this relation [27].

3.3 Motivational Features

There have been several groups that have suggested that basic motivational approach and avoidance systems differentially influence creativity. Specifically, the propensity for approach-based psychopathologies (e.g., associated with a greater risk of developing BD) may be linked with increased creativity. On the other hand, the inclination for avoidance-based psychopathologies (e.g., depression) is linked with reduced creativity. Indeed, one meta-analyses found that certain risk factors for BD (e.g., hypomania, mania-like features) were positively associated with creativity, whereas depressive mood was negatively (albeit weakly) associated with creativity [28]. Granted, this contradicts other work and other meta-analyses linking depression diagnoses with increased creativity (as outlined in previous sections), indicating that approach motivations might only be one aspect linking creativity and mental illness.

Others have explored the relationship between motivation (an aspect of behavioural approach systems) and creativity. Ambition, which is heightened in BD and associated with creativity in the general population, might be an important variable linking increased creativity with BD. Indeed, research has found that self-reported measures of ambition (e.g., using the Willingly Approached Set of Statistically Unlikely Pursuits [WASSUP] scale, which measures the willingness to pursue implausible goals, i.e., one means of operationalizing ambition) were significantly elevated in individuals with BD compared with normative levels. Additionally, WASSUP scores were correlated with lifetime creative accomplishments within an artistic sample. Further, a sample of university students at increased risk for mania (assessed using the Hypomanic Personality Scale) had greater levels of ambition and creativity, and ambition was also related with greater creativity [29]. Thus, ambition may be one feature linking mood disorders and creativity, though, this is likely more true for BD than depression (Fig. 1).

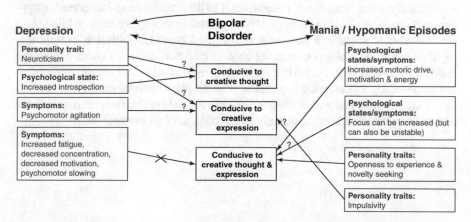

Fig. 1 An illustration of the various traits, states and symptoms of mood disorders and how they might influence creative thought, expression or both

4 Neural Features Underlying the Link Between Mood Disorders and Creativity

4.1 Overview of Neural Features in Mood Disorders

Relatively little has been written about the brain features that may underlie the link between mood disorders and creativity; as such, we will attempt to review pertinent existing evidence.

While there are many theories regarding the neurobiological features of mood disorders, most of the existing literature (and associated pharmacotherapy used to treat mood disorders) suggests that mood disorders, particularly depression, are characterized by disturbances in monoamine system function (i.e., dysfunction in the brain chemicals, or neurotransmitters, serotonin, noradrenaline and dopamine) [30]. However, there are numerous other changes in the brain that occur as a result of, or in conjunction with, these neurotransmitter deficiencies in depression. These include neural structural changes (e.g., decreased volumes of the hippocampus, a structure that is critical in memory; altered cortical thickness [the layer on the surface of the brain]) as well as changes in various other neurotransmitter systems (e.g., changes in the brain's excitatory neurotransmitter, glutamate, and the inhibitory neurotransmitter, gamma aminobutyric acid [GABA]) [31]. As a result of these modifications (derived from both pre-clinical and clinical evidence), there is increasing consensus that major depressive disorder (MDD) may be best characterized by disturbances within, and between, neural networks sub-serving various cognitive and affective processes [32].

Imaging work suggests overlap regarding the neural features underlying bipolar disorder (BD) and MDD. Although substantial heterogeneity exists, both disorders tend to be associated with impaired or altered function in prefrontal cortical regions, which are implicated in cognitive processes, including cognitive flexibility. Further, activity in regions involved in emotional processing, introspection and arousal (i.e., very broadly, more 'emotional' centers, such as the anterior cingulate cortex, amygdala and insula) tends to be increased/dysregulated in mood disorders. While overly simplistic, it is postulated that there is impaired cross-talk between centers that regulate cognition and emotion in the context of mood disorders (both depression and BD). Thus, in sum, the bulk of brain imaging studies shows rather strong overlap between BD and unipolar depression (Fig. 2). Nevertheless, mania—in particular—may be associated with decreased ability to regulate neural features (particularly neurotransmitter balances), especially in the context of an external challenge [33].

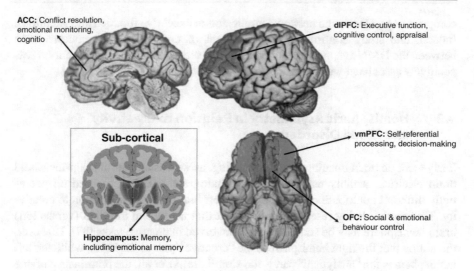

Fig. 2 Brain regions commonly implicated in mood disorders and involved in creative endeavors. Cortical regions: *ACC* anterior cingulate cortex, *dlPFC* dorsolateral prefrontal cortex, *OFC* orbitotrontal cortex, *vmPFC* ventromedial prefrontal cortex. Sub-cortical regions: hippocampus and amygdala (not shown)

4.2 Overview of Creativity and Neural Features

Relatively limited work has been carried out systematically assessing the neural features underlying creativity. Given that creativity is not a unitary phenomenon and tends to be characterized by divergent thinking typically leading to some sort of an output (with some degree of usefulness), it is unlikely to be underscored by a single brain aspect or feature. In other words, the creative process, and creative expression, is likely a *whole brain* phenomenon; emerging evidence supports this notion. Although further details are discussed in subsequent sections, tasks that tap into divergent thinking (i.e., generally considered to be a critical aspect of creativity) indicate the involvement of the brain's default mode network (DMN), in particular [34]. The DMN is comprised of co-activated brain regions that tend to be most active during non-task conditions (i.e., at rest) including during introspective thinking, mind-wandering and perspective-taking [35]. Further, involvement of DMN activity has been noted during the generation of new ideas and certain tasks that involve creative approaches. Intriguingly, disturbances in DMN function have been extensively reported in mood disorders, particularly depression [36] (discussed in subsequent sections).

Brain imaging studies also implicate the involvement of cognitive control regions and networks linked with executive function (i.e., mental operations that include working memory, flexible thinking and self-control/regulation) in creativity; disturbances in these networks, and their control over other networks, have been noted in mood disorders [36]. Thus, creativity likely relies not only on activity in separate brain areas, but on interactions between various areas and the networks they

comprise (e.g., DMN, and networks implicated in executive function and attention). Indeed, one study confirmed that the extent of correlations (or cohesiveness) between the DMN and networks implicated in executive function and attention was positively associated with Torrance Tests of Creative Thinking scores [34].

4.3 Hemispheric Asymmetry in Relation to Creativity and Mood Disorders

Early work on brain imaging, or neuroimaging, as well as indices of scalp-measured brain electrical activity using electroencephalography (EEG), focused on potentially different contributions of right versus left brain activity in relation to creativity. This accumulating research does suggest that activity in the right (versus left) brain hemisphere may be somewhat more involved in creative tasks [37]. However, the notion that the right hemisphere is the "creative" part of the brain, while the left hemisphere is the "analytical" part is too simplistic. After all, the prominence of one hemisphere in the context of a particular task or thought process is related to the nature of the task/behaviour, and level of expertise. For example, while less trained individuals may engage their right hemisphere more (i.e., exhibit greater right than left brain hemisphere activity) when processing the features of a painting or musical piece, skilled musicians or painters engage the left hemisphere more [38]. Another study found that high creativity on standardized tasks (tapping into divergent thinking) was associated with greater bilateral hemispheric activation [39]. One putative explanation of such data is that creative individuals might adhere less strictly to the evolutionary functions associated with hemispheric lateralization. Another possible explanation is that skilled and experienced artists might take a more analytic approach to their own or others' artistic output, thereby engaging the left hemisphere more extensively resulting in more symmetric brain activation.

Hemispheric lateralization has also been linked with motivation systems, which play a role in creative expression. EEG-based studies (and corroborating neuroimaging work) have found that the left (versus right) frontal hemisphere may be more implicated in approach-based motivational systems, while the right frontal hemisphere may be more involved in avoidance motivations, though there are certainly exceptions/notable caveats to this theory [40]. Further elaborations of this frontal brain asymmetry motivation model indicate that more posterior regions of the right hemisphere (i.e., parietal brain lobe/region) may be associated with increased arousal, especially emotion-related autonomic arousal [41]. As such, the right hemisphere may play a role in facilitating arousal and perhaps novelty detection by way of activity in more posterior right brain regions, but, also greater avoidance or regularly behaviors (i.e., top-down control) by way of enhanced frontal right brain activation. Thus, an altered hemispheric "balance" may emerge or underscore bouts of creativity. Intriguingly, individuals with MDD tend to exhibit relative left frontal cortical hypoactivity (i.e., decreased activity in approach-motivation brain regions)

[42]. This suggests that depression may be associated with decreased activity in the left frontal cortex, known to play a role in motivation. However, the hemisphere lateralization hypothesis is likely too simplistic as a potential explanatory mechanism underlying creativity.

4.4 Neural Connectivity Features in Mood Disorders: An Overview

A growing body of research has centered on exploring whether neural network disturbances exist in depression. A meta-analysis by Kaiser et al. (2015) found that MDD was, on average, characterized by decreased connectivity within the frontal-parietal network [36] which is involved in the selection of/focus on sensory content (though directed attention mechanisms). On the other hand, as outlined, depression is generally characterize by hyper-connectivity within the DMN [36]. Further, depressed individuals tend to exhibit altered connectivity between regions involved in processing emotional content or salient information (e.g., regions such as the amygdala and nucleus accumbens) and midline frontal cortical regions (e.g., medial prefrontal cortex), implicated in self-referential processing. This suggests that there are changes in the "cross-talk" between higher-order and self-referential (and, to a certain extent, regulatory) regions, and those implicated in emotional responses/salience detection. Finally, other data suggest decreased connectivity between the DMN and executive networks in depression. One interpretation of this is that there may be dominance of neural features associated with introspection over more "executive" regions in depressive disorders.

Data assessing neural networks (and more regional brain connections) in BD are less systematically studied. Additionally, research on the neural features in BD is generally limited to either euthymic (i.e., relatively symptom-free) states or depressed stages as manic states are generally rather short. Further, logistically, it is difficult to scan the brains of patients who are acutely manic (i.e., they are generally too unwell/unstable to participate in such research, which requires laying still in the scanner for a certain period of time). Existing evidence suggests that BD tends to be associated with altered connectivity between the amygdala (a region central to emotion processing, particularly fear processing) and certain areas of the prefrontal cortex [43]. Thus, much like in depression, BD may be associated with altered regulation between "emotional" and "higher-level" regulatory centers.

Creativity, just like every aspect of complex human emotions and behaviour, is fundamentally the product of brain function; in other words, there is really no way to uncouple creativity from the brain. As such, at the brain or even the neuronal level, creativity can be conceptualized as a "brain state" that leads to the generation of novel or non-linear ideas that are associated with an output that can be appreciated (or, simply measured) by the self or broader community/society [44].

4.5 Creativity in MDD and BD: Changes in the Whole Brain and its Topography

Given that various regions and networks are implicated in MDD and BD, these same neural features may be important biological substrates for creativity. By extension, this suggests that the whole brain and its particular spatial configuration (i.e., its topography) might be involved in mediating creativity in the context of mood disorders.

The relationship between global and local activity changes is a common phenomenon of complex systems in the natural world. For instance, global warming of the earth's atmosphere affects the climate in various countries and continents in different ways, depending on their respective local or regional features (e.g., ice melting in colder regions and creation of deserts in warmer regions) [45]. What holds true for the complex climate system (i.e., regional and global interactions/consequences) may also apply to the brain. Recent evidence suggests that the brain also displays 'global' activity (see below for a definition of the term 'global') that modulates and is represented in different ways in its various local regions and networks. That may, in part, be related to subcortical-cortical modulations: subcortical nuclei like the serotoninergic raphe nucleus, acetylcholinergic nucleus basalis meynert, and dopaminergic substantia nigra modulate cortical activity in a multiregional 'global' manner, including regulating the balance between different brain networks that support distinct and overlapping functions [46–48]. Additionally, recent studies in animals show that, generally, multiple regions are implicated in inducing and mediating one specific behavior (rather than a specific brain region) [49]. Such data support the role of the brain's more global activity in regulating behavior, including in creative expression.

Importantly, the brain's global activity is not homogenously distributed throughout the whole brain in the same way across all regions. Instead, it is represented to varying degrees in different regions: this is referred to as global signal (or global brain) topography. Global signal topography can be measured by co-relating the brain's global activity with each regions' activity, i.e., its time series. Such global brain topography may shed light onto the balance between different regions/networks and their respective functions, such as affective, motivational and cognitive functions, which are key dimensions in creativity.

Interestingly, major changes in global brain activity topography have been demonstrated in both depression and BD. For instance, Zhang et al. (2018) [50] showed increased global signal representation in the motor cortex in mania which, most likely, is related to the often-observed increased motor activity in such states (i.e., often referred to as psychomotor agitation). Further, during states of depression in BD, the hippocampus was found to exhibit increased global signal; this may be related to the increased autobiography memory recall in these patients (i.e., consistent with the notion of increased introspection). Hence, shifts in brain global signal topography may be related to corresponding shifts in behavior and cognition such as motor activity and memory recall. Both motoric output and memory (e.g.,

inspiration from life's events or the feelings that these past events may evoke) would -presumably- play a role in creative expression.

As outlined, depression is characterized by increased internally-oriented cognitive states such as 'mind-wandering', rumination and self-referential thought; these states are typically associated with increased regional/network activity in the DMN. Numerous brain imaging findings have noted abnormal brain global signal correlations with DMN regions, such as the medial prefrontal cortex and hippocampus [51–56]; the extent/strength of these correlations have been linked with depressive symptoms [55]. Further, such brain connections been found to be predictive of treatment response [56]. Additionally, one study demonstrated that connectivity of non-DMN networks to the DMN was significantly higher in depressed than non-depressed individuals. In other words, the DMN might "enslave" non-DMN networks (dominate the brain global signal) in depression [53]. Moreover, the degree of DMN-to-non-DMN connectivity (i.e., abnormal brain global signal topography in the context of depression) predicted clinical MDD diagnosis to a high degree. As such, these brain profiles appear to be sensitive to distinguishing individuals with depression from those without the disorder. It is feasible that the shift of the global brain signal towards DMN 'dominance' in depression may underline the abnormally strong representation of internally-oriented cognitions in the disorder (i.e., increased rumination, and self-focus), at the expense of externally-oriented cognitions (i.e., decreased environment focus). This is consistent with the notion that depression may be conducive for spurring/setting the stage for creative thinking, though, not necessarily for its expression (or, not until depression symptoms abate).

Collectively, what do these findings regarding brain global signal and network alterations tell us about creativity in mood disorders? First and foremost, these data indicate that mood disorders concern the whole brain rather than solely specific regions or even single large-scale networks (though, certain networks may be more implicated in mood disorders than others, e.g. DMN). Rather, the whole structure and organization of the brain appears to be altered in the context of mood disorders. As a consequence, normal motor, affective, cognitive, motivational, and social functions can become unbalanced in a manner that, in some cases, may favour creativity.

5 Neurotransmitters that Play a Role in the Link Between Mood Disorders and Creativity

While it is beyond the scope of this chapter to provide a comprehensive overview of all of the putative molecular underpinnings that may link (from a brain perspective) creativity and mood disorders, we will highlight two neurotransmitter systems that have been most widely and consistently implicated in this relationship. Namely, we will provide a brief overview of the role that the dopamine and serotonin systems likely play in the overlap between mood disorders and creativity.

5.1 Dopamine

As outlined, certain personality features, such as openness to experience, novelty seeking and impulsivity (aspects of what are sometimes referred to as "externalizing" traits) have been related to increased creativity [57]. The majority of work assessing externalizing traits and brain features has focused on the brain's dopamine system, as dopamine is known to be involved in motivation, particularly reward-based learning and "drives". Much of the dopamine activity involved in reward processing originates from the midbrain and projects to the striatum, particularly the ventral striatum, which is a central region implicated in reward processing and reward-seeking behaviours. Indeed, reward processing has been linked with increased dopamine activity in both striatal and extra-striatal regions [58]. Generally, greater striatal dopamine activity is associated with higher impulsivity and novelty-seeking, both of which are elements of or key ingredients in creativity. Greater cognitive flexibility and motivation have also been linked with higher dopamine activity in frontal regions [59]. As such, the interplay between frontal and striatal dopaminergic systems likely has an important role in creative drive as well as creative and artistic expression [60].

Dopamine is highly implicated in hallucinations; indeed, positive symptoms (e.g., auditory hallucinations or "hearing voices", and visual hallucinations) in psychotic disorders are typically treated by blocking dopamine-2 (D2) receptors. Thus, mental imagery, which is also a component of creativity [61], and could be viewed along the same continuum as hallucinations (i.e., disordered or 'extreme' mental imagery), might also be underscored by modulations in dopamine activity. Importantly, dopamine receptor agonists (i.e., stimulation or activation of the receptor that, in turn, induces changes in dopamine-mediated brain activity) can induce hypomania symptoms and hallucinations [62]. Indeed, manic episodes, in particular, appear to be associated with a hyper-dopaminergic state, particularly elevations in striatal D2/3 receptor availability [63]. The role of dopamine in the context of creativity is further corroborated by genetic studies. Specifically, genetic codes for neuronal receptors specific for dopamine, as well as molecules that participate in the metabolism of dopamine, have been linked with divergent thinking [60, 64], a key component of creativity, as previously discussed.

Broadly, depression appears to be associated with altered dopamine activity (though large inter-individual variability certainly exists); after all, most existing antidepressant pharmacotherapies tend to increase dopamine activity with longer term use [65]. Given that one of the hallmarks of depression is anhedonia (i.e., diminished pleasure and motivation to seek pleasure), which tends to be associated with or largely mediated by fronto-striatal dopamine activity, this could underscore some of the decreased motoric expression of creativity in individuals suffering from severe depression. Again, this would be consistent with the notion that depression may be more conducive to introspection, which could be an important substrate for creative thought. However, the expression of creativity (i.e., motoric output) would likely occur when symptoms abate, and perhaps when dopamine neurotransmission is normalized.

5.2 Serotonin or 5-Hydroxytryptamine (5HT)

The role of serotonin, also called 5-hydroxytyptamine (5-HT), in the context of depression is well documented. Indeed, an early molecular theory of depression, dubbed the "monoamine hypothesis of depression", posited that the primary basis of the disorder is that it is underscored by lowered levels of monoamines (i.e., the neurotransmitters serotonin, norepinephrine and dopamine) in the central nervous system, and -in particular- serotonin [30]. While the theory is now regarded as too simplistic and incomplete, the vast majority of antidepressant drugs work by modulating, and in the long-term, upregulating serotonin activity. Indeed, the most common class of antidepressant medications, the selective serotonin reuptake inhibitors (SSRIs), are specifically designed to increase available serotonin levels in the neuronal synapse. Based on this pharmacological evidence, as well as countless animal and human studies, it is well-known that the serotonin system plays a critical role in mood/emotion regulation [66]. Further, similarly to dopamine, serotonin plays a role in motivation regulation; specifically, it appears to decrease withdrawal symptoms (versus increase approach to positive stimuli, which is more central to dopamine function) [67]. It has been proposed that decreased aversiveness may decreases stress, as such, serotonin might indirectly increase pleasure and openness/curiosity. In this way, serotonin may play a role in creativity. Granted, it is difficult to square how decreased or deficient serotonin (i.e., such as what may occur—at least to a certain extent—in depression) may be putatively conducive to creativity. It has also been posited that increased serotonin may not only lower aversive motivations but also some approach-based/appetitive motivations [68]. This is generally supported by slightly elevated apathy in some individuals who are treated with SSRIs (i.e., slightly blunted motivations) [69]. As such, depression may be associated with modulated motivations (including towards adverse stimuli)/heightened emotionality, which may be partially driven by decreased serotonergic neurotransmission; this, in turn, could be conducive towards abstract and divergent thinking (i.e., a key component of creativity). However, this is speculative.

Links between altered serotonin neurotransmission based on genetic mutations in the serotonin system (e.g., polymorphisms in the serotonin transporter gene) have been associated with verbal and figural creative ability [70]. Such data further lends credence to the role of serotonin in creativity, and the link between creativity and mood disorders. Finally, another source of evidence for a link between serotonin and creativity comes from research (largely anecdotal) indicating that psychedelic drugs (e.g., psilocybin) can enhance creative thinking. Psychedelic drugs, such as psilocybin and lysergic acid diethylamide (LSD) act on the serotonin system (specifically, they are agonists of the serotonin/5-HT-2A receptor). A recent placebo-controlled study found that psilocybin increased ratings of spontaneous creative insights, while decreasing deliberate task-based creativity. Further, a week after the administration of this acute dose of psilocybin, the number of novel ideas was increased. Additionally, these changes in creative processes were largely associated with changes within and between the DMN [71]. Such data suggest a link between modulated serotonin function, different aspects of creative thought and expression, as well as brain networks underscoring this relation.

5.3 Modulations of Serotonin and Dopamine on Brain Networks

Fundamentally, neurotransmitter activity underlies global brain function, including large-scale brain network activity and global brain topography. In other words, the activity of the serotonin and dopamine systems (along with other neurotransmitter systems) is what underlies activity in brain networks and global brain activity organization, which play a role in mood disorders and creativity. Nuclei (i.e., clusters of neuronal cell bodies), typically originating in sub-cortical regions, tend to be responsible for the production of neurotransmitters that then project to other brain regions, including cortical projections. It has been shown that dopamine pathways originating from the substantia nigra pars compacta (a midbrain nucleus) and projecting to the striatum (i.e., the dopamine nigrostriatal pathway) influences the sensorimotor network [46]. The sensorimotor network, as the name implies, is comprised of brain regions involved in sensory and motor function. Dopamine projections originating from the midbrain ventral tegmental to the nucleus accumbens/ventral striatum and prefrontal cortex comprise the mesocorticolimbic pathway. This pathway is central to the activity of the salience network [72], which is generally implicated in vigilance/attentional resource allocation, and switching between other large-scale networks. Thus, dopamine plays a role in activity of large-scale brain networks that mediate sensory-motor function and salience-detection. Previous work has noted an association between salience network activity and creativity [73], and engagement of the sensorimotor network would be expected with any creative output/expression activity.

The nuclei for serotonin-containing cells are located in the midbrain raphe nuclei, and have been shown to be involved in regulating activity within the DMN but also the sensorimotor network [46]. Thus, changes in the activity of both serotonin and dopamine neurotransmitters would presumably impact the activity of large-scale networks known to underscore some of the symptoms associated with mood disorders and in aspects of creativity. The changes in the balance of serotonin/dopamine (among other neurotransmitters) that may occur throughout the course of a mood disorder episode could thus modulate the activity of these networks and their interplay (i.e., global brain signal changes). This, in turn, could influence creative thought and expression.

6 Conclusion

Despite the "mad genius" label sometimes ascribed to artists, data for a direct link between mood disorders (specifically depression and bipolar disorder [BD]) and increased creativity is thin. This might be largely due to various methodological issues that hamper the study of this relationship (e.g., operationalizing creativity). Nevertheless, depressed states might be associated with increased introspection which, in turn, could lead to increased creativity and creative expression when symptoms abate. Manic or hypomanic states are typically associated with increased

drive/motivation, focus and motoric energy which could facilitate creative expression. However, the relation between mood disorder severity and creativity likely follows a U-shape, wherein severe depression and mania symptoms likely hamper creativity. Additionally, certain personality traits are over-represented in both creative individuals and in those with BD, in particular (e.g., novelty-seeking). This commonality could account for a link between mood disorders and creativity.

From a neural perspective, many of the brain regions implicated in mood disorders, such as the prefrontal cortex (cognitive regulation) and limbic regions (emotional processes), are also involved in creativity, thereby pointing to overlapping neural substrates. Further, many of these regions comprise large-scale brain networks that regulate emotions and behaviours. One such example is the default mode network (DMN), whose activity has been linked with creativity. However, mood disorders have been associated with altered DMN activity. As such, activity in these brain networks (and their inter-connectedness with other networks), and the neurochemicals that underlie their function (e.g., serotonin and dopamine), might account for the link between mood disorders and creativity. In sum, there the relation between creativity and mood disorders is non-linear, multifaceted, and certainly warrants further study.

References

1. First MB, Williams JBW, Karg RS, Spitzer RL. Structured clinical interview for DSM-5® disorders—clinician version (SCID-5-CV). American Psychiatric Association Publishing; 2016. p. 94.
2. American Psychological Association (APA). Diagnostic and statistical manual of mental disorders: diagnostic and statistical manual of mental disorders, fifth edition. 5th ed. Arlington, VA: American Psychiatric Association; 2013.
3. World Health Organization (WHO). International statistical classification of diseases and related health problems. 11th ed. Geneva: World Health Organization; 2016.
4. Beck AT, Steer RA, Brown KG. Manual for the Beck depression inventory-II. San Antonio, TX: Psychological Corp. Cavanagh, K, Shapiro, D A; 1996.
5. Hamilton M. A rating scale for depression. J Neurol Neurosurg Psychiatry. 1960;23:334–40.
6. Kessler RC. Lifetime and 12-month prevalence of DSM-III-R psychiatric disorders in the United States. Arch Gen Psychiatry [Internet]. 1994;51(1):8. Available from: http://archpsyc.jamanetwork.com/article.aspx?doi=10.1001/archpsyc.1994.03950010008002
7. Mathers CD, Loncar D. Projections of global mortality and burden of disease from 2002 to 2030. Samet J, editor. PLoS Med [Internet]. 2006;3(11):e442. https://doi.org/10.1371/journal.pmed.0030442.
8. Whiteford HA, Degenhardt L, Rehm J, Baxter AJ, Ferrari AJ, Erskine HE, et al. Global burden of disease attributable to mental and substance use disorders: findings from the global burden of disease study 2010. Lancet [Internet]. 2013;382(9904):1575–86. Available from: https://linkinghub.elsevier.com/retrieve/pii/S0140673613616116.
9. Greenberg PE, Kessler RC, Birnbaum HG, Leong SA, Lowe SW, Berglund PA, et al. The economic burden of depression in the United States. J Clin Psychiatry [Internet]. 2003;64(12):1465–75. Available from: http://article.psychiatrist.com/?ContentType=START&ID=10000620
10. Nübel J, Guhn A, Müllender S, Le HD, Cohrdes C, Köhler S. Persistent depressive disorder across the adult lifespan: results from clinical and population-based surveys in Germany. BMC Psychiatry. 2020;20(1):58.
11. Cooper B. Sylvia Plath and the depression continuum. J R Soc Med. 2003;96(6):296–301.

12. Rowland TA, Marwaha S. Epidemiology and risk factors for bipolar disorder. Ther Adv Psychopharmacol [Internet]. 2018;8(9):251–69. Available from: http://journals.sagepub.com/doi/10.1177/2045125318769235
13. Kessler R. Epidemiology of women and depression. J Affect Disord [Internet]. 2003;74(1):5–13. Available from: https://linkinghub.elsevier.com/retrieve/pii/S0165032702004263
14. Lange-Eichbaum WPM (trans. EC, Paul). The problem of genius. Kegan Paul & Co; 1931.
15. Taylor CL. Creativity and mood disorder: a systematic review and meta-analysis. Perspect Psychol Sci [Internet]. 2017;12(6):1040–76. Available from: http://journals.sagepub.com/doi/10.1177/1745691617699653
16. Patra BN, Balhara YPS. Creativity and mental disorder. Br J Psychiatry [Internet]. 2012;200(4):346. Available from: https://www.cambridge.org/core/product/identifier/S0007125000079344/type/journal_article
17. Welsh GS, Barron F. Barron-Welsh art scale. Palo Alto, CA: Consulting Psychologists Pr; 1959.
18. Carson SH, Peterson JB, Higgins DM. Reliability, validity, and factor structure of the creative achievement questionnaire. Creat Res J [Internet]. 2005;17(1):37–50. Available from: http://www.tandfonline.com/doi/abs/10.1207/s15326934crj1701_4
19. Jamison KR. Touched with fire: manic-depressive illness and the artistic temperament. Touched with fire: manic-depressive illness and the artistic temperament, vol. xii, 370–xii. New York, NY, US: Free Press; 1993. p. 370.
20. Northoff G, Magioncalda P, Martino M, Lee HC, Tseng YC, Lane T. Too fast or too slow? Time and neuronal variability in bipolar disorder - a combined theoretical and empirical investigation. Schizophr Bull. 2018;44(1):54–64.
21. Frantom C, Sherman MF. At what price art? Affective instability within a visual art population. Creat Res J. 1999;12(1):15–23.
22. Kinney DK, Richards R. Creativity as "compensatory advantage": bipolar and schizophrenic liability, the inverted-U hypothesis, and practical implications. In: Kaufman JC, editor. Creativity and Mental Illness [Internet]. Cambridge: Cambridge University Press. p. 295–318. Available from: https://www.cambridge.org/core/product/identifier/CBO9781139128902A027/type/book_part.
23. Szakács R. A kreativitás arculatai a bipoláris hangulatzavar tükrében. Ideggyogy Sz [Internet]. 2018:63–71. Available from: https://elitmed.hu/en/publications/clinical-neuroscience/the-facets-of-creativity-in-the-light-of-bipolar-mood-alterations
24. Taylor K, Fletcher I, Lobban F. Exploring the links between the phenomenology of creativity and bipolar disorder. J Affect Disord [Internet]. 2015;174:658–64. Available from: https://linkinghub.elsevier.com/retrieve/pii/S0165032714006715
25. Power RA, Pluess M. Heritability estimates of the big five personality traits based on common genetic variants. Transl Psychiatry [Internet]. 2015;5(7):e604. Available from: http://www.nature.com/articles/tp201596
26. Widiger TA, Oltmanns JR. Neuroticism is a fundamental domain of personality with enormous public health implications. World Psychiatry [Internet]. 2017;16(2):144–5. Available from: http://www.ncbi.nlm.nih.gov/pubmed/28498583
27. Johnson SL, Tharp JA, Holmes MK. Understanding creativity in bipolar I disorder. Psychol Aesthetics, Creat Arts. 2015;9(3):319–27.
28. Baas M, Nijstad BA, Boot NC, De Dreu CKW. Mad genius revisited: vulnerability to psychopathology, biobehavioral approach-avoidance, and creativity. Psychol Bull [Internet]. 2016;142(6):668–92. Available from: http://doi.apa.org/getdoi.cfm?doi=10.1037/bul0000049
29. Johnson SL, Murray G, Hou S, Staudenmaier PJ, Freeman MA, Michalak EE. Creativity is linked to ambition across the bipolar spectrum. J Affect Disord. 2015;178:160–4.
30. Hirschfeld RM. History and evolution of the monoamine hypothesis of depression. J Clin Psychiatry [Internet]. 2000;61(Suppl 6):4–6. Available from: http://www.ncbi.nlm.nih.gov/pubmed/10775017
31. Zhang F-F, Peng W, Sweeney JA, Jia Z-Y, Gong Q-Y. Brain structure alterations in depression: Psychoradiological evidence. CNS Neurosci Ther [Internet]. 2018;24(11):994–1003. Available from: http://doi.wiley.com/10.1111/cns.12835

32. Jaworska N, Wang H, Smith DM, Blier P, Knott V, Protzner AB. Pre-treatment EEG signal variability is associated with treatment success in depression. NeuroImage Clin [Internet]. 2018;17:368–77. Available from: http://www.ncbi.nlm.nih.gov/pubmed/29159049

33. Cuellar AK, Johnson SL, Winters R. Distinctions between bipolar and unipolar depression. Clin Psychol Rev [Internet]. 2005;25(3):307–39. Available from: https://linkinghub.elsevier.com/retrieve/pii/S0272735804001710

34. Liu Z, Zhang J, Xie X, Rolls ET, Sun J, Zhang K, et al. Neural and genetic determinants of creativity. Neuroimage [Internet]. 2018;174:164–76. Available from: https://linkinghub.elsevier.com/retrieve/pii/S1053811918301745

35. Andrews-Hanna JR, Smallwood J, Spreng RN. The default network and self-generated thought: component processes, dynamic control, and clinical relevance. Ann N Y Acad Sci [Internet]. 2014;1316(1):29–52. Available from: http://doi.wiley.com/10.1111/nyas.12360

36. Kaiser RH, Andrews-Hanna JR, Wager TD, Pizzagalli DA. Large-scale network dysfunction in major depressive disorder: a meta-analysis of resting-state functional connectivity. JAMA Psychiatry. 2015;72(6):603–11.

37. Mashal N, Faust M, Hendler T, Jung-Beeman M. An fMRI investigation of the neural correlates underlying the processing of novel metaphoric expressions. Brain Lang [Internet]. 2007;100(2):115–26. Available from: https://linkinghub.elsevier.com/retrieve/pii/S0093934X05003093

38. Berkowitz AL, Ansari D. Expertise-related deactivation of the right temporoparietal junction during musical improvisation. Neuroimage [Internet]. 2010;49(1):712–9. Available from: https://linkinghub.elsevier.com/retrieve/pii/S1053811909009525

39. Carlsson I, Wendt PE, Risberg J. On the neurobiology of creativity. Differences in frontal activity between high and low creative subjects. Neuropsychologia [Internet]. 2000;38(6):873–85. Available from: https://linkinghub.elsevier.com/retrieve/pii/S0028393299001281

40. Spielberg JM, Stewart JL, Levin RL, Miller GA, Heller W. Prefrontal cortex, emotion, and approach/withdrawal motivation. Soc Personal Psychol Compass [Internet]. 2008;2(1):135–53. Available from: http://doi.wiley.com/10.1111/j.1751-9004.2007.00064.x

41. Heller W, Nitschke JB, Etienne MA, Miller GA. Patterns of regional brain activity differentiate types of anxiety. J Abnorm Psychol. US: American Psychological Association. 1997;106:376–85.

42. Kemp AH, Griffiths K, Felmingham KL, Shankman SA, Drinkenburg W, Arns M, et al. Disorder specificity despite comorbidity: resting EEG alpha asymmetry in major depressive disorder and post-traumatic stress disorder. Biol Psychol [Internet]. 2010;85(2):350–4. Available from: https://linkinghub.elsevier.com/retrieve/pii/S0301051110002188

43. Chase HW, Phillips ML. Elucidating neural network functional connectivity abnormalities in bipolar disorder: toward a harmonized methodological approach. Biol Psychiatry Cogn Neurosci Neuroimaging [Internet]. 2016;1(3):288–98. Available from: https://linkinghub.elsevier.com/retrieve/pii/S2451902216000604

44. Carson SH. Creativity and psychopathology: a shared vulnerability model. Can J Psychiatry [Internet]. 2011;56(3):144–53. Available from: http://journals.sagepub.com/doi/10.1177/070674371105600304

45. Intergovernmental Panel on Climate Change. Detection and attribution of climate change: from global to regional. Climate Change 2013 - The Physical Science Basis [Internet]. Cambridge: Cambridge University Press. 867–952. Available from: https://www.cambridge.org/core/product/identifier/CBO9781107415324A030/type/book_part.

46. Conio B, Martino M, Magioncalda P, Escelsior A, Inglese M, Amore M, et al. Opposite effects of dopamine and serotonin on resting-state networks: review and implications for psychiatric disorders. Mol Psychiatry [Internet]. 2020;25(1):82–93. Available from: http://www.nature.com/articles/s41380-019-0406-4

47. Grandjean J, Corcoba A, Kahn MC, Upton AL, Deneris ES, Seifritz E, et al. A brain-wide functional map of the serotonergic responses to acute stress and fluoxetine. Nat Commun [Internet]. 2019;10(1):350. Available from: http://www.nature.com/articles/s41467-018-08256-w

48. Zerbi V, Floriou-Servou A, Markicevic M, Vermeiren Y, Sturman O, Privitera M, et al. Rapid reconfiguration of the functional connectome after Chemogenetic locus Coeruleus activation. Neuron [Internet]. 2019;103(4):702–718.e5. Available from: https://linkinghub.elsevier.com/retrieve/pii/S0896627319304878

49. Stringer C, Pachitariu M, Steinmetz N, Reddy CB, Carandini M, Harris KD. Spontaneous behaviors drive multidimensional, brainwide activity. Science (80-) [Internet]. 2019;364(6437):eaav7893. Available from: https://www.sciencemag.org/lookup/doi/10.1126/science.aav7893

50. Zhang J, Magioncalda P, Huang Z, Tan Z, Hu X, Hu Z, et al. Altered global signal topography and its different regional localization in motor cortex and hippocampus in mania and depression. Schizophr Bull [Internet]. 2019;45(4):902–10. Available from: https://academic.oup.com/schizophreniabulletin/article/45/4/902/5114616

51. Murrough JW, Abdallah CG, Anticevic A, Collins KA, Geha P, Averill LA, et al. Reduced global functional connectivity of the medial prefrontal cortex in major depressive disorder. Hum Brain Mapp [Internet]. 2016;37(9):3214–23. Available from: http://doi.wiley.com/10.1002/hbm.23235

52. Scheinost D, Holmes SE, DellaGioia N, Schleifer C, Matuskey D, Abdallah CG, et al. Multimodal investigation of network level effects using intrinsic functional connectivity, anatomical covariance, and structure-to-function correlations in Unmedicated major depressive disorder. Neuropsychopharmacology [Internet]. 2018;43(5):1119–27. Available from: http://www.nature.com/articles/npp2017229

53. Scalabrini A, Vai B, Poletti S, Damiani S, Mucci C, Colombo C, et al. All roads lead to the default-mode network—global source of DMN abnormalities in major depressive disorder. Neuropsychopharmacology [Internet]. 2020;45(12):2058–69. Available from: http://www.nature.com/articles/s41386-020-0785-x

54. Abdallah CG, Averill CL, Salas R, Averill LA, Baldwin PR, Krystal JH, et al. Prefrontal connectivity and glutamate transmission: relevance to depression pathophysiology and ketamine treatment. Biol Psychiatry Cogn Neurosci Neuroimaging. 2017;2(7):566–74.

55. Han S, Wang X, He Z, Sheng W, Zou Q, Li L, et al. Decreased static and increased dynamic global signal topography in major depressive disorder. Prog Neuro-Psychopharmacology Biol Psychiatry [Internet]. 2019;94:109665. Available from: https://linkinghub.elsevier.com/retrieve/pii/S0278584619301514

56. Zhang L, Wu H, Xu J, Shang J. Abnormal global functional connectivity patterns in medication-free major depressive disorder. Front Neurosci [Internet]. 2018;9:12. Available from: https://www.frontiersin.org/article/10.3389/fnins.2018.00692/full

57. Kaufman SB, Quilty LC, Grazioplene RG, Hirsh JB, Gray JR, Peterson JB, et al. Openness to experience and intellect differentially predict creative achievement in the arts and sciences. J Pers [Internet]. 2016;84(2):248–58. Available from: http://doi.wiley.com/10.1111/jopy.12156

58. Vrieze E, Ceccarini J, Pizzagalli DA, Bormans G, Vandenbulcke M, Demyttenaere K, et al. Measuring extrastriatal dopamine release during a reward learning task. Hum Brain Mapp [Internet]. 2013;34(3):575–86. Available from: http://www.ncbi.nlm.nih.gov/pubmed/22109979

59. Klanker M, Feenstra M, Denys D. Dopaminergic control of cognitive flexibility in humans and animals. Front Neurosci [Internet]. 2013;7. Available from: http://journal.frontiersin.org/article/10.3389/fnins.2013.00201/abstract

60. Khalil R, Godde B, Karim AA. The link between creativity, cognition, and creative drives and underlying neural mechanisms. Front Neural Circuits [Internet]. 2019;22:13. Available from: https://www.frontiersin.org/article/10.3389/fncir.2019.00018/full

61. Palmiero M, Piccardi L, Nori R, Palermo L, Salvi C, Guariglia C. Editorial: creativity and mental imagery. Front Psychol [Internet]. 2016;25:7. Available from: http://journal.frontiersin.org/Article/10.3389/fpsyg.2016.01280/abstract

62. Peet M, Peters S. Drug-induced mania. Drug Saf [Internet]. 1995;12(2):146–53. Available from: http://link.springer.com/10.2165/00002018-199512020-00007

63. Ashok AH, Marques TR, Jauhar S, Nour MM, Goodwin GM, Young AH, et al. The dopamine hypothesis of bipolar affective disorder: the state of the art and implications for treatment. Mol Psychiatry [Internet]. 2017;22(5):666–79. Available from: http://www.nature.com/articles/mp201716

64. Flaherty AW. Frontotemporal and dopaminergic control of idea generation and creative drive. J Comp Neurol [Internet]. 2005;493(1):147–53. Available from: http://doi.wiley.com/10.1002/cne.20768

65. Belujon P, Grace AA. Dopamine system dysregulation in major depressive disorders. Int J Neuropsychopharmacol [Internet]. 2017;20(12):1036–46. Available from: http://academic.oup.com/ijnp/article/20/12/1036/3901225

66. Albert PR, Benkelfat C. The neurobiology of depression—revisiting the serotonin hypothesis. II. Genetic, epigenetic and clinical studies. Philos Trans R Soc B Biol Sci [Internet]. 2013;368(1615):20120535. Available from: https://royalsocietypublishing.org/doi/10.1098/rstb.2012.0535

67. Cools R, Roberts AC, Robbins TW. Serotoninergic regulation of emotional and behavioural control processes. Trends Cogn Sci [Internet]. 2008;12(1):31–40. Available from: https://linkinghub.elsevier.com/retrieve/pii/S1364661307003051

68. Barnhart WJ, Makela EH, Latocha MJ. SSRI-induced apathy syndrome: a clinical review. J Psychiatr Pract [Internet]. 2004;10(3):196–9. Available from: http://journals.lww.com/00131746-200405000-00010

69. Padala PR, Padala KP, Majagi AS, Garner KK, Dennis RA, Sullivan DH. Selective serotonin reuptake inhibitors-associated apathy syndrome. Medicine (Baltimore) [Internet]. 2020;99(33):e21497. Available from: https://journals.lww.com/10.1097/MD.0000000000021497

70. Volf NV, Kulikov AV, Bortsov CU, Popova NK. Association of verbal and figural creative achievement with polymorphism in the human serotonin transporter gene. Neurosci Lett [Internet]. 2009;463(2):154–7. Available from: https://linkinghub.elsevier.com/retrieve/pii/S0304394009010192

71. Mason NL, Kuypers KPC, Reckweg JT, Müller F, Tse DHY, Da Rios B, et al. Spontaneous and deliberate creative cognition during and after psilocybin exposure. Transl Psychiatry [Internet]. 2021;11(1):209. Available from: http://www.nature.com/articles/s41398-021-01335-5

72. Menon V, Uddin LQ. Saliency, switching, attention and control: a network model of insula function. Brain Struct Funct [Internet]. 2010;214(5–6):655–67. Available from: http://www.ncbi.nlm.nih.gov/pubmed/20512370

73. Beaty RE, Kenett YN, Christensen AP, Rosenberg MD, Benedek M, Chen Q, et al. Robust prediction of individual creative ability from brain functional connectivity. Proc Natl Acad Sci [Internet]. 2018;115(5):1087–92. Available from: http://www.pnas.org/lookup/doi/10.1073/pnas.1713532115

Art Making in Schizophrenia: A Vision Science Perspective

Daniel Graham and Steven Silverstein

1 Introduction

Schizophrenia is a disorder characterized by psychotic symptoms (e.g., symptoms indicating reduced reality testing, such as hallucinations and delusions), disorganization (loose associations in speech, odd and out-of-context movements), negative symptoms (anhedonia, flat affect, low motivation), and cognitive impairment, as well as significant functional decline. It is also a highly heterogeneous disorder, with great variability in age of onset, number of lifetime psychotic episodes, long-term course of illness, and degree of recovery of normal role functions. In addition, it is possible for two people to meet criteria for the diagnosis of schizophrenia while having non-overlapping symptoms, and symptom expression can vary significantly across cultures [1]. Schizophrenia is known to be highly heritable, although most people with the condition do not have a parent or sibling with the condition. It is found in slightly less than 1% of the population worldwide [2–4] and appears to have been in existence since early in human history. The causes of schizophrenia have been studied for decades, but an understanding of them remains elusive. It is now generally thought that many genes can contribute to the development of schizophrenia, each with a small contribution [5]. Epigenetic factors, such as the influence

D. Graham (✉)
Department of Psychological Science, Hobart and William Smith Colleges,
Geneva, NY, USA
e-mail: GRAHAM@hws.edu

S. Silverstein
Department of Psychiatry, University of Rochester Medical Center, Rochester, NY, USA

Department of Neuroscience, University of Rochester Medical Center, Rochester, NY, USA

Department of Ophthalmology, University of Rochester Medical Center, Rochester, NY, USA

of interpersonal and environmental stress and toxins on gene expression, are also thought to be important in mediating gene x environment interactions [6]. Traditionally, biological theories have emphasized dopamine (DA) dysfunction [7]. However, it is becoming clear that excess dopamine is primarily found in the striatum, whereas dopamine activity in cortical regions appears to be reduced [8]. Also, newer theories emphasize the role of glutamatergic dysfunction (e.g., NMDA receptor hypofunction) [7], GABA-ergic (i.e., inhibitory interneuron) dysfunction leading to excessive neural excitation [9], as well as imbalances in acetylcholine [10] and histamine [11]. Because all of these neurotransmitter systems interact, disentangling primary causes from downstream effects has been and continues to be challenging. There is also evidence that the neural findings in schizophrenia may be secondary to changes in vascular function, and that changes in the vasculature (e.g., reduced density of blood vessels) may be a secondary effect of a neuroinflammatory process [12, 13]. This evidence has led to the perspective that schizophrenia is a multi-system disease, involving dysregulation of multiple homeostatic mechanisms [14, 15]. Evidence for this includes overlap between schizophrenia candidate genes and genes involved in cardiovascular function [13], as well as an increased prevalence of metabolic and cardiovascular conditions even at the first episode of psychosis [16]. While the behavioral changes (e.g., delusional ideation, speaking back to auditory hallucinations) in schizophrenia are typically the most striking aspects of the condition, effects such as cardiovascular disease play a major role in the shortened lifespan of patients with the condition [17]. Regardless of the sequence and interactive nature of the potential causes of schizophrenia, there is no doubt that the condition affects multiple brain regions involved in perception, cognition, and sense of self and the world, and that understanding and treatment of people with lived experience of it needs to take into account these changes in brain and mind.

Despite the psychiatric, physical (e.g, increased rate of serious medical illness, even at first episode; [3, 16]), cognitive, economic, and social challenges associated with schizophrenia, people with schizophrenia are over-represented among artists [18–20]. Nevertheless, people with schizophrenia face great challenges in producing art, especially in institutional settings. At the outset it is important to note that most people with schizophrenia probably do not regularly perform visual art making on their own. Yet some do, and their artwork and art making process are an important and growing interest among researchers in a variety of areas of psychiatry, neuroscience, and other areas. However, interest in artwork by people with schizophrenia [21, 22], and with milder versions of psychotic symptoms (e.g., schizotypal symptoms) [23, 24] has a long history.

2 Visual Artwork by People with Schizophrenia

For decades before schizophrenia acquired its modern name and description [25], several European mental institutions displayed small collections of visual artworks by patients. But these works were typically viewed by the psychiatrists who collected them as curiosities, and were displayed along with escape tools and casts of patients' abnormal body parts as parts of the Wunderkammer tradition (i.e., cabinets of curiosity in central European aristocratic homes) that stretched back to the early Enlightenment era.

Concerted scientific study of art by people with schizophrenia began with a group of pictures collected from patients in a Heidelberg institution by psychiatrist Karl Wilmanns. With Wilmann's encouragement, the collection grew rapidly and systematically under the aegis of Hans Prinzhorn (1886–1933). Prinzhorn was a psychiatrist who studied art history as an undergraduate at the University of Vienna. Prinzhorn's goal of encouraging visual art making among psychiatric patients was not conceived as a form of therapy. Rather, the goal was to promote individual expression [26]. His hope, and expectation, was that the resulting works would be seen as reflecting the artists' actual perception, experience, and cognitive state.

By 1921, the collection contained around 5000 images, which were analyzed in Prinzhorn's landmark work *Artistry of the Mentally Ill* (1922). The book aimed to connect art historical formal analysis of the works with patterns of thought and behavior in patients, both to characterize general patterns found in the disorder, as well as idiosyncrasies of individual cases.

The works were by largely untrained artists, including, perhaps most famous among them today, Adolf Wölfli, a Swiss artist who likely had schizophrenia, and was also the subject of a biography by psychiatrist Walter Morganthaler [27]. Prinzhorn [28] describes, with apparent wonder, one of Wölfli's works (Fig. 1) as showing how:

a completely uneducated person with strong symbolic tendencies creates a form language for himself. For him the sheet is not intended for spatial depiction but for decorative division with flat stereotypical forms, each of which is given a distinct range of meaning by countless repetition. Similar pictures suggest that the large figure is a sort of guardian angel with wings. The drawer means himself by "St. Adolf, Great-God-Father." He repeats the snake and "birdie" motif, which was always very important to him, as often as possible by using the interstices. The "bell" motif on the edge shows that the sheet is also to be read as music, the "bells" indicating the meter. The suggestive effect of arbitrary colorfulness can hardly be shown more impressively than in this picture.

Fall 450. Abb. 74. Dekorativ-symbolische Zeichnung (Buntstift) 24×34

Fig. 1 A work of Adolf Wölfli analyzed by Hans Prinzhorn. Public Domain

3 Critique of the Prinzhorn Approach

Despite Prinzhorn's clear engagement with formal properties of the work, there is an important difficulty in this approach. Like many other artists with schizophrenia whose work was part of the Prinzhorn collection, Wölfli was both untrained and mentally ill. Thus, the violation of art historical conventions is difficult to disentangle from the effects of the disorder. Indeed, Prinzhorn himself was well aware of this problem, but lacked the tools of modern vision science that could have helped him to move beyond it.

Nevertheless, modernist art historical narratives of works by people with mental illness tend to attribute to these images qualities associated with the disease, such as novelty-seeking, flexible associations, and lowered inhibitions. These impressions, which have little scientific basis, are of a piece with similar interpretations of other forms of "primitive" art (e.g., [29]).

Analyzing the artistic qualities and allusions of a work by an artist with schizophrenia is freighted with cultural biases rooted in Kantian philosophy and the notion of "fine arts". Indeed, treating the entire category of "art" as somehow distinct from other types of visual production is not supported by neuroscientific evidence, which has yet to show systems for the processing and appreciation of art that are separate from those of other stimuli [30].

4 Quantitative Study of Visual Artwork: Enter Vision Science

Yet, an artwork still holds important clues to the artist's visual experience. Artwork often seeks to depict objects and scenes from the physical world. One approach is to examine the "artistic transform" or the mathematical relationships between colors, intensities, and spatial distributions of photons in the world and those in corresponding artworks. Although direct comparison of a scene and its corresponding depiction is occasionally possible (see 31–33]), in the case of artwork by people with schizophrenia we would be left with just a few idiosyncratic transforms. Moreover, artwork—especially by people with schizophrenia, like Wölfli—is often dense with abstraction and bears little resemblance to a particular scene from the natural world, despite containing recognizable objects and spatial relationships of parts of scenes.

However, if we look at statistical properties of images in aggregate we can begin to make progress. The idea is to examine general statistical properties of a corpus of art images produced by larger groups of people with schizophrenia in comparison to diverse corpora sampled from the wide sweep of art history. This approach is sensible because there are constraints on low-level statistical properties of natural images, and, in turn, of artwork. Constraints on natural scenes are in a sense "assumed" in the architecture of human neural processing of vision (see e.g., [34]). These constraints result in regularities in artwork as well (though artwork has additional constraints including, typically, 2-D representation, lower dynamic range of

luminance, etc.). Put another way, humans share the same visual world, which possesses certain regularities, and should on average capture these regularities in art—at least to the extent that humans share low-level visual processing capabilities.

An important consideration in this discussion is the role of visual system changes in schizophrenia in relation to affective and higher cognitive changes that can also determine the nature of art that is produced. For example, people with schizophrenia, as a group (albeit a group with significant inter-individual variability) have been shown to experience less positive affect and more negative affect [35], have looser (i.e., less typical context-based) verbal associations [36], are more perseverative [37], have more intense visual imagery [38], have less visual and cognitive inhibition and more access to default mode network activity [39, 40], and experience more of the taken for granted (i.e., pre-reflective) aspects of mental experience [41], in addition to other cognitive and phenomenological changes [29, 42, 43]. This raises the questions of what comes first, and what is the relative importance of any of these factors (including basic visual changes) in art-making in schizophrenia. For example, while basic perceptual changes can lead to altered experience of the world, which can lead to delusional explanations and anxiety, it is also possible that phenomenological changes in the experience of the self and world can lead to shifts in vigilance and visual attention, and mood, that could affect perception. These issues are currently unresolved, and have not been a focus of research in schizophrenia. In the current chapter, our focus is on possible changes in the visual system that could account for the visual characteristics of art of people with schizophrenia. Our assumption is, based on much prior work, that these changes are part of the fundamental neurobiology of the disorder. However, the relative contributions of cognitive and affective factors to the art of people with schizophrenia, and to the perceptual changes that are reflected in that art, require further study. For example, visual hallucinations in schizophrenia appear to involve hyperconnectivity between the amygdala and visual cortex [44], and to the extent that these hallucinations influence the direction of visual art productions, these would then reflect both visual and affective changes.

5 Natural Image Statistics and Low-Level Vision

Natural scenes show strong pairwise correlations across space: neighboring points in scenes are likely to resemble one another in terms of light intensity, and this relationship decreases as the two points are moved further and further apart. This relationship holds across image scales: we can zoom in or out in a scene and we will find the same correlation (equivalently, we can consider a pair of "points" to be of almost any spatial size). This is termed $1/f$ behavior, since the Fourier spatial frequency amplitude spectrum typical of natural scenes falls as $1/f^p$ where p is about 1 for almost any natural scene. This means that the contrast energy is greatest for low spatial frequencies (large-scale structure) and falls off linearly with slope p at higher frequencies (when plotted in log-log coordinates).

In both representational art as well as abstract art, humans largely recapitulate the average spatial frequency spectra of natural images, generating slopes of about 1 [31, 32, 45–47]. In addition, artists largely recapitulate biases in spatial frequency amplitude across orientation, which is to say biases in edge and contour orientation. For example, horizontal lines are common in natural images. Their presence leads to greater average contrast in corresponding spatial frequency components, at least at low spatial frequencies, and therefore greater spectral amplitude for these orientations. As Schweinhart and Essock [33] and Essock and Schweinhart [48] have shown, artists depicting a particular scene largely reproduce this bias (as well as the bias for vertically oriented edges and contours, e.g., trees), in comparison to contrast energy at oblique orientations, though they found that this bias also existed in high spatial frequencies in art. This finding is consistent with our knowledge of visual system processing of scenes, which is likewise biased in terms of spatial filter orientations (e.g., [49]). Beyond the Fourier domain, edges and contours in general do show lower biases (i.e., lower orientation anisotropies) in artwork than in scenes but the differences are small and depend on image content [47].

We can explain these findings because artwork is designed for viewing by the eye, and therefore its structure is constrained by the properties of the world and by the evolved visual processing strategies that operate in that world. Consider an unnatural image: white noise. Humans have almost never sought to make such images by hand, which lack pairwise correlations [50]. In a white noise image, like Fig. 2, all pairs of points—regardless of their separation—have the same average correlation in intensity. Because neural mechanisms such as center-surround

Fig. 2 White noise patterns. Each pixel has been assigned a random intensity in these images. Thus, there is no average spatial correlation between pixel values. In contrast, natural scenes possess strong correlations between pixels, which fall off as a function of the distance separating the pixels. The lack of such regularities makes images very difficult to perceive, as in the white noise. For example, are these two images the same or different? The answer would be immediately obvious for almost any pair of natural scenes but is challenging for images lacking spatial correlations. (Answer: the two images are identical but the right image has been rotated by 90 degrees). Images by Daniel Graham

receptive field organization in the retina instantiate this and other assumptions of statistical regularities [51, 52], and because these neurons serve largely to feed the brain information about local deviations from natural scene regularities [52], the brain struggles to process such images. They are consequently "imperceptible" [50].

6 Visual Dysfunction in Schizophrenia

Given basic regularities in scenes and artwork, as well as neural systems adapted to such regularities, how might disease-related visual dysfunction affect these relationships? Visual dysfunction in schizophrenia has been observed at least since Kraepelin [53–55]). In recent years, psychiatrists, psychologists and neuroscientists have increasingly focused on the visual dimension of the disorder using modern neuroscientific tools. Though visual hallucinations have long been associated with the disorder, occurring in about 25–30% of patients, more subtle visual dysfunctions and their neural underpinnings have been increasingly demonstrated.

One of the most striking observations as to the importance of visual processes in schizophrenia is that very few, if any, congenitally blind or early blind persons have been recorded as having schizophrenia, with this inverse relationship being particularly strong in cases of cortical (vs. eye-related) blindness [56–58]. There is evidence that this potentially protective trait is specific to schizophrenia, and that other forms of sensory loss do not confer a protective effect against schizophrenia (and may actually increase risk, as in the case of deafness; [56, 59, 60]). One explanation for this could be that functional reorganization in the brain due to congenital/early (C/E) blindness augments specific perceptual and cognitive skills, in which deficits develop in schizophrenia, thereby reducing risk for developing psychosis. For example, C/E blind people show recruitment of visual cortex regions for somatosensory and auditory processing, which seems to correspond to enhanced performance of tasks involving touch, sound localization, speech discrimination, and other auditory tasks compared to controls (see e.g., [61]). In contrast, people with schizophrenia show lower average performance on sound localization and discrimination tasks compared to controls [56]. In those with C/E blindness, the recruitment of these areas for non-visual tasks may protect individuals from what might otherwise be core vision-related aspects of the disorder. It may be that without vision, there can be no visual dysfunction, and perhaps no schizophrenia. While direct evidence of this from animal models is lacking, it is consistent with findings of increased visual cortex plasticity in dark-reared mice [62, 63], and with the theory that congenital blindness is associated with increases in NMDA receptor functioning [64], which is the opposite of what is typically found in schizophrenia [65–67].

In sighted people, however, schizophrenia-related visual dysfunction can be highly consequential. There is now substantial evidence that the neurochemical effects of the disorder alter basic spatial processing in the retina and dorsal thalamus. Importantly, these dysfunctions would change the basic spatial statistics of the visual world as represented in the visual system of someone with schizophrenia. The interesting question for present purposes is, are these changes reflected in artwork by people with schizophrenia? We will present recent evidence relating to this

question. Importantly, by examining low-level statistical regularities common to the natural world, this work mitigates the possible conflation of violation of convention and effects of visual dysfunction.

What, then, is the evidence regarding basic visual dysfunctions in schizophrenia? Most (but not all) studies of contrast sensitivity show deficits among people with schizophrenia ([68–71]; see [54, 55] for a review). This means that, compared to control participants, people with schizophrenia require a larger difference in luminance between two adjacent image patches in order to detect a perceptual difference from uniformity. Deficits have been shown behaviorally using grating detection tasks [68, 72] and grating discrimination tasks [73], as well as with electrophysiological [68, 74–77], and fMRI approaches [78–80]. Studies have generally found greater deficits at low spatial frequencies (large-scale image structure; [68, 69, 71–73, 75]). Others have shown deficits across a wider range of spatial frequencies including lower and higher frequencies [70, 73, 81, 82]. However, the picture is further complicated by effects of medication, which are not fully understood. Data from unmedicated first-episode patients have shown enhanced contrast sensitivity, whereas data from people with more years of being ill (whether medicated or not) show reduced contrast sensitivity [54, 55]. In any case, contrast processing deficits appear related to specific neuro-biochemical dysfunctions [68, 74, 78], although again in complex ways [54, 55].

What can these deficits tell us about art making? Interestingly, compared to controls, contrast processing deficits have been shown to be greater at higher luminance levels, i.e. well above absolute luminance thresholds [70]. Since most natural vision is also suprathreshold, this suggests that these deficits may be more than just a laboratory curiosity, and in fact would impact patients in most natural situations. These deficits might be especially salient in art making because making a representational work requires not only careful observation of light and contrast in a scene but also on the canvas, and indeed of the relationships between the canvas and the scene. And even when there is no referent tableau, the canvas itself must be highly scrutinized using spatial vision.

To complement laboratory studies of visual performance on spatial frequency detection tasks in patients (and models of neural underpinnings of performance differences), researchers have studied visual artwork by people with schizophrenia as a window into their naturalistic visual experiences. To the extent that art by people with schizophrenia differs systematically from art more generally, the question arises of whether we can possibly explain such differences in terms of low-level statistics of contrast in artwork.

7 Using Knowledge of Visual Deficits and Image Statistical Measures to Study Visual Art Making in Schizophrenia

Graham and Meng [83] first studied potential effects of contrast sensitivity deficits in schizophrenia on art making. They measured the spatial frequency amplitude spectrum of digitized images, where amplitude corresponds to contrast at a given

spatial frequency, averaged across orientations. They collected 12 high-resolution images of paintings by people with schizophrenia in the NARSAD Artworks collection. In addition, they studied a corpus of 39 works by an artist with schizoaffective disorder, Karen Sorenson. Both sets showed average spatial frequency amplitude spectra that fell as $1/f^p$. However, the slopes of the spectra were significantly steeper (more negative value of p) compared to a corpus of Western painting (Fig. 1). This implies that artists with schizophrenia compensate for lower contrast sensitivity at low spatial frequencies by increasing contrast energy in this range in particular. At the same time, other basic image statistics did not show consistent patterns of difference between the artists with schizophrenia and controls. For example, pixel intensity variance, which is related to total contrast energy, was not significantly different between the schizophrenia and control groups. Graham and Meng [83] also asked if there were differences in terms of anisotropies in edge orientation: these would not be expected since proposed neurochemical and neurodynamic models of spatial frequency deficits do not predict biases of deficits in terms of orientation. Supporting this hypothesis, they found that the image sets did not show significant differences in overemphasis of edges and contours at particular 2D orientations. Instead, the schizophrenia and control groups both largely recapitulated statistical biases for horizontal and vertical orientations found in natural scenes (see Table 1) (Fig. 3).

As with the study of contrast sensitivity deficits, an important question in the analysis of artwork by people with schizophrenia is again the effect of medication. In Graham and Meng's [83] study, measurements across the corpus of the artist with schizoaffective disorder (Karen Sorenson) also allowed analysis of the influence of medication since the artist recorded the medication being taken during the production of each work. Graham and Meng [83] did not find differences in amplitude spectrum slope across paintings made during treatment with four different antipsychotic medications. Because Sorenson maintained consistent medication during this time, a comparison with no medication was not possible; in fact, Sorenson reports that she takes medication largely to provide the energy and focus needed for art making [84]. In any case, longitudinal studies are needed that examine large samples of artists with schizophrenia over time at different chlorpromazine (or

Table 1 Mean statistics by image class, with standard error in parentheses

Image set	Amplitude spectrum slope	Anisotropy index	Pixel intensity mean	Pixel intensity variance	Pixel intensity skewness	Pixel intensity kurtosis
Artists with Schizophrenia	−1.421* (0.045)	0.307 (0.006)	150.8* (7.3)	2386.3 (199.2)	−0.063 (0.163)	−0.410 (0.278)
Sorenson paintings	−1.425* (0.017)	0.293 (0.001)	109.3* (6.3)	2824.7 (220.4)	0.466 (0.137)	−0.071* (0.194)
Control group	−1.229 (0.014)	0.302 (0.002)	119.6 (3.5)	2464.5 (150.5)	0.046 (0.096)	1.054 (0.25)

*indicates significant differences ($p < 0.05$) in these statistics compared with the control group, calculated according to a two-sample t-test

Data from Ref. [83]. CC-BY

-1.16 -1.26 -1.29 -1.31

-1.38 -1.38 -1.47 -1.49

-1.49 -1.52 -1.56 -1.74

Fig. 3 Portions of the paintings by artists with schizophrenia analyzed in this study, shown with calculated amplitude spectrum slopes. From Graham and Meng [83]. CC-BY

olanzapine) equivalent doses of medication, and on and off medication, as well as at different phases of illness (e.g., prodromal, acute, stabilization, stable; see discussion of Louis Wain, below).

Redies and colleagues [85] performed a similar analysis on a larger data set comparing spatial frequency spectrum slope for 14 artists diagnosed with or presumed to have schizophrenia whose work is included in the Prinzhorn collection (see Fig. 4). These images were compared to large samples of Western art. They measured the spatial frequency power spectrum, which is the square of the amplitude spectrum, which falls with a slope of about −2 for natural scenes. As with Graham and Meng [83], Henemann et al. [85] compared the mean slope for the schizophrenia group to that of several corpora of Western artwork. These control works were organized into separate sets of media (graphic and painted works), and the type of medium does seem to affect this analysis. They found that the schizophrenia group had amplitude spectrum slopes that were significantly steeper (increased contrast energy in large-scale structure) than the control sample of graphic art (drawings, lithographs, etc.). On the other hand, the slope of the schizophrenia group was significantly shallower (increased contrast energy in fine detail) than that for the Western paintings (a grouping that did not include graphic works). However, unlike

Fig. 4 Images by an artist with schizophrenia, Paul Goesch, from the Prinzhorn Collection, which were among those tested by Henemann et al. [85]. The Fourier power spectrum slope of these images (labeled a-f) is shown in the accompanying plot along the horizontal axis (vertical axis corresponds to the sigma for linear fits, indicating deviation from linearity). Red dots indicate other images by this artist. These can be compared to slopes for works by artists assumed not to have been affected by schizophrenia: pink dots indicate oil paintings; green dots indicate graphic art; and light blue dots indicate "Bad Art" (i.e., works deemed kitsch). Reproduced from Henemann et al. [85], CC-BY

Graham and Meng [83], the Henemann et al. [85] sample of schizophrenia works included both paintings and graphic works, as well as calligraphy. Thus, these results are somewhat ambiguous because of the effects of artistic media. Paintings overall have a lower (more negative) slope compared to graphic works, likely due to the inclusion of more shading and chiaroscuro in painted media. Because the proportion of paintings versus graphic works in the schizophrenia sample is not specified, it is hard to draw conclusions from these data. In addition, two of the artists had unknown diagnoses. Henemann et al. [85] did find significant differences in edge orientation biases (i.e. anisotropies in edge orientation energy) between the schizophrenia works and both graphic and painted Western art. However, these differences were small.

8 Repetition and Micrographia

Going back at least to Prinzhorn, observers have remarked on the repetitive, finely detailed elements of many artistic productions by people with schizophrenia. Are these visual traits characteristic of art by people with schizophrenia? There are a variety of hypotheses one could put forward.

Micrographia and repetitive marks would leave traces in spatial frequency spectra. A large area filled with small, ordered marks would boost relative amplitude of high spatial frequencies. All else being equal, this would lead to a flatter amplitude spectrum (p closer to zero). More generally, repetitive marks—especially grids of points—would boost specific spatial frequencies corresponding to the frequency of the grid. However, there was no evidence for this effect in Graham and Meng's [83] data, and it is not possible to discern if the effect was present in Henemann et al.'s [85] data due to confounds introduced by differences in media.

However, several other factors could be at play. In one view, repetition and micrographia may not be primarily related to visual dysfunction. The Prinzhorn collection artworks tested in the Henemann et al. [85] study were produced by institutionalized people, which could have contributed to repetitive elements and/or micrographia. This is because these artists may be more likely to use graphic media that are close at hand like pencil and crayon, rather than oil pigment, and these media facilitate creation of small marks as well as repetition, whereas paint is less conducive to such patterns since the brush needs to be loaded with pigment frequently. It is possible that repetitive imagery could be in part a side-effect of antipsychotic (dopamine D_1 and/or D_2 receptor antagonist) medication, which can cause Parkinson-like symptoms, including micrographia (small writing). However, examples of repetitive imagery such as Wölfli's predate the use of antipsychotic medications. It is also possible, however, that repetitive drawing/painting behavior could be due to excessive dopaminergic tone in the basal ganglia, and perseveration could be due to reduced frontal lobe dopaminergic activity [86], both of which have been observed in schizophrenia [8, 87, 88].

The possibility that contrast sensitivity deficits are broadly distributed across spatial frequency, rather than being limited to low spatial frequencies, may also be relevant. At suprathreshold levels [70]. contrast sensitivity deficits are of similar relative magnitude at low (0.5 cycles/degree), medium (4.5 cycles/degree) and high (11 cycles/degree) spatial frequencies (and at very short and longer presentation times). In this case, artists with schizophrenia may selectively boost contrast at low and/or higher spatial frequencies to make image structure visible to themselves, depending on the needs of the artwork: representing scenes may require boosting contrast at lower frequencies, while works that make use of fine detail could require boosting higher frequency contrast, in part with repetitive or grid-like patterns. In aggregate, these effects may cancel out. In any case, larger and more careful study of the effects of media and image content on art making in schizophrenia is warranted.

9 Perceptual Disorganization

Repetitive elements may also reflect a perceptual organization deficit leading to an excessive focus on detail at the expense of the whole/Gestalt. For example, relative to controls, schizophrenia patients, especially those with disorganized symptoms (e.g., fragmented thought and speech, unusual movements) have trouble integrating

separated contour segments into shape representations (reviewed in [89–91]). This implies that patients are less able to integrate image elements, especially across larger areas of space, into object representations a hypothesis that has been confirmed in an fMRI study of perceptual organization in schizophrenia [92]. Although artists with schizophrenia such as Wölfli show a clear ability to execute a composition across extended areas of space, there is often evidence of fragmentation and reduced integration within a given area of space.

These effects may contribute to altered representations of whole objects and scenes in art by people with schizophrenia. Subjective experience of this impairment can be seen in the following statements from patients (cited in [93, 94]): "I have to put things together in my head. If I look at my watch I see the watch, watchstrap, face, hands, and so on, then I have got to put them together to get it into one piece" [95]; and "For I saw the individual features of her face, separated from each other: the teeth, then the nose, then the cheeks, the one eye, and the other. Perhaps it was this independence of each part that inspired such fear and prevented my recognizing her even though I knew who she was" [96]. In the two images below, painted by the daughter (unknown diagnosis) of a mother with schizophrenia, fragmentation is seen in the form of what Jung [97] called "lines of fracture", which he believed revealed psychic "faults" that revealed severe alienation from feelings, and that were found in the art of people with schizophrenia and others (including Picasso) with similar issues of alienation from self and others (i.e., schizoid features). In our view, this type of fragmentation in the art of people with schizophrenia may also reflect a reduced perception of wholeness in faces and other objects, and therefore represent an attempt to express the feeling of fragmented perception and the sense of emotional distance it causes.[1] In schizophrenia, the experience of fragmentation in vision is also observed in scene perception, such as in this example: "I only saw fragments: a few people, a kiosk, a house. To be quite correct, I cannot say that I see all of that, because the objects seemed altered from the usual. They did not stand together in an overall context, I saw them as meaningless details." [98] (Fig. 5).

There are several potential sequelae of perceptual organization failures in people with schizophrenia that are also relevant to art production. One is that, as a result of the lack of an overall Gestalt, individual details in an object (or individual objects in a scene) may capture attention and become infused with excessive meaning. A second consequence is that the distinction between what is figure and what is ground can become unstable, leading to a sense of disorientation, and also heightening a focus on normally irrelevant details. The perceptual organization impairment is also found in moving stimuli. For example, medicated individuals with schizophrenia have higher thresholds for detecting coherent motion of random dot patterns [99].

[1] In some respects, the fragmentation observed in face portrayals of people with schizophrenia resembles the fragmentation seen in prosopagnosia, a more severe condition characterized by an inability to integrate facial features into a coherent whole. While we could not identify scientific studies of this issue, reports and examples of art of people with prosopagnosia have appeared in the popular literature, e.g., https://www.bbc.com/news/stories-53192821

Fig. 5 Examples of portraits showing lines of fracture, which Jung [97] believed were characteristic of artwork by people with schizoid features. Works of Irene Kleinman, 1909–1980. Collection of Steven M. Silverstein

Other visual changes in schizophrenia that also may affect art creation include changes in intensity of light and color, reduced perceptual stability, an increased tendency towards metamorphopsia (changes in object form, including the appearance of one's own body) and prosometamorphopsia (changes in the appearance of faces), distorted experiences of space (e.g., flatter, deeper), and increased abstraction, among others (reviewed in [93, 94]). These perceptual changes are often frightening, and are accompanied by subjective changes of meaningful alterations in the self or the world, emotional consequences which can also affect the artistic representation of the world (see also [100]).

Possible examples of these changes have been hypothesized to have occurred in the art of Louis Wain (1860–1939), who is famous for his drawings and paintings of cats (and the subject of the 2021 fictionalized biographical film *The Electrical Life of Louis Wain*). As seen in Fig. 6, there are striking qualitative differences between his renderings of cats from early in his career compared to later in his life, when he was diagnosed with schizophrenia and spent long periods of time in psychiatric hospitals. His later images demonstrate many features commonly associated with art, and perception, in people with schizophrenia. There is controversy, however, over whether Wain actually had schizophrenia [102, 103], and the extent to which his art reflected changes in his mental functioning vs. changes in artistic style over time (which occurred with many artists living during the same era, including Picasso, Braque, Klimt, etc.). This and similar demonstrations must be considered

Fig. 6 A realistic drawing of a cat from early in Louis Wain's career (top) and a series of drawings from later in his life while in psychiatric hospitals (bottom). The images in the bottom panel demonstrate hyperintensity in color, distortions of form, integration of figure and ground, increased abstraction and (in the last 3 images) emergence of mandala-like characteristics, which are often interpreted as compensatory efforts to preserve psychic stability [101]. Note that the chronological order of the images in the bottom panel is not known, nor is the degree to which the level of abstraction corresponds to levels of psychosis vs. remission over time. Top and bottom images are in the Public Domain

Fig. 6 (continued)

tentative, interesting, and suggestive, until research data is obtained on the relationships between these perceptual changes noted above and artistic works in people with schizophrenia.

Although the quality and generalizability of the evidence reviewed above varies greatly, several summary points can be extracted from the discussion. These include that: (1) there are a number of significant changes in visual perception that could be expected to affect visual artistic productions in people with schizophrenia; (2) at the same time, since there is no perceptual or cognitive impairment, or symptom, that is shared by all people with the disorder, there is no characteristic of visual art that should be expected to be present in the art of all people with the disorder; and (3) even in cases when between-group differences in perceptual (or other aspects of the disorder) signs and symptoms are present, there is significant overlap between groups [104]. Therefore, art by people with schizophrenia is not *sui generis*. Given this, one intriguing possibility is that the strength of the visual deficit in an individual might be positively correlated with the amount of statistical variation in their artwork, albeit in a way that may be moderated by media, current artistic trends, medication, illness phase, scene content, and other factors.

10 Visual Deficits and Art Appreciation

We briefly turn to the question of how visual deficits might affect the appreciation of art. Chen et al. [105] investigated schizophrenia patients' aesthetic judgments of two famous Western artworks and one natural landscape photograph after manipulation of basic image properties. The idea is that, if schizophrenia patients experience visual deficits, they should be less sensitive to manipulations of images that align with those deficits. If this were the case, one might conclude that people with schizophrenia are less able to appreciate a work of art since they are less sensitive to certain forms of variability. However, Chen et al. [105] found that the effects of visual deficits do not show strong evidence of manifesting in aesthetic responses: some manipulations showed marginally significant differences in aesthetic ratings between patients and controls. In particular, patients' decrements in ratings compared to unmodified art and landscape images were smaller for certain

manipulations (removal of color; high pass filtering; and polygonization, i.e., local averaging of pixel values in polygon regions). However, population response differences were slight in these cases and no differences were found for other manipulations (low pass filtering and white noise addition). There is also known to be high subjectivity (high baseline inter-rater disagreement in aesthetic judgments of images, especially art and abstract images; [106, 107]) and high intra-individual variability[108] in aesthetic preference judgments, along with a small cohort in the Chen et al. [105] study (29 patients and 30 controls). It is also likely that changes in art appreciation after the premorbid phase will be influenced by the current severity of symptoms and overall disease burden, in addition to the chronicity of the illness. Larger, more systematic studies will be needed to determine if and how art appreciation is affected by visual dysfunction.

11 The Question of "Generalized Deficits"

It has been suggested that tests for sensory and perceptual deficits in schizophrenia may be confounded by a "generalized deficit": patients' performance could be due to general difficulty with cognitive tasks, rather than a specific sensory or processing deficit [109, 110]. However, there is now ample evidence from experimental paradigms that control for these confounds that visual deficits are often independent of generalized deficits [111, 112] and that a number of them precede the onset of the diagnosis by many years [15, 113–115] and can be found in young people at high risk for the disorder. In terms of art making, the large output of some—but certainly not all—artists with schizophrenia also argues against the notion that "generalized deficits" in schizophrenia limit or preclude artistic output, given the large degree of cognitive performance (e.g., planning and attention) needed to produce a finished work.

In addition, there is evidence that visual dysfunction can generate "superior," i.e., more veridical, perception of 3-D stimuli that normally cause illusions, in people with schizophrenia compared to both normal controls and people with bipolar disorder [116]. People with schizophrenia also appear less susceptible to pareidolia, i.e. mistaking face-like patterns for actual faces [117]. These findings may in fact have interesting implications for art making. If people with schizophrenia are more able to perceive what is actually in the photoreceptor array (cf. [118])—rather than what prior knowledge and visual processing tell us *should* be there—this may help to explain apparent differences in their art.

Putting these findings together, we propose that artists with schizophrenia might be less reliant on matching the brain's expectations of scene layout and appearance, and instead be able to capture idiosyncrasies of scene structure. This ability may also mean that artists with schizophrenia can escape representational expectations imposed by artistic convention—even if they are trained artists, and even if their work is abstract—since the visual world they experience may be less biased by prior experience [119].

A tentative example of this representational approach might be shown in the painting The Fairy Feller's Master Stroke (1855–1864) by Richard Dadd (Fig. 7),

who suffered long periods of psychosis linked to schizophrenia (though other causes of his psychosis cannot be ruled out). This painting, unlike most Western representational art, includes naturalistic occlusions and conjunctions and it lacks highlights around contours. Typically, Western representational art avoids potentially confusing occlusions and conjunctions [120] and it often uses simultaneous contrast to

Fig. 7 *The Fairy Feller's Master Stroke* (1855–1864) by Richard Dadd. Dadd, who suffered long periods of psychosis, is notable for its contravention of certain types of representational strategies typical in Western art, which may be characteristic of psychosis. Public domain

bring out contours. These techniques promote readability of images and may align with predictive strategies of object perception in the brain [121]. But such representations differ from typical natural scenes. In defying conventions and expectations, Dadd captures something perhaps closer to raw, idiosyncratic scene data.

But to make the images visible to themselves, artists with schizophrenia may need to boost contrast energy beyond what would be needed in an artist without schizophrenia. When and how these alterations are introduced may be individualized and depend on both illness-related factors and scene content and media. It will be interesting to see if these effects can be disentangled. It has already been demonstrated, however, in a computational modeling study of schizophrenia, that reduced strength of retinal cell activity of the type found in patients (reviewed in [122]) could lead to compensatory increases, at the level of visual cortex, in perception of features such as contrast and brightness [93, 94].

12 Art Making in Schizophrenia: A Wider View and a Case Study

Though it is beyond the scope of this chapter to discuss in detail, artistic activities are today seen as a promising avenue for therapy in schizophrenia and other mental disorders (see, e.g [123]., for a large review of evidence). Yet as Prinzhorn argued, people with schizophrenia may wish to simply express themselves, and to do so outside of a therapeutic regimen.

Even in the grip of psychosis, artistic production may continue, albeit in rigid forms. The need for expression is indeed an important aspect of art making in schizophrenia, but one that is difficult to study empirically. It can be helpful to consider case studies such as that of Henry Cockburn, an artist with schizophrenia (see Fig. 8) who has documented his life and art in a book co-authored with his father, journalist Patrick Cockburn [125]. Their joint work sheds light on some aspects of art making in schizophrenia such as repetitive elements. In a subsequent article in the *Independent* newspaper, [124], Patrick writes:

When Henry was sunk deep in psychosis, he would draw what he called "a rune" – a sort of ideogram – again and again on a piece of paper. When he was slightly better, this would change to his tag or graffiti name again drawn time after time on different sheets of paper. The next step in his return to rationality was the gradual appearances of people, houses, streets, cities, trees and birds in his pictures.

A case study of this kind also helps psychiatrists and other practitioners, as well as the wider society, to understand how people with schizophrenia who create artwork wish to be viewed by society and understood as artists. As Henry [124] puts it,

When people ask me what my profession is I answer "I'm an artist". When people ask what my art is about, I say that it tells stories. Then when people ask what the stories are about I stumble.

Fig. 8 *Hunted* by Henry Cockburn [124]. Used with permission of the artist. http://www.henry-cockburn.com/paintings/

13 Cautions in Studying Art Making in Schizophrenia

It is crucial in this area of inquiry that we not read too much into artwork by people with schizophrenia as this has historically lead in dangerous directions. In 1818, a British magistrate sentenced Jonathan Martin to lifetime confinement in an asylum in large part based on the court's viewing of Martin's "strange drawings." Moreover, the notion of "degenerate art," and the need to destroy it, were amplified by the Nazi regime in the 1930s with devastating consequences (see [126]). Indeed, following Prinzhorn's death in 1933, the collection's new director, Carl Schneider, used it to attack modern German artists as "degenerate." Schneider soon helped launch the regime's infamous T4 program that murdered hundreds of thousands of German and Austrian psychiatric patients including thousands of children, and sterilized hundreds of thousands more [127]. No study of art making in schizophrenia should be undertaken without serious consideration of this dark history or of the possibility of unintended stigmatization of those with the disorder resulting from such research.

14 Outlook

We have seen how vision science can inform cautious research into art making processes and their interplay with neural processing mechanisms in the visual system. The goal is to leave aside high-level interpretations of the content of artwork by people with schizophrenia and instead focus on basic visual structure relevant to natural human vision. If successful, we may gain greater insight into patients' natural experience of the illness as well as putative group-level differences in their patterns of art making. Further study is needed and will have the benefit of building on studies of basic statistical regularities in visual artwork created by people with schizophrenia.

Indeed, much remains unknown. How might other statistical regularities in artwork be affected by visual deficits? For example, all artists must compress the large range of luminances in a scene down to the far smaller dynamic range available in flat media with pigments [128]. This compression serves to make luminance distributions more Gaussian and less skewed. Though Graham and Meng [83] found no significant differences in pixel intensity skewness between controls and artists with schizophrenia, the images were not calibrated for luminance. It is important to determine the degree of covariation between between heightened affect and increased sensitivity to certain visual features such as color, contrast, (implied) motion, or high spatial frequencies, and conversely, between reduced affect or sad mood and reduced perception of these same features, as has been preliminarily observed in patients with major depressive disorder [129, 130]. Covariation of perceptual sensitivities, or degrees of compensation, with level of psychosis is another important an unexplored issue.

One method in vision science research that has recently been applied with increasing success to the study of visual art is the study of color statistics. This approach exploits new hyperspectral imaging systems that measure reflected wavelengths in many narrow bands, rather than in three sensors with overlapping sensitivity, as in standard imaging systems. A series of studies by Nascimento and colleagues has shown that artists statistically match viewers' expectations of color use across a canvas [131–134]. For example, Nascimento et al. [133] gave observers the opportunity to shift color palettes of abstract paintings systematically through a perceptually uniform color space, starting from an image with a randomly-shifted gamut (derived from hyperspectral images). After performing "gamut rotations," observers came close to matching the original color relationships of the painting (a similar result has been obtained for natural images; [135]). This result holds even when pixels are scrambled [136]. Interestingly, people with schizophrenia have been reported to have higher incidence of color vision deficiencies compared to the larger population [137] and patient reports of distortions of color perception are common [138]. There is evidence that color deficiencies are in general relatively subtle and idiosyncratic in schizophrenia, and partly due to medication ([139]; see also [140]). In addition, there is evidence for disturbances in cone photoreceptor function in people at increased genetic risk for schizophrenia [113, 141]. In principle it should be possible to link color vision deficits with differences in color

palettes used in artwork (as measured with hyperspectral imaging) to further clarify this issue.

With further study, we may ultimately be able to determine the extent to which alterations in visual art by people with schizophrenia relative to unaffected individuals reflect low level visual deficits as opposed to cumulative effects of low- and high-level deficits, possibly in combination with motor dysfunctions [142]. It will also be necessary to disentangle effects of medication.

Finally, and more generally, we would like to know what influences the proclivity of people with schizophrenia to make art in the first place. Data indicating an over-representation of people with schizophrenia (as well as people with bipolar and major depressive disorder) among artists has led to speculations that the perceptual and conceptual differences associated with these disorders are linked genetically to creativity [20]. If this is true, an important issue is how this trait would survive throughout evolution since most people with schizophrenia (especially men) don't have children. It has been proposed that at least some of the genes/alleles that predispose to schizophrenia allow people to perceive, structure, and conceptualize the world differently than others, and this can lead to being great artists, inventors, and other types of innovators, a status associated with increased mating opportunities. However, excessive expression of these genes (perhaps due to epigenetic factors) and/or too many of the schizophrenia-related alleles can be disabling when they create the syndrome we call schizophrenia, thereby reducing mating opportunities [18, 19]. A related line of thought suggests that personality traits such as high openness may promote creative behavior when paired with other traits. To the extent that these traits are relatively abundant in schizophrenia, they may help explain apparent evolutionary survival of creative enhancement in the disorder [143, 144].

Acknowledgments Thanks to Ed Vessel, David Field, and Anjan Chatterjee for helpful suggestions.

References

1. McLean D, Thara R, John S, Barrett R, Loa P, McGrath J, Mowry B. DSM-IV "criterion A" schizophrenia symptoms across ethnically different populations: evidence for differing psychotic symptom content or structural organization? Cult Med Psychiatry. 2014;38(3):408–26. https://doi.org/10.1007/s11013-014-9385-8. PMID: 24981830; PMCID: PMC4140994.
2. Bhugra D. The Global Prevalence of Schizophrenia. PLoS Med. 2005;2(5):e151. https://doi.org/10.1371/journal.pmed.0020151.
3. Roy B, Shah A, Bloomgren G, Wenten M, Li J, Lally C. Disease Prevalence, Comorbid Conditions, and Medication Utilization Among Patients with Schizophrenia in the United States. CNS Spectr. 2021;26(2):157. https://doi.org/10.1017/S1092852920002515. PMID: 34127114
4. Saha S, Chant D, Welham J, McGrath J. A Systematic Review of the Prevalence of Schizophrenia. PLoS Med. 2005;2(5):e141. https://doi.org/10.1371/journal.pmed.0020141.
5. Gejman PV, Sanders AR, Duan J. The role of genetics in the etiology of schizophrenia. Psychiatr Clin North Am. 2010;33(1):35–66. https://doi.org/10.1016/j.psc.2009.12.003.

6. Srivastava A, Dada O, Qian J, Al-Chalabi N, Fatemi AB, Gerretsen P, Graff A, De Luca V. Epigenetics of Schizophrenia. Psychiatry Res. 2021;305:114218. https://doi.org/10.1016/j.psychres.2021.114218. Epub ahead of print. PMID: 34638051

7. McCutcheon RA, Krystal JH, Howes OD. Dopamine and glutamate in schizophrenia: biology, symptoms and treatment. World Psychiatry. 2020;19(1):15–33. https://doi.org/10.1002/wps.20693. PMID: 31922684; PMCID: PMC6953551.

8. Slifstein M, van de Giessen E, Van Snellenberg J, Thompson JL, Narendran R, Gil R, Hackett E, Girgis R, Ojeil N, Moore H, D'Souza D, Malison RT, Huang Y, Lim K, Nabulsi N, Carson RE, Lieberman JA, Abi-Dargham A. Deficits in prefrontal cortical and extrastriatal dopamine release in schizophrenia: a positron emission tomographic functional magnetic resonance imaging study. JAMA Psychiat. 2015;72(4):316–24. https://doi.org/10.1001/jamapsychiatry.2014.2414. PMID: 25651194; PMCID: PMC4768742.

9. Schmidt MJ, Mirnics K. Neurodevelopment, GABA system dysfunction, and schizophrenia. Neuropsychopharmacology. 2015;40(1):190–206. https://doi.org/10.1038/npp.2014.95. Epub 2014 Apr 24. PMID: 24759129; PMCID: PMC4262918.

10. Tani M, Akashi N, Hori K, Konishi K, Kitajima Y, Tomioka H, Inamoto A, Hirata A, Tomita A, Koganemaru T, Takahashi A, Hachisu M. Anticholinergic Activity and Schizophrenia. Neurodegener Dis. 2015;15(3):168–74. https://doi.org/10.1159/000381523. Epub 2015 Jun 30. PMID: 26138495.

11. Hu W, Chen Z. The roles of histamine and its receptor ligands in central nervous system disorders: An update. Pharmacol Ther. 2017;175:116–32. https://doi.org/10.1016/j.pharmthera.2017.02.039. Epub 2017 Feb 20. PMID: 28223162

12. Hanson DR, Gottesman II. Theories of schizophrenia: a genetic-inflammatory-vascular synthesis. BMC Med Genet. 2005;11(6):7. https://doi.org/10.1186/1471-2350-6-7. PMID: 15707482; PMCID: PMC554096

13. Moises HW, Wollschläger D, Binder H. Functional genomics indicate that schizophrenia may be an adult vascular-ischemic disorder. Transl Psychiatry. 2015;5(8):e616. https://doi.org/10.1038/tp.2015.103. PMID: 26261884; PMCID: PMC4564558

14. Little JD. Schizophrenia: a multi-system disorder? Aust N Z J Psychiatry. 2015;49(4):390. https://doi.org/10.1177/0004867415573058. Epub 2015 Feb 17. PMID: 25690748

15. Silverstein SM, Lai A, Green KM, Crosta C, Fradkin SI, Ramchandran RS. Retinal Microvasculature in Schizophrenia. Eye Brain. 2021a;24(13):205–17. https://doi.org/10.2147/EB.S317186. PMID: 34335068; PMCID: PMC8318708

16. Correll CU, Robinson DG, Schooler NR, Brunette MF, Mueser KT, Rosenheck RA, Marcy P, Addington J, Estroff SE, Robinson J, Penn DL, Azrin S, Goldstein A, Severe J, Heinssen R, Kane JM. Cardiometabolic risk in patients with first-episode schizophrenia spectrum disorders: baseline results from the RAISE-ETP study. JAMA Psychiat. 2014;71(12):1350–63. https://doi.org/10.1001/jamapsychiatry.2014.1314. PMID: 25321337

17. Kritharides L, Chow V, Lambert TJ. Cardiovascular disease in patients with schizophrenia. Med J Aust. 2017;206(2):91–5. https://doi.org/10.5694/mja16.00650. PMID: 28152356

18. Burns JK. An evolutionary theory of schizophrenia: cortical connectivity, metarepresentation, and the social brain. Behav Brain Sci. 2004;27(6):831–55. https://doi.org/10.1017/s0140525x04000196. discussion 855-85. PMID: 16035403

19. Giotakos O. Persistence of psychosis in the population: The cost and the price for humanity. Psychiatriki. 2018;29(4):316–26. https://doi.org/10.22365/jpsych.2018.294.316. PMID: 30814041

20. MacCabe JH, Sariaslan A, Almqvist C, Lichtenstein P, Larsson H, Kyaga S. Artistic creativity and risk for schizophrenia, bipolar disorder and unipolar depression: a Swedish population-based case–control study and sib-pair analysis. Br J Psychiatry. 2018;212(6):370–6.

21. Acar S, Chen X, Cayirdag N. Schizophrenia and creativity: A meta-analytic review. Schizophr Res. 2018;195:23–31. https://doi.org/10.1016/j.schres.2017.08.036. Epub 2017 Sep 1. PMID: 28867517.

22. Rennert H. Die "vertikale Blickwinkelverschiebung" in der schizophrenen Bildnerei. Ein Beitrag zur Problematik der Raumabbildungsanomalien ["Vertical displacement of the visual

angle" in schizophrenic creative art. Spatial conception anomalies]. Psychiatr Neurol Med Psychol (Leipz). 1969;21(9):325–9. PMID: 5363121

23. Burch GSJ, Pavelis C, Hemsley DR, Corr PJ. Schizotypy and creativity in visual artists. Br J Psychol. 2006;97(2):177–90.

24. Degmečić D. Schizophrenia and creativity. Psychiatr Danub. 2018;30(Suppl 4):224–7. PMID: 29864764

25. Bleuler E. Dementia praecox oder Gruppe der Schizophrenien, vol. 4. Deuticke; 1911.

26. Peiry L. L'Art Brut. Paris: Flammarion; 1997.

27. Morgenthaler W. Ein Geisteskranker als Künstler. E. Bircher; 1921.

28. Prinzhorn H. Artistry of the Mentally Ill. New York: Springer; 1922/1972.

29. Goldwater R. Primitivism in modern art. Harvard University Press; 1938/2013.

30. Skov M, Nadal M. A farewell to art: Aesthetics as a topic in psychology and neuroscience. Perspect Psychol Sci. 2020;15(3):630–42.

31. Graham DJ, Field DJ. Global nonlinear compression of natural luminances in painted art. In Computer image analysis in the study of art, vol. 6810. International Society for Optics and Photonics; 2008a. p. 68100K.

32. Graham DJ, Field DJ. Variations in intensity statistics for representational and abstract art, and for art from the eastern and western hemispheres. Perception. 2008b;37:1341–52.

33. Schweinhart AM, Essock EA. Structural content in paintings: artists overregularize oriented content of paintings relative to the typical natural scene bias. Perception. 2013;42(12):1311–32.

34. Graham DJ, Field DJ. Natural images: coding efficiency. In: Squire LR, editor. Encyclopedia of Neuroscience, vol. VI. Oxford: Academic; 2009. p. 19–27.

35. Cho H, Gonzalez R, Lavaysse LM, Pence S, Fulford D, Gard DE. Do people with schizophrenia experience more negative emotion and less positive emotion in their daily lives? A meta-analysis of experience sampling studies. Schizophr Res. 2017;183:49–55. https://doi.org/10.1016/j.schres.2016.11.016. Epub 2016 Nov 21. PMID: 27881233.

36. Solovay MR, Shenton ME, Holzman PS. Comparative studies of thought disorders. I. Mania and schizophrenia. Arch Gen Psychiatry. 1987;44(1):13–20. https://doi.org/10.1001/archpsyc.1987.01800130015003. PMID: 3800579

37. Crider A. Perseveration in schizophrenia. Schizophr Bull. 1997;23(1):63–74. https://doi.org/10.1093/schbul/23.1.63. PMID: 9050113.

38. Sack AT, van de Ven VG, Etschenberg S, Schatz D, Linden DE. Enhanced vividness of mental imagery as a trait marker of schizophrenia? Schizophr Bull. 2005;31(1):97–104. https://doi.org/10.1093/schbul/sbi011. Epub 2005 Jan 31. PMID: 15888429.

39. Anticevic A, Gancsos M, Murray JD, Repovs G, Driesen NR, Ennis DJ, Niciu MJ, Morgan PT, Surti TS, Bloch MH, Ramani R, Smith MA, Wang XJ, Krystal JH, Corlett PR. NMDA receptor function in large-scale anticorrelated neural systems with implications for cognition and schizophrenia. Proc Natl Acad Sci U S A. 2012;109(41):16720–5. https://doi.org/10.1073/pnas.1208494109. Epub 2012 Sep 25. PMID: 23012427; PMCID: PMC3478611.

40. Silverstein SM, Lai A. The Phenomenology and neurobiology of visual distortions and hallucinations in schizophrenia: an update. Front Psych. 2021;11(12):684720. https://doi.org/10.3389/fpsyt.2021.684720. PMID: 34177665; PMCID: PMC8226016.

41. Sass LA. Self-disturbance and schizophrenia: structure, specificity, pathogenesis (Current issues, New directions). Schizophr Res. 2014;152(1):5–11. https://doi.org/10.1016/j.schres.2013.05.017. Epub 2013 Jun 14. PMID: 23773296.

42. Sass LA, Parnas J. Schizophrenia, consciousness, and the self. Schizophr Bull. 2003;29(3):427–44. https://doi.org/10.1093/oxfordjournals.schbul.a007017. PMID: 14609238.

43. Sheffield JM, Karcher NR, Barch DM. Cognitive Deficits in Psychotic Disorders: A Lifespan Perspective. Neuropsychol Rev. 2018;28(4):509–33. https://doi.org/10.1007/s11065-018-9388-2. Epub 2018 Oct 20. PMID: 30343458; PMCID: PMC6475621.

44. Ford JM, Palzes VA, Roach BJ, Potkin SG, van Erp TG, Turner JA, Mueller BA, Calhoun VD, Voyvodic J, Belger A, Bustillo J, Vaidya JG, Preda A, Mc Ewen SC. Functional Imaging Biomedical Informatics Research Network, Mathalon DH. Visual hallucinations are associated

with hyperconnectivity between the amygdala and visual cortex in people with a diagnosis of schizophrenia. Schizophr Bull. 2015;41(1):223–32. https://doi.org/10.1093/schbul/sbu031. Epub 2014 Mar 11. PMID: 24619536; PMCID: PMC4266287

45. Graham DJ, Field DJ. Statistical regularities of art images and natural scenes: Spectra, sparseness and nonlinearities. Spat Vis. 2007;21:149–64.

46. Graham DJ, Redies C. Statistical regularities in art: Relations with visual coding and perception. Vis Res. 2010;50(16):1503–9.

47. Redies C, Amirshahi SA, Koch M, Denzler J. PHOG-derived aesthetic measures applied to color photographs of artworks, natural scenes and objects. In: European Conference on Computer Vision. Berlin; Heidelberg: Springer; 2012. p. 522–31

48. Essock EA, Schweinhart AM. Structural content in paintings ii: Artists commissioned to reproduce a specific image over-regularize orientation biases in their paintings. Perception. 2016;45(6):657–69.

49. Furmanski CS, Engel SA. An oblique effect in human primary visual cortex. Nat Neurosci. 2000;3(6):535–6.

50. Graham DJ. The use of visual statistical features in empirical aesthetics. In: Nadal M, Vartanian O, editors. Oxford Handbook of Empirical Aesthetics. Oxford: Oxford University Press; 2021. https://doi.org/10.1093/oxfordhb/9780198824350.013.19.

51. Atick JJ, Redlich AN. What does the retina know about natural scenes? Neural Comput. 1992;4(2):196–210.

52. Graham DJ, Chandler DM, Field DJ. Can the theory of "whitening" explain the center-surround properties of retinal ganglion cell receptive fields? Vis Res. 2006;46:2901–13.

53. Kraepelin E. Lehrbuch der Psychiatrie. 7th ed. Leipzig: Barth; 1903.

54. Silverstein SM. Visual perception disturbances in schizophrenia: a unified model. In: The neuropsychopathology of schizophrenia; 2016a. p. 77–132

55. Silverstein SM. Visual Perception Disturbances in Schizophrenia: A Unified Model. Neb Symp Motiv. 2016;63:77–132. https://doi.org/10.1007/978-3-319-30596-7_4. PMID: 27627825

56. Silverstein SM, Wang Y, Keane BP. Cognitive and neuroplasticity mechanisms by which congenital or early blindness may confer a protective effect against schizophrenia. Front Psychol. 2012;3:624. https://doi.org/10.3389/fpsyg.2012.00624. PMID: 23349646; PMCID: PMC3552473.

57. Leivada E, Boeckx C. Schizophrenia and cortical blindness: protective effects and implications for language. Front Hum Neurosci. 2014;28(8):940. https://doi.org/10.3389/fnhum.2014.00940. PMID: 25506321; PMCID: PMC4246684

58. Morgan VA, Clark M, Crewe J, Valuri G, Mackey DA, Badcock JC, Jablensky A. Congenital blindness is protective for schizophrenia and other psychotic illness. A whole-population study Schizophr Res. 2018;202:414–6. https://doi.org/10.1016/j.schres.2018.06.061. Epub 2018 Jul 7. PMID: 30539775

59. Landgraf S, Osterheider M. "To see or not to see: That is the question." The "Protection-Against- Schizophrenia" (PaSZ) model: Evidence from congenital blindness and visuocognitive aberrations. Front Psychol. 2013;4:352. https://doi.org/10.3389/fpsyg.2013.00352.

60. Silverstein SM, Rosen R. Schizophrenia and the eye. Schizophrenia Research: Cognition. 2015;2(2):46–55.

61. Merabet LB, Rizzo JF, Amedi A, Somers DC, Pascual-Leone A. What blindness can tell us about seeing again: merging neuroplasticity and neuroprostheses. Nat Rev Neurosci. 2005;6(1):71–7.

62. Chen WS, Bear MF. Activity-dependent regulation of NR2B translation contributes to metaplasticity in mouse visual cortex. Neuropharmacology. 2007;52:200–14.

63. Chen Q, He S, Hu XL, Yu J, Zhou Y, Zheng J, et al. Differential roles of NR2A-and NR2B-containing NMDA receptors in activity-dependent brain-derived neurotrophic factor gene regulation and limbic epileptogenesis. J Neurosci. 2007;27:542–52.

64. Sanders GS, Platek SM, Gallup GG. No blind schizophrenics: are NMDA-receptor dynamics involved? Behav Brain Sci. 2003;26:103.

65. Balu DT. The NMDA Receptor and Schizophrenia: from pathophysiology to treatment. Adv Pharmacol. 2016;76:351–82. https://doi.org/10.1016/bs.apha.2016.01.006. Epub 2016 Mar 4. PMID: 27288082; PMCID: PMC5518924.
66. Olney JW, Farber NB. Glutamate receptor dysfunction and schizophrenia. Arch Gen Psychiatry. 1995;52(12):998–1007. https://doi.org/10.1001/archpsyc.1995.03950240016004. PMID: 7492260
67. Phillips WA, Silverstein SM. Convergence of biological and psychological perspectives on cognitive coordination in schizophrenia. Behav Brain Sci. 2003;26(1):65–82. https://doi.org/10.1017/s0140525x03000025. discussion 82-137, PMID: 14598440.
68. Butler PD, Zemon V, Schechter I, Saperstein AM, Hoptman MJ, Lim KO. Early-stage visual processing and cortical amplification deficits in schizophrenia. Arch Gen Psychiatry. 2005;62:495–504. https://doi.org/10.1001/archpsyc.62.5.495.
69. Keri S. The magnocellular pathway and schizophrenia. Vis Res. 2008;48:1181–2. https://doi.org/10.1016/j.visres.2007.11.021.
70. Qian N, Lipkin RM, Kaszowska A, Silipo G, Dias EC, Butler PD, Javitt DC. Computational modeling of excitatory/inhibitory balance impairments in schizophrenia. Schizophr Res. 2020; https://doi.org/10.1016/j.schres.2020.03.027.
71. Slaghuis WL. Contrast sensitivity for stationary and drifting spatial frequency gratings in positive- and negative-symptom schizophrenia. J Abnormal Psychol. 1998;107:49–62.
72. Butler PD, Javitt DC. Early-stage visual processing deficits in schizophrenia. Curr Op Psychiatry. 2005;18:151–7.
73. O'Donnell BF, Potts GF, Nestor PG, Stylianopoulos KC, Shenton ME, McCarley RW. Spatial frequency discrimination in schizophrenia. J Abnorm Psychol. 2002;111(4):620.
74. Butler PD, Martinez A, Foxe JJ, Kim D, Zemon V, Silipo G, et al. Subcortical visual dysfunction in schizophrenia drives secondary cortical impairments. Brain. 2007;130(2):417–30.
75. Dias EC, Butler PD, Hoptman MJ, Javitt DC. Early sensory contributions to contextual encoding deficits in schizophrenia. Arch Gen Psychiatry. 2011;68(7):654–64.
76. Schechter I, Butler PD, Zemon VM, Revheim N, Saperstein AM, Jalbrzikowski M, et al. Impairments in generation of early-stage transient visual evoked potentials to magno-and parvocellular-selective stimuli in schizophrenia. Clin Neurophysiol. 2005;116(9):2204–15.
77. Martínez A, Gaspar PA, Hillyard SA, Bickel S, Lakatos P, Dias EC, Javitt DC. Neural oscillatory deficits in schizophrenia predict behavioral and neurocognitive impairments. Front Hum Neurosci. 2015;9:371.
78. Martinez A, Hillyard SA, Dias EC, Hagler DJ Jr, Butler PD, Guilfoyle DN, Jalbrzikowski M, Silipo G, Javitt DC. Magnocellular pathway impairment in schizophrenia: evidence from functional magnetic resonance imaging. J Neurosci. 2008;28:7492–500. https://doi.org/10.1523/JNEUROSCI.1852-08.2008.
79. Martínez A, Hillyard SA, Bickel S, Dias EC, Butler PD, Javitt DC. Consequences of magnocellular dysfunction on processing attended information in schizophrenia. Cereb Cortex. 2012;22(6):1282–93.
80. Martínez A, Revheim N, Butler PD, Guilfoyle DN, Dias EC, Javitt DC. Impaired magnocellular/dorsal stream activation predicts impaired reading ability in schizophrenia. NeuroImage: Clinical. 2013;2:8–16.
81. Kiss I, Janka Z, Benedek G, Keri S. Spatial frequency processing in schizophrenia: Trait or state marker? J Abnorm Psychol (1965). 2006;115(3):636–8.
82. Skottun BC, Skoyles JR. Minireview: Contrast sensitivity and magnocellular functioning in schizophrenia. Vis Res. 2007;47:2923–33. https://doi.org/10.1016/j.visres.2007.07.016.
83. Graham D, Meng M. Altered spatial frequency content in paintings by artists with schizophrenia. i-Perception. 2011;2(1):1–9.
84. Sorenson K. Blog post of 10 March 2017. Ren Hang. http://karensearchformeaning.blogspot.com/. Retrieved 13 July 2021; 2017
85. Henemann GM, Brachmann A, Redies C. Statistical image Properties in Works from the Prinzhorn collection of artists with schizophrenia. Front Psych. 2017;8:273.

86. Ridley RM. The psychology of perserverative and stereotyped behaviour. Prog Neurobiol. 1994;44(2):221–31. https://doi.org/10.1016/0301-0082(94)90039-6. PMID: 7831478
87. Perez-Costas E, Melendez-Ferro M, Roberts RC. Basal ganglia pathology in schizophrenia: dopamine connections and anomalies. J Neurochem. 2010;113(2):287–302. https://doi.org/10.1111/j.1471-4159.2010.06604.x. Epub 2010 Jan 20. PMID: 20089137; PMCID: PMC2929831.
88. Weinstein JJ, Chohan MO, Slifstein M, Kegeles LS, Moore H, Abi-Dargham A. Pathway-specific dopamine abnormalities in Schizophrenia. Biol Psychiatry. 2017;81(1):31–42. https://doi.org/10.1016/j.biopsych.2016.03.2104. Epub 2016 Mar 31. PMID: 27206569; PMCID: PMC5177794
89. Silverstein SM, Kovacs I, Corry R, Valone C. Perceptual processing, the disorganization syndrome, and context processing in chronic schizophrenia. Schiz Res. 1999;43:11–20.
90. Silverstein SM, Keane BP. Perceptual organization impairment in schizophrenia and associated brain mechanisms: review of research from 2005 to 2010. Schizophr Bull. 2011;37(4):690–9. https://doi.org/10.1093/schbul/sbr052. PMID: 21700589; PMCID: PMC3122298.
91. Uhlhaas PJ, Silverstein SM. Perceptual organization in schizophrenia spectrum disorders: empirical research and theoretical implications. Psychol Bull. 2005;131(4):618–32. https://doi.org/10.1037/0033-2909.131.4.618. PMID: 16060805
92. Silverstein SM, Berten S, Essex B, Kovács I, Susmaras T, Little DM. An fMRI examination of visual integration in schizophrenia. J Integr Neurosci. 2009;8(2):175–202. https://doi.org/10.1142/s0219635209002113. PMID: 19618486
93. Silverstein SM, Demmin DL, Bednar JA. Computational Modeling of Contrast Sensitivity and Orientation Tuning in First-Episode and Chronic Schizophrenia. Comput Psychiatr. 2017;1(1):102–31. https://doi.org/10.1162/CPSY_a_00005. PMID: 30090855; PMCID: PMC6067832.
94. Silverstein SM, Demmin D, Skodlar B. Space and Objects: On the Phenomenology and Cognitive Neuroscience of Anomalous Perception in Schizophrenia (Ancillary Article to EAWE Domain 1). Psychopathology. 2017;50(1):60–7. https://doi.org/10.1159/000452493. Epub 2017 Jan 11. PMID: 28073112.
95. Chapman J. The early symptoms of schizophrenia. Br J Psychiatry. 1966;112:225–51.
96. Sèchehaye M. Autobiography of a Schizophrenic Girl. New York: Signet Books; 1970.
97. Jung CG. Jung's 1932 article on Picasso; 1932. Retrieved from http://web.org.uk/picasso/jung_article.html=
98. Matussek P. Studies in delusional perception, transl, condensed. In: Cutting J, Shepherd M, editors. Clinical Roots of the Schizophrenia Concept Translations of Seminal European Contributions on Schizophrenia. Cambridge: Cambridge University Press; 1987.
99. Chen Y, Nakayama K, Levy D, Matthysse S, Holzman P. Processing of global, but not local motion detection is deficient in schizophrenia. Schiz. Res. 2003;61:215–27.
100. Kandel ER. The disordered mind: What unusual brains tell us about ourselves. Hachette UK. 2018
101. Silverstein SM. Jung's views on causes and treatments of schizophrenia in light of current trends in cognitive neuroscience and psychotherapy research I. Aetiology and phenomenology. J Anal Psychol. 2014;59(1):98–129.
102. Fitzgerald M. Louis Wain and Asperger's Syndrome. Ir J Psychol Med. 2002;19(3):101.
103. McGennis A. Louis Wain: His life, his art and his mental illness. Ir J Psychol Med. 1999;16(1):27–8. https://doi.org/10.1017/S0790966700005000.
104. Walker E, Kestler L, Bollini A, Hochman KM. Schizophrenia: etiology and course. Ann Rev Psychol. 2004;55:401–30.
105. Chen Y, Norton D, McBain R. Can persons with schizophrenia appreciate visual art? Schizophr Res. 2008;105(1–3):245–51.
106. Vessel EA, Maurer N, Denker AH, Starr GG. Stronger shared taste for natural aesthetic domains than for artifacts of human culture. Cognition. 2018;179:121–31.
107. Vessel EA, Rubin N. Beauty and the beholder: Highly individual taste for abstract, but not real-world images. J Vis. 2010;10(2):18.

108. Pugach C, Leder H, Graham DJ. How stable are human aesthetic preferences across the lifespan? Front Hum Neurosci. 2017;11:289.
109. Chapman LJ, Chapman JP. The measurement of differential deficit. J Psychiatr Res. 1978;14(1–4):303–11.
110. Gershman SJ, Lai L. The reward-complexity trade-off in schizophrenia. bioRxiv. 2020.
111. Knight RA, Silverstein SM. A process-oriented approach for averting confounds resulting from general performance deficiencies in schizophrenia. J Abnorm Psychol. 2001;110(1):15.
112. Silverstein SM. Measuring specific, rather than generalized, cognitive deficits and maximizing between-group effect size in studies of cognition and cognitive change. Schizophr Bull. 2008;34(4):645–55.
113. Gagné AM, Moreau I, St-Amour I, Marquet P, Maziade M. Retinal function anomalies in young offspring at genetic risk of schizophrenia and mood disorder: The meaning for the illness pathophysiology. Schizophr Res. 2020;219:19–24. https://doi.org/10.1016/j.schres.2019.06.021. Epub 2019 Jul 15. PMID: 31320175
114. Mittal VA, Gupta T, Keane BP, Silverstein SM. Visual context processing dysfunctions in youth at high risk for psychosis: Resistance to the Ebbinghaus illusion and its symptom and social and role functioning correlates. J Abnorm Psychol. 2015;124(4):953–60. https://doi.org/10.1037/abn0000082. Epub 2015 Aug 3. PMID: 26237183; PMCID: PMC4658222.
115. Silverstein SM, Thompson JL, Gold JM, Schiffman J, Waltz JA, Williams TF, Zinbarg RE, Mittal VA, Ellman LM, Strauss GP, Walker EF, Woods SW, Levin JA, Kafadar E, Kenney J, Smith D, Powers AR, Corlett PR. Increased face detection responses on the mooney faces test in people at clinical high risk for psychosis. NPJ Schizophr. 2021b;7(1):26. https://doi.org/10.1038/s41537-021-00156-1. PMID: 34001909; PMCID: PMC8129098.
116. Keane BP, Silverstein SM, Wang Y, Roché MW, Papathomas TV. Seeing more clearly through psychosis: depth inversion illusions are normal in bipolar disorder but reduced in schizophrenia. Schizophr Res. 2016;176(2–3):485–92.
117. Rolf R, Sokolov AN, Rattay TW, Fallgatter AJ, Pavlova MA. Face pareidolia in schizophrenia. Schizophr Res. 2020;218:138–45.
118. Perdreau F, Cavanagh P. Do artists see their retinas? Front Hum Neurosci. 2011;5:171.
119. Deneve S, Jardri R. Circular inference: mistaken belief, misplaced trust. Curr Opin Behav Sci. 2016;11:40–8.
120. Gillam B. Occlusion issues in early Renaissance art. i-Perception. 2011;2(9):1076–97.
121. Zeki S. Art and the brain. J Conscious Stud. 1999;6(6–7):76–96.
122. Silverstein SM, Fradkin SI, Demmin DL. Schizophrenia and the retina: Towards a 2020 perspective. Schizophr Res. 2020;219:84–94. https://doi.org/10.1016/j.schres.2019.09.016. Epub 2019 Nov 7. PMID: 31708400; PMCID: PMC7202990.
123. Fancourt D, Finn S. What is the evidence on the role of the arts in improving health and wellbeing? A scoping review. Copenhagen: WHO Regional Office for Europe; (Health Evidence Network (HEN) synthesis report 67); 2019.
124. Cockburn PHC.. On Schizophrenia: Father and son discuss battling mental illness and the art it inspires; In the first of a three-part series, Patrick Cockburn and his son Henry, reflect on the trauma of schizophrenia Henry has experienced for the past 16 years - and how painting helped. Independent, The/The Independent on Sunday: Web Edition Articles (London, England); 2017.
125. Cockburn P, Cockburn H. Henry's demons: Living with schizophrenia, a father and son's story. Simon and Schuster; 2011.
126. MacGregor JM. The Discovery of the Art of the Insane. Princeton: Princeton University Press; 1992.
127. Tuffs A. Collection of artworks by psychiatric patients finds permanent home. BMJ. Br Med J. 2001;323(7315):712.
128. Graham DJ, Friedenberg JD, Rockmore DN. Efficient visual system processing of spatial and luminance statistics in representational and non-representational art. In: Proc. SPIE: human vision and electronic imaging 7240:72401N; 2009.

129. Bubl E, Kern E, Ebert D, Bach M. Tebartz van Elst L. Seeing gray when feeling blue? Depression can be measured in the eye of the diseased. Biol Psychiatry. 2010;68(2):205–8. https://doi.org/10.1016/j.biopsych.2010.02.009. Epub 2010 Mar 31. PMID: 20359698.
130. Bubl E, Ebert D, Kern E, van Elst LT, Bach M. Effect of antidepressive therapy on retinal contrast processing in depressive disorder. Br J Psychiatry. 2012;201:151–8. https://doi.org/10.1192/bjp.bp.111.100560. Epub 2012 Jun 14. PMID: 22700080.
131. Masuda O, Nascimento SM. Lighting spectrum to maximize colorfulness. Opt Lett. 2012;37(3):407–9.
132. Montagner C, Linhares JM, Vilarigues M, Nascimento SM. Statistics of colors in paintings and natural scenes. JOSA A. 2016;33(3):A170–7.
133. Nascimento SM, Linhares JM, Montagner C, João CA, Amano K, Alfaro C, Bailão A. The colors of paintings and viewers' preferences. Vis Res. 2017;130:76–84.
134. Nascimento SMC, Masuda O. Best lighting for visual appreciation of artistic paintings—experiments with real paintings and real illumination. JOSA A. 2014;31(4):A214–9.
135. Nascimento SM, Albers AM, Gegenfurtner KR. Naturalness and aesthetics of colors–Preference for color compositions perceived as natural. Vis Res. 2021;185:98–110.
136. Albers AM, Gegenfurtner KR, Nascimento SM. An independent contribution of colour to the aesthetic preference for paintings. Vis Res. 2020;177:109–17.
137. Hardy LH, Rand G, Rittler MC. Incidence of defective color vision among psychotic patients. Arch Ophthalmol. 1948;40(2):121–33.
138. Silverstein SM, Thompson JL. A vision science perspective on schizophrenia. Schizophrenia Research: Cognition. 2015;2(2):39.
139. Fernandes TMP, Silverstein SM, Butler PD, Kéri S, Santos LG, Nogueira RL, Santos NA. Color vision impairments in schizophrenia and the role of antipsychotic medication type. Schizophr Res. 2019;204:162–70.
140. Shuwairi SM, Cronin-Golomb A, McCarley RW, O'Donnell BF. Color discrimination in schizophrenia. Schizophr Res. 2002;55(1–2):197–204.
141. Hébert M, Gagné AM, Paradis ME, Jomphe V, Roy MA, Mérette C, Maziade M. Retinal response to light in young nonaffected offspring at high genetic risk of neuropsychiatric brain disorders. Biol Psychiatry. 2010;67(3):270–4. https://doi.org/10.1016/j.biopsych.2009.08.016. Epub 2009 Oct 14. PMID: 19833322
142. Hirjak D, Thomann PA, Kubera KM, Wolf ND, Sambataro F, Wolf RC. Motor dysfunction within the schizophrenia-spectrum: A dimensional step towards an underappreciated domain. Schizophr Res. 2015;169(1–3):217–33.
143. Kaufman SB, Paul ES. Creativity and schizophrenia spectrum disorders across the arts and sciences. Front Psychol. 2014;5:1145.
144. Miller GF, Tal IR. Schizotypy versus openness and intelligence as predictors of creativity. Schizophr Res. 2007;93(1–3):317–24.

Epilepsy and Autism as Disorders of Brain Connectivity and Their Link to Artistic Expression

Raluca Pana ⓘD

1 Introduction

Medicine was long considered a form of art. It is therefore not surprising that popular culture has often linked medical disorders to enhanced creativity and art production. All too often, this association pertained to neuropsychiatric disorders such as Alzheimer's disease, schizophrenia, autism spectrum disorder and epilepsy, many of which remain largely misunderstood.

In recent years, the use of an interdisciplinary approach combining mathematical concepts, such as graph theory and modern imaging techniques, has helped shed some light into the pathophysiology of some of these disorders [1–3]. There is growing consensus that the brain represents a complex system of interacting units [4]. This is based on observations that local brain pathology can have global impacts on cerebral function [4]. Different brain regions are thus connected functionally even to anatomically distant regions. Many neuropsychiatric disorders are thought to result from a disruption in this connectivity.

The cognitive processes underlying art production also implicate cerebral networks under normal circumstances [5, 6]. One therefore wonders how connectivity disorders impact creativity and whether these disorders enhance or inhibit artistic capabilities. In this chapter, epilepsy and autism are chosen to explore this relationship.

R. Pana (✉)
Department of Neurology and Neurosurgery, Faculty of Medicine, McGill University,
Montreal, QC, Canada
e-mail: raluca.pana@mcgill.ca

Epilepsy is classically defined by its main clinical manifestation, the seizure, which often causes transient alterations of consciousness followed by a gradual, but rapid return to normal cerebral function. Autism, on the other hand, is representative of neurodevelopmental disorders, manifesting with a continuous neuro-cognitive disturbance, with prominent deficits in communication and social behavior. Interestingly, these conditions occur independently but also frequently co-exist in the same individual [7]. Many patients suffering from epilepsy exhibit a certain degree of cognitive dysfunction even in the absence of seizures. Modern conceptualizations of epilepsy thus push the seizure out of focus, viewing it rather as a symptom of an underlying aberrant cerebral network. Hence, epilepsy and autism are likely more similar than previously thought, as both conditions can present with seizures and a range of neurocognitive symptoms that are manifestations of an underlying disorder of cerebral connectivity. Though much remains to be learnt about the link between these disorders and creativity, the available literature on the topic is reviewed here in the hopes of guiding future studies.

2 Section 1: Art and Epilepsy

The term "epilepsy" has its origin in Ancient Greece and means "to seize" or "to take hold of". It was often termed the "sacred disease" [8]. Over time, this disorder has been associated with demonic possession, religiosity and mythical processes and thus, it has been the subject of many artistic creations [8]. The treatment of epilepsy has even been portrayed in various works of art as the removal of the "stone of folly or lunacy," implying that patients suffering from epilepsy are peculiar (i.e., "lunacy" meaning "from the moon") or crazy [9]. Interestingly, there is a common perception that creative genius and psychopathology are characteristics defining many prominent artists, and that creativity itself could be a type of mild neurosis [10]. However, the literature substantiating the link between creative genius and epilepsy is scarce and mostly focused on famous artists who were thought to have suffered from epilepsy.

2.1 Famous Artists with Epilepsy

Notable examples of eminent artists with epilepsy include Vincent Van Gogh, Kyffin Williams, Charles Altamont Doyle, Edward Lear and Giorgio de Chirico [11]. Lear, Doyle, and Williams were painters and/or illustrators who were most likely diagnosed with epilepsy. Photographs and Self-portraits of select artists are shown in Figure 1 below.

Fig. 1 Famous painters with epilepsy. (**a**) Giorgio de Chirico. Portrait. Carl Van Vechten- Library of Congress LC-USZ62–42530 DLC (b&w film copy neg). https://upload.wikimedia.org/wikipedia/commons/e/e4/Giorgio_de_Chirico_%28portrait%29.jpg, accessed on November 28th, 2021. (**b**) Edward Lear. Photograph of 1866. Unknown author-Actia Nicopolis Foundation. Obtained from https://en.wikipedia.org/wiki/Edward_Lear#/media/File:Edward_Lear_1866.jpg, accessed on November 28th, 2021. (**c**) Vincent Van Gogh. self-portrait oil on canvas, September 1889. Art Institute of Chicago. Obtained from https://en.wikipedia.org/wiki/File:Vincent_van_Gogh_-_Self-Portrait__Google_Art_Project_(454045).jpg, accessed on November 28th, 2021

Lear often alluded to his condition in his diaries calling it the "demon," and the co-existing depression, the "morbids." It is thought he had an aura that allowed him to seek privacy before a seizure, later mentioning that he was pleased the "fits" never came to light, that he had "kept up as he had" and that he "had not gone utterly to the mad bad sad" [10]. Lear described some of his seizures as "cataleptic pauses," while others were violent, leaving him confused at times for over an hour. He was ashamed of his condition, and it is speculated he traveled to paint beautiful landscapes as a form of therapy [11].

The case of Vincent Van Gogh has been debated for many years with regards to the etiology of the attacks and declining mental health in the years preceding his death. Much of his work is thought to have been influenced by the treatment of his illness rather than the illness itself. The characteristic yellow halos in his paintings were possibly a reflection of xanthopsia, a known side effect of digitalis toxicity. It is generally accepted that his extraordinary skill as a painter was not a consequence of his illness, but rather that he was a genius despite his epilepsy [12].

Giorgio de Chirico, the Italian painter, is one of the rare artists who admitted to drawing inspiration from his paroxysmal neurological disorder to produce his work. Much debate exists over whether he suffered from episodic migraine or temporal lobe epilepsy [11]. He reported recurrent gustatory and visual hallucinations,

anxiety, fear and abdominal discomfort without a clear description of associated headache to suggest migraine. At times, de Chirico would report an impression of having previously seen his colleague's work, perhaps suggesting déjà-vu manifestations—another common symptom of temporal lobe epilepsy. He was also known to manifest recurrent periods of impaired consciousness, which followed the abdominal symptoms. Some argue that de Chirico had the typical personality traits associated with temporal lobe epilepsy and that it was the main influence on his metaphysical art [13]. The painter himself recognized he adopted the metaphysical style around the time when his neurological condition was most disruptive.

Though it cannot be said with any degree of certainty, it is generally thought that these artists' seizures did not serve as inspiration for their work. One could speculate that, as Lear himself admitted, a certain degree of shame was associated with the disorder. In fact, though there are many artistic depictions of epilepsy throughout the ages, these are often not performed by artists suffering from the illness, but rather by artists fascinated by the mystical connotation of the condition [8].

2.2 Art Portraying Epilepsy

The works of art depicting epilepsy through different eras, and thus reflecting the cultural perspectives on epilepsy at the time they were produced, is elegantly detailed in the reviews by Ladino and colleagues [8, 9]. One can see how the cultural perception of epilepsy fluctuates between a divine punishment for immorality or sin and a mere physical illness of the brain. Interestingly, the treatment of epilepsy with surgery has been depicted in works of art from ancient times up to the eighteenth century, regardless of whether the disorder was interpreted as demonic possession or a cerebral ailment. The surgical intervention often consisted of performing an opening in the skull, a technique known as "trepanning," allowing for the demons to escape in the first scenario, and in the second, to remove stones (possibly representing calcified tumors), as well as to address skull fractures. The Renaissance brought about depictions of epilepsy that were more focused on displaying the semiology of the seizures. Contemporary work has evolved even further, now presenting the impact of the condition on both the physical and psychosocial aspects of a person's life and conveying a more optimistic outlook. This progression is likely a reflection of scientific advances made in the treatment of epilepsy [8, 9].

Contemporary artists may thus be more likely to incorporate the experience of their epileptic condition into their art. Schacter has published several compilations of visual art produced by artists with epilepsy. He argues this work should be given much attention as it is a unique opportunity to gain insight into the patients' experience and therefore further guide our understanding of the disease. In his analysis, he noted the work could be classified into themes: artists either conveyed details of the seizure itself (ictal phase), the symptoms felt in the aftermath of the seizure (postictal phase) or the general social aspects of living with epilepsy. He also noted these artists produced beautiful art that had no apparent relationship to their epilepsy. The majority of the artwork fell into this last category [14]. Despite advances in our

understanding of epilepsy, much stigma and marginalization persist even today. More likely, however, artists with epilepsy are artists above all, and their medical condition does not define them.

Individuals with epilepsy can lead successful careers as artists, however, it is difficult to infer from what is presented above that epilepsy predisposes to increased artistic capabilities or creative genius. In addition, from a neuroscientific point of view, one does wonder how epilepsy and its treatment could impact artistic creation.

2.3 Type of Artistic Expression in Artists with Epilepsy

A noteworthy observation is the lack of famous musical composers or poets reported to have suffered from epilepsy in the literature. This was particularly apparent at a conference held in 2009, in Prague, about art and epilepsy, where different artforms serving as modes of expression for people with epilepsy were displayed. The use of music was noticeably absent [15]. This was re-iterated in a more recent review of the literature by Hesdorrfer and Trimble. The authors recognize that definite conclusions cannot be drawn as the literature detailing the relationship between neuropsychiatric illness and creativity available for review often fails to use modern terminology to define the illness or to describe specific artforms [10]. Moreover, women were disproportionally absent as a result of fewer published biographies. With this in mind, they identify Mussorgsky as a composer suffering from epilepsy, though they do note his seizures were most likely related to alcohol withdrawal. There were previous reports suggesting Handel, Beethoven, Schumann, Berlioz, Tchaikovsky, and Chopin had epilepsy, though this has since been refuted.

Hikari Oe, son of Nobel Prize laureate Kenzaburo Oe, is a contemporary composer known to have autism, visual impairment, and epilepsy. According to his father, Hikari Oe expresses himself best through musical composition. Interestingly, he has achieved this as a result of extraordinary creative capabilities, despite lacking in performance skill [10]. Stoker identified other music composers referring to epilepsy in their work. The most famous being Neil Percival Young. Though, once again, little of his work is thought to have been based on his experience with epilepsy. Interestingly, he composed an entire album reflecting his fear of death prior to a cerebral aneurysm surgery later in his life. Other modern artists that have publicly admitted to suffering from epilepsy include *Prince, Lil Wayne and Adam Horowitz*. Little is known about how or even if their condition influences their art. Though Stoker in his review mentions other musicians and composers with epilepsy, not all experienced the disorder firsthand, and one cannot draw any firm conclusions with regards to a predisposition to creative genius as a result of their condition [15]. Nevertheless, whether their work will endure to fascinate future generations, as the work of the painters mentioned above, remains to be seen.

The same observation can be made with regards to eminent poets who had epilepsy. Not surprisingly since several parallels can be drawn between music and poetic composition.

a

> How pleasant to know Mr. Lear!
> Who has written such volumes of stuff!
> Some think him ill-tempered and queer,
> But a few think him pleasant enough.
> His mind is concrete and fastidious,
> His nose is remarkably big
> His visage is more or less hideous,
> His beard it resembles a wig

b

> I felt a Funeral, in my Brain,
> And Mourners to and fro
> Kept treading—treading—till it seemed
> That Sense was breaking through—
> And when they all were seated,
> A Service, like a Drum—
> Kept beating—beating—till I thought
> My Mind was going numb—
> And then I heard them lift a Box
> And creak across my Soul
> With those same Boots of Lead, again,
> Then Space—began to toll,
> As all the Heavens were a Bell,
> And Being,but an Ear,
> And I, and Silence, some strange Race
> Wrecked, solitary, here—
> And then a Plank in Reason, broke,
> And I dropped down, and down—
> And hit a World, at every plunge,
> And Finished knowing—then—

Fig. 2 Examples of poetry by subjects with epilepsy. (**a**) Poem by Edward Lear describing his own personality. (**b**) Poem by Emily Dickinson describing a possible epileptic seizure both taken from Hesdoffer & Trimble 2016

George Byron and Algernon Charles Swinburne were identified as poets having suffered seizures at some point in their lives. However, these seizures were experienced in the context of a febrile illness in the former and were alcohol related in the latter. These would not meet criteria for epilepsy based on today's definitions. Other poets include Vachel Lindsay, Edward Lear and Emily Dickinson. The quality of their work has been heavily criticized, perhaps reflecting the impact of epilepsy on their poetic style [10]. Examples of their work is shown in Figure 2.

The relative absence of classical musical composition and poetry by artists with epilepsy may suggest that epilepsy has an impact on certain intellectual capabilities required to produce music of a certain complexity, which would not be affected when producing visual art. In their review, Hesdorffer and Trimble propose that in order to compose a classical musical masterpiece, one must possess excellent abstraction and memory skills in order to keep a picture of the whole while composing each part. These neuropsychological features may be disproportionally affected in patients with epilepsy [10].

2.4 Epilepsy Impacting the Neural Substrates of Creativity

In order to try to understand how epilepsy may affect creative artistic production, one must first look at the cerebral structures thought to be involved in creativity. Creativity is defined as "the ability to understand, develop and

express, in systematic fashion, novel orderly relationships" [16]. Though it is mostly considered a human quality, animals can display creativity and innovation in their behaviors to promote survival. As such, creativity underlies much of human progress. The ability to produce art is unique to humans and represents a form of creativity that creates a symbolic communication system reflecting societal values and esthetic norms [17]. In order to be successful, it must be recognized and accepted by the rest of society. Much of the work on creativity has been derived from artists with acquired brain lesions and from the way these injuries impacted their work. In general, professional artists go on to execute their art having been minimally impacted. Interestingly, some types of brain injuries promote artistic qualities in patients who were not previously artists. One possible explanation is that this newly acquired interest is a form of compensation for loss of other forms of communication, such as language, possibly representing a form of biological adaptation for survival [17]. The exact origin of the ideas behind creative artistic work is a question that is still being answered. The fact that artistic ability and creativity may be both impaired, preserved or newly developed after brain pathology goes against there being a single cerebral anatomical region involved.

Early theories of creativity included the *lateralization model* which hypothesized that the nondominant (frequently right) hemisphere was specialized in creative and innovative functions, whereas the left hemisphere would be specialized in language and analytical processes. This theory has since been contested as it doesn't account for language-based creativity. More recent theories consider that in order to create, one must have the drive to do so, thus implicating the limbic system as well as the frontal and temporal lobes [18].

The frontal lobe is the largest brain segment and is composed of the orbitofrontal, prefrontal, premotor and motor cortices [19]. The orbitofrontal cortex is responsible for emotional processing and sociability; the prefrontal cortex is thought to be responsible for socio-emotional, language and executive functions and the premotor cortex and motor cortices function primarily in movement selection and execution. It is generally accepted that the more rostral frontal cortex functions in abstract cognitive processes whereas caudal regions process more concrete information closer to motor output [20].

The frontal lobe likely plays a dual role in creativity, at the same time enabling and inhibiting its processes. This is likely the result of various contributions of frontal lobe subsystems.

For example, when lesioned, the medial pre-fontal cortex results in abulia and loss of motivation, whereas lesions of the orbitofrontal cortex produce a manic state, which has had a more robust association with successful creativity.

Studies have demonstrated increased activity in the pre-frontal cortex of subjects actively generating new ideas when using fMRI imaging. The prefrontal cortex may be activated as part of the default mode network, which also comprises the posterior cingulate, precuneus and bilateral inferior parietal regions (angular gyri). These structures also activate on fMRI studies during wandering thoughts, mental imagery, and internal thought [18].

Few studies have specifically examined the effect of epilepsy arising from the frontal lobe on artistic creation. Giovagnoli recently compared creative abilities using a design fluency test between temporal and frontal lobe epilepsy patients. He found that frontal lobe epilepsy, regardless of laterality, impacted their ability to generate creative designs. The performance of temporal lobe patients was similar to controls who did not have epilepsy [21]. Little detail is provided with regard to the type of frontal lobe epilepsy and its manifestations. It is therefore difficult to draw conclusions about the effect of frontal lobe epilepsy on creativity at this point in time.

The temporal lobe plays a role in assigning meaning and emotion to sensory information it receives from associative brain regions. The mesial portions of the temporal lobe are also important structures of the limbic system. Temporal lobe epilepsy is the most frequent type of epilepsy, and it is assumed that several great artists suffered from this type of epilepsy. This association is probably at the root of the theory that epilepsy promotes creative genius.

Many have described a phenomenon in temporal lobe epilepsy termed "hypergraphia" or the compulsive desire to write or draw. Fyodor Dostoevsky is frequently cited as an example of this phenomenon. However, most people who are affected by hypergraphia do not necessarily produce literary works of art. It is often associated with hyposexuality and hyperreligiosity, manifestations that are altogether known as Geschwind syndrome and that are usually associated with non-dominant, or right temporal lobe epilepsy [18]. Hypergraphia is thought to result from a phenomenon called "paradoxical functional facilitation," whereby a lesion in one area of the brain may result in functional gains in another [21]. Geschwind proposed that the interictal epileptiform abnormalities lead to altered responsiveness in the limbic system and possibly disinhibit the dominant temporal lobe, resulting in this need for prolific writing. Conversely, others have noted a similar phenomenon in patients with left temporal lobe epilepsy, who seem to acquire enhanced visual artistic abilities [22]. Still others have brought forward that temporal lobe epilepsy may result in heightened artistic aptitudes due to interictal epileptic activity resulting in a certain "neuronal lability," which may lead to "overinclusiveness." This is a cognitive concept defined as a "tendency not to limit oneself only to relevant associations, thus creating novel relationships between concepts," a hallmark of the definition of creativity [23]. In addition, this epileptic activity may result in kindling and enhanced sensory-limbic connectivity. As a consequence, patients with temporal lobe epilepsy are "hyperemotional," assigning emotional meaning to typically neutral experiences and objects, possibly facilitating artistic expression. This is further supported by the findings of Okamura and colleagues, in their series of patients with temporal lobe epilepsy and hypergraphia. They noted that the patients most likely to develop hypergraphia had a history of psychiatric comorbidity and emotional maladjustment, again possibly alluding to this hyperemotionality [24]. Interestingly, they found no relationship with the laterality of the epilepsy. Other studies seem rather to suggest that temporal lobe epilepsy has a negative impact on creativity. A study compared the drawing abilities of 58 adults, without a specific artistic background, with either temporal lobe

epilepsy or non-epileptic seizures. The study concluded that the patients with epilepsy had more difficulty drawing continuous lines and their drawings were more fragmented and unbalanced as a whole [25]. It is difficult to conclude if this was related to the epilepsy itself or the effects of pharmacotherapy used to treat the condition.

More contemporary studies suggest that the disruption of the physiological activity in the anterior temporal lobes may affect the way that sensory information is filtered. Studies have shown this using transcranial magnetic stimulation applied to the anterior temporal lobes, which enabled healthy individuals to detect errors more efficiently and produce very detailed drawings, almost with savant-like abilities [18]. Similar studies have shown enhanced creativity with drawing tasks when using transcranial magnetic stimulation applied to the frontal lobes as well [23]. It appears as though the frontal and temporal lobes possess reciprocal mutually inhibitory connections and therein likely lies a fine balance that modulates creativity. Though there is some evidence that the frontal and temporal lobes are at least involved in the brain networks responsible for producing creative thought, conclusions regarding the impact of epilepsy seated among these pathways on artistic production have yet to be fully drawn.

Moreover, patients with epilepsy are frequently undergoing treatment for their disorder, adding further complexity to the matter. There is some evidence that some anti-seizure medications can impact creativity, for instance, by lowering arousal states—such as is the case for benzodiazepines and barbiturates [18]. Other medications such as carbamazepine and oxcarbazepine were demonstrated to produce pitch perception disturbances, which may impact musical artists [26]. The surgical treatment of epilepsy may impair the perception of pitch, timbre, tone and rhythm, particularly after right temporal lobectomy [18, 26]. Resection of the lateral temporal cortex resulted in dramatic musical taste and personality changes in a patient. Frontal resection of the right parasagittal region, however, resulted in an inability to produce accurate pitch and rhythm but preserved comprehension of all of these elements when listening to music.

Limited evidence also suggests that individuals undergoing corpus callosotomy for epilepsy express themselves more passively, that they had trouble expressing emotions and interpreting symbols. This last finding adds further evidence to the fact that anatomical substrates responsible for creativity likely involve the connections between multiple cerebral regions in both hemispheres [18]. The effects of neurostimulation are still being investigated, however, one published study showed reduced creativity and mental flexibility in patients receiving vagal nerve stimulation within the first 3 months of therapy. In general, therapy for epilepsy appears to dampen creativity, but once again, these effects remain to be validated using more systematic methodology and outcome measures.

In summary, it seems that creativity in the epileptic brain is either enhanced or inhibited and that the presence of interictal epileptic activity, the location of the lesion or epileptic generator and treatment type could be factors exerting influence on the outcome. On the other hand, it might be interesting to examine the relationship between creativity and autism, as another disorder of brain connectivity. Individuals typically lack interictal epileptic activity, focal brain lesions and are not subjected to the same treatments as epileptic patients, but several known affected

brain regions, including the fronto-temporal, fronto-parietal and limbic brain regions overlap with areas important for creativity [5, 27]. The following section explores known artists with autism and the proposed cognitive profile responsible for the art they produce.

3 Section 2: Art and Autism

The discourse surrounding art in autistic patients is quite different than the one surrounding art and epilepsy. In epilepsy, authors attempt to ascribe remarkable displays of art and creativity to the neurological disorder. On the other hand, with autism, the literature seeks to prove that subjects with this disorder can produce art that is on par with the kind produced by neurotypical artists.

Autism falls under the umbrella of neurodevelopmental disorders and is characterized by "persistent deficits in social communication and interaction and restricted, repetitive patterns of behavior, interests or activities" [28]. It was described much later than epilepsy, with the first descriptions emerging around 1943. Autism spectrum disorders were traditionally viewed as a manifestation of various cognitive deficits. From this perspective, the autistic mind, it was argued, cannot be capable of imagination or self-awareness, which would be important to produce art [29].

Authors seek to bring focus to the fact that the current diagnostic criteria for autism perpetuate stereotypes and undermine the abilities of autistic individuals. Possessing a "limited pattern of behavior, interest or activities" portrays the autistic person as the antithesis of originality and creativity [29, 30]. Whether autistic individuals are capable of self-awareness is a matter of debate and may be related to their well-established difficulties in social and communication skills. The concept of self is formed through interactions with others and the environment, which represent common challenges for individuals with autism [31]. In fact, the term autism originates from Ancient Greek where "*autos*" means "self" reflecting early descriptions of the disorder, which focused on abnormalities in self-perception [32]. As a consequence, adults and children on the spectrum are said to have difficulty constructing and comprehending narrative discourse [33].

Presenting autism spectrum disorders in this way portrays these individuals as simply lacking the fundamental characteristics necessary for artistic creativity. Nevertheless, there are numerous examples of individuals who clearly meet the diagnostic criteria for autism who were or are successful in creative fields. Interestingly, for subjects who are considered to lack imagination and self-awareness and who struggle with narrative discourse, several autistic artists succeeded in the field of poetry.

3.1 Artists with Autism

Young authors such as Tito Mukhopadhyay, Jasmine Lee O'Neill and Donna Williams. Tito Mukhopadhyay, even at his young age of 32, has written three poetry books. An excerpt of his poem is included in Figure 3 below. These authors' writing

Fig. 3 Example of poetry by subjects with autism. From "The Mind Tree," by Tito Mukhopadhyay (at age 11; from Beyond the Silence 104- taken from Roth, I 2008

> When I had been gifted this mind of mine
> I recall his voice very clearly
> To you I have given this mind
> And you shall be the only kind
> No one ever will like you be
> And I name you the mind tree
> I can't see or talk
> Yet I can imagine
> I can hope and I can expect
> I can feel pain but I cannot cry
> So Ijust be and wait for the pain to subside

is not only an impressive accomplishment in light of their disorder, but it opens a window into the mind of the autistic individual. This accomplishment is even more remarkable in Mukhopadhyay's case, as he is considered to be low functioning on the spectrum and to have a severe disability, with limited speech [33].

Jasmine Lee O'Neill is another example of a poet with autism, who is mostly non-verbal, yet who expresses herself through her literary work [34]. O'Neill is a good example of an autistic person capable of self-awareness, as her poetry takes on an autobiographical, almost diary-like style. She refers to the repetitive, stereotypical symptoms of autism in her poetry, using such descriptions as "rocking body," "fingers floating" and "feet wandering in soothing circles." Her poetry paints an image of childhood that is simple, dreamy and separate from the rest of society, almost like a cocoon or a refuge. She writes poetry in the hopes of reaching a wide audience and improving the understanding of the autistic mind.

Donna Williams, a poet with Asperger's syndrome, and who is thus high functioning, also portrays a world that misunderstands people with autism. In her poetry, she speaks of a "crystal world" that protects her from a beastly society [34]. Autistic poets Dave Spicer and David Miedzianik partially echo this feeling in their works. To them, being autistic means being separated from the world. Unlike O'Neill and Williams, who construct a separate world where they find refuge, Spicer and Midezianik appear angry at the world condemning its values and hostility.

These autistic poets not only use poetry as a means to express themselves but offer proof that autistic individuals possess self-awareness. Their poetry clearly demonstrates a capacity to reflect on their thoughts and emotions and present it to their audience in an imaginative manner.

Critics have suggested that perhaps autistic poets produce their art according to a set of rules, almost in a formulaic manner [33]. They suggest that their writings take on the form of poetry but without features that are indispensable for the work to be considered art. Perhaps, autistic poetry is published not because the poetry possesses a high degree of artistic quality, but because it is produced by an author who by common perception should be incapable of producing any art at all. In response to this criticism, Ilona Roth published a systematic analysis comparing poetry produced by autistic and neurotypical individuals. Authors were matched for age, sex, and education [33].

She found that autistic poets varied their style, rhymes and length of their lines. They did not excessively rely on rhyme, rhythm and repetition as one might expect

if they were applying a formula, and all but one poet made use of imaginative language to an extent similar to that observed in neurotypical controls.

Roth did establish a few interesting differences in the style of autistic authors that separated them from neurotypical controls. When using metaphors, autistic authors were less creative and were often idiosyncratic, displaying a more ambiguous connection to what was represented. Autistic poets often wrote in their own voice, often inspired by their own experience.

In contrast, neurotypical poets demonstrated the capacity to distance themselves from their immediate world, more frequently depicting both internal and external sources of inspiration from a neutral standpoint. Their topics were more varied, often writing about philosophy, nature, places or political events. It is possible that autistic poets use poetry as a form of self-expression rather than as a means of communication.

Autistic artists, much like artists with epilepsy, often choose visual arts as their means of artistic expression. One of the most frequently cited autistic artists is Stephen Wiltshire, shown in Figure 4a, who excelled at architectural paintings and drawings. His talent was initially recognized around the age of 6 by family members and teachers. He, like other autistic artists, was also mute. According to some, his determination to draw is what allowed him to develop limited language skills [30]. He rose to fame after his talent was recognized by a renowned architect, Hugh Casson.

The artistic quality of his work has been put into question by skeptics of autistic art, stating that it lacked creativity and that it is merely a "very accurate representation of reality."

Roth argues there is a certain "aesthetic double standard" in that accuracy or realism in the visual arts is a well-perceived style when the artists are not on the spectrum. In addition, other prominent neurotypical artists, such as Canaletto, depicted the same architectural structures as Wiltshire, with a similar degree of attention to detail, without being subject to the same criticism.

Another commonly cited autistic artist is Gregory Blackstock, shown in Figure 4b below. He, like many other autistic artists, was labeled as a paranoid schizophrenic

Fig. 4 Artists with Autism. (**a**) Stephen Wiltshire 2016. https://commons.wikimedia.org/wiki/File:Stephen_Wiltshire_IMG_3910_(30308695430).jpg. Gobierno CDMX, CC0, via Wikimedia Commons. Accessed November 28th 2021. (**b**) Gregory Blackstock 2010. Joe Mabel, CC BY-SA 3.0. https://creativecommons.org/licenses/by-sa/3.0, via Wikimedia Commons. Accessed November 28th 2021

initially, and later on was given the label of autistic savant. His work constitutes a form of extensive cataloguing of everyday objects or animals, emphasizing subtle differences between them in each category. His work was recognized rather late in his life, at the age of 58. He has been criticized for lacking artistic creativity, merely presenting repetitive objects or animals with extreme accuracy and attention to detail. However, one can think of Andy Warhol who similarly presented everyday objects in a repetitive sequence, such as his famous Campbell's soup cans, yet he was exempted from such criticism. In fact, he was celebrated for constructing a new type of art [30].

Autistic artists appear to be burdened with the label of their diagnosis, having to continuously defend the quality of their art. In recent years, however, there has been a growing interest in what Roger Cardinal calls "outsider art," sometimes termed "autistic art." He borrowed and translated the term "art brut" from Dubuffet, referring to art created outside the boundaries of official art culture and galleries. This type of art can be created by any individual given that art is considered a ubiquitous human activity [35]. The association to autism originates from early collectors of this kind of art, such as Hans Prinzhorn and Arnulf Rainer, who described the artists as eccentric or strange, cut off from the world and with a certain indifference to the audience. There are now entire galleries dedicated to this style.

Examples of artists who produced this type of art include James Castle, Roy Wenzel and Jeroen Pomp. James Castle was intellectually delayed, deaf and had limited verbal communication skills. He lived on his family's farm in Idaho and developed a passion for portraying common paraphernalia, as well as scenes from his rural surroundings. The diagnosis of autism was made later, retrospectively. What drew interest to his art was the materials he used to produce it. He would use soot, spit, and homemade tools to create his complex scenes. His work only gained recognition around the 1950s after a nephew showed Castle's paintings to his art teachers.

Roy Wenzel, a Dutch artist diagnosed with autism around the age of 11, had displayed early signs of artistic talent while hospitalized, in his psychotherapy sessions. Much like Castle, he gained artistic recognition a bit later in life. His art depicts mostly urban scenes with semi-transparent figures and repeating rows of houses and rooftops. These are thought to be the product of his photographic memory. He has been featured in many international exhibitions and galleries.

Jeroen Pomp creates scrambled cityscapes and nature themes in his extremely colorful drawings that fill the entire paper. He is thought to have horror vacui, a fear of leaving empty spaces in his artistic works. He has both autism and epilepsy [35].

Though these artists do not directly draw inspiration from their autism, their art displays traits that are often associated with the diagnosis, such as the need for repetition or completeness.

Through its increasing popularity, outsider art is likely to shed light on many autistic artists bringing their work into the world of public galleries. However, a label such as "outsider art" risks diminishing the merit of the art and creating an audience that is intrigued by the oddity of its creators [30].

3.2 Neural Substrates Impacting Creativity in Autism

These artists are living proof that autistic individuals can express themselves creatively and reach a certain degree of success in their field. However, the way in which autism affects the creative process is still a matter of debate. Autistic artists are likely to possess cognitive processes underlying their creativity that differ from neurotypical artists. Some have explained the artistic abilities of autistic individuals as a result of enhanced cognitive abilities, such as exceptional memory and attention to detail masquerading as creativity [30, 36]. Other characteristics commonly found in autism, such as increased sensitivity and a tendency to systematize the world, could form the basis for creativity in autistic individuals. This perspective explains creativity as a consequence of unique cognitive processing of experiences and the immediate environment, thus classifying autism as a different cognitive style rather than an ensemble of cognitive deficits. However, this does not provide an explanation for innate talent, or genius, that some individuals with autism display.

Moreover, this would not account for the fact that many autistic individuals possess excellent memory yet are not successful artists [37]. In fact, according to Treffert, one in ten individuals with autism show features consistent with savant syndrome. He defined savant syndrome as "a rare, but extraordinary, condition in which persons with serious mental disabilities, including autistic disorder, have some 'island of genius' which stands in marked, incongruous contrast to overall handicap." Conversely, nearly 50% of individuals with this syndrome are autistic. This phenomenon is better accounted for by the theory that autistic individuals likely have altered cerebral connectivity, allowing for brain regions to interact in such a way that it produces extraordinary capacities or these "islands of genius" leading to an "original" view of the world [37, 38]. An original view of the world is somewhat synonymous with "divergent thinking," and these individuals' tendency to hypersystematize the world may confer efficacy, both crucial components of creativity, according to many academics [37].

Pennisi and Colleagues recently performed a systematic review of the literature published from 2009 to 2019, trying to define the cognitive profile of the autistic artist. They analyzed 13 studies that were specifically looking at the link between creativity and autism. They assessed comparisons between autistic individuals and controls in different tasks, evaluating linguistic and visual skills, as well as their performance on practical tasks. Control groups were most frequently composed of typically developed individuals, but some studies used subjects with either a learning disability or a developmental delay as controls.

They used the Torrance Test of Creative Thinking to analyze four characteristics in both autistic and neurotypical individuals. They evaluated fluency (the quantity of responses produced for each request), flexibility (producing semantically different ideas), elaboration (level of detail reached by each answer) and lastly, originality (statistical rarity of an answer). Together, these characteristics are a fairly good indicator of an individual's creativity [39].

In this systematic review, Pennisi and colleagues found that generally, creativity is less prevalent in the autistic population. They also found that testing methodology

affects the prevalence of creativity in the autism population, in that it is less frequent when tested through cross-sectional studies.

In addition, the autism group demonstrated lower flexibility and fluency when compared to control groups. They were not affected in terms of elaboration when the tests were looking at visual skills, but elaboration was decreased when the tests were performative. The autism group also performed better in terms of originality, specifically when evaluated with linguistic tests [37].

According to the authors, slower reaction times could at least in part explain the decreased fluency seen in the autistic patients. Alternatively, the autistic subjects might not have been motivated to perform well on the test as they traditionally lack social motivation.

Decreased flexibility is a finding often linked to repetitive behaviors, which are a strong clinical feature of autism. High levels of elaboration are also in keeping with their well-accepted attention to detail.

The authors also specifically evaluated the link between language development and creativity and found that higher communication skills are often associated with higher levels of creativity.

Though this study was limited by the relative dearth of literature on the subject, it still confirms that there are some significant differences in the cognitive profile of autistic individuals and that this likely impacts their creative abilities.

4 Conclusion

Brain connectivity disorders have an undeniable impact on artistic creativity. However, despite significant interest manifested by both the artistic and scientific world, the nature and extent of this impact has yet to be described. Epilepsy, autism, and artistic production were examined here; however, no definite conclusions can be drawn. The current literature is limited by the heterogeneity of the studies and the disorders themselves; both encompassing varying etiologies grouped together by their clinical manifestations. Still, some interesting observations have emerged.

The literature surrounding art and epilepsy hypothesizes that the disorder, if localized to specific brain regions, increases creativity. Focal interictal epileptic activity, particularly in the limbic system, could facilitate pathways involved in artistic creation.

It is therefore possible that a disruption of normal neuronal activity in some areas of the brain enhances the networks responsible for artistic production. Some authors provide a similar explanation for the extraordinary capacities of autistic artists, explaining that somehow the socio-communicative deficits, which define autism, produce "islands of genius" that manifest as creativity. As most autistic patients lack interictal epileptiform abnormalities, the disruption is likely explained by other factors, which have yet to be identified.

The specific impact of epilepsy on the artistic work itself is not explored in the literature, since most artists deny the condition's effect or were diagnosed with epilepsy a posteriori. The more recent studies surrounding autism are focused on the

features of the art itself, debating whether it is truly art or rather a subject of medical examination that contributes to the scientific enlightenment of the biological underpinnings of the condition. Nevertheless, it is clear that artists with either epilepsy or autism are capable of producing art that is internationally acclaimed and they likely achieve this despite their neuropsychiatric disorder.

The impact of these conditions on artistic creativity surely deserves more scientific attention, as it is an interesting avenue to further our understanding of the mind-brain connection.

References

1. Sporns O, Tononi G, Kötter R. The human connectome: a structural description of the human brain. PLoS Comput Biol. 2005;1(4):e42. https://doi.org/10.1371/journal.pcbi.0010042.
2. Holmes MD, Tucker DM. Identifying the epileptic network. Front Neurol. 2013;4:84. https://doi.org/10.3389/fneur.2013.00084.
3. Du Y, Fu Z, Calhoun VD. Classification and prediction of brain disorders using functional connectivity: promising but challenging. Front Neurosci. 2018;12:525. https://doi.org/10.3389/fnins.2018.00525.
4. Stram CJ. Modern network science of neurological disorders. Nat Rev Neurosci. 2014;15:pages683–695.
5. Chrysikou E. Creativity in and out of (cognitive) control. Curr Opin Behav Sci. 2018;2019(27):94–9. https://doi.org/10.1016/j.cobeha.2018.09.012.
6. Shi L, Sun J, Xia Y, Ren Z, Chen O, Wei D, Yang W, Qiu J. Large-scale brain network connectivity underlying creativity in resting-state and task fMRI: cooperation between default network and frontal-parietal network. Biol Psychol. 2018;135:102–11.
7. Lukmanji S, Manji SA, Kadhim S, Sauro KM, Wirrell EC, Kwon C, Jette N. The co-occurrence of epilepsy and autism: a systematic review. Epilepsy Behav. 2019;98(2019):238–48.
8. Ladino LD, Rizvi S, Tellez-Zenteno JF. Epilepsy through the ages: an artistic point of view. Epilepsy Behav. 2016;57:255–64. https://doi.org/10.1016/j.yebeh.2015.12.033.
9. Ladino LD, Hunter G, Tellez-Zenteno JF. Art and epilepsy surgery. Epilepsy Behav. 2013;29:82–9. https://doi.org/10.1016/j.yebeh.2013.06.028.
10. Hesdorffer DC, Trimble M. Musical and poetic creativity and epilepsy. Epilepsy Behav. 2016;57:234–7. https://doi.org/10.1016/j.yebeh.2015.12.042.
11. Thomas RH, Mullins JM, Waddington T, Nugent K, Smith PEM. Epilepsy: creative sparks. Pract Neurol. 2010;10:219–26.
12. Voskuil P. Vincent van Gogh and his illness. A reflection on a posthumous diagnostic exercise. Epilepsy Behav. 2016;111:107258. https://doi.org/10.1016/j.yebeh.2020.107258.
13. Blanke O, Landis T. The metaphysical art of Giorgio de Chirico: migraine or epilepsy? Eur Neurol. 2003;50:191–4.
14. Schachter SC. Epilepsy and art: windows into complexity and comorbidities. Epilepsy Behav. 2016;57:265–9. https://doi.org/10.1016/j.yebeh.2015.12.024.
15. Rektor I, Schacter SC, Arzy S, et al. Epilepsy, behavior and art (epilepsy, brain, and mind, part 1). Epilepsy Behav. 2013;28:261–82. https://doi.org/10.1016/j.yebeh.2013.03.011.
16. Heilman KM, Nadeau SE, Beversdorf DO. Creative innovation: possible brain mechanisms. Neurocase. 2003;9:369–79.
17. Zaidel DW. Creativity, brain, and art: biological and neurological considerations. Front Hum Neurosci. 2014;8:3–9. https://doi.org/10.3389/fnhum.2014.00389.
18. Zubkov S, Friedman D. Epilepsy treatment and creativity. Epilepsy Behav. 2015;57:230–3. https://doi.org/10.1016/j.yebeh.2015.12.048.

19. Batista Joao R, Mattos Filgueiras R. Frontal lobe: functional neuroanatomy of its circuitry and related disconnection syndromes. Prefrontal Cortex. 2018;41 https://doi.org/10.5772/intechopen.79571.
20. Badre D, Mark D'E. Is the rostro-caudal axis of the frontal lobe hierarchical? Nat Rev Neurosci. 2009;10(9):659–69. https://doi.org/10.1038/nrn2667.
21. Giovagnoli AR. The contribution of the frontal lobe to creativity. Insights from epilepsy. Epilepsy Behav. 2020;111:107313. https://doi.org/10.1016/j.yebeh.2020.107313.
22. Ghacibeh GA, Heilman KM. Creative innovation with temporal lobe epilepsy and lobectomy. J Neurol Sci. 2013;324:45–8. https://doi.org/10.1016/j.jns.2012.09.029.
23. Cartwrigth M, Clark-Carter D, Ellis SJ, Matthews C. Temporal lobe epilepsy and creativity: a model of Association. Creat Res J. 2004;16(1):27–34.
24. Okamura T, Fukai M, Yamadori A, et al. A clinical study of hypergraphia in epilepsy. J Neurol Neurosurg Psychiatry. 1993;56:556–9.
25. Anschel DJ, Dolce S, Schwartzman A, et al. A blinded pilor study of artwork in a comprehensive epilepsy center population. Epilepsy Behav. 2005;6:196–202.
26. Maguire M. Epilepsy and music: practical notes. Pract Neurol. 2017;17:86–95. https://doi.org/10.1136/practneurol-2016-001487.
27. Ecker C. The neuroanatomy of autism spectrum disorder: an overview of structural neuroimaging findings and their translatability to the clinical setting. Autism. 2017;21(1):18–28. https://doi.org/10.1177/1362361315627136.
28. American Psychiatric Association. Diagnostic and statistical manual of mental disorders: DSM-5. Arlington: American Psychiatric Association; 2017.
29. Mills B. Chapter 5: autism and the imagination. In: Osteen M, editor. Autism and representation. New York, NY: Routledge; 2008. p. p118–32.
30. Roth I. Autism, creativity and aesthetics. Qual Res Psychol. 2020;17(4):498–508. https://doi.org/10.1080/14780887.2018.1442763.
31. Huang AX, Hughes TL, Sutton LR, Lawrence M, Chen X, Ji Z, Zeleke W. Understanding the self in individuals with autism Spectrum disorders (ASD): a review of literature. Front Psychol. 2017;8:1422. https://doi.org/10.3389/fpsyg.2017.01422.
32. Kanner L. Autistic disturbances of affective contact. Nerv Child. 1943;2:217–50.
33. Roth I. Chapter 7: imagination and the awareness of self I nAutistic Spectrum poets. In: Osteen M, editor. Autism and representation. New York, NY: Routledge; 2008. p. p145–65.
34. Roy E, Casanova MF, Jerath V. Autistic poetry as therapy. J Poet Ther. 2004;17(1):33–8. https://doi.org/10.1080/08893670410001698505.
35. Cardinal R. Outsider art and the autistic creator. Philos Trans Royal B Soc. 2009;134:1459–66. https://doi.org/10.1098/rstb.2008.0325.
36. Baron-Cohen S, Ashwin E, Ashwin C, Tavassoli T, Chakrabarti B. Talent in autism: hypersystemizing, hyper-attention to detail and sensory hypersensitivity. Philos Trans R Soc B Biol Sci. 2009;364(1522):1377–83.
37. Pennisi P, Giallongo L, Milintenda G, Cannarozzo M. Autism, autistic traits and creativity: a systematic review and meta-analysis. Cogn Process. 2021;22:1–36. https://doi.org/10.1007/s10339-020-00992-6.
38. Treffert DA. The savant syndrome: an extraordinary condition. A synopsis: past, present, future. Philos Trans R Soc B Biol Sci. 2009;364(1522):1351–7. https://doi.org/10.1098/rstb.2008.0326.
39. Torrance EP. The Torrance tests of creative thinking: technical norms manual. Bensenville: Scholastic Testing Services; 1974.

Part II

Other Research and Art Sectors

The Contribution of Non-invasive Brain Stimulation to the Study of the Neural Bases of Creativity and Aesthetic Experience

A. Ciricugno, R. J. Slaby, M. Benedek, and Z. Cattaneo

1 Introduction

Creativity has been a cornerstone of the human condition. We have sought novel and effective approaches to our life at hand, such as the invention of the wheel in ancient Mesopotamia or Michael Faraday's electric motor. The human ability to create novel ideas and solutions is particularly important in the fields of art, where artists, such as painters, use alternative and innovative ways to depict objects and scenes to convey specific semantic messages through different artistic styles and mediums. Research on the neural basis of creativity has been burgeoning in recent years,

A. Ciricugno and R.J. Slaby share first co-authorship.

A. Ciricugno
IRCCS Mondino Foundation, Pavia, Italy
e-mail: andrea.ciricugno@mondino.it

R. J. Slaby
Department of Psychology, University of Milano-Bicocca, Milan, Italy
e-mail: r.slaby@campus.unimib.it

M. Benedek
Institute of Psychology, University of Graz, Graz, Austria

BioTechMed-Graz, Research Network, University of Graz, Graz, Austria
e-mail: mathias.benedek@uni-graz.at

Z. Cattaneo (✉)
IRCCS Mondino Foundation, Pavia, Italy

Department of Human and Social Sciences, University of Bergamo, Bergamo, Italy
e-mail: zaira.cattaneo@unibg.it, zaira.cattaneo@unimib.it

© The Author(s), under exclusive license to Springer Nature Switzerland AG 2023
A. Richard et al. (eds.), *Art and Neurological Disorders*, Current Clinical
Neurology, https://doi.org/10.1007/978-3-031-14724-1_7

attempting to understand the brain mechanisms associated with creative thought processing [1–3]. However, besides studying how creativity is rooted in the human brain, it is also important to understand the neural processes underlying the perception and appreciation of artistic creations. In this regard, neuroaesthetics is a growing research field that aims to investigate the neural underpinnings involved in such aesthetic experience (for reviews: [4–6]), that may be extended to plethora of phenomena, such as visual art (e.g., [7]) and music (e.g., [8]).

Collectively, most of the available evidence on the neural correlates of creativity and aesthetic experience is based on neuroimaging or neurophysiological approaches such as functional magnetic resonance imaging (fMRI), magnetoencephalography (MEG), and electroencephalography (EEG). These techniques, although important, provide only correlational evidence on the involvement of different brain regions in creativity (e.g., [2]) and aesthetic experience (e.g., [4]). Other studies, as extensively shown in other chapters of this book, have employed neuropsychological approaches by examining patients with focal or neurodegenerative brain alterations for the investigation of both creativity (for reviews see [9–11]) and aesthetic experience [12–14]. Nevertheless, patients' studies are typically characterized by a high heterogeneity in patient characteristics (e.g., lesion location, extension, etiology) that complicate findings' interpretation and subsequentially pave the way for other brain explorative approaches. In particular, transcranial magnetic stimulation (TMS) provides a mean to overcome limitations inherent to studies based on neuropsychological patients. Indeed, TMS allows to temporarily simulate, in a controlled way, the consequences of focal cortical lesions in an otherwise healthy brain, inducing reversible *"virtual lesions"* [15, 16]. The first application of this TMS approach was in studies investigating the visual cortex where a functional disruption of the occipital cortex significantly interfered with the detection of visual stimuli [17]. The basic principle is that if temporarily interfering with neural activity in a specific cortical region (or node of a network) induces a significant modulation of task performance, that region (or the network is part of) can be considered as *causally* relevant for the task at play (for reviews, see [18–23]). Critically, TMS studies can test multiple participants on the same paradigm, evaluate the contribution of different cortical areas to a given behavior, and assess the role of a given brain region in different behaviors. The virtual lesion approach therefore allows not only to model and reproduce but also to extend patients' results. In analogy to focal TMS, behavioral effects induced by transcranial electrical stimulation (tES) have often been taken as evidence for a causal involvement of the brain region underlying one of the tES electrodes (see [24]). Although the virtual lesion approach provides a useful way to test some of the implications collected from neuropsychological studies explored throughout this book, nowadays it is not considered as fully representative of the variety of non-invasive brain stimulation (NIBS) potentialities (e.g., [25, 26]). Indeed, NIBS techniques can elicit

both the suppression and facilitation of neural activity depending on several factors (see below for details). Thus, NIBS has a great potential in clinical settings as innovative therapeutic approaches but also as a means for neuroenhancement in healthy individuals.

In this chapter, we focus on studies that have explored the neural bases of creative thinking and aesthetic experience employing NIBS. Specifically, in the following sections, we first review the main approaches that drive to date most of the NIBS research, namely transcranial magnetic stimulation (TMS) and transcranial electric stimulation (tES), together with their main functional mechanisms (note that other more recent non-invasive neuromodulatory techniques, not based on electrical or magnetic stimulation, such as low-intensity focused ultrasound, are not considered here but are covered by other chapters). A main aim of the chapter is also to provide the reader with a brief overview of the most current NIBS protocols, such as online vs. offline protocols, single-pulse vs. repetitive TMS protocols, protocols employing different types of tES, and study designs that are typically used in cognitive neuroscience and may be effectively employed in research on creativity and aesthetic appreciation. Both TMS and tES are safe for use in human subjects and have been widely used to identify causal links between specific brain structures supporting cognitive, affective, sensory and motor functions. They also offer insight into local and global brain network organization, dynamics and experience-dependent plasticity. We then address the neuroimaging and NIBS evidence within creativity and follow with a similar approach addressing the neural underpinnings behind aesthetic experience. In the concluding part, we consider the overlaps between the two domains and suggest future avenues for scientific exploration within these fields of interest.

2 Non-invasive Brain Stimulation (NIBS): An Overview of Historical Roots, Functional Mechanisms and most Common Protocols

2.1 History of NIBS

The idea that magnetic and electric fields could be applied for therapeutic purposes date back around to 2000 years ago, when Scribonio Largo applied electricity from live torpedo fish, onto the scalp of patients with headaches. However, it was only between the eighteenth and nineteenth century that, thanks to Galvani's introduction of the concept of electrophysiology, and Aldini's first evidence of mood improvement after the application of direct electrical current on the moistened scalp of a patient with "melancholy" [27], that electrical stimulation began to be appreciated as a potential tool to alleviate neurological and psychiatric conditions [28]. Following this seminal finding, few attempts have been made to apply electrical stimulation invasively (i.e., through needle electrodes in the exposed brain), which

resulted in sensory and motor responses contralateral to the stimulated cortex, though associated with important side effects (i.e., coma and death; [29]). The first studies employing transcranial electrical stimulation noninvasively date back to almost 40 years ago, with the discovery that brief high-voltage electrical shocks from a special low-output-resistance stimulator, delivered through electrodes on the skin, can excite human muscle directly (not by way of the nerves) and can also excite the motor cortex, visual cortex, and spinal cord [30].

Until the nineteenth century, greater developments in electric stimulation were reported, compared to those of magnetic stimulation. A turning point was represented by Faraday's discovery (1832) of electromagnetic induction (i.e., the physical principle of modern magnetic stimulation), showing that electricity and magnetism are not independent but rather interactive phenomena. Faraday demonstrated that a pulse of electric current passing through a wire coil generates a magnetic field, with the rate of change of this magnetic field determining the induction of a secondary current in a nearby conductor [31]. Based on these observations, in 1893 d'Arsonval applied for the first time high-frequency (about 500 kHz) time-varying magnetic fields on the human brain noninvasively with different types of coils of various sizes and reported phosphenes perception together with some unexpected side effects (e.g., vertigo and syncope) [32]. It was only in 1985 that Barker developed the first reliable noninvasive transcranial magnetic brain stimulator to efficiently stimulate the human motor cortex using transient magnetic fields [33]. Since that time, magnetic stimulation began to be regarded as a valid alternative to electric stimulation. More recently, several systematic investigations contributed to the development of magnetic and electrical stimulations protocols to noninvasively induce transient cortical effects and neural responses that can outlast the stimulation period, thus leading to the recognition of these non-invasive brain stimulation techniques as promising tools for both research and clinical purposes.

2.2 Transcranial Magnetic Stimulation (TMS)

In TMS, a brief and high-amplitude current is delivered through a coil placed above the scalp, generating a perpendicular and rapidly changing magnetic field. The magnetic pulse induces a transitory electric current in the cortical surface under the coil. When the intensity of TMS is sufficiently high, a single pulse of TMS causes highly synchronized action potentials in the targeted area. TMS of the motor cortex leads to a twitch in the target muscle evoking a motor-evoked potential on electromyography, one of the hallmark measures for noninvasive quantification of cortical and spinal excitability in cognitive and clinical neuroscience [34]. Similarly, TMS of the early visual cortex induces short-lived subjective visual sensations known as phosphenes [35]. Although producing action potential in neurons, TMS may also hamper ongoing patterns of activity in the stimulated region thus inducing a

transitory *virtual lesion* in a healthy brain [36]. Hence, if the targeted area is critical for a specific function, the short-lived virtual lesion effect induced by TMS may impair performance in tasks that rely on the perturbed brain function.

TMS has been widely applied in both offline and online protocols (for a review, [37]). In *offline* paradigms, repetitive TMS pulses (rTMS), typically either low frequency (1 Hz) or continuous theta bursts, is delivered to affect performance in a subsequent task and induces changes in brain activity that last beyond the stimulation period. Indeed, TMS conventional offline protocols' aftereffects on behavioral performances can outlast the period of stimulation by many minutes or hours (depending on stimulation parameters), with more robust effects being detectable immediately after the end of the stimulation. The main advantage of offline protocols is the avoidance of unspecific effects of stimulation on task performance (such as discomfort, muscle twitching, somatosensory sensation on the scalp, and the noise produced by the coil). However, more than one session of TMS is typically needed on different days to allow proper control conditions (at least, in within-subjects designs). In *online* TMS protocols, either single pulses or short trains of pulses (typically delivered at 10 or 20 Hz of frequency), whose aftereffects rapidly fade out in few milliseconds, are delivered whilst participants are engaged in a task to investigate whether a region is recruited to mediate a certain function (for a recent review on online TMS protocols see [38]).

One of the advantages of TMS relies on its relatively good spatial resolution. A conventional 70-mm figure-of-eight-shaped coil achieves relatively focal direct stimulation with a 2–2.5 cm diameter spread at the cortical surface under the crossing of the two 70 mm diameter circular components comprising the figure-eight [39]. Higher spatial resolution may be achieved using smaller or different-shaped TMS coils (see [40]). Indeed, TMS coil geometry plays an important role in determining the focality and depth of penetration of the induced electric field responsible for stimulation. A high level of accuracy in maintaining coil position and orientation over the targeted cortical region can be achieved combining stimulation with individual (f)MRI-guided neuronavigation systems [41]. The magnetic field reduces in intensity the further away it is from the coil: therefore, TMS is most effective at stimulating brain regions close to the scalp (~2–3 cm) whereas it is ineffective in stimulating deep brain structures (but note that different shaped coils have been developed to reach deeper regions, e.g., the H-coil; [42]). Critically, TMS does not only transiently perturb ongoing neural activity in the targeted area beneath the coil but can also significantly affect activity in distal connected sites (for a recent review see [43]). Hence, TMS can be successfully used to map and modulate functional connectivity (e.g., [44]). Moreover, thanks to its high temporal resolution (in the order of milliseconds), TMS may also provide important information about the time-course of neural information processing by using very short bursts of stimulation and varying the onset of stimulation (*chronometric-approaches*, e.g., [45, 46]).

Importantly, TMS may elicit enhancement or suppression of neural activity depending on stimulation parameters. For instance, the direction of excitability changes induced by TMS may vary according to the intensity of the stimulation [47], or the prior state of activation of the recruited brain circuit (e.g., [48, 49]; for reviews, see [16, 50]). TMS may also be employed to modulate behavior by entraining neural activity at specific frequencies that are associated with a specific function, an approach known as *frequency-tuned* or *rhythmic* TMS [51].

2.3 Transcranial Electric Stimulation (tES)

The term transcranial electrical stimulation refers to many noninvasive, neuromodulation approaches in which a small current (usually 1 or 2 mA) is delivered to the brain through electrodes applied over the scalp. The low-voltage current enables a reversible modulation of the excitability in a specific brain region by influencing the spontaneous neural activity (for reviews see [23, 52, 53]). The most widely used form of tES is transcranial direct current stimulation (tDCS), but other approaches—alternating current stimulation (tACS) and random noise stimulation (tRNS)—are increasingly employed.

In tDCS protocols, the current is typically delivered using a bipolar montage that consists in the active electrode (the anode or the cathode, depending on the experimental design) located directly over the targeted region and the reference electrode located over either another cephalic site (commonly, the contralateral supraorbital region) or an extracephalic site such as the shoulder. In contrast to TMS, tDCS does not directly induce cerebral activity but rather alters spontaneous brain activity and excitability by subthreshold modulation of the neural resting state potential. In the first studies, tDCS was applied to target the motor cortex and showed that anodal stimulation was effective in enhancing neural firing rate while cathodal stimulation reduced the firing rate, via up or down-regulation of the resting potential of the neurons' membrane voltage [54]. Following a similar rationale, anodal tDCS and cathodal tDCS have been applied to modulate the excitability of other cortical regions. However, when tDCS is applied to non-motor regions to investigate cognitive functions, polarity-dependent effects are less evident (for review see [55]). Indeed, increasing evidence from computational modeling and physiological measurements suggest that the actual direction (e.g., excitatory or inhibitory) of tDCS effects strongly depends on several factors such as current parameters (intensity, frequency, and duration), the type of electrodes (shape, size, position, and number), as well as participants' individual differences including anatomy (e.g., skull thickness) and excitability of the targeted region [56, 57]. Given its modest spatial resolution, tDCS is likely to affect a brain network rather than selectively the targeted site [58]. However, higher focality may be reached employing high-definition (HD)-tDCS, a newly developed intervention that uses arrays of smaller, specially designed electrodes [59]. In recent years, computational modeling of tDCS-induced electric field distribution is recommended to predict the pattern of electric current through the brain for a given electrode montage and given head anatomy [60, 61].

As for TMS, tDCS can be applied in offline and online protocols. In *offline* tDCS protocols, anodal or cathodal stimulation is delivered for 10–20 min before participants perform the task. In within-subjects designs, a second tDCS session is performed (usually interleaved by a few days) in which the same paradigm is repeated but with a sham (placebo) stimulation (with the order of real and sham sessions counterbalanced across participants to control for learning effects). In sham tDCS, the electrode montage is the same as for real stimulation, but the current is ramped down after 30 s to 0 mA. *Online* tDCS protocols—in which the task is administered concurrently with the stimulation—are also used and seem to be particularly suited for enhancing skill acquisition (e.g., [62]). Since the current needs to be applied for several minutes to induce changes in cortical excitability, tDCS is not suited to assess the chronometry of perceptual and cognitive functions. Finally, frequency-tuned stimulation is also possible using tES. In particular, transcranial alternating current stimulation (tACS) is increasingly employed to entrain rhythmic cortical activity in a frequency-specific way to improve cognition (for reviews, [63, 64]). Transcranial random noise stimulation (tRNS) is a modification of tACS in which the stimulation waveform is a noise signal that is filtered to contain frequency components in the range of cortical oscillations and beyond. The mechanism of action is not completely understood, although phenomena such as stochastic resonance, a general principle by which adding noise to a subthreshold signal pushes the signal over the threshold and thereby enhances it, have been proposed [65]. tRNS has been showed to be effective in improving cognitive and affective functions (e.g., [66, 67]).

3 Creativity

Creativity generally encompasses the concept of novelty and effectiveness [68, 69], and the creative process has commonly been divided into two stages: idea generation and idea evaluation/selection [70, 71]. Idea generation reflects the production of novel responses to stimuli, while idea evaluation/selection reflects the appraisal of response candidates to identify the most creative ones. These stages can be further described as divergent and convergent thinking, where divergent thinking tasks ask for several possible solutions to an open-ended problem, while convergent thinking tasks ask for a single, best solution to a problem. Higher order cognitive processes underlying creative cognition include memory retrieval and working memory to provide the executive control necessary to search for solutions for complex tasks while inhibiting the recruitment of interfering salient information [1, 72]. The dissociation of divergent and convergent thinking may be further conceptualized into both flexibility and persistence [73, 74]. Complimentary to divergent thinking and idea generation, the flexibility pathway refers to creative cognition characterized by spontaneous thinking such that attention is modulated to provide access to semantic concepts with generally weak retrieval. On the other hand, the persistence pathway refers to creative cognition characterized by cognitive control, which includes mental effort and cognitive resources to select the best solution to

the task on hand. Therefore, the interplay of flexibility and persistence posit a modulation of attentional control in creative thinking.

Neuroimaging studies have shown that the fluctuating role of attentional control in both idea generation and idea evaluation/selection mirrors the interplay of the default mode network and the executive control network (for review see [70]). The executive control network includes the dorsolateral prefrontal cortex (dlPFC) and inferior frontal gyrus (IFG), as well as anterior inferior parietal areas, and is engaged in executive function, directed attention, and working memory [75, 76]. The default mode network includes medial prefrontal cortex (mPFC), cingulate cortex, and posterior inferior parietal regions and is engaged in self-generated thought, imagination, wandering and self-referential processing [77, 78]. Both networks are comprised of frontal-striatal circuits with the striatum being related to reward computation and strategy shifting and the prefrontal cortex being related to attentional control and executive functioning (for review see [73]). Furthermore, the ventral tegmental area and substantia nigra communicate through dopaminergic circuitry to the striatum and prefrontal cortex [79] and play significant roles in dopamine release and reward computation [80]. Indeed, there seems to be a balance of dopaminergic release in these neural networks to *per se* balance the interplay of frontal-striatal circuits recruited for idea generation and idea evaluation/selection in creative thinking [74]. This suggests that the moderate and unextreme interplay of these frontal striatal circuits, partly representing the executive control and default mode networks, is necessary for successful creative thinking [81–83]. From an electrophysiological perspective, a large body of evidence demonstrates that brain oscillations in the alpha frequency band over frontal and parietal regions are strongly linked to the process of creative idea generation ([84, 85]; for a review see [86]), possibly by supporting sustained internally directed attention during imagination and mental simulation of novel ideas [71]. Accordingly, the level of alpha band power is positively associated with the originality of the produced ideas [87, 88]. Moreover, bursts of high-frequency gamma oscillatory activity have been observed to occur over temporal regions right before participants solve a problem via insight processes, thus suggesting that the switch between alpha and gamma activity may represent the basic process triggering a successful creative process [89].

Considering the neuroimaging evidence exploring the roles of cognitive control on creativity (e.g., [70]), many studies (mostly employing tDCS) have focused on inhibiting and/or exciting regions involved in the executive control network, with a particular focus on prefrontal regions given their role in focusing attention to the task on hand and relative ease to be accessed by brain stimulation. Many of these studies explore facets of both divergent and convergent thinking within their research paradigms, with the majority employing the Alternative Uses Task (AUT, [90]) and Remote Associations Test (RAT, [91]) to assess divergent and convergent thinking, respectively. The AUT asks individuals to generate novel and common uses of everyday objects or tools that are then scored in terms of fluency (i.e., number of ideas) and originality (i.e., creative quality; [92]). In contrast, the RAT asks participants to select the best solution for a problem on hand, which may be scored in terms of creative insight [93]. This section has been organized to discuss different

brain regions associated with the executive control network with the last section briefly mentioning the role of expertise and motor related areas in creativity.

3.1 Fronto-Parietal Regions

In compliance with the fronto-parietal circuits comprising the executive control network, NIBS research has directly explored the prefrontal cortex (PFC) and parietal cortex within creative thinking. The functional mechanisms of these regions within creative thinking may be attributed to a fluctuating reliance on top-down and bottom-up processing for both idea evaluation/selection and idea generation [94]. Within the PFC, NIBS research proposes the dlPFC to be critical in the modulation of the aforementioned processes. Cerruti and Schlaug [95] showed that anodal tDCS over the left (but not right) dlPFC enhanced complex verbal associative thought (as measured by the RAT). Accordingly, higher divergent thinking (as assessed by the AUT) was found with anodal tDCS over the left dlPFC and concurrent cathodal tDCS over the right dlPFC [96]; however, this pattern was found in low anxiety versus high anxiety trait individuals only. Moreover, Xiang et al. [96] found no effect of tDCS on convergent thinking as assessed by the compound RAT (CRAT). Nonetheless, the same tDCS montage was employed in another study, and the authors found increased convergent thinking as assessed by the CRAT, independent of trait anxiety [97]. Accordingly, tRNS over the left dlPFC was found to improve verbal (but not visual) convergent thinking [98]; anodal tDCS over the left dlPFC increased the recognition of meaningful patterns in ambiguous inkblots yet had no effects on measures of visual insight [99].

Overall, the above results suggest that the dlPFC has a role in mediating executive control mechanisms important in creative thinking; however, effects of dlPFC stimulation on creativity may be moderated by individual differences, such as trait anxiety and task features (e.g., visual vs. verbal modality) but also by task instructions cueing or not cueing the creative nature of the task. In this regard, Colombo et al. [100] found that anodal tDCS over the bilateral dlPFC increased creative performance on the Product Improvement subtest of the Torrance Tests of Creative Thinking (TTCT) that asked participants to think of ways to improve an object [101], with a weak modulatory effect of priming to visualize using an object in a novel way on creative performance. Similarly, anodal tDCS over more anterior left prefrontal regions improved performance in idea evaluation/selection, and in a separate task under the same tDCS paradigm, creative idea generation improved only when participants were cued to think of a creative solution versus a common solution [102]. Therefore, in addition to the general enhancing effects of anodal tDCS over the dlPFC on creative thinking, tDCS over the dlPFC may ameliorate creative performance after deliberative creative thinking [102] and after visualizing oneself using objects in an unusual way [100]. This evidence supports the theoretical role of the PFC for the integration of lower semantic stores with the creative task on hand to produce creative solutions [102], which complements the synchronicity of the

executive control network's role in attention orientation and the default mode network's role in self-referencing on creative thought.

In summation, inhibition of the left dlPFC leads to an increase in idea generation implying that the disengagement of the executive control network facilitates the production of novel ideas, which may indicate that decreased reliance on top-down processing promotes the generation of novelty. Interestingly, tACS has also been employed to boost creativity. The application of alpha frequency (10 Hz) tACS over the bilateral dlPFC increased divergent thinking measures on the verbal AUT for individuals with higher creative potential [103] and on the TTCT, though regardless of creative potential differences [104]. Moreover, creativity may be further boosted by enhancing connectivity between neural nodes within the executive control and default mode network. Accordingly, anodal tDCS over the left dlPFC and cathodal tDCS over the right inferior parietal lobe (IPL) were associated with functional connectivity changes, as assessed by EEG, in critical nodes of the default mode network, such as the IPL and posterior parietal cortex (PPC; [105]). These changes positively correlated with measures of creative thinking on the AUT. Taken together, these results suggest that the dlPFC plays a causal role in both convergent and divergent thinking, and this may occur through a modulatory effect of the dlPFC on top-down processing attributed to the executive control network with further implications on default mode network engagement.

Outside the role of the dorsal prefrontal regions in creative thinking, researchers have focused on the role of more ventral areas, such as the ventrolateral PFC (vlPFC) (including the IFG), in light of their involvement in the executive control and default mode networks. For a systematic examination of the effect of different tDCS on creativity, Chrysikou et al. [106] compared 12 different tDCS montages within a large sample and found that only cathodal stimulation over the left vlPFC improved fluency of creative idea generation, confirming their previous findings [107]; such a result suggests that inhibition of this region, in part, reduced engagement of the executive control network with subsequent consequences of improved creative performance. However, much like the dlPFC, some evidence points to the existence of lateralized roles of the vlPFC in modulating the engagement of the executive control network in both divergent and convergent thinking. Cathodal stimulation over the left IFG increased divergent thinking on the AUT while anodal stimulation decreased divergent thinking [108]. Moreover, similar increased performance on creativity tasks, including the AUT [109, 110] and verbal divergent thinking tasks [111] have been observed when the two stimulations (cathodal over the left vlPFC and anodal over the right vlPFC) are combined in a bi-hemispheric montage. This suggests a lateral balance of the vlPFC with the left vlPFC being more involved in idea evaluation/selection and the right IFG being more involved in idea generation, which has been further supported by results from Kleinmintz et al. [112] who employed a combined TMS-fMRI paradigm. As assessed by the AUT, the authors found that the left IFG was more active in idea evaluation versus idea generation and in an evaluation task measuring the novelty and appropriateness of AUT object use. Furthermore, the authors found that theta-burst TMS over the left IFG reduced performance on the evaluation task and improved performance on the AUT. Mirroring

the functional mechanisms of the dlPFC on creative thought via the modulation of top-down processing, inhibition of the left vlPFC and excitation of the right vlPFC (in particular the IFG) lead to an increase in idea generation indicating that the disengagement of the executive control network partly enables divergent thinking. Conversely, opposite stimulation within these nodes leads to improved idea evaluation/selection implicating that the engagement of the executive control network facilitates convergent thinking.

Researchers have also explored the causal role of the parietal lobe in creative thinking in light of fronto-parietal circuits partly comprising the executive control network. Accordingly, the angular gyrus (AG) is highly involved in memory, sensory integration, and storing semantic information [113, 114]. Previous neuroimaging evidence has found that creative improvisations in musicians were related to decreased right AG activation [115]. Similarly, the generation of original ideas was associated with widespread deactivation in the same region [116], a finding that is in line with evidence of reduced parietal brain activity during creative compared to non-creative cognition [84, 117, 118]. In the exploration of the AG's causal role in creativity, Lifshitz-Ben-Basat and Mashal [119] reported an improvement of novel metaphor generation with cathodal tDCS over the left AG yet an improvement of conventional metaphor generation with anodal tDCS over the left AG. Interestingly, these findings conflict with past neuroimaging research that found strong activation of the left AG during the generation of creative metaphors [120]. Moreover, anodal tDCS over the bilateral AG reduced divergent thinking abilities but increased convergent thinking abilities as assessed by the RAT [121]. Although evidence is slightly conflicting, the results posit that the AG may play a constricting role on focused attention through the executive control network, which may be moderated by top-down processing attributed to semantics and memory. In line with this, Thakral et al. [122] employed a combined TMS-fMRI paradigm and found that theta-burst TMS over the left AG reduced performance in both a divergent thinking (AUT) and an episodic memory task, which is reflected in decreased hippocampal activity. Therefore, the hippocampal role in episodic memory may be crucial to creativity via connections with the AG, and these connections may implicate top-down effects of episodic memory retrieval on divergent thinking. Furthermore, tRNS over the bilateral PPC improved convergent thinking as assessed by RAT; however, there were no effects on verbal and visual divergent thinking tasks, which suggests that the PPC orients attention for idea evaluation/selection only [123]. Taken together, these results suggest a specific role of posterior inferior parietal regions within the executive control network in directing attention to the best solution on hand via convergent thinking and imply a modulatory role of these parietal regions on the default mode network in novel idea generation via divergent thinking.

In consideration of these fronto-parietal circuits in creativity, a few studies have attempted to employ NIBS to directly investigate art creation. These studies mainly targeted frontotemporal regions in line with evidence linking these sites to the emergence of artistic talents in patients with frontotemporal lobe dementia [124]. Among these, Snyder et al. [125] observed major changes in the scheme or convention of healthy individuals' drawings following offline rTMS of the left frontotemporal

lobe. Striking improvements in drawing skills in terms of representational accuracy and artistic merit were observed also during online rTMS of the same region [126]. Moreover, Simis and collaborators [127] reported improvements in the drawing styles (in terms of creativity, perspective, realism, and representational accuracy) following anodal tDCS of the right frontotemporal area in a patient who developed a sudden artistic interest after a stroke in the left homologous region. According to Simis et al. [127], such an improvement may depend on indirect stimulation effects on right parietal regions' visual–spatial function via fronto-parietal connections (i.e., the executive control network) that facilitate creative thought.

3.2 Temporal Lobe

The temporal lobe, given its role in semantic processes and its participation to both bottom-up and top-down mechanisms, has been also explored through NIBS within the creativity domain. Specifically, considering the role of the anterior temporal lobe (ATL) in semantic representation [128], Chi and Snyder [129, 130] investigated whether reducing the top-down effects, with a consequential reliance on bottom-up processing, would affect participants' ability in choosing the best novel solution, outside prior semantic stores. Cathodal stimulation over the left ATL and anodal stimulation over the right ATL improved performance on the matchstick task [129] and 9 dot problem [130], which require novel ways of thinking in order to find a solution. Moreover, 10 Hz tACS over a similar region of the ATL (slightly shifted posteriorly) improved performance on different variations of RAT and AUT [131]; similarly, gamma frequency (40 Hz) tACS over the same region led to improved performance on the CRAT [132]. Critically, these behavioral effects have been shown to correlate with functional connectivity in the bilateral temporal lobes (as measured with resting-state functional MRI data acquired before the stimulation); accordingly, tACS induced an increase in gamma oscillations over the temporal lobes bilaterally as revealed by post-stimulation EEG [132]. These results suggest that specific creative task differences might be associated with different brain oscillations within creative thought and implies a need for researchers to critically consider the behavioral paradigms employed for the investigation of creativity. Likewise, more posterior regions of the temporal lobe have been also shown to participate in the creative process. Indeed, cathodal tDCS over the right temporoparietal junction (TPJ) and anodal tDCS over the left middle temporal gyrus led to an increased performance in verbal fluency and verbal insight, reflecting divergent and convergent thinking respectfully [133]; however, this was mostly found in non-native speakers, which suggests a role of expertise in creative thinking for language. These findings mimic neuroimaging evidence that found decreased activation of the TPJ and increased activation of the medial temporal lobe in the generation of novel ideas [134, 135]. Therefore, the role of temporal regions in semantic processing and retrieval may be connected to the interplay of the default mode and executive control networks in idea evaluation/selection and generation. Accordingly, the heightened retrieval of prior semantic stores within the temporal lobes for idea evaluation/

selection may be seen with increased engagement of the executive control network via subsequential top-down effects. In contrast, reduced temporal lobes' engagement may facilitate idea generation via increased reliance of bottom-up effects attributed to the default mode network. Therefore, much like the fronto-parietal network, further disentanglement between the top-down and bottom-up effects on creativity in the temporal lobes is necessary to clarify the specific causal roles of these regions in creative thought.

3.3 Motor-Related Areas

Neuroimaging evidence has indicated the involvement of motor-related regions within creativity. For instance, the anterior intraparietal sulcus, involved in reaching and grasping behavior, has been positively related to generating creative uses for tools [136]. However, the role of motor-related regions within creativity may depend on individual's expertise. Indeed, expert musicians show differences in the recruitment of brain regions within the mirror neuron system during listening [137] and musical performance [138], and imagined musical improvisation without motor involvement has shown to recruit premotor cortical areas [139]. Outside music, visual art training within art-expert populations induced longitudinal changes in motor cortical and cerebellar activity, which was associated with increased gesture drawing performance [140]. Likewise yet independent of creative expertise, a 5-week training based in design-oriented thinking produced longitudinal effects on brain activity within the supplementary motor area and cerebellum [141]. This suggests that the occurrence of plastic changes within motor-related areas when learning music and visual art may also be attributed to creative thinking. Notwithstanding these findings associating creativity with sensorimotor processes, brain stimulation research exploring the causal role of motor-related regions in creativity is scarce. To our best knowledge, the only available evidence applied tDCS to evaluate the role of the primary motor cortex (M1) in creative music performance [142] and showed that music improvisations composed by expert jazz-musician during anodal tDCS were rated as significantly more creative than those performed during cathodal stimulation, possibly because of a facilitation in the conversion from a preplanned creative idea to a creative motor action. Nevertheless, further investigation regarding the role of the sensorimotor cortical areas in different stages of the creative process proves fruitful.

3.4 Summary and Discussion

Taken together, the engagement and disengagement of the executive control and default mode networks mimic the fluctuation of flexible and persistent thinking necessary for idea generation and evaluation/selection within creative thinking. These processes can be attributed to cortical areas within the frontal, parietal, and temporal lobes. However, given the limitations of NIBS techniques to reach midbrain regions

constituting the default mode network, most brain stimulation research within creativity relies heavily on directly stimulating the more superficial brain regions of the executive control network with implied indirect effects on the default mode network. The disengagement and engagement of the executive control network provides much clarification about the specific roles of brain regions within both convergent and divergent thinking, and the engagement of such brain regions posits a modulation of top-down and bottom-up processing on creative thinking. Accordingly, prefrontal and parietal regions showed casual roles in both divergent [96, 106, 107], and convergent thinking [95, 97]. However, some research suggests that prefrontal regions may play a critical role in shifting attention to the task on hand, which is supported by evidence showing that anodal stimulation over the prefrontal cortex improved divergent thinking only when participants were instructed to think more divergently [100, 102]. Therefore, the prefrontal striatal circuits modulating flexibility and persistence [73] and the fronto-parietal network within the executive control network [75, 76] may induce top-down effects on creative thought with the respective prefrontal areas swaying an individual to think either more convergently or divergently. However, by combining NIBS with either fMRI or EEG (e.g., Thakral et al., [122]), researchers may continue to provide strong causal evidence to further disentangle the roles of distinct nodes of the default mode network and executive control networks within creative thinking. Through such an approach, it has been possible to observe a coupling between the dlPFC, the IPL and the PPC [105], further supporting prior neuroimaging evidence (e.g., [70]) showing that these regions may work in concert to produce both divergent and convergent thinking. Moreover, tACS studies showed encouraging results on the oscillatory activity causally mediating creative thinking, and proposed that, in addition to prefrontal and parietal areas within the executive control network, semantic processes within the temporal lobe play a pivotal role in the proposed top-down and bottom-up processes associated with creative thought. Lastly, we have shown limited NIBS evidence for the causal role of motor-related cortical areas in creative thinking; however, future research may expand on the associations between creativity and sensorimotor processes.

4 Aesthetic Experience

Current theory suggests that aesthetic experience transpires from the harmonious interaction between sensory-motor, emotion-valuation, and meaning-knowledge systems (the so-called *aesthetic triad*, [4]) which reflects the recruitment of cortical and subcortical regions. The sensory-motor system designates the activation of regions in the occipital, temporal, and parietal cortices responsible for low-level sensory abilities (e.g., [143, 144]), such as object recognition indicative of gestalt principles [145], and the engagement of the mirror neuron systems via sensorimotor embodiment necessary for the fluid comprehension of actions and their associated intentions [146, 147]. The emotion-valuation system constitutes aesthetic evaluations with frontal cortical regions deputing the appraisal of beauty [7, 148–150], liking

warranting the recruitment of reward circuitry [144, 151, 152], and affect being derived from the activation of limbic areas [153–159]. The meaning-knowledge system constitutes top-down processes of context and suggests that information about an artwork and its varying esteem have top-down effects on aesthetic experience via the further modulation of brain areas recruited during the emotion-valuation and sensory-motor systems [152, 160, 161]. Similarly to creativity, the default mode and executive control networks have been suggested to play significant roles in the emergence of aesthetic experience [162–166] and may reflect a synchronization of the neural systems akin to the aesthetic triad. In an all-encompassing explanation of aesthetic experience, the aesthetic triad rationalizes bottom-up and top-down effects on aesthetic experience through the interaction between brain areas needed for low-level sensory and high-level cognitive and affective processing.

Most of the brain stimulation research within aesthetic experience has implemented TMS to produce virtual lesions in the targeted brain areas; however, a few of these studies have investigated the neural bases of aesthetic appreciation using tDCS. In the next sections, we present the evidence concerning the causal role played by different cortical regions during aesthetic experience, focusing mostly on visual art perception and appreciation.

4.1 Prefrontal Cortex

Of important interest, aesthetic experience has been associated with engagement of subcortical limbic regions involved with reward computation and emotional processing, which includes the insula, amygdala, ventral striatum, and cingulate cortex [144, 154, 167–169]. However, given brain stimulation's limited possibility in reaching deeper areas, investigation of subcortical and limbic areas through TMS and tDCS in aesthetic experience is not feasible outside stimulating more surface level cortical areas directly involved in emotional and reward neural circuitry. Indeed, activation of frontal-cortical areas has been seen during the aesthetic judgement of beauty with utmost consideration given to the orbito-frontal cortex, mPFC, and dlPFC [7, 144, 148, 164, 169, 170]. Accordingly, anodal tDCS directed at the mPFC increased the judgement of beauty in paintings [171], whereas anodal tDCS over the left dlPFC increased subjective preference for representational but not abstract visual artwork [172]. Moreover, participants that prefer representational vs. abstract artwork (and vice versa) showed reduced liking for artworks congruent with their general preference following interfering TMS over the left dlPFC [173]. These results suggest a role of state-dependency, which posits that the neuronal population on hand is affected by the internal state of the system [50]. Accordingly, neuronal populations within the left dlPFC may be in an activated state congruent to the a-priori preference of artwork content (specifically representational vs. abstract), which suggests that individual differences in the general preference of artwork content plays a modulatory role within the left dlPFC on aesthetic appreciation. Similarly, anodal tDCS over the dorsal mPFC and cathodal tDCS over the right dlPFC increased perceived facial attractiveness and modulated the engagement of

ventral midbrain areas, as measured by post-stimulation fMRI [174], which suggests that specific neural circuitry inherent to the aesthetic appreciation of faces exists within the mPFC and right dlPFC. In contrast, anodal tDCS over the right dlPFC increased the appraisal of facial attractiveness [175]. Interestingly, the right dlPFC and striatum are connected by prefrontal-striatal dopaminergic circuits [73, 176], and this circuitry may underlie the aesthetic evaluation of facial attractiveness with reward computation being needed in judging facial attractiveness. In other words, the configural processing of faces may be integral in judging the attractiveness of faces such that the excitation of the right dlPFC reflects an enhancement of facial configural processing and results in an increase of perceived facial attractiveness [175]. Therefore, in the aesthetic appreciation of artwork, anodal stimulation of prefrontal areas may lead to higher engagement of dopaminergic frontal-striatal circuits that modulate the reward-anticipation mechanisms attributed to midbrain areas. However, outside the indirect effects of the dlPFC on reward circuitry, other neural networks may play with the modulation of neural areas underlying reward computation. Accordingly, Keeser et al. [177] employed a tDCS and fMRI paradigm and found that anodal tDCS over the left dlPFC modulated the functional connectivity of the executive control and default mode networks. In other words, excitation of the left dlPFC, as part of the executive control network, may direct attention to evaluating the artwork on hand [172] while interfering with neural activity in the left dlPFC may divert attention away from evaluating the artwork on hand [173], yet these attentional effects may be dependent on the viewer's individual differences [173, 178]. Therefore, executive control modulated by the interplay between the attentional and default mode networks may be vital in the aesthetic appreciation of art.

4.2 Parietal Cortex

Parietal activity has been suggested to reflect spatial encoding and, in effect, the scene and the aesthetic appreciation of the artwork on hand [154, 155, 162, 163]. Inspired by this neuroimaging evidence and the role of the right PPC in the processing of visual spatial attention and representation (for review see [179]), Cattaneo et al. [173] delivered TMS over the right PPC while participants were asked to rate their subjective preference of abstract and representational paintings (see previous section for findings related to the PFC). TMS reduced the liking of representational paintings for participants that generally preferred representational to abstract art, which compliments neuroimaging evidence suggesting higher engagement of the PPC for meaningful and familiar representational artwork [180]. Therefore, the right PPC may have a causal role in the analysis of familiar and meaningful representational artwork specific to the viewer. Moreover, the parietal cortex plays important roles in motor embodiment [181], value-based decision-making via communication with the ventromedial prefrontal cortex [182], and the fronto-parietal network responsible for executive control [75, 76]. In line with this, offline TMS over the right PPC increased an individual's affective rating of dance, which

suggests that disrupting the right PPC may free up cognitive resources for emotional processing [183]. Thus, TMS over the right PPC may interfere with parietal communication with other brain regions with a subsequential consequence on the emerging aesthetic experience.

4.3 Motor-Related Areas

The mirror neuron system's role in processing actions and emotion [147] posits the exploration of the embodied mechanisms possibly contributing to aesthetic perception, evaluation and appreciation. Accordingly, sensorimotor cortices have shown higher engagement during the observation of dance movements [184–187], sculptures, and figurative paintings [155–157, 188]. On the contrary, the judgment of beauty in paintings activates regions involved in sensorimotor embodiment (e.g., M1); however, their involvement has been theorized to engage motor preparation mechanisms like approach/avoidance behaviors [149, 157]. The involvement of the motor cortex in aesthetic appreciation of paintings has been assessed by Nakamura and Kawabata [189] using tDCS. This group applied tDCS to simultaneously modulate excitability of the dorso-medial PFC (dmPFC) and the left M1 while measuring the effects of stimulation on beauty and ugliness judgments on a series of abstract paintings. These sites were targeted in light of prior fMRI evidence showing that the dmPFC responds more to preferred paintings, whilst the motor cortex seems to respond more to artworks perceived as ugly, possibly reflecting motor preparation to avoid the ugly or aversive stimulus [148, 149]. In line with this, Nakamura and Kawabata [189] hypothesized that enhancing excitability in one of these two regions while concurrently inhibiting excitability of the other region would have affected beauty and ugliness evaluations. Anodal stimulation of the left M1 (combined with cathodal stimulation of the dmPFC) led to a decrease in beauty ratings, without affecting ugliness ratings; the opposite tDCS montage had no significant effect on beauty or ugly judgements. The results of this study suggest that enhancing excitability of the motor cortex (and concurrently decreasing excitability in the dmPFC), may result in decreased perceived beauty in abstract paintings. Unfortunately, the stimulation montage used in this study does not allow us to determine whether the reported effects depended on anodal stimulation of the left M1, cathodal stimulation of the dmPFC or interaction effects between the two. Disentangling between these possibilities deserves further investigation.

Considering the evidence suggesting embodied mechanisms in aesthetic experience, the investigation of cortico-spinal excitability (CSE) by measuring motor evoked potentials (MEPs) induced by single-pulse TMS over the M1 [34] has been employed in the viewing of visual artwork [190–192] and dance [193]. In particular, observation of Adam's figural arm gesture in Michelangelo's *Expulsion from Paradis* (1508–1512) increased CSE significantly more than a photographic reproduction of the same artwork [190]. Moreover, live dance performance increased CSE in comparison to a recorded dance performance [193]. Therefore, the kinesthetic depictions within art may be more stimulating than life-like reproductions,

which compliments the peak-shift principle [145] that suggests artwork is an over exaggerated portrayal of reality. Likewise, single-pulse TMS was applied over the M1 to explore the CSE related to the perceived dynamism and subjective preference of figurative and landscape paintings differing in dynamic and static content [192]. MEPs amplitude was substantially larger during the viewing of figurative dynamic artwork; however, the relation between MEP and liking was completely mediated by dynamism, which suggests embodied mechanisms behind the subjective preference of figurative art. Accordingly, a recent study [191] observed muscle-selective MEPs' facilitations in response to passive viewing of paintings of different styles (i.e., pointillist- or brushstroke-style) only during later stages of stimulus processing (i.e., 300 ms post stimulus). These findings likely reflect motor simulation of actions required to produce an artwork and the sensorimotor states embedded in its content; in turn, no modulation was reported in earlier stages of stimulus processing (i.e., 150 ms), when covert approach responses associated with the emotional valence of the stimulus are more likely to occur. Critically, M1 excitation and the resulting MEPs may not be a direct reflection of motor stimulation mechanisms [147] with afferent connections to the M1 from other cortical areas involved in higher cognitive processes providing top-down effects on CSE (for a review, see [34]). The causal investigation of aesthetic experience through MEPs proves valuable to neuroaesthetics; however, the implied results must be considered carefully.

4.4 Ventral and Dorsal Visual Stream Areas

As regards ventral visual stream areas, Calvo-Merino et al. [194] further investigated the role of the extrastriate body area (EBA), playing a significant role for local processing of bodies (e.g., body parts), and the ventral premotor cortex (vPMC), playing a significant role for the configural processing of bodies (e.g., whole bodies; for review of EBA and PMC in body perception and processing see [195]) in subjective preference. The authors delivered rTMS over the EBA and vPMC during a subjective rating task. TMS over the left and right EBA reduced aesthetic sensitivity of body stimuli in comparison to ipsilateral stimulation over the vPMC. The authors suggested that TMS over the EBA interfered with the local processing of bodies in male dancer postures and proposed a direct *causal* association for the EBA in the aesthetic appreciation of bodily stimuli. Accordingly, Cazzato et al. [196] delivered rTMS over the EBA and dorsal PMC (dPMC) while participants were asked to indicate their subjective preference for virtual bodies. In relation to the participants' sex, they found that TMS over the right EBA lead to an increase in the liking of opposite sex bodies while TMS over the dPMC lead to a decrease in the liking of same-sex bodies. The general conclusions posit that the EBA plays a causal role in the subjective preference of bodies, and complimentary to the interpretations of Calvo-Merino et al. [194], the authors suggest that this may be in relation to the local processing of bodily parts with the interference of the EBA contributing to the recruitment of additional premotor areas necessary for the configural processing of bodies. In consideration of other low-level visual areas, the lateral occipital (LO)

cortex plays a specific role in object and shape encoding [197], and neuroimaging evidence suggests that the LO plays a specific role in the subjective preference of art-images [152]. Accordingly, TMS over the LO reduced subjective preference for representational art, but not abstract art [198].

Moreover, prior evidence has shown that also dorsal visual stream regions, including V5/MT+ and superior temporal sulcus (STS) may take part to aesthetic experience [199, 200], which compliments the findings that dynamic representational paintings are more preferred than static representational paintings [201] and implied motion in static images engages the V5/MT+ [202, 203]. However, there seems to be dissociation of content with V5/MT+ activation not being related with subjective preference for representational art [200]. To investigate the possible causal role of the V5/MT+ in the aesthetic appreciation of artwork, Cattaneo et al. [204] delivered TMS over the V5/MT+ while participants were asked to rate the dynamism and their subjective preference for a series of representational and abstract paintings. TMS over the V5/MT+ reduced dynamism ratings in both representational and abstract art yet reduced liking ratings in abstract art only. These results posit that the V5/MT+ plays a more significant role in the processing of abstract art whose content encompasses more low-level visual features, which lacks vitality in representational art. As regards STS, Ferrari and collaborators [205] employed TMS to investigate the role of this region in processing the emotional expressivity of portraits. TMS reduced the perceived expressivity of moderately expressive portraits but not of moderately expressive figural representational paintings. Moreover, no effect of TMS on liking ratings were found, which suggests a direct role of the STS for processing emotional expressions in aesthetic stimuli but not in their aesthetic appreciation. Therefore, the content of visual artwork differs in the engagement of visual cortical regions for aesthetic appreciation, with abstract artwork recruiting dorsal stream visual regions, such as the V5/MT+, and representational artwork recruiting ventral stream visual areas, such as the LO. However, the more particular roles of the visual and dorsal streams for the differing and specific content within abstract and representational art require further investigation.

4.5 Summary and Discussion

NIBS research has provided further causal evidence on the neural underpinnings of aesthetic experience. This includes brain regions within the visual dorsal and ventral pathways [194, 196, 198, 204, 205], premotor and motor-related cortical areas involved in sensorimotor embodiment processes [190–194, 196], parietal regions associated with sensory encoding [173, 183], and prefrontal areas with indirect contributions to reward computation circuitry [171–175]. The recruitment of these brain areas mirrors the neural systems theorized within the aesthetic triad [4]. Prefrontal areas play a specific role in the emotion-valuation system, and although much brain stimulation evidence does not warrant conclusions about the brain regions involved in the meaning-knowledge system, the parietal cortex might contribute to modulate subjective preference based on the meaningfulness of artwork

specific to the individual [173]. Of high interest, there seems to be a functional overlap of low-level visual areas and motor areas within the sensory-motor system with a concurrent interaction with the emotion-valuation system. Taken together and in line with cognitive models of aesthetic experience [178], these results suggest a convergence of top-down and bottom-up processes in driving the aesthetic appraisal of visual stimuli. The correlational neuroimaging evidence in conjunction with the contribution of NIBS in pointing to causal brain-behavior relationships provides overwhelming support for a neural basis grounding aesthetic experience.

5 Discussion

Non-invasive brain stimulation (NIBS) techniques can offer a unique opportunity to inform about brain-behavior *causal* relationships, critically complementing neuroimaging, electrophysiological and neuropsychological findings. Within this chapter, we have reviewed the available evidence employing NIBS to investigate the neural bases of both creativity and the emerging aesthetic experience (see Fig. 1). Overall, studies conducted so far seem to suggest that both processes recruit numerous cortical regions, composing an extended and dynamic network spanning from low-level sensorimotor to higher-level associative cortices, with some areas of overlap between creativity and aesthetic experience.

The available TMS and tES studies demonstrated that interfering with the activity of prefrontal and parietal areas included in the executive control network can have both enhancing and detrimental effects on creativity as measured by

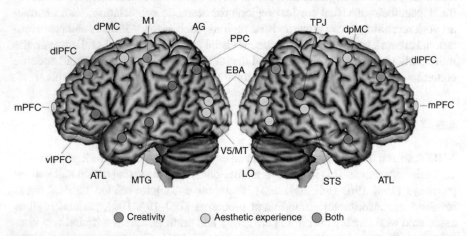

Fig. 1 Schematic representation indicating the relative locations of different cortical areas targeted using non-invasive brain stimulation to assess creativity (blue), aesthetic experience (yellow) or both (green). *dlPFC* dorsolateral prefrontal cortex, *vlPFC* ventrolateral prefrontal cortex, *mPFC* medial prefrontal cortex, *ATL* anterior temporal lobe, *M1* primary motor cortex, *dPMC* dorsal premotor cortex, *MTG* middle temporal gyrus, *STS* superior temporal sulcus, *TPJ* temporoparietal junction, *AG* angular gyrus, *PPC* posterior parietal cortex, *EBA* extrastriate body area, *LO* lateral occipital complex

convergent and divergent thinking tasks, likely as a result from top-down modulation via cognitive processes denoting attentional control and shifting, semantic representation and memory retrieval (e.g., [96, 98, 110, 122, 123]). Still, regions within the temporal lobe, particularly the anterior temporal lobe and the temporo-parietal junction, have also shown to play a causal role in modulating creative thinking, possibly through the recruitment of prior semantic information [129–133]. Critically, studies combining brain stimulation and neuroimaging techniques showed that the direct modulation of regions within the executive control network, with implications on top-down processing, induces concurrent indirect effects on nodes within the default mode network (typically less accessible with conventional TMS or tES protocols) with implications on bottom-up processing [105, 112, 122]. In support with previous neuroimaging data (e.g., [70]), these findings suggest that inhibition of the cortical nodes of the executive control network, with an indirect excitation of the default mode network, modulates creativity processes by improving divergent thinking and reducing convergent thinking (and vice versa).

A similar multifaceted picture of complex interconnected networks emerges from evidence applying NIBS to the study of the brain systems driving aesthetic experience. Indeed, the available TMS and tES studies have provided support for a causal involvement of prefrontal regions, mainly the dorsolateral and medial prefrontal cortices, in visual aesthetic evaluations [171–175, 177, 189]. However, it still needs to be clarified whether top-down attentional processes or indirect prefrontal contribution to reward-related computations through fronto-striatal connections mediates this effect. Moreover, in light of their role in spatial encoding, posterior parietal regions also appear to participate to the aesthetic appreciation of visual stimuli, possibly by allowing the analysis of familiar and meaningful elements within the stimulus that are specific to the viewer [173, 183]. Areas within the dorsal and ventral visual pathways are also involved in the aesthetic evaluation of bodies and artworks [194, 196, 198, 204, 205], supporting a prominent role of content (e.g., abstract vs. figurative) within artwork to employ different low-level visual areas within a viewer's aesthetic experience. Furthermore, although still preliminary, the research conducted so far on motor and premotor cortices supported their causal role in aesthetic experience, which has been related to mechanisms of sensorimotor embodiment during the appreciation of visual artwork [189–193].

These findings, together with prior neuroimaging and electrophysiological evidence, point to the existence of partially overlapping neural mechanisms at the basis of creative thinking and aesthetic experience, particularly within prefrontal and parietal regions included in the executive control and default mode network. Indeed, a major implication from these NIBS studies centers on the causal roles of top-down and bottom-up processes in both creativity and aesthetic experience. As regards to creativity, the reduction of top-down effects and higher reliance on bottom-up processing leads to an increase in the generation of novel solutions in creative tasks while improvement of top-down effects may allocate resources to memory retrieval for idea evaluation/selection (for review see [94]). Similarly, cognitive models of

aesthetic experience [178] propose that the recruitment of sensory-motor, affective and associative cortices during aesthetic experience is modulated by the interaction between top-down and bottom-up processes. Indeed, the involvement of prefrontal and parietal regions during the aesthetic evaluation of a visual artwork depends on participants' *a-priori* inclination toward that artwork [173], which suggests that semantic representations may play an important role not only in creative thinking [129–133] but also in aesthetic experience. Nevertheless, now that the causal role of these regions in both creativity and aesthetic appreciation has been established, it is necessary to disentangle whether their contribution to the two domains relies on common (i.e., domain-general) or independent (i.e., domain-specific) functional mechanisms. For instance, prefrontal regions' recruitment during creative tasks may reflect the modulation of top-down control mechanisms over lower-level sensory processes, whereas during aesthetic evaluations, it may depend more on implicit affective and reward-related processes through connections with subcortical structures such as the striatum [73, 176], a possibility that future studies may address. Lastly, whereas low-level sensory and motor-related cortices have been associated with bottom-up mechanisms deputed to the automatic processing of elemental features of aesthetic objects [4], NIBS studies (mostly in the field of aesthetic experience) proposed that their contribution may be extended to higher-level aspects involved in aesthetic evaluation and engagement likely through embodied mechanisms [190–193]. Brain stimulation evidence exploring the contribution of sensorimotor regions in creativity is almost lacking and represents a promising avenue for future studies.

5.1 Challenges in Using NIBS to Study Creativity and Art

Although the results from these studies are encouraging in their explanation of the neural underpinnings behind the aesthetic experience and creativity, their statistical power should be criticized as some have low sample sizes of under 20 participants. Therefore, misconceptions about the validity of these studies concluding on aesthetic experience should be considered. Importantly, one of the most glaring limitations within NIBS pertains to its inability to directly affect deeper brain areas. For creativity, this mostly concerns the investigation of nodes within the default mode network, such as the ventromedial sectors of the PFC, and although previous research has employed tDCS to explore the role of the dmPFC in aesthetic appreciation [171, 174, 189], these tDCS montages rely on the concurrent stimulation of other cortical regions [206–208]. Therefore, a paradoxical argument arises concerning the true neural underpinnings for the construct being investigated, such that results from employing NIBS protocols may either reflect the specific NIBS montage employed or the modulation of the targeted brain region(s). Moreover, subcortical limbic regions involved in the aesthetic emotion and reward computation play a central role in aesthetic experience, and stimulation of these regions is not deemed feasible with conventional NIBS paradigms.

5.2 Future Directions

Despite the limits in the use of NIBS mentioned above, there is a high potential of these techniques for developing research in creativity and art. Accordingly, the few studies utilizing NIBS paradigms to explore art creation [124–127] have helped pave the road to apply more sophisticated NIBS paradigms for the causal investigation of creativity, the emerging aesthetic experience, and the intersection of the two. For instance, now that the brain nodes causally contributing to creative and art-related processing have been established with NIBS, it is time to move the investigation forward to shed light on the functional connections causally mediating their involvement. For this purpose, specific dual sites TMS protocols, as paired-pulse TMS (pp-TMS) and cortico-cortical Paired Associative Stimulation TMS (ccPAS TMS), in which two (directly or indirectly) interconnected cortical regions are stimulated with millisecond-level asynchrony, may be employed to assess and modulate cortico-cortical functional connections implicated in creativity and art. To date, these approaches have been applied to study effective connectivity in perceptual, motor and cognitive processes (e.g., [209, 210]) and can now be extended to deepen our understanding of feedback and feedforward connections involved in different aspects of creative and aesthetic processes. Nevertheless, it is important to note that to successfully target cortico-cortical functional connections with dual-site TMS protocols, precise information on the time course of the involvement of the two target sites is essential. To this aim, the use of online TMS might be of great help to shed light on the *chronometry* of the causal contribution of different cortical regions in creative processes and aesthetic engagement, that will then constitute the basis to test specific functional connectivity hypothesis. With the same purpose of moving the investigation from isolated nodes to interconnected networks, research in creativity and art may also benefit of the combination of NIBS with fMRI (for first attempts in this direction, see [105, 122]) or EEG recording. Such a combined approach allows to better understand the interrelation between physiological and behavioral impact of brain stimulation, and to bring to light the stimulation effects on distal (cortical and subcortical) sites, contributing to the understanding of network dynamics in creative thinking and art perception/appreciation. All the above-mentioned approaches may be particularly valuable to investigate whether there are dedicated circuits for different creative processes, such as convergent and divergent thinking, as well as for different stages of aesthetic perception and appreciation. Moreover, given the overlapping neural underpinnings within creative thinking and aesthetic perception and appreciation, these approaches may be applied to explore the neural intersection of these mental faculties. Indeed, behavioral and neuroimaging evidence have already investigated individual differences of art expertise in aesthetic experience [211–215]; however, the *causal* role of different brain regions in mediating the associations between individual differences, the emerging aesthetic experience, and creativity have yet to be explored.

Another intriguing application would be the use of rhythmic TMS or tACS to interact with endogenous oscillatory neural activity. Frequency-tuned NIBS allows identifying the underlying intrinsic frequency mediating the involvement of a target

region in a specific function and disentangles whether its contribution to different behaviors may depend on specific oscillatory rhythms. Such an approach has already led to important developments in the understanding of the neural bases of creative thinking (e.g., [104]); however, it has never been applied to study the oscillatory frequencies mediating aesthetic experience. On this regard, as animal and human studies consistently suggest, reward is associated to specific oscillatory neural activity [216, 217], thus NIBS may be used to boost oscillations associated with art-related reward. Lastly, emerging stimulation protocols, such as transcranial focused ultrasound stimulation (tFUS), consisting in the delivery of a focused ultrasonic beam to a small target area in the brain, represents another promising way to study causal brain-behavior relationships in creativity and art. Indeed, the very high tFUS spatial resolution that allows to reach brain regions inaccessible with TMS and tDCS, like the thalamus (e.g., [218]), may be particularly suitable to target motor, emotional and reward-related subcortical structures involved in creative and aesthetic processes. Moreover, tFUS, as it applies acoustic waves rather than electric or magnetic fields, can be readily combined with fMRI and EEG without interfering with the recordings.

6 Conclusions

Taken together, similar underpinnings behind the cognitive processes of creativity and the aesthetic experience exist mainly within the executive control and default mode networks. Although the aesthetic experience has been shown to recruit more low-level visual areas, there is a recruitment of motor-related areas for both creativity and aesthetics, yet to date, more NIBS evidence exists supporting the involvement of motor-related areas within aesthetic experience. Given the overlap within the arts domain of both creativity and aesthetic experience, exploration of their neural and cognitive commonalties may further expand our understanding about the neural underpinnings broadly existent within the arts. This exploration may look at the individual differences of creativity and expertise on aesthetic experience or the individual differences of aesthetic evaluation in creative thinking. Future research utilizing NIBS paradigms may investigate these associations to illuminate the critical roles of motor embodiment, low-level vision perception, and the interplay between the executive control and default mode networks both outside and within the intersection of creativity and aesthetic experience to further our understanding about the core constructs comprising the arts.

References

1. Benedek M, Fink A. Toward a neurocognitive framework of creative cognition: the role of memory, attention, and cognitive control. Curr Opin Behav Sci. 2019;27:116–22. https://doi.org/10.1016/j.cobeha.2018.11.002.
2. Benedek M, Christensen AP, Fink A, Beaty RE. Creativity assessment in neuroscience research. Psychol Aesthet Creat Arts. 2019;13:218–26. https://doi.org/10.1037/aca0000215.

3. Jung RE, Vartanian O. The Cambridge handbook of the neuroscience of creativity. Cambridge University Press; 2018.
4. Chatterjee A, Vartanian O. Neuroaesthetics. Trends Cogn Sci. 2014;18(7):370–5.
5. Nadal M, Skov M (2015) Neuroesthetics, 2nd edn. In International encyclopedia of the social & behavioral sciences, vol 16. Elsevier, Oxford, pp. 656–663.
6. Pelowski M, Markey PS, Lauring JO, Leder H. Visualizing the impact of art: an update and comparison of current psychological models of art experience. Front Hum Neurosci. 2016;10:160.
7. Cela-Conde CJ, Marty G, Maestú F, Ortiz T, Munar E, Fernández A, Roca M, Rossello J, Quesney F. Activation of the prefrontal cortex in the human visual aesthetic perception. Proc Natl Acad Sci U S A. 2004;101:6321–5.
8. Huang P, Huang H, Luo Q, Mo L. The difference between aesthetic appreciation of artistic and popular music: evidence from an fMRI study. PLoS One. 2016;11(11):e0165377.
9. Abraham A. The neuropsychology of creativity. Curr Opin Behav Sci. 2019;27:71–6.
10. Bieth T, Ovando-Tellez M, Bernard M, Volle E. Contribution of lesion studies to the neuroscience to creativity. Annales Medico-Psychologiques. 2019;177(2):164–8.
11. Bogousslaysky J. Art, creativity, brain and pain of living. Annales Medico-Psychologiques. 2019;177(2):169–72.
12. Boccia M, Barbetti S, Piccardi L, Guariglia C, Giannini A. Neuropsychology of aesthetic judgment of ambiguous and non- ambiguous artworks. Behav Sci. 2017;7(1):13.
13. Bromberger B, Sternschein R, Widick P, Smith WI, Chatterjee A. The right hemisphere in esthetic perception. Front Hum Neurosci. 2011;5:109.
14. Vaidya AR, Sefranek M, Fellows LK. Ventromedial frontal lobe damage alters how specific attributes are weighed in subjective valuation. Cereb Cortex. 2018;28(11):3857–67.
15. Pascual-Leone A, Walsh V, Rothwell J. Transcranial magnetic stimulation in cognitive neuroscience–virtual lesion, chronometry, and functional connectivity. Curr Opin Neurobiol. 2000;10(2):232–7.
16. Silvanto J, Cattaneo Z. Common framework for "virtual lesion" and state-dependent TMS: the facilitatory/suppressive range model of online TMS effects on behavior. Brain Cogn. 2017;119:32–8.
17. Amassian VE, Cracco RQ, Maccabee PJ, Cracco JB, Rudell A, Eberle L. Suppression of visual perception by magnetic coil stimulation of human occipital cortex. Electroencephalogr Clin Neurophysiol. 1989;74(6):458–62.
18. Bergmann TO, Hartwigsen G. Inferring causality from noninvasive brain stimulation in cognitive neuroscience. J Cogn Neurosci. 2021;33(2):195–225.
19. Hallett M, Di Iorio R, Rossini PM, Park JE, Chen R, Celnik P, et al. Contribution of transcranial magnetic stimulation to assessment of brain connectivity and networks. Clin Neurophysiol. 2017;128(11):2125–39.
20. Parkin BL, Ekhtiari H, Walsh VF. Non-invasive human brain stimulation in cognitive neuroscience: a primer. Neuron. 2015;87(5):932–45.
21. Rothwell J. Transcranial brain stimulation: past and future. Brain and neuroscience advances. 2018;2:2398212818818070.
22. Sliwinska MW, Vitello S, Devlin JT. Transcranial magnetic stimulation for investigating causal brain-behavioral relationships and their time course. J Vis Exp: JoVE. 2014;89
23. Stagg CJ, Antal A, Nitsche MA. Physiology of transcranial direct current stimulation. J ECT. 2018;34(3):144–52.
24. Karabanov AN, Saturnino GB, Thielscher A, Siebner HR. Can transcranial electrical stimulation localize brain function? Front Psychol. 2019;10:213.
25. Luber B, Lisanby SH. Enhancement of human cognitive performance using transcranial magnetic stimulation (TMS). NeuroImage. 2014;85:961–70.
26. Romei V, Thut G, Silvanto J. Information-based approaches of noninvasive transcranial brain stimulation. Trends Neurosci. 2016;39(11):782–95.
27. Aldini G. Essai théorique et expérimental sur le galvanisme: avec une série d'expériences faites en présence des commissaires de l'Institut national de France, et en divers amphithéatres anatomiques de Londres. Fournier 1804.

28. Parent A. Giovanni Aldini: from animal electricity to human brain stimulation. Can J Neurol Sci. 2004;31(4):576–84.
29. Bartholow R. ART. I.—experimental investigations into the functions of the human brain. Am J Med Sci. 1874. (1827-1924);134:305.
30. Merton PA, Morton HB. Stimulation of the cerebral cortex in the intact human subject. Nature. 1980;285(5762):227.
31. Faraday M. V. Experimental researches in electricity. Philos Trans R Soc Lond. 1832;122:125–62.
32. d'Arsonval JA. Action physiologique de courants alternatifs a grande frequence. Arch Physiol Norm et Pathol. 1893;5(401–8):780–90.
33. Barker AT, Jalinous R, Freeston IL. Non-invasive magnetic stimulation of human motor cortex. Lancet. 1985;325(8437):1106–7.
34. Bestmann S, Krakauer JW. The uses and interpretations of the motor-evoked potential for understanding behaviour. Exp Brain Res. 2015;233(3):679–89.
35. Salminen-Vaparanta N, Vanni S, Noreika V, Valiulis V, Móró L, Revonsuo A. Subjective characteristics of TMS-induced phosphenes originating in human V1 and V2. Cereb Cortex. 2014;24(10):2751–60.
36. Pascual-Leone A. Transcranial magnetic stimulation: studying the brain--behaviour relationship by induction of 'virtual lesions'. Philos Trans R Soc Lond B Biol Sci. 1999;354(1387):1229–38.
37. Fecteau S., & Eldaief M. Offline and online "virtual lesion" protocols. In Transcranial magnetic stimulation. New York, NY: Humana Press; 2014, pp. 143–152.
38. Beynel L, Appelbaum LG, Luber B, Crowell CA, Hilbig SA, Lim W, et al. Effects of online repetitive transcranial magnetic stimulation (rTMS) on cognitive processing: a meta-analysis and recommendations for future studies. Neurosci Biobehav Rev. 2019;107:47–58.
39. Deng ZD, Lisanby SH, Peterchev AV. Electric field depth–focality tradeoff in transcranial magnetic stimulation: simulation comparison of 50 coil designs. Brain Stimul. 2013;6(1):1–13.
40. Deng ZD, Lisanby SH, Peterchev AV. Coil design considerations for deep transcranial magnetic stimulation. Clin Neurophysiol. 2014;125(6):1202–12.
41. Sack AT, Cohen Kadosh R, Schuhmann T, Moerel M, Walsh V, Goebel R. Optimizing functional accuracy of TMS in cognitive studies: a comparison of methods. J Cogn Neurosci. 2009;21(2):207–21.
42. Zangen A, Roth Y, Voller B, Hallett M. Transcranial magnetic stimulation of deep brain regions: evidence for efficacy of the H-coil. Clin Neurophysiol. 2005;116(4):775–9.
43. Beynel L, Powers JP, Appelbaum LG. Effects of repetitive transcranial magnetic stimulation on resting-state connectivity: a systematic review. NeuroImage. 2020;211:116596.
44. Riedel P, Heil M, Bender S, Dippel G, Korb FM, Smolka MN, Marxen M. Modulating functional connectivity between medial frontopolar cortex and amygdala by inhibitory and excitatory transcranial magnetic stimulation. Hum Brain Mapp. 2019;40(15):4301–15.
45. Jackson RL, Lambon Ralph MA, Pobric G. The timing of anterior temporal lobe involvement in semantic processing. J Cogn Neurosci. 2015;27(7):1388–96.
46. Sliwinska MWW, Khadilkar M, Campbell-Ratcliffe J, Quevenco F, Devlin JT. Early and sustained supramarginal gyrus contributions to phonological processing. Front Psychol. 2012;3:161.
47. Silvanto J, Cattaneo Z. Nonlinear interaction between stimulation intensity and initial brain state: evidence for the facilitatory/suppressive range model of online TMS effects. Neurosci Lett. 2021;742:135538.
48. Hanslmayr S, Roux F. Human memory: brain-state-dependent effects of stimulation. Curr Biol: CB. 2017;27(10):R385–7.
49. Mazzoni N, Jacobs C, Venuti P, Silvanto J, Cattaneo L. State-dependent TMS reveals representation of affective body movements in the anterior intraparietal cortex. J Neurosci. 2017;37(30):7231–9.
50. Silvanto J, & Cattaneo Z. State-dependent transcranial magnetic stimulation (TMS) protocols. In Transcranial magnetic stimulation. New York, NY: Humana Press, 2014; pp. 153–176.

51. Thut G, Bergmann TO, Fröhlich F, Soekadar SR, Brittain JS, Valero-Cabré A, et al. Guiding transcranial brain stimulation by EEG/MEG to interact with ongoing brain activity and associated functions: a position paper. Clin Neurophysiol. 2017;128(5):843–57.
52. Bestmann S, Walsh V. Transcranial electrical stimulation. Curr Biol. 2017;27(23):R1258–62.
53. Yavari F, Jamil A, Samani MM, Vidor LP, Nitsche MA. Basic and functional effects of transcranial electrical stimulation (tES)—an introduction. Neurosci Biobehav Rev. 2018;85:81–92.
54. Nitsche MA, Paulus W. Excitability changes induced in the human motor cortex by weak transcranial direct current stimulation. J Physiol. 2000;527(3):633–9.
55. Jacobson L, Koslowsky M, Lavidor M. tDCS polarity effects in motor and cognitive domains: a meta-analytical review. Exp Brain Res. 2012;216(1):1–10.
56. Antonenko D, Grittner U, Saturnino G, Nierhaus T, Thielscher A, Flöel A. Inter-individual and age-dependent variability in simulated electric fields induced by conventional transcranial electrical stimulation. NeuroImage. 2021;224:117413.
57. Opitz A, Paulus W, Will S, Antunes A, Thielscher A. Determinants of the electric field during transcranial direct current stimulation. NeuroImage. 2015;109:140–50.
58. To WT, De Ridder D, Hart J Jr, Vanneste S. Changing brain networks through non-invasive neuromodulation. Front Hum Neurosci. 2018;12:128.
59. Alam M, Truong DQ, Khadka N, Bikson M. Spatial and polarity precision of concentric high-definition transcranial direct current stimulation (HD-tDCS). Phys Med Biol. 2016;61(12):4506.
60. Miranda PC, Callejón-Leblic MA, Salvador R, Ruffini G. Realistic modeling of transcranial current stimulation: the electric field in the brain. Curr Opin Biomed Eng. 2018;8:20–7.
61. Salvador R, Truong DQ, Bikson M, Opitz A, Dmochowski J, & Miranda PC. Role of computational modeling for dose determination. In Practical guide to transcranial direct current stimulation. Springer, Cham; 2019; pp. 233–262.
62. Oldrati V, Colombo B, Antonietti A. Combination of a short cognitive training and tDCS to enhance visuospatial skills: a comparison between online and offline neuromodulation. Brain Res. 2018;1678:32–9.
63. Antal A, Paulus W. Transcranial alternating current stimulation (tACS). Front Hum Neurosci. 2013;7:317.
64. Riddle J, Frohlich F. Targeting neural oscillations with transcranial alternating current stimulation. Brain Res. 2021;1765:147491.
65. Antal A, Herrmann CS. Transcranial alternating current and random noise stimulation: possible mechanisms. Neural Plast. 2016;2016:3616807.
66. Murphy OW, Hoy KE, Wong D, Bailey NW, Fitzgerald PB, Segrave RA. Transcranial random noise stimulation is more effective than transcranial direct current stimulation for enhancing working memory in healthy individuals: behavioural and electrophysiological evidence. Brain Stimul. 2020;13(5):1370–80.
67. Penton T, Dixon L, Evans LJ, Banissy MJ. Emotion perception improvement following high frequency transcranial random noise stimulation of the inferior frontal cortex. Sci Rep. 2017;7(1):1–7.
68. Diedrich J, Benedek M, Jauk E, Neubauer AC. Are creative ideas novel and useful? Psychology of aesthetics. Creativity Arts. 2015;9:35–40.
69. Runco MA, Jaeger GJ. The standard definition of creativity. Creat Res J. 2012;24(1):92–6.
70. Beaty RE, Benedeck M, Silvia PJ, Schacter DL. Creative cognition and brain network dynamics. Trends Cogn Sci. 2016;20:87–95. https://doi.org/10.1016/j.tics.2015.10.004.
71. Benedek M. The neuroscience of creative idea generation. In: Kapoula Z, Renoult J, Volle E, Andreatta M, editors. Exploring transdisciplinarity in art and science. Cham: Springer Nature Switzerland AG; 2018. p. 31–48. https://doi.org/10.1007/978-3-319-76054-4.
72. Benedek M, Jauk E. Creativity and cognitive control. In: Kaufman J, Sternberg R, editors. Cambridge handbook of creativity. Cambridge: Cambridge University Press; 2019. p. 200–23. https://doi.org/10.1017/9781316979839.012.
73. Boot N, Baas M, van Gaal S, Cools R, De Dreu C. Creative cognition and dopaminergic modulation of fronto-striatal networks: integrative review and research agenda. Neurosci Biobehav Rev. 2017;78:13–23. https://doi.org/10.1016/j.neubiorev.2017.04.007.

74. Nijstad BA, De Dreu CKW, Rietzschel EF, Baas M. The dual pathway to creativity model: creative ideation as a function of flexibility and persistence. Eur Rev Soc Psychol. 2010;21:34–77.
75. Seeley WW, et al. Dissociable intrinsic connectivity networks for salience processing and executive control. J Neurosci. 2007;27:2349–56.
76. Waskom ML, Kumaran D, Gordon AM, Rissman J, Wagner AD. Frontoparietal representations of task context support the flexible control of goal-directed cognition. J Neurosci. 2014;34(32):10743–55.
77. Buckner RL, Andrews-Hanna JR, Schacter DL. The brain's default network: anatomy, function, and relevance to disease. Ann N Y Acad Sci. 2008;1124:1–38.
78. Raichle ME, et al. A default mode of brain function. Proc Natl Acad Sci U S A. 2001;98:676–82.
79. Alexander GE, DeLong MR, Strick PL. Parallel organisation of functionally segregated circuits linking basal ganglia and cortex. Annu Rev Neurosci. 1986;9:357–81.
80. Cooper S, Robison AJ, Mazei-Robison MS. Reward circuitry in addiction. Neurotherapeutics. 2017;14(3):687–97.
81. Cools R, Sheridan M, Jacobs E, D'Esposito M. Impulsive personality predicts dopamine-dependent changes in frontostriatal activity during component processes of working memory. J Neurosci. 2007;27:5506–14.
82. Dodds CM, Clark L, Dove A, Regenthal R, Baumann F, Bullmore E, Robbins TW, Müller U. The dopamine D2 receptor antagonist sulpiride modulates striatal BOLD signal during the manipulation of information in working memory. Psychopharmacology. 2009;207:35–45.
83. Durstewitz D, Seamans JK. The dual-state theory of prefrontal cortex dopamine function with relevance to catechol-o-methyltransferase genotypes and schizophrenia. Biol Psychiatry. 2008;64:739–49.
84. Fink A, Grabner RH, Benedek M, Reishofer G, Hauswirth V, Fally M, Neuper C, Ebner F, Neubauer AC. The creative brain: investigation of brain activity during creative problem solving by means of EEG and FMRI. Hum Brain Mapp. 2009;30(3):734–48.
85. Jauk E, Benedek M, Neubauer AC. Tackling creativity at its roots: evidence for different patterns of EEG α activity related to convergent and divergent modes of task processing. Int J Psychophysiol. 2012;84(2):219–25.
86. Fink A, Benedek M. EEG alpha power and creative ideation. Neurosci Biobehav Rev. 2014;44(100):111–23. https://doi.org/10.1016/j.neubiorev.2012.12.002.
87. Fink A, Neubauer AC. EEG alpha oscillations during the performance of verbal creativity tasks: differential effects of sex and verbal intelligence. Int J Psychophysiol. 2006;62(1):46–53.
88. Grabner RH, Fink A, Neubauer AC. Brain correlates of self-rated originality of ideas: evidence from event-related power and phase-locking changes in the EEG. Behav Neurosci. 2007;121(1):224–30.
89. Jung-Beeman M, Bowden EM, Haberman J, Frymiare JL, Arambel-Liu S, Greenblatt R, Reber PJ, Kounios J. Neural activity when people solve verbal problems with insight. PLoS Biol. 2004;2(4):E97.
90. Kaufman JC, Plucker JA, Baer J. Essentials of creativity assessment. Wiley; 2008.
91. Mednick SA. The associative basis of the creative process. Psychol Rev. 1962;69:220–32.
92. Guilford JP. Creativity. Am Psychol. 1950;5:444–54. https://doi.org/10.1037/h0063487.
93. Kounios J, Beeman M. The cognitive neuroscience of insight. Annu Rev Psychol. 2014;65:71–93.
94. Weinberger AB, Green AE, Chrysikou EG. Using transcranial direct current stimulation to enhance creative cognition: interactions between task, polarity, and stimulation site. Front Hum Neurosci. 2017;11:246.
95. Cerruti C, Schlaug G. Anodal transcranial direct current stimulation of the prefrontal cortex enhances complex verbal associative thought. J Cogn Neurosci. 2009;21(10):1980–7.
96. Xiang S, Qi S, Li Y, Wang L, Dai DY, Hu W. Trait anxiety moderates the effects of tDCS over the dorsolateral prefrontal cortex (DLPFC) on creativity. Personal Individ Differ. 2021;177 https://doi.org/10.1016/j.paid.2021.110804.

97. Zmigrod S, Colzato LS, Hommel B. Stimulating creativity: modulation of convergent and divergent thinking by transcranial direct current stimulation (tDCS). Creat Res J. 2015;27(4):353–60.
98. Peña J, Sampedro A, Ibarretxe-Bilbao N, Zubiaurre-Elorza L, Ojeda N. Improvement in creativity after transcranial random noise stimulation (tRNS) over the left dorsolateral prefrontal cortex. Sci Rep. 2019;9(1):7116. https://doi.org/10.1038/s41598-019-43626-4.
99. Bartel G, Rameses I, Lamm C, Riečanský I, Marko M. Left prefrontal cortex supports the recognition of meaningful patterns in ambiguous stimuli. Front Neurosci. 2020;14
100. Colombo B, Bartesaghi N, Simonelli L, Antonietti A. The combined effects of neurostimulation and priming on creative thinking. A preliminary tDCS study on dorsolateral prefrontal cortex. Front Hum Neurosci. 2015;9:403.
101. Torrance EP, & Personnel Press. *Torrance tests of creative thinking*. Princeton, NJ: Personnel Press; 1966.
102. Green AE, Spiegel KA, Giangrande EJ, Weinberger AB, Gallagher NM, Turkeltaub PE. Thinking cap plus thinking zap: tDCS of frontopolar cortex improves creative analogical reasoning and facilitates conscious augmentation of state creativity in verb generation. Cereb Cortex. 2017;27:2628–39. https://doi.org/10.1093/cercor/bhw080.
103. Grabner RH, Krenn J, Fink A, Arendasy M, Benedek M. Effects of alpha and gamma transcranial alternating current stimulation (tACS) on verbal creativity and intelligence test performance. Neuropsychologia. 2018;118(Pt A):91–8.
104. Lustenberger C, Boyle MR, Foulser AA, Mellin JM, Fröhlich F. Functional role of frontal alpha oscillations in creativity. Cortex. 2015;67:74–82. https://doi.org/10.1016/j.cortex.2015.03.012.
105. Koizumi K, Ueda K, Li Z, Nakao M. Effects of transcranial direct current stimulation on brain networks related to creative thinking. Front Hum Neurosci. 2020;14:541052.
106. Chrysikou EG, Morrow HM, Flohrschutz A, Denney L. Augmenting ideational fluency in a creativity task across multiple transcranial direct current stimulation montages. Sci Rep. 2021;11(1):8874.
107. Chrysikou EG, Hamilton RH, Coslett HB, Datta A, Bikson M, Thompson-Schill SL. Noninvasive transcranial direct current stimulation over the left prefrontal cortex facilitates cognitive flexibility in tool use. Cogn Neurosci. 2013;4:81–9.
108. Ivancovsky T, Kurman J, Morio H, Shamay-Tsoory S. Transcranial direct current stimulation (tDCS) targeting the left inferior frontal gyrus: effects on creativity across cultures. Soc Neurosci. 2019;14(3):277–85.
109. Hertenstein E, Waibel E, Frase L, Riemann D, Feige B, Nitsche MA, Kaller CP, Nissen C. Modulation of creativity by transcranial direct current stimulation. Brain Stimul. 2019;12(5):1213–21. https://doi.org/10.1016/j.brs.2019.06.004.
110. Khalil R, Karim AA, Kondinska A, Godde B. Effects of transcranial direct current stimulation of left and right inferior frontal gyrus on creative divergent thinking are moderated by changes in inhibition control. Brain Struct Funct. 2020;225(6):1691–704.
111. Mayseless N, Shamay-Tsoory SG. Enhancing verbal creativity: modulating creativity by altering the balance between right and left inferior frontal gyrus with tDCS. Neuroscience. 2015;291:167–76.
112. Kleinmintz OM, Abecasis D, Tauber A, Geva A, Chistyakov AV, Kreinin I, Klein E, Shamay-Tsoory SG. Participation of the left inferior frontal gyrus in human originality. Brain Struct Funct. 2018;223(1):329–41.
113. Ramanan S, Piguet O, Irish M. Rethinking the role of the angular gyrus in remembering the past and imagining the future: the contextual integration model. Neuroscientist. 2018;24(4):342–52.
114. Tibon R, Fuhrmann D, Levy DA, Simons JS, Henson RN. Multimodal integration and vividness in the angular gyrus during episodic encoding and retrieval. J Neurosci. 2019;39(22):4365–74.
115. Berkowitz AL, Ansari D. Expertise-related deactivation of the right temporoparietal junction during musical improvisation. NeuroImage. 2010;49:712–9.

116. Fink A, Grabner RH, Gebauer D, Reishofer G, Koschutnig K, Ebner F. Enhancing creativity by means of cognitive stimulation: evidence from an fMRI study. NeuroImage. 2010;52(4):1687–95.

117. Howard-Jones PA, Blakemore SJ, Samuel EA, Summers IR, Claxton G. Semantic divergence and creative story generation: an fMRI investigation. Brain Res Cogn Brain Res. 2005;25(1):240–50.

118. Kowatari Y, Lee SH, Yamamura H, Nagamori Y, Levy P, Yamane S, Yamamoto M. Neural networks involved in artistic creativity. Hum Brain Mapp. 2009;30(5):1678–90.

119. Lifshitz-Ben-Basat A, Mashal N. Enhancing creativity by altering the frontoparietal control network functioning using transcranial direct current stimulation. Exp Brain Res. 2021;239(2):613–26.

120. Benedek M, Beaty R, Jauk E, Koschutnig K, Fink A, Silvia PJ, Dunst B, Neubauer AC. Creating metaphors: the neural basis of figurative language production. NeuroImage. 2014a;90:99–106. https://doi.org/10.1016/j.neuroimage.2013.12.046.

121. Pick H, Lavidor M. Modulation of automatic and creative features of the remote associates test by angular gyrus stimulation. Neuropsychologia. 2019;129:348–56.

122. Thakral PP, Madore KP, Kalinowski SE, Schacter DL. Modulation of hippocampal brain networks produces changes in episodic simulation and divergent thinking. Proc Natl Acad Sci U S A. 2020;117(23):12729–40.

123. Peña J, Sampedro A, Ibarretxe-Bilbao N, Zubiaurre-Elorza L, Aizpurua A, Ojeda N. The effect of transcranial random noise stimulation (tRNS) over bilateral posterior parietal cortex on divergent and convergent thinking. Sci Rep. 2020;10(1):15559.

124. Miller BL, Cummings J, Mishkin F, Boone K, Prince F, Ponton M, Cotman C. Emergence of artistic talent in frontotemporal dementia. Neurology. 1998;51(4):978–82.

125. Snyder AW, Mulcahy E, Taylor JL, Mitchell DJ, Sachdev P, Gandevia SC. Savant-like skills exposed in normal people by suppressing the left fronto-temporal lobe. J Integr Neurosci. 2003;2(02):149–58.

126. Young RL, Ridding MC, Morrell TL. Switching skills on by turning off part of the brain. Neurocase. 2004;10(3):215–22.

127. Simis M, Bravo GL, Boggio PS, Devido M, Gagliardi RJ, Fregni F. Transcranial direct current stimulation in de novo artistic ability after stroke. Neuromodulation J Int Neuromodulation Soc. 2014;17(5):497–501.

128. Woollams AM, Lindley J, Pobric LG, Hoffman P. Laterality of anterior temporal lobe repetitive transcranial magnetic stimulation determines the degree of disruption in picture naming. Brain Struct Funct. 2017;222(8):3749–59.

129. Chi RP, Snyder AW. Facilitate insight by non-invasive brain stimulation. PLoS One. 2011;6:e16655.

130. Chi RP, Snyder AW. Brain stimulation enables the solution of an inherently difficult problem. Neurosci Lett. 2012;515:121–4. https://doi.org/10.1016/j.neulet.2012.03.012.

131. Luft C, Zioga I, Thompson NM, Banissy MJ, Bhattacharya J. Right temporal alpha oscillations as a neural mechanism for inhibiting obvious associations. Proc Natl Acad Sci U S A. 2018;115(52):E12144–52. https://doi.org/10.1073/pnas.1811465115.

132. Santarnecchi E, Sprugnoli G, Bricolo E, Costantini G, Liew SL, Musaeus CS, Salvi C, Pascual-Leone A, Rossi A, Rossi S. Gamma tACS over the temporal lobe increases the occurrence of Eureka! Moments. Sci Rep. 2019;9(1):5778.

133. Goel V, Eimontaite I, Goel A, Schindler I. Differential modulation of performance in insight and divergent thinking tasks with tDCS. J Probl Solving. 2015;8:1. https://doi.org/10.7771/1932-6246.1172.

134. Benedek M, Jauk E, Fink A, Koschutnig K, Reishofer G, Ebner F, Neubauer AC. To create or to recall? Neural mechanisms underlying the generation of creative new ideas. NeuroImage. 2014b;88(100):125–33. https://doi.org/10.1016/j.neuroimage.2013.11.021.

135. Benedek M, Schües T, Beaty R, Jauk E, Koschutnig K, Fink A, Neubauer AC. To create or to recall original ideas: brain processes associated with the imagination of novel object uses. Cortex. 2018;99:93–102. https://doi.org/10.1016/j.cortex.2017.10.024.

136. Matheson HE, Buxbaum LJ, Thompson-Schill SL. Differential tuning of ventral and dorsal streams during the generation of common and uncommon tool uses. J Cogn Neurosci. 2017;29(11):1791–802.
137. Wu CC, Hamm JP, Lim VK, Kirk IJ. Mu rhythm suppression demonstrates action representation in pianists during passive listening of piano melodies. Exp Brain Res. 2016;234(8):2133–9. https://doi.org/10.1007/s00221-016-4615-7.
138. Pau S, Jahn G, Sakreida K, Domin M, Lotze M. Encoding and recall of finger sequences in experienced pianists compared with musically naïve controls: a combined behavioral and functional imaging study. NeuroImage. 2013;64:379–87.
139. Boasen J, Takeshita Y, Kuriki S, Yokosawa K. Spectral-spatial differentiation of brain activity during mental imagery of improvisational music performance using MEG. Front Hum Neurosci. 2018;12:156.
140. Schlegel A, Alexander P, Fogelson SV, Li X, Lu Z, Kohler PJ, Riley E, Tse PU, Meng M. The artist emerges: visual art learning alters neural structure and function. NeuroImage. 2015;105:440–51. https://doi.org/10.1016/j.neuroimage.2014.11.014.
141. Saggar M, Quintin E-M, Bott NT, Kienitz E, Chien Y-H, Hong DWC, et al. Changes in brain activation associated with spontaneous improvization and figural creativity after design-thinking-based training: a longitudinal fMRI study. Cerebr Cortex. 2017;27(7):3542–52.
142. Anic A, Olsen KN, Thompson WF. Investigating the role of the primary motor cortex in musical creativity: a transcranial direct current stimulation study. Front Psychol. 2018;9:1758. https://doi.org/10.3389/fpsyg.2018.01758.
143. Vartanian O, Skov M. Neural correlates of viewing paintings: evidence from a quantitative meta-analysis of functional magnetic resonance imaging data. Brain Cogn. 2014;87:52–6.
144. Vessel EA, Starr GG, Rubin N. The brain on art: intense aesthetic experience activates the default mode network. Front Hum Neurosci. 2012;6:66.
145. Ramachandran VS, Hirstein W. The science of art: a neurological theory of aesthetic experience. J Conscious Stud. 1999;6(6–7):15–51.
146. Cattaneo L, Rizzolatti G. The mirror neuron system. Arch Neurol. 2009;66(5):557–60.
147. Freedberg D, Gallese V. Motion, emotion and empathy in esthetic experience. Trends Cogn Sci. 2007;11(5):197–203.
148. Ishizu T, Zeki S. Toward a brain-based theory of beauty. PLoS One. 2011;6(7):e21852.
149. Kawabata H, Zeki S. Neural correlates of beauty. J Neurophysiol. 2004;91(4):1699–705.
150. Nakamura K, Kawashima R, Nagumo S, Ito K, Sugiura M, Kato T, Nakamura A, Hatano K, Kubota K, Fukuda H, Kojima S. Neuroanatomical correlates of the assessment of facial attractiveness. Neuroreport. 1998;9(4):753–7.
151. Chatterjee A, Thomas A, Smith SE, Aguirre GK. The neural response to facial attractiveness. Neuropsychology. 2009;23(2):135.
152. Lacey S, Hagtvedt H, Patrick VM, Anderson A, Stilla R, Deshpande G, Hu X, Sato J, Reddy S, Sathian K. Art for reward's sake: visual art recruits the ventral striatum. NeuroImage. 2011;55(1):420–33.
153. Brown S, Gao X, Tisdelle L, Eickhoff SB, Liotti M. Naturalizing aesthetics: brain areas for aesthetic appraisal across sensory modalities. NeuroImage. 2011;58(1):250–8.
154. Cupchik GC, Vartanian O, Crawley A, Mikulis DJ. Viewing artworks: contributions of cognitive control and perceptual facilitation to aesthetic experience. Brain Cogn. 2009;70(1):84–91.
155. Di Dio C, Ardizzi M, Massaro D, Di Cesare G, Gilli G, Marchetti A, Gallese V. Human, nature, dynamism: the effects of content and movement perception on brain activations during the aesthetic judgment of representational paintings. Front Hum Neurosci. 2016;9:705.
156. Di Dio C, Canessa N, Cappa SF, Rizzolatti G. Specificity of esthetic experience for artworks: an FMRI study. Front Hum Neurosci. 2011;5:139.
157. Di Dio C, Macaluso E, Rizzolatti G. The golden beauty: brain response to classical and renaissance sculptures. PLoS One. 2007;2(11):e1201.
158. Ishizu T, Zeki S. The brain's specialized systems for aesthetic and perceptual judgment. Eur J Neurosci. 2013;37(9):1413–20.

159. Osaka N, Minamoto T, Yaoi K, Osaka M. Neural correlates of delicate sadness: an FMRI study based on the neuroaesthetics of Noh masks. Neuroreport. 2012;23(1):26–9.
160. Kirk U, Skov M, Hulme O, Christensen MS, Zeki S. Modulation of aesthetic value by semantic context: an fMRI study. NeuroImage. 2009;44(3):1125–32.
161. Silveira S, Fehse K, Vedder A, Elvers K, Hennig-Fast K. Is it the picture or is it the frame? An fMRI study on the neurobiology of framing effects. Front Hum Neurosci. 2015;9:528.
162. Belfi AM, Vessel EA, Brielmann A, Isik AI, Chatterjee A, Leder H, Pelli DG, Starr GG. Dynamics of aesthetic experience are reflected in the default-mode network. NeuroImage. 2019;188:584–97.
163. Cela-Conde CJ, Ayala FJ, Munar E, Maestú F, Nadal M, Capó MA, del Río D, López-Ibor JJ, Ortiz T, Mirasso C, Marty G. Sex-related similarities and differences in the neural correlates of beauty. Proc Natl Acad Sci U S A. 2009;106:3847–52.
164. Cela-Conde CJ, García-Prieto J, Ramasco JJ, Mirasso CR, Bajo R, Munar E, Flexas A, Del Pozo F, Maestú F. Dynamics of brain networks in the aesthetic appreciation. Proc Natl Acad Sci U S A. 2013;110(Supplement 2):10454–61.
165. Vessel EA, Isik AI, Belfi AM, Stahl JL, Starr GG. The default- mode network represents aesthetic appeal that generalizes across visual domains. Proc Natl Acad Sci U S A. 2019;116(38):19155–64.
166. Vessel EA, Starr GG, Rubin N. Art reaches within: aesthetic experience, the self and the default mode network. Front Neurosci. 2013;7:258.
167. Jacobs RH, Renken R, Cornelissen FW. Neural correlates of visual aesthetics–beauty as the coalescence of stimulus and internal state. PLoS One. 2012;7(2):e31248.
168. Jacobsen T, Schubotz RI, Höfel L, Cramon DYV. Brain correlates of aesthetic judgment of beauty. NeuroImage. 2006;29(1):276–85.
169. Vartanian O, Goel V. Neuroanatomical correlates of aesthetic preference for paintings. Neuroreport. 2004;15(5):893–7.
170. Ticini LF. The role of the orbitofrontal and dorsolateral prefrontal cortices in aesthetic preference for art. Behav Sci. 2017;7:2.
171. Cattaneo Z, Ferrari C, Schiavi S, Alekseichuk I, Antal A, Nadal M. Medial prefrontal cortex involvement in aesthetic appreciation of paintings: a tDCS study. Cogn Process. 2020;21:65.
172. Cattaneo Z, Lega C, Flexas A, Nadal M, Munar E, Cela-Conde CJ. The world can look better: enhancing beauty experience with brain stimulation. Soc Cogn Affect Neurosci. 2014a;9(11):1713–21.
173. Cattaneo Z, Lega C, Gardelli C, Merabet LB, Cela-Conde CJ, Nadal M. The role of prefrontal and parietal cortices in esthetic appreciation of representational and abstract art: a TMS study. NeuroImage. 2014b;99:443–50.
174. Chib VS, Yun K, Takahashi H, Shimojo S. Noninvasive remote activation of the ventral midbrain by transcranial direct current stimulation of prefrontal cortex. Transl Psychiatry. 2013;3(6):e268.
175. Ferrari C, Lega C, Tamietto M, Nadal M, Cattaneo Z. I find you more attractive... After (prefrontal cortex) stimulation. Neuropsychologia. 2015;72:87–93.
176. Koehler S, Ovadia-Caro S, van der Meer E, Villringer A, Heinz A, Romanczuk-Seiferth N, Margulies DS. Increased functional connectivity between prefrontal cortex and reward system in pathological gambling. PLoS One. 2013;8(12):e84565.
177. Keeser D, Meindl T, Bor J, Palm U, Pogarell O, Mulert C, et al. Prefrontal transcranial direct current stimulation changes connectivity of resting-state networks during fMRI. J Neurosci. 2011;31(43):15284–93.
178. Pelowski M, Markey PS, Forster M, Gerger G, Leder H. Move me, astonish me... delight my eyes and brain: the Vienna integrated model of top-down and bottom-up processes in art perception (VIMAP) and corresponding affective, evaluative, and neurophysiological correlates. Phys Life Rev. 2017;21:80–125.
179. Bartolomeo P, Seidel Malkinson T. Hemispheric lateralization of attention processes in the human brain. Curr Opin Psychol. 2019;29:90–6.

180. Fairhall SL, Ishai A. Neural correlates of object indeterminacy in art compositions. Conscious Cogn. 2008;17(3):923–32.
181. Fogassi L, Luppino G. Motor functions of the parietal lobe. Curr Opin Neurobiol. 2005;15:626–31.
182. Larsen T, O'Doherty JP. Uncovering the spatiotemporal dynamics of value-based decision-making in the human brain: a combined fMRI-EEG study. Philos Trans R Soc Lond Ser B Biol Sci. 2014;369(1655):20130473.
183. Grosbras MH, Tan H, Pollick F. Dance and emotion in posterior parietal cortex: a low-frequency rTMS study. Brain Stimul. 2012;5(2):130–6.
184. Calvo-Merino B, Glaser DE, Grèzes J, Passingham RE, Haggard P. Action observation and acquired motor skills: an fMRI study with expert dancers. Cereb Cortex. 2005;15(8):1243–9.
185. Calvo-Merino B, Grèzes J, Glaser DE, Passingham RE, Haggard P. Seeing or doing? Influence of visual and motor familiarity in action observation. Curr Biol. 2006;16(19):1905–10.
186. Calvo-Merino B, Jola C, Glaser DE, Haggard P. Towards a sensorimotor aesthetics of performing art. Conscious Cogn. 2008;17(3):911–22.
187. Cross ES, Kirsch L, Ticini LF, Schütz-Bosbach S. The impact of aesthetic evaluation and physical ability on dance perception. Front Hum Neurosci. 2011;5:102.
188. de Gelder B, Watson R, Zhan M, Diano M, Tamietto M, Vaessen MJ. Classical paintings may trigger pain and pleasure in the gendered brain. cortex. 2018;109:171–80.
189. Nakamura K, Kawabata H. Transcranial direct current stimulation over the medial prefrontal cortex and left primary motor cortex (mPFC-lPMC) affects subjective beauty but not ugliness. Front Hum Neurosci. 2015;9:654.
190. Battaglia F, Lisanby SH, Freedberg D. Corticomotor excitability during observation and imagination of a work of art. Front Hum Neurosci. 2011;5:79.
191. Finisguerra A, Ticini LF, Kirsch LP, Cross ES, Kotz SA, Urgesi C. Dissociating embodiment and emotional reactivity in motor responses to artworks. Cognition. 2021;212:104663.
192. Fiori F, Plow E, Rusconi ML, Cattaneo Z. Modulation of corticospinal excitability during paintings viewing: a TMS study. Neuropsychologia. 2020;149
193. Jola C, Grosbras MH. In the here and now: enhanced motor corticospinal excitability in novices when watching live compared to video recorded dance. Cogn Neurosci. 2013;4(2):90–8.
194. Calvo-Merino B, Urgesi C, Orgs G, Aglioti SM, Haggard P. Extrastriate body area underlies aesthetic evaluation of body stimuli. Exp Brain Res. 2010;204(3):447–56.
195. Urgesi C, Calvo-Merino B, Haggard P, Aglioti SM. Transcranial magnetic stimulation reveals two cortical pathways for visual body processing. J Neurosci. 2007;27(30):8023–30.
196. Cazzato V, Mele S, Urgesi C. Different contributions of visual and motor brain areas during liking judgments of same- and different-gender bodies. Brain Res. 2016;1646:98–108.
197. Grill-Spector K. The neural basis of object perception. Curr Opin Neurobiol. 2003;13(2):159–66.
198. Cattaneo Z, Lega C, Ferrari C, Vecchi T, Cela-Conde CJ, Silvanto J, Nadal M. The role of the lateral occipital cortex in aesthetic appreciation of representational and abstract paintings: a TMS study. Brain Cogn. 2015;95:44–53.
199. Osaka N, Matsuyoshi D, Ikeda T, Osaka M. Implied motion because of instability in Hokusai Manga activates the human motion-sensitive extrastriate visual cortex: an fMRI study of the impact of visual art. Neuroreport. 2010;21(4):264–7.
200. Thakral PP, Moo LR, Slotnick SD. A neural mechanism for aesthetic experience. Neuroreport. 2012;23:310–3.
201. Massaro D, Savazzi F, Di Dio C, Freedberg D, Gallese V, Gilli G, Marchetti A. When art moves the eyes: a behavioral and eye-tracking study. PLoS One. 2012;7(5):e37285.
202. Kourtzi Z, Kanwisher N. Activation in human MT/MST by static images with implied motion. J Cogn Neurosci. 2000;12(1):48–55.
203. Williams AL, Wright MJ. Static representations of speed and their neural correlates in human area MT/V5. Neuroreport. 2009;20(16):1466–70.

204. Cattaneo Z, Schiavi S, Silvanto J, Nadal M. A TMS study on the contribution of visual area V5 to the perception of implied motion in art and its appreciation. Cogn Neurosci. 2017;8(1):59–68.
205. Ferrari C, Schiavi S, Cattaneo Z. TMS over the superior temporal sulcus affects expressivity evaluation of portraits. Cogn Affect Behav Neurosci. 2018;18(6):1188–97.
206. Alekseichuk I, Turi Z, Amador de Lara G, Antal A, Paulus W. Spatial working memory in humans depends on theta and high gamma synchronization in the prefrontal cortex. Curr Biol. 2016;26(12):1513–21.
207. Manuel AL, David AW, Bikson M, Schnider A. Frontal tDCS modulates orbitofrontal reality filtering. Neuroscience. 2014;265:21–7.
208. Opitz A, Falchier A, Yan C, Yeagle EM, Linn GS, Megevand P, Thielscher A, Deborah RA, Milham MP, Mehta AD, Schroeder CE. Spatiotemporal structure of intracranial electric fields induced by transcranial electric stimulation in humans and non-human primates. Sci Rep. 2016;6:31236.
209. Gamboa OL, Brito A, Abzug Z, D'Arbeloff T, Beynel L, Wing EA, et al. Application of long-interval paired-pulse transcranial magnetic stimulation to motion-sensitive visual cortex does not lead to changes in motion discrimination. Neurosci Lett. 2020;730:135022.
210. Momi D, Neri F, Coiro G, Smeralda C, Veniero D, Sprugnoli G, et al. Cognitive enhancement via network-targeted cortico-cortical associative brain stimulation. Cereb Cortex. 2020;30(3):1516–27.
211. Bimler DL, Snellock M, Paramei GV. Art expertise in construing meaning of representational and abstract artworks. Acta Psychol. 2019;192:11–22.
212. Else JE, Ellis J, Orme E. Art expertise modulates the emotional response to modern art, especially abstract: an ERP investigation. Front Hum Neurosci. 2015;9:525.
213. Era V, Candidi M, Aglioti SM. Contextual and social variables modulate aesthetic appreciation of bodily and abstract art stimuli. Acta Psychol. 2019;199:102881.
214. Fudali-Czyż A, Francuz P, Augustynowicz P. The effect of art expertise on eye fixation-related potentials during aesthetic judgment task in focal and ambient modes. Front Psychol. 2018;9:1972. https://doi.org/10.3389/fpsyg.2018.01972.
215. Yeh Y, Peng Y. The influences of aesthetic life experience and expertise on aesthetic judgement and emotion in mundane arts. Int J Art Design Educ. 2019;38(2):492–507.
216. Levy JM, Zold CL, Namboodiri VMK, Shuler MGH. The timing of reward-seeking action tracks visually cued theta oscillations in primary visual cortex. J Neurosci. 2017;37(43):10408–20.
217. Marco-Pallarés J, Münte TF, Rodríguez-Fornells A. The role of high-frequency oscillatory activity in reward processing and learning. Neurosci Biobehav Rev. 2015;49:1–7.
218. Badran BW, Caulfield KA, Stomberg-Firestein S, Summers PM, Dowdle LT, Savoca M, et al. Sonication of the anterior thalamus with MRI-guided transcranial focused ultrasound (tFUS) alters pain thresholds in healthy adults: a double-blind, sham-controlled study. Brain Stimul. 2020;13(6):1805–12.

Holding Still, Together: Person-Centered Parkinson's Care Portrayed

Thieme B. Stap, Richard Grol, Roland Laan,
Marten Munneke, Bastiaan R. Bloem,
and Jan-Jurjen Koksma

T. B. Stap (✉) · R. Laan · J.-J. Koksma
Health Academy, Radboud University Medical Centre, Nijmegen, Netherlands
e-mail: Thieme.Stap@radboudumc.nl

R. Grol
Photographer & Emeritus Professor Quality of Care, Radboud University Medical Centre,
Nijmegen, Netherlands

M. Munneke · B. R. Bloem
Department of Neurology & Radboud University Nijmegen, Donders Institute for Brain,
Cognition and Behaviour, Radboud University Medical Centre, Nijmegen, Netherlands

© The Author(s), under exclusive license to Springer Nature Switzerland AG 2023
A. Richard et al. (eds.), *Art and Neurological Disorders*, Current Clinical
Neurology, https://doi.org/10.1007/978-3-031-14724-1_8

1 From the Fast Lane to the Slow Lane

Bas: *No one has ever photographed me like this before. You caught me in a moment of quiet, a moment of modest contemplation. All the time you are running around getting everything done, and then when you are holding still, suddenly there is this moment of serenity.*

We were trying out something new. We were exploring what photography could bring to our participatory action research methodology. It seemed a promising direction. At the same time it was also an uncertain direction within an already complex and dynamic overall research into person-centered care. But we felt we were on to something, maybe one step closer to answer that question we had been pondering for a while now: How would a scientist have to study person-centered care, if his very endeavors were to contribute to it?

Today was our first day doing photography. Bob and Bas were coming over to talk about themselves and about their relationship. Bob has Parkinson's disease, Bas is his doctor. They know each other well. Today, they would talk for 45–60 min about their personal lives and about Parkinson's care. Richard, our photographer, was going to take photographs of the two of them talking and also portray them individually. We would audio tape their conversation and every now and then ask a few questions ourselves, without intervening too much.

Bas Bloem, besides being a neurologist, is a Parkinson's care innovator. Over the past decades, together with his companion and friend Marten Munneke, and with a great many others, he has built several innovative healthcare environments, such as ParkinsonNet [1, 2] and PRIME Parkinson [3]. What drives them as innovators is a combination of big-heartedness and entrepreneurialism. What steers their innovative plans is an enormous creative expertise in the field, and doing science to study outcomes in terms of health and cost parameters. They always seem to be in the fast lane. But, as innovators, they are also very process and people oriented, and when Jur Koksma [author] first asked them if they would want to work with him to study their Parkinson's innovations from a learning perspective, they saw the added value right away.

The studio was ready. Bas came in first, being his energetic and enthusiastic self, complimenting Thieme (as his PhD candidate) [author] for setting up the session, and shaking hands with Richard (our photographer), telling him how happy he was to see him again and explaining to Thieme that Richard Grol [author], now retired, used to be one of the big names in quality of healthcare science. Bob arrived a little later, together with his wife, and we took some time for coffee together, and for everybody to settle down a bit. Then, Bob and Bas started to talk and we pressed the record button. Gradually we all moved from the fast lane to the slow lane.

Most health care institutions have person-centered care in their mission statement. What those three words mean often remains a little obscure. During this first photography session, we experienced that it has a lot to do with taking time.

2 The Other Person

Bob: *To me these photos show exactly what this project is about. I have a story to tell and I want to tell it to you. Being proud of my work and the eagerness to share my story, that is what is visible in these photos.*

Bas: *Here we see another side of Bob. This is about his professional pride. Here, I don't see the man that has Parkinson's. This is the museum curator who also happens to be an enormously kind and interesting man.*

We all get taught that listening to a patient's story is important. We also know from the literature that many doctors interrupt their patients frequently, and don't allow themselves to listen for much more than a few seconds [4]. Compared to a normal medical interview, Bob and Bas had all the time in the world here. Even though they had known each other for years, Bas learned about other aspects of Bob's life that he had not heard of before. Later, Bas reflected on this saying it could have even been valuable information for treatment. A recurring theme in our conversations with professionals is their rethinking of the relation between time and quality of care. In trenches of day to day care, they perceive time pressure as an external, limiting factor. During our sessions they experienced how instead, time is an element of co-created care, and that slowing down may prove to be the more 'efficient' direction.

When we invite our guests, we ask them to bring a personal item to the session that symbolized something valuable to them. In this way, we try to make more room for the personal, getting away from the normal frame that tells us only to bring to the table what is 'relevant' [5]. Bob brought his portfolio. He always had a creative professional life as an architect, but now, due to Parkinson's, he felt he became more creative and that he could make art more freely.

Bas:	*You see the movement of his index finger, that is quite cool. [...] It is also interesting to see how he opens his mouth a bit, as you can observe often with people that have Parkinson's. His hypokinesia manifests itself because he is working hard.*

Bob:	*In this photo I see the teacher and the little boy. I don't know whether that is a problem because it is just an exercise, but it may also happen that you enter a mode of being together that you cannot easily escape from.*

Even during this first session only (we did 21 in total), we could already tell that person-centered care has to do with space and time: it matters how you set up a meeting, how you prepare for it, how you take time for it and how you engage with one another. We wondered whether people can learn to contribute to person-centered care, and what is needed, in practice, as well as in education to do so [6]. Which skills and attitudes and qualities yet to be known must we foster?

Could we offer young care professionals a work environment where they can learn what 'quality of care' actually means? Can we create room, within or out of the work place, for acting on and thinking about who you are, in this care process? A place where you can ask 'how do I *want* to do my job?' instead of 'what *should* be done today?' And how much of your personal self, would you acknowledge, is there in your professional life, being present or suppressed? One of the ways medical practice tends to socialize young doctors is by teaching them the importance of

maintaining certain boundaries, but the effect of that may be that we lack the experiential level to really find out what the nature of a 'good boundary' would be.

> Bas: *I think this is something we don't actually learn in medical school. A certain intimacy that we do not always permit in the consultation room. I would like to see it more often. […] Some people may say it is not appropriate or it may compromise your professionalism. But sometimes it really affects you, deep inside. And we do not learn how to deal with that. If we are daring enough – Because it requires courage – to allow ourselves to be touched… Like there is no one preventing me to cry in my own consultation room, but you will never let that happen because, well, it is not done, is it?*

3 All the Way Home

Here we are, in Bob's kitchen. A hundred miles away from the hospital. He is taking his time to look carefully at the selection of photos. We see the artist in him: He is good at looking in different ways, in not jumping to conclusions, in allowing himself to see something new, over and over again.

After each duo-session at the studio, we analyze the data (photographs and transcripts of the audio recordings), and visit the participants, preferably at their homes. In these follow-up interviews, we show twelve to sixteen photographs, and ask for reactions. Looking at your own portrait, or your interaction with your doctor or patient, opens a gateway to a deeper, existential level of reflection than usually reached within interview sessions. People live their lives making mental portraits of themselves all the time: How they were, how they wanted to be, how others would see them, what they like about themselves, what they do not like. Life is lived on the threshold between dreams and acceptance, and acceptance may be even more about focusing on what matters most, than on coming to terms with loss.

The same holds true for Bob. He takes over the session and takes us on a tour through his house, that functions as a permanent exhibition of his work.

Bob: *In the end you could say that Parkinson's has helped me. It has helped me to find a new freedom in my painting. I am really creative, but I think my creativity has been strengthened by my condition.*

After our guided tour Bob's wife asked us to come out and eat sandwiches in the garden. It was a lovely garden. We sat next to a self-made pond, eating freshly made sandwiches. The conversation continued. In the end, we talked for over 2.5 h.

Bob's wife now taking part in the conversation, opened yet another dimension to our conversation. By going back and forth in time, she gave a valuable insight in their lives before Parkinson's. She also told us about how she experienced contact with different care professionals and in different hospitals. We spoke at length about Bob's mother. She might also have had Parkinson's, but in that time it was looked upon very differently:

Bob's wife:	*You know, she never talked about it. And a doctor was like a saint back then.*

Bob:	*My father thought it was a bit of nonsense. It wasn't taken seriously at all, I remember that alright. I can still hear him tell her to hurry up. My mother was slow, and couldn't stand that. I don't think she was in a lot of pain but she was slow. She was apologizing for it all the time. She was just shuffling through the kitchen, and taking care of the household took her ages. Everything was difficult for her, even talking.*

After lunch it was time to move on. While we were driving back to the hospital we wondered how far should a care provider venture out into the real world to make care personal? All the way home?

4 Practicing Sharing in a Shared Practice

Martha:	*Why I brought this? Because it symbolizes the family that made me who I am. And it tells the story of my role within the family. Look, this is me. I am the eldest child. […] The funny thing is, when I look at this family statuette I see the little girl that was longing so much after the approval of her parents. And when I look back on the journey leading up all the way to today, I realize I have found my own path.*

Joshua:	*It inspires me a lot. I do think that what you have, a family and children, is the most precious thing to have. If I look at my own family I cannot position them like in this sculpture. There was no time for it. My parents were always busy working, always away from home. I'd have to make a sculpture with our housemaids. It would tell a completely different story. I guess that's why I never wanted to start my own family.*

Joshua and Martha had known each other for quite some time. This was not the first time they shared personal stories. Their care relationship struck an interesting balance between the personal and professional, with a touch of humor and playfulness to it, even. We, as researchers, felt privileged for them opening up to us, and

both of them, in return, shared their appreciation for the special atmosphere we created together during the session.

After the session in the studio, at Martha's home, we tried to delve a bit deeper into the question how personalized care relates to practice. She told us about her professional development – from working at an academic hospital, to becoming a Parkinson's coach and be 'in the world', and going back to the hospital setting again. She explained how her vision developed over time.

Martha:	*I came to realize how important it is to bring my personal self into play. So not just the nurse specialist, but my very own person. Only then will that other person be able to really see me. And only then can we genuinely meet one another. So, that is when I started to redecorate my room and immediately felt a change, like when people asked me 'Are those your children, how lovely, what are their names?'*

Interviewer:	*Do you still remember what triggered that realization?*

Martha:	*It is the different conversations that you have. Like when you are networking and you encounter all kinds of different role models, and it makes you think. Or when you speak to a patient and they ask you a personal question, and you feel how it matters. And then by going in and out of the university hospital all the time you start to realize how important the environment is. Like when you see a patient at home, well, then you are a visitor.*

Later on in the conversation, Martha offered another experience.

Martha:	*I remember that there was a time when, here, in our university hospital, they implemented a new policy so that nobody had their own room any more, and therefore rooms should be kept 'clean' from that moment on. Well, 'there goes the personal.' I recall that's how many people responded.*

This 'clean' policy that Martha refers to, seems to become the default state more and more. It stands in sharp contrast to what practice may be, when it is considered not from an organizational perspective, but as something that is created every time a patient and health care professional meet.

Interviewer:	*Martha, have you ever told this story of the family sculpture to other patients?*

Martha:	*No. Never. Even Joshua hasn't seen it before, but Joshua knows: this is where I come from. We often have conversations that are really founded on equality. It matters that you share your own stories.*

Interviewer:	*Have you ever had such a conversation in the hospital?*

Joshua:	*In the hospital? No. In the hospital there is no time for it.*

When Martha left the hospital, where she already knew Joshua as one of her patients, she just happened to become his coach when working for another health-care organization. In this new practice they were able to adapt their relation, and find novel ways of working together.

Joshua: *Martha doesn't have Parkinson's. She can start moving from within herself. Parkinson's has taken away that potential initiative from me, a bit. I just need structure.*

Later, at his home, Joshua reflected, with this photograph in his hand:

Joshua: *Martha has a very tactile way of making contact. I can only do that with people I feel safe with. If you want to get things moving, you need this. […] That's what I mean with dancing. Starting to find a rhythm together is the basis for getting things going.*

5 Touching Base

Lidwien: *They are very beautiful photos, wonderful. Yes, I do think that the photographer has captured those moments of undivided attention. Here, Resi shows a certain restrained posture. Which is in a way logical, if someone helps you to put on your necklace.*

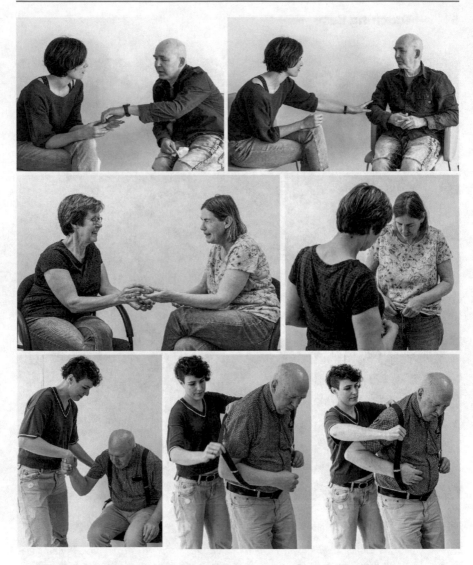

All of these photographs exhibit different types of touch. Touch became a somewhat unexpected, yet important theme in the photographs and our conversations with participants. Most care professionals *need* to touch their patients, but most are only actively reflecting on what touch *does* when a situation occurs that demands reflection. We learned together that to touch is, on the one hand, natural and easy, but may also be experienced as an intricate and vulnerable matter.

Martha: *For me it is not difficult to touch another person, it is a very natural thing to do.*

Interviewer: *Is it necessary for person-centered care to touch the other?*

Martha: *Yes it is. At the right moment, in the right context.*

How does knowing or feeling what the right moment and right context is, relate to 'professional distance', as both a practical and educational concept? In healthcare, but also in other professions, conventions of professional distance makes professionals feel 'out of touch'. In our research we further looked into the concept of distance in healthcare, where 'closeness' is valued by both professionals and people who need these professionals [7].

> Lidwien: *In my work I have to be able to touch people. Like when I want to observe if somebody is sitting straight, I tell them I have to feel how they are sitting.*

Context seems to be a crucial, and maybe overlooked, aspect of person-centered care and touch in particular [8]. Lidwien, who is an occupational therapist, gives a three word summary of her work: 'connecting to people.'

> Lidwien: *Connecting to other people, that is the basis, after all. I remember I was teaching women who came from abroad, well, they tend to be more physical, if you have made the connection that is. Then, when you are in someone's life, in someone's house, then it is a lot easier to touch somebody.*

A seemingly different perspective comes from Ramona, the professional in the last three photo's. She is a district nurse, specialized in Parkinson's. For her, touch is something practical. Something to do right.

> Ramona: *I am not really a cuddly type of person, so to speak. For me touching is very much a practical and functional kind of thing. So my kind of touching isn't the type that is pleasant or comforting. It is functional, like you see in these photos. But then I also want it be done right. So, for instance, if I have to wash people, I do it properly, never in a hasty or slapdash manner. If you do something, do it well."*

Every care professional described touch in their own way, with overlapping elements of functionality and connection to it. Notwithstanding the variety in the stories and perspectives behind it we deduce from our findings that the complex concept of touch is about finding a common ground. It is about touching base.

6 Photography as a Research Method

Photography has been a long standing 'partner' of healthcare professionals. From the moment the first photograph – a daguerreotype, was invented, they were used for all kinds of medical purposes: diagnostics, science and education all benefited from the 'perfect representations' photos provided (but for problematization of this 'objective' view, see Lorraine Daston, 2007 [9]). This also ties in with our day to day life understanding of photography: we think that a photograph shows us the situation, the object, the person, as it really is. Obviously, there is also another side of photography, that one may label as 'artistic', which conceptualizes the photographic image as something that does not represent reality but rather constructs it, based on the perspective of the photographer, who employs various methods of light and composition in doing so.

Historically, medicine, like modern science, has moved steadily towards a more mechanistic, deterministic and reductionistic view of human nature and the human condition. Together with a managerialist, neoliberal style of running hospitals like businesses, these trends have given rise to a sense of alienation among both patients and their healthcare providers. At the same time, medicine is fundamentally about the so-called human touch, and the intuitive side of the profession that seems to tap into the things that matter and that neither can nor need to be measured (cf. [10, 11]). A strong patient emancipatory movement over the past decades has even strengthened the field of narrative medicine, that has put the story of the patient as a valid and most relevant source of knowledge back on the table.

Part of the more 'holistic' tradition in medicine, the medical is safeguarded with the help of the humanities and the arts. The place of art in hospitals and healthcare is shifting towards a more central position. The arts are not only accepted in hospitals as a means to an end (to liven up the place, for instance), but they are considered a powerful set of disciplines that excel in many human faculties that medicine is yearning after, like creativity, imagination, critical and divergent thinking, sense making, engaging, perspective taking, and so on. For instance, in innovative medical education, engaging with the arts has been shown to make young professionals learn to look better, [12–14]. One could even go as far as viewing the care professional as an artist herself and look at her practice from that lens [15]. We think that gaining insights using an arts-based approach, could help make the "shift from doing things to patients, to doing things with them" [16].

Arts-based research (ABR) makes systemic use of the artistic process [17, 18], which may stimulate new thinking and can provide ethnographic knowledge [19]. This ABR process is "the actual making of artistic expressions […] as a primary way of understanding and examining experience by both researchers and the people that they involve in their studies" [20]. Often, this is an *abductive* process: there are different frames of reference present (from patients, professionals and researchers), and in juxtaposing these frames, participants come to new ways of making sense of their world [21]. The knowledge ABR yields is affective, with equal regard for intellect and imagination [22], or is unhindered by such abstract dichotomies.

In Parkinson's care, art is starting to play a vital role in understanding the disease. Not only because people with Parkinson's seem to become more creative [23], and artists who get Parkinson's may be witness to a dramatic change in their style [24], but also because art forms have proven themselves to be very helpful in dealing with Parkinson's on a psychological level [25, 26]. There are some studies on Parkinson's care using photography. One of the methods used, 'Photovoice', was an inspiration for the design of our study [27, 28].

We chose photography as method to try and understand the learning processes present within the constitution of person-centered Parkinson's care. Innovation within care is often understood as a technological issue [29]. But within the context of every innovation, either process- or product oriented, people need to learn, particularly because innovation implies steering away from extant convictions. In research terms, this land lies fallow, and is hard to investigate. Arts-based research methodology produces new forms of knowledge that may open up this dormant domain. Making photography part of an overall scientific research program

structures its empirical materials and participatory processes in such a way that gives rise to knowledge outcomes that are transferable (not generalizable) to other settings.

Indeed, a photograph is a very clear way to convey a certain 'snapshot' representation of the surroundings of an object or a person. Philosopher Susan Sontag [30] says: "Something we hear about, but doubt, seems proven when we're shown a photograph of it" (p. 14). Although, a photographer cannot intervene in the situation: "The person who intervenes cannot record; the person who is recording cannot intervene" (p. 22). It is a snapshot, because the photographer decided to click in a certain moment. It is an evaluation, because the photographer does, in fact, participate in the situation.

Sontag has argued that no two persons make the same photo of the same object, which compromises the idea that the camera creates a disinterested, objective view of reality (p. 107). What photos, then, 'prove' is not just what is out there, but also what is seen. It is not a representation of the world, but an evaluation. The frame of reference our photographer had during each session, thus weighed in at crucial moments in his process: the interest in the poses of the subject, the timing, the decision for color or black and white, etc. The 'reductionist' description of a photographers' labor seems incommensurable with the living experience of working with photography.

Portrait photography, such as present in this chapter, very much relies on the relation between the photographer and the model, and is often seen as one of the most difficult photographic genres [31]. Good portraits do not aim to capture some kind of 'identity' or 'essence' of the person in front of the camera, because the idea of representing an essence is itself reductionist. Instead, good portraits are about presenting what matters in a sincere manner. The relationship between a photographer and that person is consequently quite complex. For the model may want to present herself in a certain way ('I want to be seen for who I am'), while a photographer might want to 'take off' some of the masks the models may try to uphold in their day to day life.

For this to happen, there is a form of collaboration between the photographer and the model, but most often, the photographer is directing the other person. The power balance is skewed towards the photographer's side. This power can be used in an appreciative manner, but also in a stereotyping and dehumanizing way. Sontag goes as far as to call this the political "power to catch" someone in a certain way (p. 27). Today, we would call this 'framing'. This also means, that there needs to be trust. We see trust as one of our main design principles in our research methodology, and took explicit measures (i.e. sound and open communication before the session, starting a session with coffee, going to participants' homes, etc.). Richard, our photographer, always tells the patient and professional that he used to work in the hospital, that he is retired now and participates in this research because he cares about good care, and still learns about it every session. For our research outcomes to be transferable we think it crucially important to embrace openness as the core of the photographer's repertoire.

One last perspective we like to highlight here is yours, the eye of the beholder. Most contemporary portraits are not only about the model and the photographer, but

also about the beholder. The photographer might direct and decide, but the viewer adds another layer of interpretation from his or her own perception [32]. Here too, lies a certain 'political' power. The outcome of the interplay between photographer and model is categorized by you. In the words of Sontag: "In fact, words do speak louder than pictures. Captions do tend to override the evidence of our eyes [...]" (p. 84).

In this short methodological *exposé*, we touched upon some needs of working with photography as a research method. The value of creating these research products together with the participants and a photographer, opens up new ways of understanding healthcare. There is a dialectical process of interpretation by the photographer, and a simultaneous objectifying of the model. Next to that, one needs to be aware of epistemological aspects, power structures, and emancipatory values of working together in this process. The research team hopes to have built up this paper in such a way that it helps you, as beholders, to reflect on your own ways of looking and thinking.

7 Uncertainty of Beginning

Marlies: *I do remember I liked the idea of participating in such a, well... 'unorthodox' type of research. And I liked the idea of doing it together with her. I think we have a really nice relationship, so it was like going on an adventure together. She was a bit anxious, having no clue what to expect and neither did I, but that also added to the pleasure of anticipation. We had fun. And then there is the unease of having you picture taken, I have never been good at that.*

Writing a paper can be one of the most clarifying but also most reductive steps in scientific research. All the expertise that went into the research, and all the processes involved in carrying it out, all the results that were harvested: only a fraction of it ends up in the final report. This piece of paper then—or series of 0 s and 1 s assembled in a cloud—only comes alive when read, and only insofar as the expertise and imagination of the reader goes. Its closed mountain landscape is epitomized by its highest peak: the one-liner impeccable truth statement which is its conclusion.

Our research does not end here. Both its processes and outcomes pivot around openness. To stumble upon openness takes a beginner's mind, a readiness to be unprepared. From a traditional standpoint, there is nothing to conclude, yet on the basis of our research, all the more to include. This is how person-centered care may start: with the uncertainty of beginning.

References

1. Bloem BR, Munneke M. Revolutionising management of chronic disease: the ParkinsonNet approach. BMJ. 2014;348
2. Bloem BR, Rompen L, Vries NM, Klink A, Munneke M, Jeurissen P. ParkinsonNet: a low-cost health care innovation with a systems approach from the Netherlands. Health Aff. 2017;36(11):1987–96.
3. Tenison E, Smink A, Redwood S, Darweesh S, Cottle H, van Halteren A, et al. Proactive and integrated management and empowerment in Parkinson's disease: designing a new model of care. Parkinson's Disease. 2020;2020
4. Ospina NS, Phillips KA, Rodriguez-Gutierrez R, Castaneda-Guarderas A, Gionfriddo MR, Branda ME, et al. Eliciting the patient's agenda-secondary analysis of recorded clinical encounters. J Gen Intern Med. 2019;34(1):36–40.
5. Melo S, Bishop S. Translating healthcare research evidence into practice: the role of linked boundary objects. Soc Sci Med. 2020;246:112731.
6. Vijn TW, Kremer JA, Koksma J-J. Putting patient centred care at the core of medical education. BMJ. 2018;
7. Green R, Gregory R, Mason R. Professional distance and social work: stretching the elastic? Aust Soc Work. 2006;59(4):449–61.
8. Gallace A, Spence C. The science of interpersonal touch: an overview. Neurosci Biobehav Rev. 2010;34(2):246–59.
9. Daston L. Galison P. Objectivity: Princeton University Press; 2021.
10. Koksma J-J, Kremer JA. Beyond the quality illusion: the learning era. Acad Med. 2019;94(2):166–9.
11. Veen M, Skelton J, de la Croix A. Knowledge, skills and beetles: respecting the privacy of private experiences in medical education. Perspect Med Educ. 2020;9(2):111–6.
12. Jones EK, Kittendorf AL, Kumagai AK. Creative art and medical student development: a qualitative study. Med Educ. 2017;51(2):174–83.
13. van Woezik TE, Stap TB, van der Wilt GJ, Reuzel RP, Koksma JJ. Transforming the medical perspective through the arts. Med Educ. 2021;

14. Koksma JJ, van Woezik T, van den Bosch S, van den Bergh C, Geerling L, Keunen JE. Learning to see things from a different perspective: interns and residents collaborate with artists to become better doctors. Ned Tijdschr Geneeskd. 2017;161:–D1840.
15. Bloem BR, Pfeijffer IL, Krack P. Art for better health and wellbeing. BMJ. 2018;363
16. Richards T. Welcome to the hospital of the patient. BMJ. 2014;349:16–8.
17. Staricoff RL. Arts in health: a review of the medical literature. Arts Council England London; 2004.
18. Boydell K, Gladstone BM, Volpe T, Allemang B, Stasiulis E, editors. The production and dissemination of knowledge: a scoping review of arts-based health research. Forum Qualitative Sozialforschung/Forum: Qualitative Social Research; 2012.
19. Degarrod LN. Making the unfamiliar personal: arts-based ethnographies as public-engaged ethnographies. Qual Res. 2013;13(4):402–13.
20. McNiff S. Philosophical and practical foundations of artistic inquiry. Handbook of arts-based research 2017:22–34.
21. Dorst K. The core of 'design thinking' and its application. Des Stud. 2011;32(6):521–32.
22. Finley S. Multimethod arts-based research. Handbook of arts-based. Research. 2017;
23. Chacko J, George S, Cyriac S, Chakrapani B. A tale of two patients: levodopa and creative awakening in parkinson's disease–a qualitative report. Asian J Psychiatr. 2019;43:179–81.
24. Shimura H, Tanaka R, Urabe T, Tanaka S, Hattori N. Art and Parkinson's disease: a dramatic change in an artist's style as an initial symptom. J Neurol. 2012;259(5):879–81.
25. Wadeson H. Art as therapy for Parkinson's disease. Art Ther. 2003;20(1):35–8.
26. Raglio A. Music therapy interventions in Parkinson's disease: the state-of-the-art. Front Neurol. 2015;6:185.
27. Hermanns M, Greer DB, Cooper C. Visions of living with Parkinson's disease: a photovoice study. Qual Rep. 2015;20(3):336–55.
28. Roger K, Wetzel M, Penner L. Living with Parkinson's disease–perceptions of invisibility in a photovoice study. Ageing Soc. 2018;38(5):1041–62.
29. Dixon-Woods M, Amalberti R, Goodman S, Bergman B, Glasziou P. Problems and promises of innovation: why healthcare needs to rethink its love/hate relationship with the new. BMJ Quality Safety. 2011;20(Suppl 1):i47–51.
30. Sontag S. On photography. New York: RosettaBooks LLC; 1973.
31. Badger G. The genius of photography: how photography has changed our lives. Quadrille. 2007;
32. Huizing C, Meester HS-D. Dutch identity: Nederlandse portretfotografie nu. Zwolle, The Netherlands: Uitgeverij Waanders & de Kunst; 2016.

Linking the Neural Correlates of Reward and Pleasure to Aesthetic Evaluations of Beauty

Tomohiro Ishizu, Tara Srirangarajan, and Tatsuya Daikoku

1 Is the Sense of Beauty Different from Pleasure?

In the fields of neuroaesthetics and empirical aesthetics, there has been much discussion in recent years about the relationship between the experience of beauty and the experience of pleasure [1–3]. These debates have centered on whether experiences of beauty and pleasure can be disentangled experimentally. Even before this debate arose in neuroaesthetics, similar doubts about neuroaesthetic findings had been raised in philosophy and empirical aesthetics (e.g., the role of the medial orbitofrontal cortex versus the nucleus accumbens in evaluating aesthetic value). For example, a common argument against equating beauty and pleasure was as follows: "Although it is worth knowing that musical 'chills' are neurologically akin to the responses invoked by sex or drugs, an approach that cannot distinguish Bach from barbiturates is surely limited" [4]. In other words, if the experiences of viewing beautiful artworks/scenery and eating a delicious meal were found to be associated with very similar patterns of brain activity, such findings may suggest that beauty and pleasure are virtually indistinguishable in terms of neural representations. If such findings were true, they would not provide any new insights into existing neuroscientific theories of aesthetics [5].

In this chapter, we explore this question with regard to the brain systems involved in reward processing and pleasure. We attempt to reconsider this question by

T. Ishizu (✉)
Department of Psychology, Kansai University, Osaka, Japan

Open Innovation Institute, Kyoto University, Kyoto, Japan
e-mail: t.ishizu@ucl.ac.uk

T. Srirangarajan
Department of Psychology, Stanford University, Stanford, CA, USA

T. Daikoku
International Research Center for Neurointelligence (WPI-IRCN), The University of Tokyo, Tokyo, Japan

categorizing qualitatively distinct experiences of beauty. Finally, we discuss the possibility that neurological disorders may selectively influence specific types of aesthetic experiences.

The experience of beauty is often coupled with feelings of pleasure. A body of neuroscientific evidence has shown that the experience of beauty recruits the brain's reward system, including the ventral striatum (VS), anterior cingulate cortex (ACC), caudate nucleus, and insular cortex as well as the orbitofrontal cortex (OFC) (see [6] for a review of the reward system). The reward system consists of a group of brain structures that are responsible for reward-related cognition including positively valenced emotions involving pleasure [7]. This may suggest that the experience of beauty itself has intrinsic reward value, but does not address the fundamental question of how the experience of beauty might differ from that of pleasure. Though it is no easy feat to cleanly disentangle the experience of beauty from that of pleasure, certain qualitative attributes may help to tease them apart. Beauty is usually accompanied by feelings of pleasure, awe, or comfort, whereas pleasure does not necessarily have to co-occur with an experience of beauty. For example, food, sex, and drugs can provide intense pleasure without aesthetic qualities playing a role. Thus, a few key questions may emerge:

Is there any difference between "pleasure derived from beauty" and "pleasure without beauty?" How might it be possible to distinguish between them?

To address this question, we must first define pleasure and categorize distinct types of pleasurable experiences.

2 Pleasure and Reward

Receiving a reward evokes feelings of pleasure. But what is a reward? For example, food and water are extrinsic or physiological rewards since they act directly on the body for maintaining homeostasis. They are also referred to as "primary rewards" (Table 1). On the other hand, secondary rewards such as money are learned, and derive their subjective value from being exchanged for primary rewards (e.g., buying food with money).

Table 1 Categorizing different types of rewards. Rewards can take many forms: physiological rewards, learned rewards, etc. Although learned rewards can be exchanged for primary/physiological rewards, we classify learned rewards and intrinsic rewards (which do not involve physiological pleasure) as non-physiological rewards. The brain regions listed in this table have been largely reported to be active for both reward types

Primary rewards (physiological)		Secondary rewards (learned/non-physiological)	
Food, water	Money	Altruistic behaviour, moral behaviour	Appreciation/ production of art, music, etc.
Sexual contact	Power	Social interaction	
Shelter			
Ventral tegmental area, substantia nigra, striatum (especially nucleus accumbens), frontal association area (orbital, medial and lateral regions), anterior cingulate gyrus			

Positive social interactions can also be regarded as rewards. For example, affection, praise, or admiration from others (e.g., resulting from prosocial or altruistic behaviour) can be powerful social rewards. Interpersonal relationships are of great importance to humans, who are social creatures that survive by cooperating and building strong bonds with one another. Therefore, it may be important for us to be perceived favourably by others and engage in moral behaviour which has these rewarding incentives.

What if the act of helping others is not known to anyone else but yourself? Prior studies have reported that altruistic acts themselves can be rewarding [8]. This may be thought of as an intrinsic reward (i.e., driven by intrinsic motivation), which drives behaviour due to a particular action being inherently pleasurable without the expectation of external praise or other social rewards [9] (see Table 1).

How does the brain process rewarding stimuli and give rise to feelings of pleasure? The study of neural mechanisms of reward and pleasure has a long history, stemming from animal studies, to functional Magnetic Resonance Imaging (fMRI) studies of the human brain in the 1990s–2000s. The neural correlates of pleasure have been well-explored in the neuroscientific literature, with a wealth of studies showing that feelings of pleasure are associated with activity in the brain's reward system. Prior studies have shown that the reward system includes subcortical brain regions such as the ventral tegmental area (VTA) of the midbrain, the substantia nigra pars compacta (SN), the ventral striatum of the basal ganglia (including the nucleus accumbens (NAcc), putamen, and caudate), and the amygdala [6]. Researchers have found that cortical areas including the orbitofrontal and insular cortices of the cerebral neocortex are also key components of the brain's reward system [10]. In particular, the nucleus accumbens, putamen, caudate, and orbitofrontal cortex are common targets in studies of reward processing [7] (see Fig. 1).

Neurotransmitters such as dopamine, serotonin, and oxytocin play key roles in reward processing. For example, the OFC is primarily innervated by dopaminergic neurons, which are important for reward, motivation, and movement execution [11].

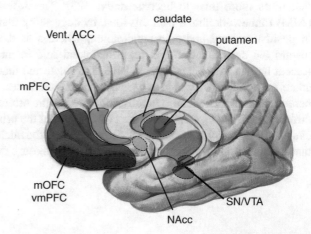

Fig. 1 Brain regions involved in pleasure and reward processing (medial surface of the brain depicted). *Vent. ACC* ventral anterior cingulate cortex, *mOFC/vmPFC* medial orbitofrontal cortex/ventromedial prefrontal cortex, *NAcc* nucleus accumbens, *mPFC* medial prefrontal cortex, *SN/VTA* substantia nigra/ventral tegmental area

Neurotransmitters such as GABA and enkephalin are present in the ventral striatum, which is arguably the most important subcortical reward-related region [7]. Enkephalins are endogenous opioids, or naturally-occurring substances with opium-like properties (e.g., intracerebral morphine and intracerebral cannabinoids) that have been implicated in drug addiction [12]. It is important to note that the presence of a neurotransmitter does not correspond one-to-one with the activation of a par-ticular brain region. For example, the "Cortex → Striatum → Thalamus → Cortex" feedback loop has been shown to be important for reward processing, and involves the complex interplay of different neurotransmitters and patterns of brain activity [13]. Nevertheless, we hypothesize that there are two core brain regions underlying pleasurable feelings: the ventral striatum and the orbitofrontal cortex, both of which are tied to dopaminergic activity [14].

Interestingly, it has been suggested that different dopamine pathways (which play an important role in the experience of pleasure) may differentially influence activity within the ventral striatum and mOFC/vmPFC. The mOFC/vmPFC are tar-gets of both the mesolimbic and mesocortical dopamine pathways, whereas the striatum is strongly modulated by the mesolimbic dopamine pathway. The mesolim-bic pathway projects to the ventral striatum (primarily the NAcc), the hippocampus, as well as the mOFC/vmPFC, whereas the mesocortical pathway transmits dopa-mine from the VTA to the PFC (especially the dorsolateral PFC) and eventually through parietal, occipital, and temporal areas [15–18]. Afferent projections to the VS include the cerebral cortex, thalamus, and midbrain dopaminergic neurons [6]. The main cortical connections of the VS include the OFC, anterior cingulate cortex, and midbrain dopaminergic neurons. Primate physiology studies most often pin-point the OFC as a region important for reward processing [19–21]. Consistent with prior lesion studies [22], neuroimaging evidence suggests that sensory and abstract rewards can recruit the OFC [6].

These different projections of the dopaminergic system may contribute to func-tional dissociations between the NAcc and OFC [6]. The NAcc and OFC/vmPFC also seem to play temporally distinct roles in reward processing, with the NAcc being recruited even before the receipt of rewarding stimuli (i.e., during reward anticipation). On the other hand, the vmPFC/OFC may play a more integrative role that takes more time to become active [23]. The Affect-Integration-Motivation (AIM) framework aligns with this idea, by suggesting that the NAcc is implicated in positive arousal and gain anticipation, whereas as the signal travels upwards toward the cortex, the mPFC plays a crucial role in integrative processes [24]. Recent human fMRI experiments have also suggested that the nucleus accumbens and orbitofrontal cortex tend to be active at different times, with the nucleus accum-bens responding much more rapidly compared to the orbitofrontal cortex [25]. This difference has led researchers to the possibility that the orbitofrontal cortex is asso-ciated with a conscious valuation process, whereas the nucleus accumbens is impor-tant for automatic and anticipatory responses to pleasure or reward [26].

3 The Two Reward Systems

As depicted in Table 1, food and water are physiological rewards whereas social interaction, praise, and intrinsic joys (e.g., art and music) can be considered non-physiological rewards. Though these two types of rewards differ, both are known to activate the brain's reward system. There is some evidence suggesting that social and intrinsic rewards (without physiological pleasure) recruit similar brain regions as physiological rewards [27, 28]. On the other hand, a growing body of neuroscientific studies has reported the presence of a core "reward system" along with some brain regions whose activity is reward type-dependent [28]. For instance, physiological rewards have been shown to activate the ventral striatum, whereas social and intrinsic rewards seem to recruit the orbitofrontal cortex and caudate nucleus [23, 29].

Berridge [30] suggested that dopamine may contribute to a "*desire circuit*," which underlies the sense of desire rather than feelings of liking. The desire circuitry can also be regarded as motivation circuitry that affects real-world behaviour and decision-making. Thus, the orbitofrontal cortex seems to be more involved in desire and motivation than more basic feelings of pleasure. On the other hand, the nucleus accumbens has been shown to play a key role in pleasure, and has therefore been referred to as the "*preference circuit*." Prior studies have suggested that it is likely that the difference between the two systems (i.e., the orbitofrontal cortex and the nucleus accumbens) gives rise to the difference between desire and liking, respectively [7, 31].

In studies investigating how primary and secondary rewards activate the brain's reward system, common patterns of activity have been found in both the VS and the mOFC/vmPFC [28]. On the other hand, for non-physiological rewards, mOFC/vmPFC activity may be more dominant. For example, it has been reported that OFC activity is more dominant than VS activity for altruistic donations [29], and mathematicians' experiences of mathematical beauty also reportedly increased only mOFC but not VS activity [32]. Furthermore, an fMRI study directly comparing physical attractiveness judgments with moral attractiveness judgments (i.e., judgments about whether an action is morally right) found that physical attractiveness judgments activated the mOFC as well as the basal ganglia, including the VS. In contrast, only mOFC activity was observed for moral attraction judgments [33]. Other neuroimaging studies of moral attractiveness judgments also reported correlations between moral beauty and OFC activity, but did not find significant activity in the VS [34].

Emotions evoked by music, as a non-physiological reward, have also been shown to recruit the orbitofrontal cortex [35]. Other neuroimaging studies have suggested that the nucleus accumbens is not implicated in musical expectancy [36, 37], but rather the perceptual uncertainty of musical structure [38]. Integrating this evidence, we hypothesize that for certain non-physiological rewards related to aesthetic evaluation, mOFC/vmPFC activity is likely to be more dominant than VS activity. However, it should be noted that there is conflicting evidence in the literature. For example, prior findings have shown that social approval and monetary rewards have

common neural underpinnings (i.e., striatal activity), suggesting the presence of a "common neural currency" of reward [39].

Further evidence in support of the proposed hypothesis can be found in the relationship between brain function and inter-regional connections. VS and OFC, the two main reward systems, both receive direct dopaminergic projections from the substantia nigra (SN) and ventral tegmental area (VTA) [6, 15]. The differences in function between reward-related regions (and why these differences occur in the same dopamine pathway) have therefore been disputed. One hypothesis is that the function of each reward-related region can be explained by differences in the connections between each region and other brain areas [40]. In other words, differences in the structural connections of the mOFC and the NAcc may account for functional differences. The OFC has been reported to have direct connections mainly with the lateral PFC, hippocampus [41], other frontal cortices [42, 43], as well as the amygdala and sensory cortex [44]. In other words, it is strongly intra-frontally connected.

On the other hand, the connections of the VS have been reported to include the globus pallidus, SN/VTA [45], thalamus, brainstem [46], as well as some cortical inputs (e.g., PFC, ACC). There are connections to the frontal lobes, but mainly to the subcortical limbic system. The intra-frontal connections may be responsible for cognitive inferences and top-down regulation [47, 48], while subcortical limbic connections are thought to be mainly responsible for the automatic processing of sensory and affective stimuli (see [49] for a review). Therefore, we hypothesize that the processing of physiological rewards may be based on immediate and automatic mechanisms in the VS and subcortical dopaminergic system, whereas the processing of non-physiological rewards may rely on later cognitive evaluation in the mOFC and prefrontal regions.

In summary, there may be key differences between the two reward systems associated with the orbitofrontal cortex and the nucleus accumbens. That is, (1) the nucleus accumbens responds immediately during anticipation and receipt of primary rewards and some secondary rewards like money, and (2) the orbitofrontal cortex primarily responds to the receipt of rewards that may not be physiologically pleasurable, and which may be related to conscious desire, motivation, or meaning. This process would involve the valuation of internal and social rewards without physiological pleasure being necessary.

A variety of mental states, such as pleasure, desire, anticipation, excitement, and satisfaction are intertwined in the experience of pursuing and obtaining rewards. Therefore, we note that it is difficult to separate these systems as two completely disparate processes. For example, music combines various emotional states such as pleasure, anticipation, and excitement. Thus, although emotion induced by music is a non-physiological reward, it engages several reward-related brain areas including the NAcc and OFC [50–53]. Integrating evidence from animal studies and human fMRI studies can lead to a deeper understanding of the different brain systems involved in desire and preference.

4 Two Types of Beauty: Biological Versus Higher-Order Beauty

Now that we have a broad understanding of pleasure and the brain's reward system, we return to the first question of whether the sense of beauty is different from pleasure. As discussed, there may be no straightforward answer due to the existence of at least two distinct types of pleasure: pleasure derived from physiological rewards and pleasure derived from non-physiological (i.e., social or intrinsic) rewards. How about beauty, then? Just as feelings of pleasure can be divided into categories, it may be possible to distinguish between beauty that can be traced to physiological desires, and beauty that is learned from experience, culture, and education. The former is a kind of beauty that we sense from biologically salient stimuli, such as faces and bodies, which could convey meaningful information for determining a potential mate's physical health and reproductive fitness.

There are also other types of beauty which are based on physiological and biological desires. Housing or shelter can be included in this category since safe shelter is important for survival. Prior research has shown that people find curved spaces more beautiful than angular ones, likely due to the fact that a space composed of curves gives off an impression of softness and safety [54]. Thus, it is likely that the beauty of faces, bodies, and physical spaces is based on biological and physiological desires. Let us tentatively refer to this as "biological beauty."

Evaluations of facial beauty, which can be classified as biological beauty, have been found to be relatively stable and consistent across different cultures, compared to aesthetic evaluations of artificial objects such as abstract artworks [55, 56]. This pattern has also been found in other domains of biological beauty (e.g., stable evaluations of scenic beauty) [57]. Although this is not always the case (see [58]), facial beauty (and likely scenic beauty as well) could be an example of universal beauty that does not depend heavily on culture or education. This could potentially be explained by the fact that biological beauty is based on physiological and homeostatic demands which are relatively stable across cultural contexts.

On the other hand, the beauty of social and intrinsic rewards is distinct from physiological pleasure. For example, mathematical beauty as well as moral beauty perceived in altruistic behaviour neither satisfy one's hunger nor provide sexual arousal. This type of beauty may require learning of sociocultural norms or the acquisition of specific knowledge. Thus, it is not the kind of beauty that is biologically meaningful or salient. The perception of beauty in artwork may belong in this category as well. Let us refer to this as "higher-order beauty."

As described above, there seem to be at least two distinct types of experiences of beauty, which can be categorized as (1) biological beauty based on physiological desires and homeostatic demands, and (2) higher-order beauty that is shaped by culture and learning. The former may be more culturally stable and the latter may be more socioculturally malleable and context-dependent. Indeed, previous evidence has suggested that both the ventral striatum and orbitofrontal cortex are

recruited when perceiving facial beauty, but only the orbitofrontal cortex is implicated in perceiving moral beauty [33]. That is, the difference in the neural correlates of pleasure (i.e., the orbitofrontal cortex versus the nucleus accumbens) seems to be paralleled in differential judgments of beauty as either biological beauty or higher-order beauty.

There are certainly numerous areas of overlap between feelings of beauty and pleasure. However, we emphasize that not all beautiful or pleasurable experiences have a one-to-one correspondence, but each domain may be primarily based on a specific neural system. The beauty of morality or mathematics is beyond a simple physiological desire, and the brain responses underlying those experiences are likely to reflect this distinction.

The proposed classification of biological beauty as distinct from higher-order beauty may be insufficient to answer the question of why we recognize beauty in artwork and acts of moral justice regardless of the fact that they do not fulfill physiological needs. To the best of our knowledge, neuroaesthetics has not yet provided an empirical answer. However, revisiting the categorization of beauty in this manner may be an intriguing opportunity to reconsider the notion that beauty can be equated to pleasure. By studying the neural underpinnings of these diverse sensory experiences, it may be possible to use neuroscientific research to contribute to philosophical inquiries in the field of empirical aesthetics.

5 Stimulus Categories of Biological Versus Higher-Order Beauty

We have introduced biological beauty based on physiological pleasure and higher-order beauty tied to higher cognition. Next, it is interesting to revisit this categorical framework in accordance with diverse stimuli, objects, and events which fall into each category of beauty. We have categorised beauty in faces and bodies as biological beauty because these stimuli are important to our survival and reproductive fitness. Developmental psychology studies have shown that infants gaze at beautiful faces for longer periods of time, suggesting that even they can distinguish beautiful faces from less beautiful ones [59]. Individual differences in aesthetic preference of faces is less variable compared to preferences of higher-order aesthetic stimuli such as abstract paintings [57]. While the beauty of biological stimuli relates to physiological desires and homeostasis, and hence less individual and cultural differences seem to exist, the beauty of acquired concepts can be dynamically shaped by experience and learning. In other words, stimuli associated with physiological rewards based on biological desires are characterized by relatively minor individual differences. On the other hand, social norms are regulated by the environment and personal upbringing, and can change flexibly depending upon cultural context. For instance, morally good/right acts are often regarded as beautiful acts, whereas morally unacceptable acts tend to be judged as ugly acts. Such moral judgments are learned based on social norms, and can be modulated by contextual factors.

The experience of beauty derived from physiologically pleasing stimuli is typically associated with positive emotional value. In contrast, the higher-order or learned type of beauty can be accompanied by negatively valenced emotions, such as sadness or pain [60–64]. This is because physiological pleasure does not have to be met. For instance, beauty found in morally good or self-sacrificing acts is perceived as aesthetically positive (beautiful) but can be negatively valenced. Such instances of beauty may be regarded as separate from biological and individual survival motivations.

6 Neural Correlates of Aesthetic Judgements

As discussed above, neural activity related to physiological rewards is primarily evident in the ventral striatum, which is activated by enkephalins, Gamma-aminobutyric acid, and dopamine [65]. Likewise, neuroimaging studies have shown that biological beauty, such as facial beauty, activates the ventral striatum in addition to the OFC [33, 66].

Medial orbitofrontal cortex activity has been implicated in experiences of biological beauty, as well as higher-order beauty. Interestingly, ventral striatal activity tends to be less evident for higher-order beauty [33]. We have proposed that higher-order beauty is shaped by learning, experience, and sociocultural factors. Past studies have shown that judgments of beauty can be shaped by contextual information [67, 68]. These studies have suggested that OFC activity related to these evaluations may be regulated by cortical brain areas, such as the dorsolateral prefrontal cortex [68, 69]. Additionally, negatively valenced beauty has been shown to be associated with activity in the supplemental motor cortex, midcingulate cortex, and DLPFC [61], which are regions that support empathy [70, 71]. Taken together, these findings suggest that prosocial acts may offer some aesthetic value, which requires meta-cognition and is likely to be supported by functional connections between the orbitofrontal cortex and other brain regions involved in empathy. In other words, higher-order beauty may involve the orbitofrontal cortex being functionally coupled with other brain regions to process the aesthetic value of complex learned experiences. This discussion aligns with our earlier hypothesis regarding the two systems underlying pleasure and reward processing. Likewise, the two types of beauty are likely to engage different brain systems.

7 What Can Neuroaesthetics Tell us about Beauty?

Beauty is a ubiquitous judgment or experience in daily life. We perceive it in a multitude of domains, from faces and artwork to morality and mathematics. What does the experience of beauty mean for us? What have we learnt about beauty through the study of neuroaesthetics?

Our perceptions of beauty can drive the judgements and choices we make, especially those related to rightness or goodness [72]. In Plato's philosophy, truth, goodness, and beauty are universal values that humans pursue as ideals. A wealth of evidence has revealed a fundamental cognitive bias that links beauty with goodness as well as truth [73–75]. In this respect, the sense of beauty may seem to provide information that allows us to judge the "rightness" or "goodness" of things. Compared to modern civilization, where there is relatively little pressure related to day-to-day survival, it seems reasonable that in evolutionary terms, aesthetic judgements could have been crucial in determining the choice of a healthy mate, a safe place to live, etc.

Furthermore, in modern society where survival pressures are relatively minor, what is right or good often varies according to social and contextual factors. The ever-present problem we face is that there is not always a "right answer" to what is true or good. Therefore, the sense of beauty that each of us experiences may drive the innumerable decisions we make each day of our lives.

As discussed above, we introduced the hypothesis that beauty may be classified into at least two kinds: biological beauty and higher-order beauty. Biological beauty is likely to be relatively stable and consistent across individuals and cultural groups. This aligns with the relative strictness of biological demands, and could be associated with ventral striatal activity. Higher-order beauty, on the other hand, has the flexibility of being dynamically shaped by the surrounding environment and the greater sociocultural context. We hypothesize that it is associated with the interaction between brain systems that are important for aesthetic evaluation (i.e., mOFC) and higher brain regions such as the dorsolateral prefrontal cortex and other frontal regions.

8 A Pleasure-Based Biological Desire and a Meaning-Based Humanity

We have proposed a distinction between two types of beauty, as a parallel to the distinction between two types of pleasure. The first was beauty related to physiological rewards (biological beauty), and the other was beauty connected to intrinsic and social rewards (higher-order beauty). It is intriguing to examine this distinction from the perspective of reinforcement. In decision science, reinforcement is considered a crucial factor in understanding and modelling behaviour. Upon receipt of a reward, we are motivated to continue the action that led to that reward. The reward itself, which facilitates the causative action, is called a reinforcer: food is a reinforcer when we are hungry, and money is a reinforcer in modern society. In this sense, biological beauty is itself pleasurable because it is directly associated with primary/physiological rewards and can become the reinforcer or motivator in and of itself. However, higher-order or learned beauty seems qualitatively different; the aesthetic value found in tragedy, hardship, and self-sacrifice are by no means simple physiological pleasures. These experiences tend to be painful and sorrowful, and may even go against optimizing survival. Nevertheless, many of them are deeply

rooted in our value system, as reflected by societal norms surrounding morality and altruism.

Humans typically pursue positive, pleasurable feelings and seek to prolong them. However, humans have the capability to derive meaning from challenging experiences, and to even motivate themselves towards such experiences. Perhaps higher-order beauty bolsters this ability, and serves as the reinforcer/motivator for those acts. This idea may harken back to an age-old philosophical debate on happiness proposed by Aristotle, who argued that the well-being of humankind consists of two distinct elements: *hedonia* and *eudaimonia* [76]. Hedonia can be translated as the pursuit of pleasure, while eudaimonia refers to a sense of meaning, personal fulfillment, or virtue. Aristotle argued that it is necessary to pursue both elements in order to achieve true happiness. The relationship between biological beauty and acquired beauty can also be applied in this philosophical framework. The experience of acquired beauty, which lacks physiological pleasure, may be a reinforcer of eudaimonic value.

9 Clinical Implications

We have proposed that (1) aesthetic evaluations of beauty may be categorised into two different types: one tied to hedonic value and another tied to eudaimonic value; (2) each relies on two separable brain reward systems, the NAcc and mOFC, respectively; (3) it may be the case that beauty associated with hedonic pleasure mostly engages the NAcc. Considering aesthetic judgments in terms of the different reward systems in the brain may reveal new directions for understanding the pathogenesis of some neurological diseases.

Dysfunction in aesthetic judgment can have serious repercussions for physical and mental health, with some psychiatric disorders involving deficits in aesthetic judgement. One such disorder is body dysmorphic disorder (BDD), which is characterized by excessive worry and obsessive preoccupation with one's appearance [77]. BDD has high comorbidity with other psychiatric illnesses such as depression, obsessive-compulsive disorder, and eating disorders. Excessive introversion and childhood abuse have been identified as key risk factors, but the pathological differences from other obsessive-compulsive disorders are unclear. Therefore, a multifaceted understanding of BDD's pathology is necessary.

Recently, however, researchers have raised the possibility that disruptions in aesthetic judgment may be a contributing factor for BDD [78]. Interestingly, BDD occurs only in aesthetic judgments of one's own body image, while aesthetic judgments of other people and objects are not affected. Therefore, a higher-order integrative process of self-directed cognitive and sensory evaluations may be involved. Among the two different reward systems underlying aesthetic judgments, it seems reasonable to suspect some dysfunction in higher-order aesthetic information processing, especially in the mOFC. Indeed, atrophy within the OFC has been reported in BDD [79]. Neuroscientific studies of BDD have been largely limited to body perception/cognition and dysfunctions in respective brain regions (e.g., extrastriate

body area (EBA)). However, from the perspective of our hypothesis, it may be beneficial to consider a new direction in investigating the neural underpinnings of BDD. For example, examining functional connectivity between the mOFC and EBA may help to shed light on the pathogenesis of the disease.

The proposed hypothesis may also help to address recent psychopharmacological findings. Prior research has suggested that the ingestion of a dopaminergic antagonist, such as naltrexone, decreases subjective pleasure in visual and auditory domains [80]. For example, naltrexone has been shown to decrease liking and wanting responses to attractive faces, while an opioid agonist (i.e., morphine) leads to increased liking and wanting responses [81]. These findings lead to an intriguing question. Given a strong association between hedonic pleasure and biologically-based beauty as proposed above, dopamine antagonists could dampen subjective experiences of biological beauty, with higher-order beauty not being impacted.

A fruitful line of future neuroaesthetic research would include examining the neural correlates of aesthetic experiences, together with their underlying neurochemical mechanisms. Moreover, this neuro/psychopharmacological approach could contribute to studies of neurodegenerative disease. In fact, behavioural research has shown that Alzheimer's disease patients who exhibit impaired memory still maintain previous aesthetic preferences [82, 83]. This finding suggests that memory systems related to aesthetic preference might differ in some way from more general memory systems. Likewise, a recent empirical study has suggested that the sudden artistic creativity that sometimes appears in patients with Parkinson's disease may be attributable to the differential effects of dopamine agonist medication on two dopamine pathways, namely the mesolimbic and mesocortical dopamine pathways [17, 18]. Ultimately, a thorough examination from multiple levels of analysis should lead to a deeper understanding of the phenomenon in question and hopefully provide convergent evidence [84].

Considering these clinical findings together with the proposed hypothesis of two different reward systems underlying aesthetic judgements, it may be possible to gain a deeper understanding of various neurological diseases, such as disorders of memory consolidation/impairment, dysfunction of aesthetic evaluation (e.g., BDD), and disruptions in the experience of pleasure (e.g., anhedonia and severe depression). The differences may be in accordance with the specific reward circuits (i.e., mOFC and NAcc), and their functional and structural connections with other brain regions. Hence, psychopharmacological interventions targeting these brain networks may offer not only clinical applications, but also new directions that bridge basic neuroaesthetics research and applied domains.

Acknowledgement This research was supported by JSPS KAKENHI Grant Number 21H05063 (Transformative Research Areas [B]), 21H03531 (Grant-in-Aid for Scientific Research [B]), Suntory Foundation (2021G124).

References

1. Christensen JF. Pleasure junkies all around! Why it matters and why 'the arts' might be the answer: a biopsychological perspective. Proc Biol Sci. 2017;284(1854):20162837. https://doi.org/10.1098/rspb.2016.2837.
2. Brielmann AA, Pelli DG. Intense beauty requires intense pleasure. Front Psychol. 2019:2420. https://doi.org/10.3389/FPSYG.2019.02420.
3. Skov M, Nadal M. Art is not special: an assault on the last lines of defense against the naturalization of the human mind. Rev Neurosci. 2018;29(6):699–702. https://doi.org/10.1515/REVNEURO-2017-0085.
4. Ball P. Neuroaesthetics is killing your soul. Nature. 2013; https://doi.org/10.1038/nature.2013.12640.
5. Hyman J. Art and neuroscience. In: Frigg R, Hunter MC, editors. Beyond mimesis and convention: representation in art and science. New York: Springer; 2010. p. 245–61.
6. Haber SN, Knutson B. The reward circuit: linking primate anatomy and human imaging. Neuropsychopharmacology. 2010;35(1):4–26. https://doi.org/10.1038/npp.2009.129.
7. Berridge KC, Kringelbach ML. Affective neuroscience of pleasure: reward in humans and animals. Psychopharmacology. 2008;199(3):457–80. https://doi.org/10.1007/S00213-008-1099-6.
8. Fehr E, Rockenbach B. Human altruism: economic, neural, and evolutionary perspectives. Curr Opin Neurobiol. 2004;14(6):784–90. https://doi.org/10.1016/J.CONB.2004.10.007.
9. Schultz W. Neuronal reward and decision signals: from theories to data. 2015;95(3):853–951. https://doi.org/10.1152/PHYSREV.00023.2014.
10. O'Doherty J, Kringelbach ML, Rolls ET, Hornak J, Andrews C. Abstract reward and punishment representations in the human orbitofrontal cortex. Nat Neurosci. 2001;4(1):95–102. https://doi.org/10.1038/82959.
11. Schultz W. Reward functions of the basal ganglia. J Neural Transm. 2016;123(7):679–93. https://doi.org/10.1007/S00702-016-1510-0.
12. Belluzi JD, Stein L. Enkephalin may mediate euphoria and drive-reduction reward. Nature. 1977;266(5602):556–8. https://doi.org/10.1038/266556a0.
13. Stahl SM. Antipsychotics and mood stabilizers: Stahl's essential psychopharmacology. Cambridge University Press; 2008. https://books.google.co.uk/books?hl=en&lr=lang_en%7Clang_ja&id=jwfrLrYc7d0C&oi=fnd&pg=PR9&dq=Stahl+2008+cstc&ots=wOwN4WE2ut&sig=GOGIc39IXmGmfLNqHwQ7-dH9oeI#v=onepage&q=Stahl2008cstc&f=false
14. Knutson B, Cooper JC. Functional magnetic resonance imaging of reward prediction. Curr Opin Neurol. 2005;18(4):411–7. https://doi.org/10.1097/01.WCO.0000173463.24758.F6.
15. Spee B, Ishizu T, Leder H, Mikuni J, Kawabata H, Pelowski M. Neuropsychopharmacological aesthetics: a theoretical consideration of pharmacological approaches to causative brain study in aesthetics and art. Prog Brain Res. 2018;237:343–72. https://doi.org/10.1016/BS.PBR.2018.03.021.
16. Vessel EA, Ishizu T, Bignardi G. Neural correlates of visual aesthetic appeal. In: Skov M, Nadal M, editors. The Routledge international handbook of neuroaesthetics. London: Routledge; 2022. p. 103–33.
17. Lauring JO, Ishizu T, Kutlikova HH, Dörflinger F, Haugbøl S, Leder H, Kupers R, Pelowski M. Why would Parkinson's disease lead to sudden changes in creativity, motivation, or style with visual art?: a review of case evidence and new neurobiological, contextual, and genetic hypotheses. Neurosci Biobehav Rev. 2019a;100 https://doi.org/10.1016/j.neubiorev.2018.12.016.
18. Lauring JO, Pelowski M, Specker E, Ishizu T, Haugbøl S, Hollunder B, Leder H, Stender J, Kupers R. Parkinson's disease and changes in the appreciation of art: a comparison of aesthetic and formal evaluations of paintings between PD patients and healthy controls. Brain Cogn. 2019b;136 https://doi.org/10.1016/j.bandc.2019.103597.

19. Roesch MR, Olson CR. Neuronal activity related to reward value and motivation in primate frontal cortex. Science. 2004;304(5668):307–10. https://doi.org/10.1126/SCIENCE.1093223.
20. Rolls ET. The orbitofrontal cortex and reward. Cereb Cortex. 2000;10(3):284–94. https://doi.org/10.1093/CERCOR/10.3.284.
21. Tremblay L, Schultz W. Reward-related neuronal activity during go-Nogo task performance in primate orbitofrontal cortex. 2000;83(4):1864–76. https://doi.org/10.1152/JN.2000.83.4.1864.
22. Bechara A, Damasio AR, Damasio H, Anderson SW. Insensitivity to future consequences following damage to human prefrontal cortex. Cognition. 1994;50(1–3):7–15. https://doi.org/10.1016/0010-0277(94)90018-3.
23. Kim H, Shimojo S, O'Doherty JP. Overlapping responses for the expectation of juice and money rewards in human ventromedial prefrontal cortex. Cereb Cortex. 2011;21(4):769–76. https://doi.org/10.1093/CERCOR/BHQ145.
24. Knutson B, Genevsky A. Neuroforecasting aggregate choice. 2018;27(2):110–5. https://doi.org/10.1177/0963721417737877.
25. Kim H, Adolphs R, O'Doherty JP, Shimojo S. Temporal isolation of neural processes underlying face preference decisions. Proc Natl Acad Sci. 2007;104(46):18253–8. https://doi.org/10.1073/PNAS.0703101104.
26. Brown S, Gao X, Tisdelle L, Eickhoff SB, Liotti M. Naturalizing aesthetics: brain areas for aesthetic appraisal across sensory modalities. NeuroImage. 2011;58(1):250–8. https://doi.org/10.1016/J.NEUROIMAGE.2011.06.012.
27. Plassmann H, O'Doherty J, Rangel A. Orbitofrontal cortex encodes willingness to pay in everyday economic transactions. J Neurosci. 2007;27(37):9984–8. https://doi.org/10.1523/JNEUROSCI.2131-07.2007.
28. Sescousse G, Caldú X, Segura B, Dreher JC. Processing of primary and secondary rewards: a quantitative meta-analysis and review of human functional neuroimaging studies. Neurosci Biobehav Rev. 2013;37(4):681–96. https://doi.org/10.1016/J.NEUBIOREV.2013.02.002.
29. Moll J, Krueger F, Zahn R, Pardini M, de Oliveira-Souza R, Grafman J. Human fronto–mesolimbic networks guide decisions about charitable donation. Proc Natl Acad Sci. 2006;103(42):15623–8. https://doi.org/10.1073/PNAS.0604475103.
30. Berridge KC. Wanting and liking: observations from the neuroscience and psychology laboratory. Inquiry (Oslo). 2009;52(4):378. https://doi.org/10.1080/00201740903087359.
31. Peciña S, Cagniard B, Berridge KC, Aldridge JW, Zhuang X. Hyperdopaminergic mutant mice have higher "wanting" but not "liking" for sweet rewards. J Neurosci. 2003;23(28):9395–402. https://doi.org/10.1523/JNEUROSCI.23-28-09395.2003.
32. Zeki S, Romaya JP, Benincasa DMT, Atiyah MF. The experience of mathematical beauty and its neural correlates. Front Hum Neurosci. 2014;8:68. https://doi.org/10.3389/fnhum.2014.00068.
33. Wang T, Mo L, Mo C, Tan LH, Cant JS, Zhong L, Cupchik G. Is moral beauty different from facial beauty? Evidence from an fMRI study. Soc Cogn Affect Neurosci. 2015;10(6):814–23. https://doi.org/10.1093/scan/nsu123.
34. Tsukiura T, Cabeza R. Shared brain activity for aesthetic and moral judgments: implications for the beauty-is-good stereotype. Soc Cogn Affect Neurosci. 2011;6(1):138–48. https://doi.org/10.1093/scan/nsq025.
35. Koelsch S. Investigating the neural encoding of emotion with music. Neuron. 2018;98(6):1075–9. https://doi.org/10.1016/J.NEURON.2018.04.029.
36. Goupil L, Aucouturier J-J. Musical pleasure and musical emotions. Proc Natl Acad Sci. 2019;116(9):3364–6. https://doi.org/10.1073/PNAS.1900369116.
37. Royal I, Vuvan DT, Zendel BR, Robitaille N, Schönwiesner M, Peretz I. Activation in the right inferior parietal lobule reflects the representation of musical structure beyond simple pitch discrimination. PLoS One. 2016;11(5):e0155291. https://doi.org/10.1371/JOURNAL.PONE.0155291.
38. Cheung VKM, Harrison PMC, Meyer L, Pearce MT, Haynes JD, Koelsch S. Uncertainty and surprise jointly predict musical pleasure and amygdala, hippocampus, and auditory cortex activity. Curr Biol. 2019;29(23):4084-4092.e4. https://doi.org/10.1016/J.CUB.2019.09.067.

39. Izuma K, Saito DN, Sadato N. Processing of social and monetary rewards in the human striatum. Neuron. 2008;58(2):284–94. https://doi.org/10.1016/J.NEURON.2008.03.020.
40. Tsutsui KI, Watanabe M. Neural representation of reward. Jpn J Physiol Psychol Psychophysiol. 2008;26(1):5–16. https://doi.org/10.5674/jjppp1983.26.5.
41. Haber SN, Behrens TEJ. The neural network underlying incentive-based learning: implications for interpreting circuit disruptions in psychiatric disorders. Neuron. 2014;83(5):1019–39. https://doi.org/10.1016/J.NEURON.2014.08.031.
42. Haber SN. Neural circuits of reward and decision making: integrative networks across corticobasal ganglia loops. Neural Basis of Motivational and Cognitive Control. 2011:21–35. https://books.google.co.jp/books?hl=en&lr=&id=A_eoYgtLmFMC&oi=fnd&pg=PA21 &dq=info:V7XzNyDfQfIJ:scholar.google.com&ots=YfmKHUZiLU&sig=nyMA2JMw Nbi_gpi3LLiHdQIMQmo&redir_esc=y#v=onepage&q&f=false
43. Haber SN. Corticostriatal circuitry. Dialogues Clin Neurosci. 2016;18(1):7. https://doi.org/10.31887/DCNS.2016.18.1/SHABER.
44. Barbas H, de Olmos J. Projections from the amygdala to basoventral and mediodorsal prefrontal regions in the rhesus monkey. J Comp Neurol. 1990;300(4):549–71. https://doi.org/10.1002/CNE.903000409.
45. Haber S, Kunishio K, Mizobuchi M, Lynd-Balta E. The orbital and medial prefrontal circuit through the primate basal ganglia. J Neurosci. 1995;15(7):4851–67. https://doi.org/10.1523/JNEUROSCI.15-07-04851.1995.
46. Chowdhury R, Lambert C, Dolan RJ, Düzel E. Parcellation of the human substantia nigra based on anatomical connectivity to the striatum. NeuroImage. 2013;81:191–8. https://doi.org/10.1016/J.NEUROIMAGE.2013.05.043.
47. Chikazoe J. Localizing performance of go/no-go tasks to prefrontal cortical subregions. Curr Opin Psychiatry. 2010;23(3):267–72. https://doi.org/10.1097/YCO.0B013E3283387A9F.
48. Ochsner KN, Ray RR, Hughes B, McRae K, Cooper JC, Weber J, Gabrieli JDE, Gross JJ. Bottom-up and top-down processes in emotion generation: common and distinct neural mechanisms. 2009;20(11):1322–31. https://doi.org/10.1111/J.1467-9280.2009.02459.X.
49. Kötter R, Meyer N. The limbic system: a review of its empirical foundation. Behav Brain Res. 1992;52(2):105–27. https://doi.org/10.1016/S0166-4328(05)80221-9.
50. Gold BP, Mas-Herrero E, Zeighami Y, Benovoy M, Dagher A, Zatorre RJ. Musical reward prediction errors engage the nucleus accumbens and motivate learning. Proc Natl Acad Sci. 2019;116(8):3310–5. https://doi.org/10.1073/PNAS.1809855116.
51. Martínez-Molina N, Mas-Herrero E, Rodríguez-Fornells A, Zatorre RJ, Marco-Pallarés J. Neural correlates of specific musical anhedonia. Proc Natl Acad Sci. 2016;113(46):E7337–45. https://doi.org/10.1073/PNAS.1611211113.
52. Salimpoor VN, Benovoy M, Larcher K, Dagher A, Zatorre RJ. Anatomically distinct dopamine release during anticipation and experience of peak emotion to music. Nat Neurosci. 2011;14(2):257–62. https://doi.org/10.1038/nn.2726.
53. Salimpoor VN, Van Den Bosch I, Kovacevic N, McIntosh AR, Dagher A, Zatorre RJ. Interactions between the nucleus accumbens and auditory cortices predict music reward value. Science. 2013;340(6129):216–9. https://doi.org/10.1126/SCIENCE.1231059.
54. Vartanian O, Navarrete G, Chatterjee A, Fich LB, Leder H, Modroño C, Nadal M, Rostrup N, Skov M. Impact of contour on aesthetic judgments and approach-avoidance decisions in architecture. Proc Natl Acad Sci. 2013;110(Supplement 2):10446–53. https://doi.org/10.1073/PNAS.1301227110.
55. Langlois JH, Kalakanis L, Rubenstein AJ, Larson A, HaUam M, Lar-son A, Hallam M, Smoot M, Langlois We thank Rebecca Bigler, J. H, Buss D, Cohen D, Feingold A, Holden G, Kalick D, Miller P, Swann WB. Psychological bulletin maxims or myths of beauty? A Meta-Analytic and Theoretical Review. 2000;126(3):390–423. https://doi.org/10.1037/0033-2909.126.3.390.
56. Bignardi G, Ishizu T, Zeki S. The differential power of extraneous influences to modify aesthetic judgments of biological and artifactual stimuli. PsyCh J. 2021;10(2):190–9. https://doi.org/10.1002/pchj.415.

57. Vessel EA, Maurer N, Denker AH, Starr GG. Stronger shared taste for natural aesthetic domains than for artifacts of human culture. Cognition. 2018;179:121–31. https://doi.org/10.1016/J.COGNITION.2018.06.009.

58. Sorokowski P, Kościński K, Sorokowska A. Is beauty in the eye of the beholder but ugliness culturally universal? Facial preferences of polish and Yali (Papua) people. 2013;11(4):907–25. https://doi.org/10.1177/147470491301100414.

59. Langlois JH, Roggman LA, Casey RJ, Ritter JM, Rieser-Danner LA, Jenkins VY. Infant preferences for attractive faces: rudiments of a stereotype? Dev Psychol. 1987;23(3):363–9. https://doi.org/10.1037/0012-1649.23.3.363.

60. Hanich J, Wagner V, Shah M, Jacobsen T, Menninghaus W. Why we like to watch sad films. The pleasure of being moved in aesthetic experiences. Psychol Aesthet Creat Arts. 2014;8(2):130–43. https://doi.org/10.1037/a0035690.

61. Ishizu T, Zeki S. The experience of beauty derived from sorrow. Hum Brain Mapp. 2017;38:8. https://doi.org/10.1002/hbm.23657.

62. Ishizu T, Zeki S. A neurobiological enquiry into the origins of our experience of the sublime and beautiful. Front Hum Neurosci. 2014;8:891. https://doi.org/10.3389/fnhum.2014.00891.

63. Menninghaus W, Wagner V, Hanich J, Wassiliwizky E, Jacobsen T, Koelsch S. The distancing–embracing model of the enjoyment of negative emotions in art reception. Behav Brain Sci. 2017:1–58. https://doi.org/10.1017/S0140525X17000309.

64. Hur Y-J, Gerger G, Leder H, McManus IC. Facing the sublime: physiological correlates of the relationship between fear and the sublime. Psychol Aesthet Creat Arts. 2020;14(3):253–63. https://doi.org/10.1037/aca0000204.

65. Zhang M, Balmadrid C, Kelley AE. Nucleus accumbens opioid, GABAergic, and dopaminergic modulation of palatable food motivation: contrasting effects revealed by a progressive ratio study in the rat. Behav Neurosci. 2003;117(2):202–11. https://doi.org/10.1037/0735-7044.117.2.202.

66. Cloutier J, Heatherton TF, Whalen PJ, Kelley WM. Are attractive people rewarding? Sex differences in the neural substrates of facial attractiveness. J Cogn Neurosci. 2008;20(6):941–51. https://doi.org/10.1162/JOCN.2008.20062.

67. Izuma K, Adolphs R. Social manipulation of preference in the human brain. Neuron. 2013;78(3):563–73. https://doi.org/10.1016/J.NEURON.2013.03.023.

68. Kirk U, Skov M, Hulme O, Christensen MS, Zeki S. Modulation of aesthetic value by semantic context: an fMRI study. NeuroImage. 2009;44(3):1125–32. https://doi.org/10.1016/J.NEUROIMAGE.2008.10.009.

69. Kirk U, Harvey A, Montague PR. Domain expertise insulates against judgment bias by monetary favors through a modulation of ventromedial prefrontal cortex. Proc Natl Acad Sci. 2011;108(25):10332–6. https://doi.org/10.1073/pnas.1019332108.

70. Fan Y, Duncan NW, de Greck M, Northoff G. Is there a core neural network in empathy? An fMRI based quantitative meta-analysis. Neurosci Biobehav Rev. 2011;35(3):903–11. https://doi.org/10.1016/J.NEUBIOREV.2010.10.009.

71. Lamm C, Decety J, Singer T. Meta-analytic evidence for common and distinct neural networks associated with directly experienced pain and empathy for pain. NeuroImage. 2011;54(3):2492–502. https://doi.org/10.1016/J.NEUROIMAGE.2010.10.014.

72. Zeki S. Neurobiology and the humanities. Neuron. 2014;84(1):12–4. https://doi.org/10.1016/J.NEURON.2014.09.016.

73. Dion K, Berscheid E, Walster E. What is beautiful is good. J Pers Soc Psychol. 1972;24(3):285–90. https://doi.org/10.1037/H0033731.

74. Ramsey JL, Langlois JH, Hoss RA, Rubenstein AJ, Griffin AM. Origins of a stereotype: categorization of facial attractiveness by 6-month-old infants. Dev Sci. 2004;7(2):201–11. https://doi.org/10.1111/J.1467-7687.2004.00339.X.

75. Synnott A. Truth and goodness, mirrors and masks—part I: a sociology of beauty and the face. Br J Sociol. 1989;40(4):607. https://doi.org/10.2307/590891.

76. Aristotle. Nichomachean ethics (T. Irwin, translator). Indianapolis, IN: Hackett; 1985.

77. Cororve MB, Gleaves DH. Body dysmorphic disorder: a review of conceptualizations, assessment, and treatment strategies. Clin Psychol Rev. 2001;21(6):949–70. https://doi.org/10.1016/S0272-7358(00)00075-1.
78. Stein DJ, Carey PD, Warwick J. Beauty and the beast: psychobiologic and evolutionary perspectives on body dysmorphic disorder. CNS Spectr. 2006;11(6):419–22. https://doi.org/10.1017/S1092852900014590.
79. Atmaca M, Bingol I, Aydin A, Yildirim H, Okur I, Yildirim MA, Mermi O, Gurok MG. Brain morphology of patients with body dysmorphic disorder. J Affect Disord. 2010;123(1–3):258–63. https://doi.org/10.1016/J.JAD.2009.08.012.
80. Ferreri L, Mas-Herrero E, Cardona G, Zatorre RJ, Antonijoan RM, Valle M, Riba J, Ripollés P, Rodriguez-Fornells A. Dopamine modulations of reward-driven music memory consolidation. Ann N Y Acad Sci. 2021; https://doi.org/10.1111/NYAS.14656.
81. Chelnokova O, Laeng B, Eikemo M, Riegels J, Løseth G, Maurud H, Willoch F, Leknes S. Rewards of beauty: the opioid system mediates social motivation in humans. Mol Psychiatry. 2014;19(7):746–7. https://doi.org/10.1038/mp.2014.1.
82. Halpern AR, Ly J, Elkin-Frankston S, O'Connor MG. "I know what I like": stability of aesthetic preference in alzheimer's patients. Brain Cogn. 2008;66(1):65–72. https://doi.org/10.1016/J.BANDC.2007.05.008.
83. Graham D, Stockinger S, Leder H. An island of stability: art images and natural scenes—but not natural faces—show consistent esthetic response in Alzheimer's-related dementia. Front Psychol. 2013;4:107. https://www.frontiersin.org/articles/10.3389/fpsyg.2013.00107.
84. Knutson B, Srirangarajan T. Toward a deep science of affect and motivation. In: Neta M, Haas I, editors. Emotion in the mind and body. Nebraska symposium on motivation, vol. 66. Cham: Springer; 2019. https://doi.org/10.1007/978-3-030-27473-3_7.

Part III

The Next Steps Neurodegenerative Diseases and Creativity

The Potential of Causal Approaches in Creativity Using Ultrasonic Brain Stimulation

Julia Sophia Crone

Producing and appreciating art is a fundamental trait of the human species and, at least to this extent, seems to be unique in evolution [1]. The production of art, as a central part of all human cultures, has an important evolutionary motivation since it promotes survival and a shared identity. One specific aspect of art production is creativity; a multifaceted concept, most often described as the phenomenon when something novel and valuable is created and expressed in numerous domains ranging from artistic enactment, scientific progress, to problem-solving. Creativity, as the main driver of a long history of artmaking, has always been a focus of investigation in many different disciplines, such as the humanities, art history, and psychology; but only very lately, this field has been a subject of interest in neuroscience.

1 The Brain as a Dynamic Network Balancing Flexibility and Stability

Although the biological underpinnings of creativity are discussed in depth elsewhere in this book, some aspects are worth highlighting here in a slightly different context. Creativity is not a unique characteristic of the human kind. In fact, many animals are creative, especially birds and non-human primates [2]. In both, the size of specific brain areas correlates with the capability for creativity and innovation [3]. Deviations from common behavior enhancing survival is associated with larger brains in animals [3]; and in the human brain, the size of these areas have grown much larger compared to other animals [4]. The advantage of a larger brain is specifically the increasing capacity for more complex connections.

J. S. Crone (✉)
Vienna Cognitive Science Hub, University of Vienna, Vienna, Austria

Department of Psychology, University of California Los Angeles, Los Angeles, CA, USA
e-mail: julia.crone@univie.ac.at

© The Author(s), under exclusive license to Springer Nature Switzerland AG 2023
A. Richard et al. (eds.), *Art and Neurological Disorders*, Current Clinical
Neurology, https://doi.org/10.1007/978-3-031-14724-1_10

The brain is designed as a network with subnetworks that are segregated in order to allow flexibility to adapt to specific needs, but also integrated in order to share information [5]. These global brain networks form unique patterns of connections, so-called *brain states*, that vary not just across individuals but also with function within a general preserved anatomical structure [6, 7]. These fluctuations of different brain states, that is, the emergence and disappearance of the correlated activity across widespread neural networks and multiple timescales [8, 9], are the basis for information processing. Networks with more potential configurations across spatial and temporal dimensions have a greater repertoire of possible responses to process information, to learn, and to induce actions for hypotheses testing [7, 10–12]. In addition to the number of total brain states, the repertoire of these networks can be quantified by different properties including dwell time (the time spent in a given state), frequency (the number of times a given state occurs), and transitions (the number of times one brain state transitions to the other). A larger repertoire, that is, more variability and transient changes of brain states, is directly linked to the extent of flexibility that allows an individual to adapt its behavior to environmental challenges [5, 13–16]. This variability has an inverted u-shaped association with age, meaning it increases with age and at a certain point starts to decline again [17]. Variability also correlates negatively with reaction time and positively with accuracy [17]. Younger and better-performing adults show an increase in brain variability during task performance compared to resting state, while older and worse-performing adults exhibit less differentiation in brain variability across tasks [18]. Thus, a larger brain with its greater capacity of connections allows a higher variability of possible brain states which, as discussed above, is associated with higher cognitive flexibility to adapt to situations, and thus, exhibits the potential for innovation and creativity.

Nevertheless, variability comes with a cost. Naturally, there is a need for an optimal balance between stability (focus on a given task) and flexibility (switching between brain states) to respond to new input. Too much stability and too little flexibility will prevent one from adapting successfully to environmental changes. Too little stability and too much flexibility makes it impossible to focus and reach any goal. Thus, there exists a stability-flexibility dilemma in the properties of the global brain network [19]. In other words, one often needs to be flexible and persistent at the same time to pursue a goal. Thus, stability and flexibility are unlikely to be the result of one single mechanisms with opposite dimensions. The postulation of two separate mechanisms is therefore much more plausible.

2 Neurobiological Mechanisms Underlying Creativity

Research on creativity has always been interested to understand the underlying neurobiological mechanisms. However, the critical point here is how this investigation can be achieved. Most studies are of correlative nature in which cognitive processes of creativity are associated with simultaneous measurements of brain activity, and thus, lacking a validation of the causal function of the identified process in

creativity. For example, the default mode network has become a popular candidate in research on creativity [20–22] since the synchronous activity of this network is reduced during attention-demanding tasks, that is, during highly focused and stabilized brain states, [23, 24]. However, most of these studies have linked the activity of single regions belonging to the default mode network or their intercorrelation to creativity rather than associating states and properties of connectivity patterns of this network with the creative process. Since the default mode network has been associated with multiple forms of complex cognition and plays a prominent role in information segregation and integration, evidence speaks for a more general role of the default mode network in cognitive processing [25, 26] rather than a specific involvement in creativity per se.

To validate a causal function of specific mechanisms, research has been conducted in patients with focal brain damage. Interestingly though, numerous cases of visual artists with acquired focal brain damage demonstrate that lesions in specific regions of the brain do not seem to significantly affect creativity [27]. This is actually in line with the notion that there exists no regional hotspot for creativity but rather specific properties of connectivity patterns (such as temporal and spatial flexibility as well as stability), that is, creativity does not emerge in a certain region of the brain but rather through the possibility of flexible adaption, see discussion above. Thus, the question is not *where* in the brain creativity is produced but rather *how*.

A similar finding has been shown for patients with neurodegenerative diseases who also provide a causal glimpse into the relationship between brain function and creativity. Despite their general decline in the "dynamic repertoire" of brain states [28], visual artists with neurodegenerative diseases practice their artistic passion well beyond the undoubtable onset of their condition [29]. In fact, artistic production can even emerge *de novo* (i.e., for the first time) after disease onset [30–34]. One line of reasoning attributes this sudden emergence of artistic ability and motivation to a loss of inhibitory control over the cortex due to a disease-related degeneration of relevant neuronal pathways [31], especially within the prefrontal cortex and the basal ganglia circuit [35]. Yet, there must be other factors involved in addition to a degeneration of relevant pathways. Although this has not been studied well yet, first evidence suggests that only a portion of patients with neurodegenerative diseases actually experience changes in creativity. One study conducting a retrospective survey in the common neurodegenerative disorder Parkinson's disease, found that 19.3% of the 280 patients surveyed actually showed increased artistic creativity after diagnosis [36]. Another study, also in Parkinson's disease but measuring creativity with a standardized assessment scale, found a prevalence of only 14.5% of 76 patients for enhanced creativity (for which artistic work started or exacerbated after beginning of medication treatment) [37]. If a degeneration of pathways within the prefrontal cortex necessary for inhibition were the main cause, the prevalence of a sudden spike in creativity would be expected to be higher. In fact, a general degeneration [38, 39] of prefrontal regions, as well as lesions [40, 41] is rather associated with a decline in creativity. The organization of the prefrontal cortex and its role in inhibition is complex and different alterations may affect

different aspects of creativity [42]. In addition, non-neural-typical patients as a study sample are difficult to control for, and the causal effects of damage are not always straightforward.

One theory here is that alterations in the dopaminergic pathways of the reward system lead to an increased rate of creativity and artistic output [34, 43, 44]. Indeed, evidence suggests that the chemical neuromodulator dopamine is responsible for the adaption of the otherwise structural fixed global networks to an ever-changing environment [19, 45]. A major site for dopamine release is the reward circuit (the mesolimbic circuit) which originates in the ventral tegmental area with pathways spreading further to the nucleus accumbens (located in the ventral striatum), as well as to the prefrontal cortex [46] and plays a significant role in pleasure, reward learning, aesthetic emotions, motor control, and creativity. A key principle of dopaminergic neuromodulation is regional specificity, meaning the functional and behavioral consequence of its action is heavily dependent on the exact location due to differences in density, combination of receptors, projecting neurons, and speed of neurochemical processes [19]. For example, lesions in the prefrontal cortex lead to an increase in flexibility [47] but lesions in the striatum lead to impaired flexibility [48]. In line with these findings, another study could show that stimulation of dopamine D1 receptors in the prefrontal cortex increases stabilization of the network [49]. Blockade of D2 receptors, in contrast, also improved stability and impaired flexibility [50, 51]. In general, D1-dominated brain communication is suggested to enhance stability of the network due to excessive blockade of new input while D2-dominated brain communication facilitates neuronal excitability, and thus, elicits fast and flexible switching between brain states [52]. Interestingly, dopamine D2 receptors are much more common in the striatum compared to the prefrontal cortex which has far less dopamine D2 receptors than D1 receptors [53–56]. Based on these findings, the theory is that a dopamine-dependent balance between distinct prefrontal and striatal brain regions modulates cognitive focus and flexibility depending on the situational needs and the dopamine baseline level [19, 57]. Optimal dopamine levels in the prefrontal cortex support stabilization but reduce flexibility, while optimal dopamine levels in the striatum enhance flexibility but reduce stabilization. This theory would explain why therapeutic dopaminergic medication has different behavioral effects on individual patients depending on their dopamine baseline level globally and in specific areas of the brain, which modulates the balance between stability and flexibility.

Patients with Parkinson's disease, for example, are characterized by severe depletion of the striatal dopamine level associated with the degeneration, death, and loss of dopaminergic cells in the substantia nigra pars compacta, as well as a decrease of dopamine biosynthesis ability of the surviving neurons. These alterations are closely related to the motor impairments and deficits in action selection which are characteristic for Parkinson's disease [58], but can also affect other behavior associated with the dopamine system as well. At the beginning of the disease, alterations are restricted to the dorsal striatum (i.e., the putamen and the dorsal caudate nucleus), and only in later stages of the disease, alterations progress to structures within the core of the reward circuit such as the nucleus accumbens and

eventually the prefrontal cortex [59–61]. Parkinson's patients exhibit not just reduced flexibility [62–64], but also excessive stability [65, 66]. Once patients receive dopamine replacement therapy, however, (that is, dopamine agonists—a medication that boosts dopamine-related mechanisms in the brain) the reversing pattern emerges; flexibility enhances and stability is reduced to a normal level [67, 68]. In consequence, some of these medicated patients demonstrate a de novo spike in creative output [34, 43, 44, 69]. Furthermore, reduction of the dose of dopamine due to alternative therapeutic strategies correlates strongly with a decrease in creativity in Parkinson disease [37]. This dopamine medication related burst in creativity has initially been associated with pathological changes in impulse control, which is a well-known side-effect of dopaminergic medication and results in all kinds of addictive-like behavior [70] including excessive productivity, excessive gambling, eating, shopping, etc. However, two studies specifically examining the relationship between enhanced artistic production and impulse control disorders in Parkinson's disease suggest that there is no association between creativity and pathological changes in impulse control [37, 71]. This makes complete sense when considering that productivity due to impaired impulse control is by all means not the same as creativity, with the former entailing repetitiveness as its main feature and the latter novelty. When dopamine agonists are given, not only does activity increase in those parts of the striatum and prefrontal cortex [72] which have been shown to be directly connected [73], but dopaminergic agonists also increase the variability of connectivity patterns in prefrontal regions and striatal areas of the reward system, and lead to an increase in the attractiveness assessment of facial stimuli [74]. This regional specificity for the mediation of different effects of dopamine could be verified in another study with healthy subjects. Dopamine receptor stimulation modulates prefrontal activity during cognitive stabilization but striatal activity during flexible switching [75]. Moreover, only subjects with low-baseline levels of dopamine in either region exhibit changes in flexibility or stability, respectively, when they receive dopaminergic medication [75, 76]. Thus, there seems to be a strong dissociative effect of dopamine agonists depending on the local baseline level of dopamine. This dissociation may be associated with the phasic variations in dopamine concentration which correlate with movement and are suggested to be induced by reward and external events [77]. Computational models demonstrate that with a rising signal-to-noise ratio, phasic variations become more difficult to distinguish from mere fluctuations until they are impossible to distinguish, consistent with the predicted amount of loss of dopamine neurons at which parkinsonian motor deficits are first observed [58]. The more dopamine neurons that are lost, the higher the signal-to-noise ratio, and the less effectively do phasic variations, induced by neuronal signal, change the dopamine concentration [78]. The combination of reduced signal-to-noise ratio and increased receptor sensitivity as a compensation effect may lead to aberrant activation of the D1 and D2 receptors, uncoupled from external events, and thus, produces—rather than the general concentration level of dopamine per se—the characteristic symptoms of Parkinson's disease. In addition, D2 receptors are more sensitive to the loss of dopamine terminals [78] which has effects specifically on flexibility. Since in healthy regions in which neurodegeneration of

dopaminergic neurons are not as prominent, there exists no impaired differentiation of phasic dopamine release from background noise [78], and thus, a general increase of the dopamine level through dopamine boosting medication does not show any effects on the imbalance between flexibility and stability. This may explain why only individuals with low-level dopamine are affected by dopamine agonists [75, 76]. .

Since patients with Parkinson's disease demonstrate dopamine depletion in striatal areas but not in prefrontal areas, dopamine agonists repair excessive stability and enhance flexibility by restoring dopamine levels in the striatum but overdosing dopamine levels in the relatively intact prefrontal cortex with no consequences. In contrast, patients with attention deficit hyperactivity disorder receive dopamine agonists to counteract attention deficits and impulsivity. Here, effects of higher stability may be achieved by restoring prefrontal dopamine levels and overdosing striatal dopamine levels with no consequences.

Following the reasoning outlined above, differences in creative behavior in patients are due to variances in the balance of the dopaminergic system due to neurodegenerative diseases and/or dopaminergic medication and the resulting imbalance of stability and flexibility.

3 Measuring Creativity

With the rising interest in creativity and its underlying neuronal mechanisms, it is important to emphasize at this point that there exists no one single straightforward measure of creativity due to a lack of a general definition of what creativity actually entails [79]. This is especially important to mention in this context because it makes the increasing but still small amount of scientific evidence difficult to compare. Most studies published so far, do not even discuss the specific definition of creativity they are focusing on.

Creativity, as mentioned at the begin of this chapter and throughout the entire book, is a polysemous concept which expresses itself in multiple fields and domains. Historically, creativity is defined as the mark of a genius, a mysterious gift to create, something ordinary people are not capable of [80]. In contrast to this historic view, modern theories of creativity include features we all share and which, in a certain combination, lead to a varying magnitude of creative output. However, there are more than 100 different definitions of creativity [81]. For example, Herbert Simon and his collaborators define creativity as a type of problem-solving: "creative activity appears simply to be a special class of problem-solving activity characterized by novelty, unconventionality, persistence, and difficulty in problem formulation" [82]. Another approach is to define different levels of creativity as has been implemented in the Four-C Model of Creativity [83] to account for the differences in magnitude of creative outlet and highlight the need for different assessment strategies. Nevertheless, creativity can be generally defined by specific key features. Some of the most prominent ones are problem-solving, evaluation, novelty, distance of connections, resources/effort, and naivety [84]. The definition of

creativity is also dependent on specific elements, such as specified in the 4P framework [85]: process (mental processes involved in creative thought and work), person (personality traits associated with creativity), product (products which are judged to be creative by a relevant social group), and press (environmental influences that affect the creative process, for example, sociocultural context or trauma). In line with these different theories, there exist unsurprisingly a multitude of psychometric measures of creativity. And although the creative process is based on multiple cognitive processes including problem-solving, selective encoding, evaluation, decision-making, associative thinking, flexibility, and divergent thinking, most assessments rely only on divergent thinking alone. A very popular test that is based on divergent thinking, for example, is the Torrance Tests of Creative Thinking (TTCT) which has a relatively good reliability [86]. A test which actually incorporates a wider range of cognitive concepts is the Test for Creative Thinking – Drawing Production (TCT-DP). It demonstrates, unsurprisingly, an even better reliability [87]. But besides these two, there are countless other tests that have been implemented to measure creativity which makes a comparison of results problematic. In addition, creativity is not only defined as a function of cognition, but can be assessed as a general personality trait (based, for example, on the five-factor theory), as a function of the product itself, and even with a focus on the environmental factors which influence the creative process. Thus, it is important to keep this in mind when discussing research on creativity, and especially, when designing new studies and incorporating novel methods.

4 Causal Approaches in Creativity Research: Non-invasive Brain Stimulation

The recent progress in computing technology have given rise to the development of advanced computational approaches which embrace the distributed nature and continuous dynamics of neuronal communication, the huge amount of data with its complex features and dimensions, and the statistical benefits of performing joint interference across space and time. While the wide-spread implementation of these methods has indeed increased our knowledge of how the brain is functioning and makes it possible to assess flexibility and stability at the brain network level, most studies in the domain of creativity and aesthetics, as already mentioned above, only rely on correlational approaches investigating the association between changes in events of neuronal activity and behavioral measures which completely lacks the prospect of identifying causal mechanisms. Depending on the research question, understanding the causal mechanisms underlying creativity is crucial. For example, if we only want to create a tool to diagnose early onset of Parkinson's disease, correlational approaches that use probabilistic models are sufficient (e.g., the comparison of a huge sample of brain and creativity measures in patients with a sample of the same brain and creativity measures in neuro-typical subjects using learning machine algorithms). If we, however, are interested to develop novel treatment approaches that prevent the progression of Parkinson's disease or boost creativity,

we need to obtain a causal understanding of the underlying neuronal mechanisms to know which mechanisms to target—which requires a causal model.

To investigate the causal link between biological mechanisms and behavior, researchers usually implement invasive neuromodulation methods such as targeted micro-stimulation [88], deep brain stimulation [89], and optogenetics [90]. In the animal model, these techniques provide detailed information on brain-function relationships with high spatial precision and even cell-specific effects. In humans, however, the use of invasive techniques is limited, and generally restricted to clinical research. An alternative approach for causal studies, thus, are pharmacological interventions [91]. As outlined above, there is a vast amount of studies investigating the effects of pharmacological manipulation of the dopaminergic system (although only a few investigate creativity). However, a downside of these pharmacological approaches in humans is that they are affecting brain function globally. In other words, it is difficult to manipulate specific mechanisms locally. Thus, using pharmacological approaches, further investigation of the dissociation between prefrontal and striatal dopaminergic mechanisms and its effects on creativity only goes so far.

For basic research, non-invasive brain stimulation (also known as NIBS) is generally the method of choice and, besides their possible benefit as a complementary therapeutic method, a powerful tool to modulate the brain and investigate causality. Thus, there are a number of techniques that are used for this purpose, such as transcranial magnetic stimulation (TMS) and transcranial electrical stimulation–transcranial direct current stimulation (tDCS) as well as transcranial alternating current stimulation (tACS). TMS produces an electromagnetic field to induce electrical current into the brain which at the cortical surface is quite focal but worsens as a function of depth [92]. Transcranial electrical stimulation, on the other hand, delivers current directly between electrodes which are placed on the scalp producing weak but diffuse electrical fields largely affecting non-targeted brain regions as well.

There are a few studies that have implemented transcranial electrical stimulation techniques to manipulate creativity and investigate the causal relationship between network modulation and creative output. In case of tDCS, anodal stimulation increases excitability of whole areas, while cathodal stimulation reduces excitability [93]. Especially the frontal cortex is a target in these studies with the purpose of impairing inhibition mechanisms which, according to the assumptions underlying these studies, will result in a boost of creativity. One study, for example, investigated the effects on creativity of bilateral stimulation of the inferior frontal gyrus [94] which has been suggested to play a significant role in inhibition [35, 95, 96]. This work measured creativity verbally by implementing a divergent thinking task [94]. The authors found that divergent scorings increased when the left inferior frontal gyrus was deactivated and the right inferior frontal gyrus was activated simultaneously, but not when the left inferior frontal gyrus was activated while the right inferior frontal gyrus was deactivated or when the left inferior frontal gyrus was deactivated and the right inferior frontal gyrus was activated separately. In contrast, another study [97] implemented the alternate uses task, in which the

participant is asked to report as much alternative uses for a common object as they can think of within a 4 min period [98], and found that deactivation of the left inferior frontal gyrus alone leads to an increase in scores. The reverse set-up, that is, activating the left inferior frontal gyrus, led to reduced creativity scores. Interestingly, the disruption of the prefrontal cortex has a direct effect on cognitive flexibility as other studies were able to demonstrate [99, 100].

However, there is an increasing critical debate on the putative physiological mechanisms, predictability of localization, and limitations of resolution for techniques using transcranial electrical stimulation. Depending on the size of the electrodes, the focality is between 35 and 12 cm^2 at the surface of the brain in which the magnitude of the current density is within 50% of its maximum power [101]. Even through the spatial resolution of TMS is better than transcranial electrical stimulation, TMS produces diffuse fields that decay exponentially in amplitude from the brain surface with depth. At a depth of 1.5 cm, for example, the focality of TMS is over 10 cm^2 [92]. In addition, mislocalization is common due to the non-uniform current flow depending on the individual anatomy and conductivities [102–104] which may be fundamentally altered in pathological brains such as neurodegenerative diseases [105]. Transcranial current stimulation procedures are also criticized for their attenuated electrical fields that actually reach the cortical surface [106]. Due to the lack of knowledge regarding the precise mechanisms actually targeted with these methods, acquiring a comprehensive understanding of causal brain mechanism underlying the balance of flexibility and stability in the dopaminergic reward circuit and its role in creativity is illusive. In addition to these methodological restrictions, the obvious disadvantage of these common stimulation techniques is the strict limitation on the depth of the target region [107]. Only cortical areas close to the surface can be directly affected by standard non-invasive stimulation methods. The depths of most targets of interest in research on neurodegenerative diseases and creativity, that is, areas within the reward circuit and the dopaminergic system such as the striatum and the medial prefrontal cortex cannot be reached. As a consequence, all studies using non-invasive brain stimulation methods so far have targeted mechanisms not really central to theories on creativity or research on neurodegenerative diseases. Thus, the interpretation and expediency of the above reported work for our topic is limited.

5 A New Brain Stimulation Technology: Low-Intensity Focused Ultrasound

A new technology, low-intensity focused ultrasonic brain stimulation, has been recently introduced that, instead of inducing neuronal activity with electrical stimulation, delivers mechanical forces in form of acoustic pressure waves (see Fig. 1). In contrast to modest or high-intensity ultrasound, low-intensity focused ultrasound is a non-invasive and reversible neuromodulation tool. And unlike electrical currents or magnetic fields as used in standard brain stimulation methods, ultrasound can be focused through different tissues and structures with minimal power loss and

Fig. 1 A 3-D image
displaying the transducer
fixed to the human scull
and the ultrasound wave
targeting the thalamus

M.Monti

minimal effects outside of the focused area [108]. With a spatial resolution of millimeters [109], it outperforms other non-invasive brain stimulation methods by far and has a spatial resolution comparable to invasive methods such as deep brain stimulation (DBS). The acoustic waves can be focused to a particular location with a spatial resolution on the order of the wavelength of the driving frequency (at 0.5 MHz, this would be approximately 3 mm) without affecting cells along the propagation path. In addition, ultrasonic brain stimulation has further significant advantages to other approaches due to the reduced susceptibility of acoustic fields in respect to different tissue structures. But even more evident is the benefit regarding the potential ability of ultrasound to target any region in the brain. Regions and mechanisms that are involved in neurodegenerative diseases and/or creativity are mostly located in deeper layers of the brain including especially the subcortical areas such as the striatum. Another benefit of ultrasonic brain stimulation is that it effectively modulates the human blood-oxygen level dependent (BOLD) response measured with functional magnetic resonance imaging (fMRI) [110, 111]. This is especially important in respect to the implementation targeting deep brain structures since fMRI has a high spatial resolution capable of identifying effects modulating brain networks as a whole.

Ultrasound generates acoustic waves with characteristic properties including wavelength (that is, the distance between the peaks), amplitude (that is, the height of a peak), and frequency (that is, the number peaks in a fixed period of time). The different parameter settings such as frequency, amplitude, tone burst duration, interstimulus interval, and duty cycle are controlled by the transducer, which

converts the alternating current into pressure waves of mechanical energy affecting the stimulation outcome and efficiency. The intensity of ultrasound is associated with the amplitude (the average of pulse amplitudes during tone bursts or during the pulse repetition period) and measured in watts per centimeter squared (W/cm^2). The exact intensity at the target location is estimated with computer simulations to account for tissue and skull attenuation [112–115]. Depending on the intensity, ultrasound is used for three different approaches: (1) destructive, non-reversible modulation of tissue; (2) non-destructive, targeted local drug delivery or local gene therapy by focal opening of the restrictive blood-brain barrier; (3) non-destructive, reversible neuromodulation. High intensity (above 200 W/cm^2), for example, leads to tissue ablation, medium intensity (100–200 W/cm^2) opens the blood-brain barrier and is used for drug delivery, and low intensity (below 100 W/cm^2) modulates neuronal activity. The frequency determines focality with an increase in frequency leading to higher spatial precision. The duty cycle is the percentage of the sonication duration in which the acoustic waves are actually being delivered, that is, the ratio of the actual duration of the acoustic wave (called tone burst duration) and the total period before the next acoustic wave starts. Low-intensity focused ultrasound pulsation (LIFUP) is the specific technique that is commonly used for neuromodulation which involves long-train sonication with trains of acoustic waves repeated over the course of a few seconds in a low-intensity range below 100 W/cm^2. It has been shown to be safe for human application [116–118], and the USA Federal Drug Administration (FDA) has approved LIFUP as a non-significant risk device. Its precision in targeting the area of focus has also been demonstrated in recent work of our group in a simulation approach targeting subcortical areas such as the globus pallidus [119].

In this work, a simulation of the ultrasound beam, one in water (see red in Fig. 2) and one through the temporal bone (cyan in Fig. 2), demonstrates the effects of bone and tissue which flattens, deforms, and laterally retracts the ultrasound beam compared to water. But importantly, the general location of the maximum pressure (see Fig. 2b) is retained; both beams, propagated through water (red) and bone (blue), reside inside the left pallidal target. While the effect of bone moves the peak pressure somewhat ventral and lateral, the total translation is less than a cm. With this simulation technique, it is possible to exactly model the trajectory of the ultrasound beam (see Fig. 2c).

However, although the broad range of parameter settings has been established as safe, the exact mechanisms of action and the specific effects of parameter settings, such as frequency, intensity, number of pulses, and duty cycle on neuronal modulation are still not clear. The most common and detailed theory, the neuronal intramembrane cavitation excitation (NICE) hypothesis [120], suggests that excitation of neurons is induced by mechanical force of ultrasound intramembrane cavitation. The differences in stimulation effects, that is, inhibitory vs excitatory effects, is also explained by this theory and are suggested to depend on a network of multiple types of neurons and interneurons as well as the specifics of the duty cycle. With high duty cycles, LIFUP studies show excitatory effects [110, 111, 116, 121–124] which

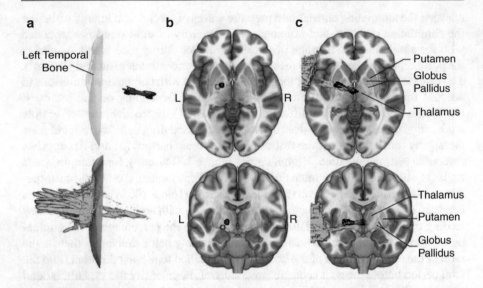

Fig. 2 Numerical modeling through bone (cyan) and water (red); (**a**) effects of the temporal bone on the ultrasound beam; (**b**) location of maximum pressure; (**c**) model of the trajectory of the ultrasound beam

is in line with the NICE model. These differences are independent of the stimulation duration but weakly related to the ultrasound frequency. With low duty cycles, however, the findings are more controversial [116, 121], and thus, question the prediction of the NICE model that low duty cycles have inhibitory effects. In sum, it seems that the mechanisms of actions of LIFUP and similar techniques are multi-faceted and may vary depending on specific parameter settings such as frequency and duty cycle or a combination of them.

Since Tyler et al. [125] showed that LIFUP stimulates electrical activity and signaling in neurons in 2008, a growing number of studies has aimed in verifying the effects and safety of LIFUP. In addition, work in rodents suggest that ultrasonic stimulation is able to modulate extracellular levels of dopamine, and thus, induce striatal dopamine levels [126–128]. First data in the animal model suggests that the longer the stimulation and the higher the intensity, the more dopamine is released in the striatum. Importantly, although the thalamus was sonicated, the extracellular level of dopamine was sampled from the frontal lobe [126]. This indicates that ultrasound stimulation has global and long-lasting effects on the entire dopaminergic network.

So far, there have not been many studies implemented in patients with neurodegenerative diseases using LIFUP or similar low-intensity ultrasonic techniques. One multicenter study demonstrated the safe application of ultrasonic transcranial pulse stimulation in large areas of the cortex of Alzheimer's patients with long-term improvement (3 months post treatment) in the language and memory domain after 2 weeks of treatment [129]. Another study in Parkinson's disease combined ultrasonic brain stimulation with conventional electrical deep brain stimulation aiming at silencing the subthalamic nucleus [130] – in contrast to a non-invasive but also non-reversible subthalamotomy.

6 Conclusions and Future Outlook

Based on first evidence that ultrasonic stimulation has global and long-lasting effects on the dopamine level within the reward circuit [126–128], ultrasonic brain stimulation is a promising new tool to non-invasively and reversibly modulate the balance of flexibility and stability by locally manipulating specific mechanisms of the dopaminergic reward circuit to alter creativity. In contrast to pharmacological approaches using dopamine agonists, it would now become possible to locally restrict the manipulation to specific mechanisms. For example, ultrasonic brain stimulation in combination with functional magnet resonance imaging (fMRI) could be implemented to validate whether regions with prominent dopamine D1-receptors density are crucially involved in the stabilization of the network and regions with prominent dopamine D2-receptors density are involved in the fast and flexible switching of brain states. This could be achieved by contrasting the effects on brain connectivity dynamics of the stimulation of areas with higher dopamine D1-receptor density with the stimulation of areas with higher dopamine D1-receptor density. A similar evaluation can be made by comparing the stimulation of prefrontal and striatal areas and investigating whether there is a dissociation in effects on dynamic properties of connectivity patterns. Up to now, such a spatial specificity in healthy humans or patients was not possible to obtain with non-invasive methods. When controlling for the dopamine levels at baseline, influences on creativity and its dependency on baseline levels of dopamine can be causally evaluated. Using computational models of the cortico-basal ganglia-thalamo-cortical circuit (for a review see reference [131]), more complex interactions of the association between spatial and temporal network patterns can be modelled and these models causally validated.

However, in future studies it is important to carefully define and accordingly measure creativity with a combination of different scales to avoid common pitfalls in research on creativity. Since there still exists no standard definition of creativity that can be measured with a standardized assessment scale, it is essential that future work also focuses on identifying the aspects of creativity that are altered with dopamine agonists and develop a standardized assessment strategy which can be implemented in research on creativity using patients and healthy subjects alike.

In conclusion, ultrasonic brain stimulation tools are an exciting and groundbreaking new path to evaluate alterations in creativity and its underlying neuronal mechanisms. Since this method allows a non-invasive, reversible modulation of neuronal mechanisms with high spatial precision and broad access to all structures deep within the brain, future research on creativity, its underlying neuronal mechanisms, and its alterations in neurodegenerative diseases will experience an unprecedented boost of novel and revolutionary insights that will enhance our knowledge in basic science and open up to innovative opportunities in clinical treatment. This will finally enable research on creativity and art—a domain that has been, up to now, ignored by natural science despite its central role in human cultures and a centuries-long focus of interest in multiple disciplines—to make valuable contributions to the most pressing problems of society in the twenty-first century.

References

1. Dissanayake E. The arts after Darwin: does art have an origin and adaptive function. In: Zijlmans K, van Damme W, editors. World art studies: exploring concepts and approaches. Amsterdam: Valiz; 2008. p. 241–63.
2. Lefebvre L. Brains, innovations, tools and cultural transmission in birds, non-human primates, and fossil hominins. Front Hum Neurosci. 2013;7:245.
3. Lefebvre L, Reader SM, Sol D. Brains, innovations and evolution in birds and primates. Brain Behav Evol. 2004;63(4):233–46.
4. Buckner RL, Krienen FM. The evolution of distributed association networks in the human brain. Trends Cogn Sci. 2013;17(12):648–65.
5. Sporns O, Tononi G, Kötter R. The human connectome: a structural description of the human brain. PLoS Comput Biol. 2005;1(4):e42.
6. Sporns O. The human connectome: origins and challenges. NeuroImage. 2013;80:53–61.
7. Ghosh A, Rho Y, McIntosh AR, Kötter R, Jirsa VK. Noise during rest enables the exploration of the Brain's dynamic repertoire. PLoS Comput Biol. 2008;4(10):e1000196.
8. Fox MD, Raichle ME. Spontaneous fluctuations in brain activity observed with functional magnetic resonance imaging. Nat Rev Neurosci. 2007;8(9):700–11.
9. Honey CJ, Kotter R, Breakspear M, Sporns O. Network structure of cerebral cortex shapes functional connectivity on multiple time scales. Proc Natl Acad Sci U S A. 2007;104(24):10240–5.
10. Deco G, Jirsa VK, McIntosh AR. Emerging concepts for the dynamical organization of resting-state activity in the brain. Nat Rev Neurosci. 2011;12(1):43–56.
11. Tsuda I. Toward an interpretation of dynamic neural activity in terms of chaotic dynamical systems. Behav Brain Sci. 2001;24(5):793–810.
12. Buzsáki G. The brain from inside out. New York: Oxford University Press; 2019. p. 424.
13. Nomi JS, Vij SG, Dajani DR, Steimke R, Damaraju E, Rachakonda S, et al. Chronnectomic patterns and neural flexibility underlie executive function. NeuroImage. 2017;147:861–71.
14. Chen T, Cai W, Ryali S, Supekar K, Menon V. Distinct global brain dynamics and spatiotemporal Organization of the Salience Network. PLoS Biol. 2016;14(6):e1002469.
15. Douw L, Wakeman DG, Tanaka N, Liu H, Stufflebeam SM. State-dependent variability of dynamic functional connectivity between frontoparietal and default networks relates to cognitive flexibility. Neuroscience. 2016;339:12–21.
16. Vidaurre D, Smith SM, Woolrich MW. Brain network dynamics are hierarchically organized in time. Proc Natl Acad Sci U S A. 2017;114(48):12827–32.
17. McIntosh AR, Kovacevic N, Itier RJ. Increased brain signal variability accompanies lower behavioral variability in development. PLoS Comput Biol. 2008;4(7):e1000106.
18. Garrett DD, Kovacevic N, McIntosh AR, Grady CL. The modulation of BOLD variability between cognitive states varies by age and processing speed. Cereb Cortex. 2013;23(3):684–93.
19. Cools R. Chemistry of the adaptive mind: lessons from dopamine. Neuron. 2019;104(1):113–31.
20. Takeuchi H, Taki Y, Hashizume H, Sassa Y, Nagase T, Nouchi R, et al. The association between resting functional connectivity and creativity. Cereb Cortex. 2012;22(12):2921–9.
21. Beaty RE, Kaufman SB, Benedek M, Jung RE, Kenett YN, Jauk E, et al. Personality and complex brain networks: the role of openness to experience in default network efficiency. Hum Brain Mapp. 2016;37(2):773–9.
22. Beaty RE, Benedek M, Wilkins RW, Jauk E, Fink A, Silvia PJ, et al. Creativity and the default network: a functional connectivity analysis of the creative brain at rest. Neuropsychologia. 2014;64:92–8.
23. Fox MD, Snyder AZ, Vincent JL, Corbetta M, Van EDC, Raichle ME. The human brain is intrinsically organized into dynamic, anticorrelated functional networks. Proc Natl Acad Sci U S A. 2005;102(27):9673–8.
24. Raichle ME, MacLeod AM, Snyder AZ, Powers WJ, Gusnard DA, Shulman GL. A default mode of brain function. Proc Natl Acad Sci U S A. 2001;98(2):676–82.

25. Smallwood J, Bernhardt BC, Leech R, Bzdok D, Jefferies E, Margulies DS. The default mode network in cognition: a topographical perspective. Nat Rev Neurosci. 2021;22:503.
26. Vatansever D, Menon DK, Manktelow AE, Sahakian BJ, Stamatakis EA. Default mode dynamics for global functional integration. J Neurosci. 2015;35(46):15254.
27. Zaidel DW. Creativity, brain, and art: biological and neurological considerations. Front Hum Neurosci. 2014;8:389.
28. Córdova-Palomera A, Kaufmann T, Persson K, Alnæs D, Doan NT, Moberget T, et al. Disrupted global metastability and static and dynamic brain connectivity across individuals in the Alzheimer's disease continuum. Sci Rep. 2017;7:40268.
29. Crutch SJ, Rossor MN. Artistic changes in Alzheimer's disease. Int Rev Neurobiol. 2006;74:147–61.
30. Miller BL, Cummings J, Mishkin F, Boone K, Prince F, Ponton M, et al. Emergence of artistic talent in frontotemporal dementia. Neurology. 1998;51(4):978–82.
31. Miller ZA, Miller BL. Artistic creativity and dementia. Prog Brain Res. 2013;204:99–112.
32. Miller BL, Hou CE. Portraits of artists: emergence of visual creativity in dementia. Arch Neurol. 2004;61(6):842–4.
33. Chakravarty A. De novo development of artistic creativity in Alzheimer's disease. Ann Indian Acad Neurol. 2011;14:291–4.
34. Lauring JO, Ishizu T, Kutlikova HH, Dörflinger F, Haugbøl S, Leder H, et al. Why would Parkinson's disease lead to sudden changes in creativity, motivation, or style with visual art?: a review of case evidence and new neurobiological, contextual, and genetic hypotheses. Neurosci Biobehav Rev. 2019;100:129–65.
35. Aron AR, Durston S, Eagle DM, Logan GD, Stinear CM, Stuphorn V. Converging evidence for a fronto-basal-ganglia network for inhibitory control of action and cognition. J Neurosci. 2007;27(44):11860–4.
36. Joutsa J, Martikainen K, Kaasinen V. Parallel appearance of compulsive behaviors and artistic creativity in Parkinson's disease. Case Rep Neurol. 2012;4(1):77–83.
37. Lhommée E, Batir A, Quesada J-L, Ardouin C, Fraix V, Seigneuret E, et al. Dopamine and the biology of creativity: lessons from Parkinson's disease. Front Neurol. 2014;5:55.
38. de Souza LC, Volle E, Bertoux M, Czernecki V, Funkiewiez A, Allali G, et al. Poor creativity in frontotemporal dementia: a window into the neural bases of the creative mind. Neuropsychologia. 2010;48(13):3733–42.
39. Rankin KP, Liu AA, Howard S, Slama H, Hou CE, Shuster K, et al. A case-controlled study of altered visual art production in Alzheimer's and FTLD. Cogn Behav Neurol. 2007;20(1):48–61.
40. Shamay-Tsoory SG, Adler N, Aharon-Peretz J, Perry D, Mayseless N. The origins of originality: the neural bases of creative thinking and originality. Neuropsychologia. 2011;49(2):178–85.
41. Abraham A, Beudt S, Ott DV, Yves von Cramon D. Creative cognition and the brain: dissociations between frontal, parietal-temporal and basal ganglia groups. Brain Res. 2012;1482:55–70.
42. de Souza LC, Guimarães HC, Teixeira AL, Caramelli P, Levy R, Dubois B, et al. Frontal lobe neurology and the creative mind. Front Psychol. 2014;5:761.
43. Kulisevsky J, Pagonabarraga J, Martinez-Corral M. Changes in artistic style and behaviour in Parkinson's disease: dopamine and creativity. J Neurol. 2009;256(5):816–9.
44. Chatterjee A, Hamilton RH, Amorapanth PX. Art produced by a patient with Parkinson's disease. Behav Neurol. 2006;17(2):105–8.
45. Schultz W. Multiple dopamine functions at different time courses. Annu Rev Neurosci. 2007;30:259–88.
46. Dunlop BW, Nemeroff CB. The role of dopamine in the pathophysiology of depression. Arch Gen Psychiatry. 2007;64(3):327–37.
47. Roberts AC, De Salvia MA, Wilkinson LS, Collins P, Muir JL, Everitt BJ, et al. 6-Hydroxydopamine lesions of the prefrontal cortex in monkeys enhance performance on

an analog of the Wisconsin Card Sort test: possible interactions with subcortical dopamine. J Neurosci. 1994;14(5):2531–44.

48. Collins P, Wilkinson LS, Everitt BJ, Robbins TW, Roberts AC. The effect of dopamine depletion from the caudate nucleus of the common marmoset (Callithrix jacchus) on tests of prefrontal cognitive function. Behav Neurosci. 2000;114(1):3.

49. Durstewitz D, Seamans JK, Sejnowski TJ. Dopamine-mediated stabilization of delay-period activity in a network model of prefrontal cortex. J Neurophysiol. 2000;

50. Mehta MA, Manes FF, Magnolfi G, Sahakian BJ, Robbins TW. Impaired set-shifting and dissociable effects on tests of spatial working memory following the dopamine D 2 receptor antagonist sulpiride in human volunteers. Psychopharmacology. 2004;176(3):331–42.

51. Floresco SB, Magyar O, Ghods-Sharifi S, Vexelman C, Maric TL. Multiple dopamine receptor subtypes in the medial prefrontal cortex of the rat regulate set-shifting. Neuropsychopharmacology. 2006;31(2):297–309.

52. Seamans JK, Yang CR. The principal features and mechanisms of dopamine modulation in the prefrontal cortex. Prog Neurobiol. 2004;74(1):1–58.

53. Lidow MS, Goldman-Rakic PS, Gallager DW, Rakic P. Distribution of dopaminergic receptors in the primate cerebral cortex: quantitative autoradiographic analysis using [3H] raclopride,[3H] spiperone and [3H] SCH23390. Neuroscience. 1991;40(3):657–71.

54. Camps M, Cortes R, Gueye B, Probst A, Palacios JM. Dopamine receptors in human brain: autoradiographic distribution of D2 sites. Neuroscience. 1989;28(2):275–90.

55. Cortes R, Gueye B, Pazos A, Probst A, Palacios JM. Dopamine receptors in human brain: autoradiographic distribution of D1 sites. Neuroscience. 1989;28(2):263–73.

56. Camps M, Kelly PH, Palacios JM. Autoradiographic localization of dopamine D1 and D2 receptors in the brain of several mammalian species. J Neural Transm/General Section JNT. 1990;80(2):105–27.

57. Cools R, D'Esposito M. Inverted-U–shaped dopamine actions on human working memory and cognitive control. Biol Psychiatry. 2011;69(12):e113–e25.

58. Kordower JH, Olanow CW, Dodiya HB, Chu Y, Beach TG, Adler CH, et al. Disease duration and the integrity of the nigrostriatal system in Parkinson's disease. Brain. 2013;136(Pt 8):2419–31.

59. Kish SJ, Shannak K, Hornykiewicz O. Uneven pattern of dopamine loss in the striatum of patients with idiopathic Parkinson's disease. N Engl J Med. 1988;318(14):876–80.

60. Agid Y, Ruberg M, Damier P, Villares J, Zhang P. Are dopaminergic neurons selectively vulnerable to Parkinson's disease? Adv Neurol. 1993;60:148–64.

61. Sawamoto N, Piccini P, Hotton G, Pavese N, Thielemans K, Brooks DJ. Cognitive deficits and striato-frontal dopamine release in Parkinson's disease. Brain. 2008;131(5):1294–302.

62. Cools R, Barker RA, Sahakian BJ, Robbins TW. Mechanisms of cognitive set flexibility in Parkinson's disease. Brain. 2001;124(12):2503–12.

63. Fales CL, Vanek ZF, Knowlton BJ. Backward inhibition in Parkinson's disease. Neuropsychologia. 2006;44(7):1041–9.

64. Cameron IGM, Watanabe M, Pari G, Munoz DP. Executive impairment in Parkinson's disease: response automaticity and task switching. Neuropsychologia. 2010;48(7):1948–57.

65. Cools R, Miyakawa A, Sheridan M, D'Esposito M. Enhanced frontal function in Parkinson's disease. Brain. 2010;133(1):225–33.

66. Moustafa AA, Sherman SJ, Frank MJ. A dopaminergic basis for working memory, learning and attentional shifting in Parkinsonism. Neuropsychologia. 2008;46(13):3144–56.

67. Cools R, Barker RA, Sahakian BJ, Robbins TW. L-Dopa medication remediates cognitive inflexibility, but increases impulsivity in patients with Parkinson's disease. Neuropsychologia. 2003;41(11):1431–41.

68. Cools R, Barker RA, Sahakian BJ, Robbins TW. Enhanced or impaired cognitive function in Parkinson's disease as a function of dopaminergic medication and task demands. Cereb Cortex. 2001;11(12):1136–43.

69. Schrag A, Trimble M. Poetic talent unmasked by treatment of Parkinson's disease. Mov Disord. 2001;16(6):1175–6.

70. Weintraub D, Nirenberg MJ. Impulse control and related disorders in Parkinson's disease. Neurodegener Dis. 2013;11(2):63–71.
71. Canesi M, Rusconi ML, Isaias IU, Pezzoli G. Artistic productivity and creative thinking in Parkinson's disease. Eur J Neurol. 2012;19(3):468–72.
72. van Schouwenburg MR, Zwiers MP, van der Schaaf ME, Geurts DEM, Schellekens AFA, Buitelaar JK, et al. Anatomical connection strength predicts dopaminergic drug effects on fronto-striatal function. Psychopharmacology. 2013;227(3):521–31.
73. van Schouwenburg MR, Onnink AMH, ter Huurne N, Kan CC, Zwiers MP, Hoogman M, et al. Cognitive flexibility depends on white matter microstructure of the basal ganglia. Neuropsychologia. 2014;53:171–7.
74. Bellucci G, Münte TF, Park SQ. Resting-state dynamics as a neuromarker of dopamine administration in healthy female adults. J Psychopharmacol. 2019;33(8):955–64.
75. Cools R, Sheridan M, Jacobs E, D'Esposito M. Impulsive personality predicts dopamine-dependent changes in frontostriatal activity during component processes of working memory. J Neurosci. 2007;27(20):5506–14.
76. van Holstein M, Aarts E, van der Schaaf ME, Geurts DE, Verkes RJ, Franke B, et al. Human cognitive flexibility depends on dopamine D2 receptor signaling. Psychopharmacology. 2011;218(3):567–78.
77. Howe MW, Dombeck DA. Rapid signalling in distinct dopaminergic axons during locomotion and reward. Nature. 2016;535(7613):505–10.
78. Dreyer JK. Three mechanisms by which striatal denervation causes breakdown of dopamine signaling. J Neurosci. 2014;34(37):12444–56.
79. Plucker JA, Beghetto RA, Dow GT. Why isn't creativity more important to educational psychologists? Potentials, pitfalls, and future directions in creativity research. Educ Psychol. 2004;39(2):83–96.
80. Miller AI. Insights of genius: imagery and creativity in science and art. Springer Science & Business Media; 2012.
81. Treffinger DJ. Dimensions of creativity: Center for Creative Learning; 1996.
82. Newell A, Shaw JC, Simon HA, editors. The processes of creative thinking 1962: Atherton Press.
83. Kaufman JC, Beghetto RA. Beyond big and little: the four c model of creativity. Rev Gen Psychol. 2009;13(1):1–12.
84. Moruzzi C. Measuring creativity: an account of natural and artificial creativity. Eur J Philos Sci. 2020;11(1):1.
85. Rhodes M. An analysis of creativity. The Phi delta kappan. 1961;42(7):305–10.
86. Kim KH. Proven reliability and validity of the Torrance Tests of Creative Thinking (TTCT). 2011.
87. Jellen HG, Urban KK. The TCT-DP (test for creative thinking-drawing production): an instrument that can be applied to most age and ability groups. Creative Child Adult Quarterly. 1986;11:138.
88. Tehovnik EJ, Tolias AS, Sultan F, Slocum WM, Logothetis NK. Direct and indirect activation of cortical neurons by electrical microstimulation. J Neurophysiol. 2006;96(2):512–21.
89. Gubellini P, Salin P, Kerkerian-Le Goff L, Baunez C. Deep brain stimulation in neurological diseases and experimental models: from molecule to complex behavior. Prog Neurobiol. 2009;89(1):79–123.
90. Liu J, Lee HJ, Weitz AJ, Fang Z, Lin P, Choy M, et al. Frequency-selective control of cortical and subcortical networks by central thalamus. elife. 2015;4:e09215.
91. Katz LN, Yates JL, Pillow JW, Huk AC. Dissociated functional significance of decision-related activity in the primate dorsal stream. Nature. 2016;535(7611):285–8.
92. Deng ZD, Lisanby SH, Peterchev AV. Electric field depth-focality tradeoff in transcranial magnetic stimulation: simulation comparison of 50 coil designs. Brain Stimul. 2013;6(1):1–13.
93. Sehm B, Schäfer A, Kipping J, Margulies D, Conde V, Taubert M, et al. Dynamic modulation of intrinsic functional connectivity by transcranial direct current stimulation. J Neurophysiol. 2012;108(12):3253–63.

94. Mayseless N, Shamay-Tsoory SG. Enhancing verbal creativity: modulating creativity by altering the balance between right and left inferior frontal gyrus with tDCS. Neuroscience. 2015;291:167–76.

95. Aron AR, Fletcher PC, Bullmore ET, Sahakian BJ, Robbins TW. Stop-signal inhibition disrupted by damage to right inferior frontal gyrus in humans. Nat Neurosci. 2003;6(2):115–6.

96. Swick D, Ashley V, Turken AU. Left inferior frontal gyrus is critical for response inhibition. BMC Neurosci. 2008;9:102.

97. Guilford JP. Alternate uses: Sheridan supply Company; 1978.

98. Ivancovsky T, Kurman J, Morio H, Shamay-Tsoory S. Transcranial direct current stimulation (tDCS) targeting the left inferior frontal gyrus: effects on creativity across cultures. Soc Neurosci. 2019;14(3):277–85.

99. Leite J, Carvalho S, Fregni F, Gonçalves ÓF. Task-specific effects of tDCS-induced cortical excitability changes on cognitive and motor sequence set shifting performance. PLoS One. 2011;6(9):e24140.

100. Chrysikou EG, Hamilton RH, Coslett HB, Datta A, Bikson M, Thompson-Schill SL. Noninvasive transcranial direct current stimulation over the left prefrontal cortex facilitates cognitive flexibility in tool use. Cogn Neurosci. 2013;4(2):81–9.

101. Faria P, Hallett M, Miranda PC. A finite element analysis of the effect of electrode area and inter-electrode distance on the spatial distribution of the current density in tDCS. J Neural Eng. 2011;8(6):066017.

102. Janssen AM, Oostendorp TF, Stegeman DF. The effect of local anatomy on the electric field induced by TMS: evaluation at 14 different target sites. Med Biol Eng Comput. 2014;52(10):873–83.

103. Opitz A, Windhoff M, Heidemann RM, Turner R, Thielscher A. How the brain tissue shapes the electric field induced by transcranial magnetic stimulation. NeuroImage. 2011;58(3):849–59.

104. Laakso I, Tanaka S, Koyama S, De Santis V, Hirata A. Inter-subject variability in electric fields of motor cortical tDCS. Brain Stimul. 2015;8(5):906–13.

105. Minjoli S, Saturnino GB, Blicher JU, Stagg CJ, Siebner HR, Antunes A, et al. The impact of large structural brain changes in chronic stroke patients on the electric field caused by transcranial brain stimulation. Neuroimage Clin. 2017;15:106–17.

106. Lafon B, Henin S, Huang Y, Friedman D, Melloni L, Thesen T, et al. Low frequency transcranial electrical stimulation does not entrain sleep rhythms measured by human intracranial recordings. Nat Commun. 2017;8(1):1199.

107. Spagnolo PA, Wang H, Srivanitchapoom P, Schwandt M, Heilig M, Hallett M. Lack of target engagement following low-frequency deep transcranial magnetic stimulation of the anterior insula. Neuromodulation. 2019;22(8):877–83.

108. O'Brien WD Jr. Ultrasound-biophysics mechanisms. Prog Biophys Mol Biol. 2007;93(1–3):212–55.

109. Tufail Y, Matyushov A, Baldwin N, Tauchmann ML, Georges J, Yoshihiro A, et al. Transcranial pulsed ultrasound stimulates intact brain circuits. Neuron. 2010;66(5):681–94.

110. Ai L, Bansal P, Mueller JK, Legon W. Effects of transcranial focused ultrasound on human primary motor cortex using 7T fMRI: a pilot study. BMC Neurosci. 2018;19(1):56.

111. Lee W, Kim HC, Jung Y, Chung YA, Song IU, Lee JH, et al. Transcranial focused ultrasound stimulation of human primary visual cortex. Sci Rep. 2016;6:34026.

112. Legon W, Ai L, Bansal P, Mueller JK. Neuromodulation with single-element transcranial focused ultrasound in human thalamus. Hum Brain Mapp. 2018;39(5):1995–2006.

113. Mueller JK, Ai L, Bansal P, Legon W. Numerical evaluation of the skull for human neuromodulation with transcranial focused ultrasound. J Neural Eng. 2017;14(6):066012.

114. Legon W, Bansal P, Tyshynsky R, Ai L, Mueller JK. Transcranial focused ultrasound neuromodulation of the human primary motor cortex. Sci Rep. 2018;8(1):10007.

115. Chandrasekaran S, Tripathi BB, Espindola D, Pinton GF. Modeling ultrasound propagation in the moving brain: applications to shear shock waves and traumatic brain injury. IEEE Trans Ultrason Ferroelectr Freq Control. 2021;68(1):201–12.

116. Yoon K, Lee W, Lee JE, Xu L, Croce P, Foley L, et al. Effects of sonication parameters on transcranial focused ultrasound brain stimulation in an ovine model. PLoS One. 2019;14(10):e0224311.
117. Pasquinelli C, Hanson LG, Siebner HR, Lee HJ, Thielscher A. Safety of transcranial focused ultrasound stimulation: a systematic review of the state of knowledge from both human and animal studies. Brain Stimul. 2019;12(6):1367–80.
118. Legon W, Adams S, Bansal P, Patel PD, Hobbs L, Ai L, et al. A retrospective qualitative report of symptoms and safety from transcranial focused ultrasound for neuromodulation in humans. Sci Rep. 2020;10(1):5573.
119. Cain JA, Visagan S, Johnson MA, Crone J, Blades R, Spivak NM, et al. Real time and delayed effects of subcortical low intensity focused ultrasound. Sci Rep. 2021;11(1):6100.
120. Plaksin M, Kimmel E, Shoham S. Cell-type-selective effects of intramembrane cavitation as a unifying theoretical framework for ultrasonic neuromodulation. eNeuro. 123:32016.
121. Yu K, Niu X, Krook-Magnuson E, He B. Intrinsic cell-type selectivity and inter-neuronal connectivity alteration by transcranial focused ultrasound. 2019.
122. Ai L, Mueller JK, Grant A, Eryaman Y, Legon W. Transcranial focused ultrasound for BOLD fMRI signal modulation in humans - IEEE Conference Publication. 38th Annual International Conference of the IEEE Engineering in Medicine and Biology Society (EMBC); Orlando, FL, USA: IEEE; 2016.
123. Gibson BC, Sanguinetti JL, Badran BW, Yu AB, Klein EP, Abbott CC, et al. Increased excitability induced in the primary motor cortex by transcranial ultrasound stimulation. Front Neurol. 2018;9:1007.
124. Lee W, Kim H, Jung Y, Song IU, Chung YA, Yoo SS. Image-guided transcranial focused ultrasound stimulates human primary somatosensory cortex. Sci Rep. 2015;5:8743.
125. Tyler WJ, Tufail Y, Finsterwald M, Tauchmann ML, Olson EJ, Majestic C. Remote excitation of neuronal circuits using low-intensity, low-frequency ultrasound. PLoS One. 2008;3(10):e3511.
126. Min B-K, Yang PS, Bohlke M, Park S, Vago D, Maher TJ, et al. Focused ultrasound modulates the level of cortical neurotransmitters: potential as a new functional brain mapping technique. Int J Imaging Syst Technol. 2011;
127. Xu T, Lu X, Peng D, Wang G, Chen C, Liu W, et al. Ultrasonic stimulation of the brain to enhance the release of dopamine—a potential novel treatment for Parkinson's disease. Ultrason Sonochem. 2020;63:104955.
128. Wang W, Li L, Wu W, Zhang W, Ga Y, Chen C, editors. Effects of ultrasound on behavior and dopamine content in striatum of Parkinson's disease model mouse 2017 2017.
129. Beisteiner R, Matt E, Fan C, Baldysiak H, Schönfeld M, Philippi Novak T, et al. Transcranial pulse stimulation with ultrasound in Alzheimer's disease-a new navigated focal brain therapy. Adv Sci (Weinh). 2020;7(3):1902583.
130. Tarnaud T, Joseph W, Schoeters R, Martens L, Tanghe E. Improved alpha-beta power reduction via combined electrical and ultrasonic stimulation in a parkinsonian cortex-basal ganglia-thalamus computational model. bioRxiv. 2021; 2021.02.03.429377
131. Humphries MD, Obeso JA, Dreyer JK. Insights into Parkinson's disease from computational models of the basal ganglia. J Neurol Neurosurg Psychiatry. 2018;89(11):1181–8.

Part IV

Short Chapters for Artist' View and Experiences

The Healing Power of Creativity and Art

Ellis Schoonhoven

1 Preliminary Reflections

"Muse, sing to me......"

In Greek mythology, the nine muses—daughters of Zeus and Mnemosyne—blow the breath of spirit: INSPIRATION and represents the arts, science, and philosophy. "Inspirare" literally means to breathe in. Mnemosyne is the Goddess of recollection and memory. In Greek mythology, art and science were one. The separation of these two disciplines occurred about 250 years ago. The nine muses represented, among other things, poetry, where each genre had its own cadence—its own rhythm. This was a tool to make the text easier to remember, after all, the poetry was not read but recited. It reminds me of a metronome used in music to keep a tempo—a measure. A cellist friend of mine used as a music therapist the pulse or the heartbeat for people with Parkinson's to find their inner rhythm with amazing results. It helped them to move; to walk with the pulse in their favorite music.

Let's return to the source where breath is blown in by our muses, where energy is passed, and inspiration is received.

A holistic view, in which everything is connected, would serve us better. In ancient Egypt, there was an essential difference between the art of healing and medicine. A physician was also a healer and a priest—a Shaman. Look at Michelangelo. He was a sculptor, a painter, an architect, and a poet. Or consider Pythagoras, who was a philosopher and mathematician and musician, and who linked relationships between musical notes to mathematical problems and to the creation of the world. The very first scientists were called natural philosophers, recalling the golden section and the Fibonacci sequence so visible in nature. In our society, we want to

E. Schoonhoven (✉)
De Nieuwe Creatieven, Nijmegen, Netherlands
e-mail: ellis@denieuwecreatieven.onmicrosoft.com, info@denieuwecreatieven.com

subdivide, to label and to pigeonhole everything. As far as I am concerned, this is a huge limitation on everyone's creativity.

A creative mind is a free mind, a playful mind. We have come to overvalue the ratio. The cognitive brain has become dominant; from there we act. We rely completely on the cognitive, logical brain. The artistic brain is at rest, dormant, sometimes even almost in deep sleep. We have lost the connection with our feelings, and we no longer trust our intuition which is our sacred source. What is the value of art, craft, and creativity today? How does it affect the diseased person and how does it possibly activate the neurotransmitter dopamine, also known as the happiness hormone? Embroidery was used extensively in the first and second world wars for traumatized soldiers. In the hospital they embroidered daily. It proved to have a strong healing effect. Art and creativity are fundamental elements in healing and happiness and may play an important role in making new connections in the brain. How is our brain wired and can we prevent, delay, or, after damage, find and make new wires in our brain? Is our happiness hormone dopamine activated by creativity? These are questions I have been exploring for years in my work as a visual artist and my creative coaching. Unexpected and very organic I became a creative therapist. In this chapter I may explore, deepen, possibly even find answers from my experiences and perceptions. The healing power of creativity and art is something I have experienced up close with others and with myself.

2 Introduction

"Every child is an artist. The problem is how to remain an artist once (s)he grows up".
Pablo Picasso

Pablo Picasso's quote has resonated within me—for years—and with those around me. Do you remember your early carefree childhood? As a child you were completely free in your play, in your world of experience, and you were not (yet) blocked by an inner critic, your censor. I recently learned that in psychology this is called the punishing parent.

As a child, the sandbox was your bakery or pastry shop, and you baked sand cakes for your parents or your friends, playfully absorbed in the game. This was your reality. You were one with the game, with the creation and the experience. Completely present in the NOW, with full attention and focus. Pure BEING. This state of being is about feeling, perceiving, tuning in—connected to your right brain, your artistic brain. By the way, you were not aware of this. You simply did what came into you, what you felt from within.

Devoid of an inner critic, your censor, you moved in the big world full of admiration, carefree, free, and inspired. Virtually all actions are directed from the artistic brain. A wonderful time. You were still very pure and in touch with your source.

And then........

You become absorbed into society, the big human world, the structures and the system. For many the big shift starts here, from artistic brain you switch—whether you like it or not—to a cognitive brain and you welcome your censor unwittingly.

I have experienced it at first hand. I would like to introduce myself to you.

My name is Ellis Schoonhoven, born of a half Surinamese mother and Dutch father. I have an older brother and sister, respectively eight and seven years older.

My mother was a very creative, active, and inspiring woman. She was an outstanding cook; sang in choirs; the sewing machine was almost always on the table to make her own clothes and to design and make rather eccentric pieces for me (at the time I thought it was terrible, now I look back on it with love and pride). Knitting needles with a piece of work were on the couch. She founded a theater group at the school where she worked (as one of the few women in our street who did work). She danced and taught dance. I was her assistant and filled in when one of the 60+ students wasn't there and that's how I learned the Rumba, Cha Cha Cha, and English Waltz. A woman with "black blood", soul, and chi. A feisty lady.

I realize now that she is at the source of my creativity. She taught me to crochet, knit, sew, dance, go crazy—she was very good at that. She taught me to be in the flow of life with every fiber in my body. On Saturdays I was allowed to buy new colors of mini-stick (i.e., parts from a system toy for creating mosaic images) at "The Hobbycorner" and all weekend I created a Mona Lisa or a ballerina. As a hyperactive child, I turned inward and found my peace through creation. Furthermore, I loved being outside on adventures, playing, playing, and playing again. Creativity is play and play is creativity. My kindergarten days I still came through well. I had wonderful grades—can you imagine getting grades in kindergarten?—an eight for drawing, a nine for being sweet and the doll corner. In elementary school things got more difficult. Virtually everything was cognitive and praised and judged on a cognitive level. I was and am a dreamer, always looked out the window, that's where my learning originated. My self-confidence sank unconsciously, and I thought I could not learn, was stupid.

The creativity at school disappeared more and more, my only respite was many hours of ballet after school and crafting and making clothes at home. That was my outlet and my anchor, my relaxation, my own world where I felt completely safe and happy.

In high school this cognitive line and for me downward spiral continued. It was a very unpleasant time where I lost connection with myself.

When it turned out that there was a school for "people who think differently" or even better "people who feel differently," I started to feel better and got my self-confidence back. The creative subjects also gave me attention for and pleasure in the cognitive subjects. Creation and cognition as a beautiful pas de deux. Yet for a long time the system—and with the knowledge and wisdom of today I would say I let myself be pushed into the system—pushed me in a direction in which I would be of value to society, assured of a living and more of these kinds of apparent certainties. My father—an accountant and very accurate man—said, "the blood creeps where it cannot go". At 33 I changed course and chose to be an artist. The best choice ever. Walking this spiritual path through trial and error and getting closer and closer to who I am meant to be, I have embraced my inner critic and largely freed myself from it. Accept from writing a chapter.

The writing for this chapter started with feelings of anxiety. I wrote a short introduction of which possibly half will be deleted again. The flow, however, was

wonderful. It feels like I conquered, broke through the fear of the white sheet. That profound wisdom returns again and again. The issue is to start, to do, to get to work, to get moving, because from that comes an infinite flow, sometimes rippling, sometimes thundering through your veins with enormous force, in one straight line or with an extraordinary number of side arms, something begins to show, something awakens. In this there is magic, frequent surprises, new paths, possibilities and insights. My head goes off. My heart and hands turns on. I enter a timeless space, a holy place where everything is good, pure, where only the NOW exists. No past, no future, no worries, tension, or pain. Here, in this sacred space, I am connected to BEING, to lightness. It is magical, over and over again. And then I wake up and look around in wonder. Where was I, what did I create? Slowly I return to this world, to time. The reflections on the created work can be very diverse: from ecstatic euphoria to deep doubt, and everything in between. All the experiences, emotions, pocket-sized and world-sized questions and answers, doubts, and deeper personal themes have been revisited, acknowledged, processed and healed. In phases and based on the subconscious I heal what is broken, develop self-knowledge and self-confidence in order to reach a deeper consciousness. Images are my language, layered with emotions and materials.

"Art is a guarantee of Sanity" is a quote from my muse Louise Bourgeois that I can fully relate to and connect with. The five live interviews and 45 written responses to the three questions I asked further reinforced this statement. In all these interviews, the importance and healing power of creativity and art becomes apparent.

In this chapter I would like to take you into the feelings and thoughts of these interviewees. The 5 have all been diagnosed with a neurodegenerative or psychological disorder. These five wonderful creators speak very candidly about their current state of being and about the value of art and creativity in their lives and their current process. The remaining interviews were answered, for the most part, by participants in the creative trainings in my company "De Nieuwe Creatieven". Together with a dream team, we provide training to bring you back to your inspiration and creativity, to discover and connect with your child artist again. The first year is based on the bestseller "The Artist's Way" by Julia Cameron. We now have a series of programs, all focused on personal development, self-knowledge, awareness and self-awareness. The lubricant is art and creativity.

It is my mission to get creativity flowing through everyone's veins again, to reactivate it, so that you become a creator of your own life and can stand with freedom and self-confidence in every phase of your life, deploying your divine artistic spark in everything you do.

"Every human being is an artist," said Joseph Beuys, "a freedom being, called to participate in transforming and reshaping the conditions, thinking and structures that shape and inform our lives."

Beuys is saying that everyone is creative and needs creativity. Not in the form of becoming a sculptor, photographer or painter but become creative as a human being, as a mother, as a doctor, as a manager, as a garbage collector. Be creative in what you do.

I dedicate this chapter to my dear father who lived with Parkinson's for 21 years and to my dear friend and colleague Johan who was recently diagnosed with probably a very rare auto immune disease that affects his brain. The final diagnosis is still not known.

My gratitude goes to all the interviewees, their candid stories and thoughtfully formulated responses. They bring this chapter to life, to reality. Their permission using their first name makes the stories tangible.

Be Inspired, Ellis Schoonhoven

3 A New Age Monk

To introduce this wonderful personality, Johan, I will take the liberty to dedicate some more sentences to this. In 1998, shortly after the death of his son, I got to know Johan. A deep friendship arose from this. Johan is an artist and teacher, my dear friend, mentor, soul-brother, and carries the honorary title of New Age Monk.

I gave him this title when he was working on his first Thangka scroll. A 13 meter long scroll, filled with symbols from all world religions representing the themes of birth, life and death. The resulting infinity is a recurring theme in his—and our—work. The scroll is dazzling, colorful, sophisticated, and made with gel pens, ecoline, and gold leaf. In addition to sculpting in marble, drawing and coloring are his daily activities. Call it a prayer, a ritual.

We have done a lot together, taken sculpture classes in Italy, visited exhibitions worldwide; developed teaching programs. We work together every Tuesday in my studio. These days are sacred to us. He may also bear the title of New Age Monk because of his deep wisdom, quiet aura, and great capacity for empathy. He is a gifted creative therapist and has been of great significance to many. He still is.

Who would have thought his life would take such a turn?

Johan comes to my house for the interview. It feels a little strange to interview him. I know him so well. The reason to interview him in particular arose two weeks ago when Johan was diagnosed with a neurodegenerative disorder. Investigations are currently ongoing: possible a rare auto immune disease that affects his brain. And now, collaborating for 23 years and working out plans to run a creative program in my studio with people with Parkinson's in collaboration with neurologists and researchers, Johan is suddenly on the other side. Through this lens, this interview was held.

After we have a cup of coffee, during which I observe his tremors as well as the search for words, especially at the beginning of a sentence, I realize how the tide has turned. Suddenly it is Johan with a neurodegenerative disease. It hits me, I take my time. Johan settles a bit, and the tremors become milder.

Johan tells...

"As a child I was always creating, making". I cannot remember anything else but creation. Drawing, painting, carving in found stones, wood carving, modeling. I got the creativity mostly from my father and in our home it was encouraged. All my life

I have created and it has helped me through difficult times, like the loss of our son at almost 18 years of age.

At first, I had no ambition to pursue creativity professionally, it didn't even occur to me. Later when I aspired to the Art Academy, my parents advised me against it with the words "you can't earn a good living with that". I took a different path and continued to create. In retrospect, I am not sorry. At that time, I heard from many students at the Art Academy that they were taken away from their individuality.

I met Joset and we had three children. There was always creativity, also frequently with the children. If I ran into something, a problem, then I would start drawing and while drawing I would get other insights, other perspectives. By creating, I go out of time, I enter another dimension. I have the conviction that in that dimension a great deal of information is stored which we pass by. I reach another existence; deep wisdoms rise up like bubbles.

When Youri died, I threw paint and had a box of balloons filled with paint. I also hung up balloons filled with paint and threw them to pieces. I could let the emotions, the pain, the aggression, and the sadness flow out of me this way. Creating was very important, I could put everything into it, without damaging anyone else. This was a process of mourning and healing. Later I saw that Nikki de St Phalle was even shot with paint. I didn't have a gun. From these first little works came my first sales. Through the pain of the loss of our son I went almost completely out of touch with the world and my wife Joset. She pointed that out to me, which was good.

After the death of Youri I took a sabbatical and followed a one-year course in Art Dynamic Coaching at De Kleine Tiki, School for art, coaching, and personal development. After three months I was asked if I wanted to become a teacher. I hesitated, since I found myself to be strong one-on-one but not in a group. I tried a class. It turned out to be totally my thing. I never stopped. In my studio in the "Kruittoren," a medieval beautiful three story tower, I worked as a therapist. Always in the combination of conversation and creation. I was very busy. At some point I started to phase it out.

Creativity for me is a form of remembering who I am meant to be according to the cosmic, universal, divine plan and shaping that through the process of creation so that I can show: this is me. In that sense, creativity is essential to me. When I came into your house, I read the embroidered text on the wall Who Am I? I discovered that through creativity over the years. The moment I enter the process of creating, I step out of time and into another dimension. When I create there is no time, no past, no future, there is NOW. The cognitive brain, thinking, is switched off and the artistic brain is activated. I start to feel and then work very intuitively. I listen to that and give it form. Working intuitively is tuning into and descending into my subconscious. That is my conviction, I reach a deep knowing. That's where those bubbles pop up again. These bubbles are deep, old wisdoms. Then later when I look at the created work, I ask myself the question: how did I come to this? The creation is given through me. When I am in such a thoughtless phase I am in another dimension.

Creativity is very important for mankind, for the well-being of the world, because creativity—as I have experienced it in my life—has something to tell. Artists have been very important to me. Artists are very important for the world. Artists and their message should be more visible.

Now I have very recently been diagnosed with a neurodegenerative disease and I am suddenly on the other side. In terms of creating, Ellis and I are still on the same side together; but I feel in everything that my system is changing. I feel it, you see it (tremors), and you notice it in my speech. The remarkable thing is that when I color, the tremors subside and are almost completely gone. It is focus, complete focus, and there is peace, relaxation. Then, when I go to drink coffee and want to pick up the cup, I can't. I feel that I am focusing on a certain part of my body. I feel that I am focusing on a point and that gives a certain peace.

I (Ellis) can't help but exclaim that this is insanely interesting for research and the future.

Johan proceeds: When I wake up in the morning, I often feel a shock, a kind of vibration going through my body. I always have to think of your father Ellis then. He told me how exhausting it was for him. (My father lived with Parkinson's for 21 years).

I am now waiting for investigations. If it is allowed to stay as it is now, I thank God on my bare knees. I stopped teaching at De Nieuwe Creatieven, which was a very tough decision. I am insecure in the transfer to the students, the search for words reinforces that even more. However tough the choice, it gives me peace of mind. Stress is disastrous and should be avoided.

At first, I was not aware of this degeneration in my system, then—becoming more aware of this process—I played strategically and recently while driving, showing very strange behavior, my wife Joset brought it up.

For me creativity is a tool to make new connections in my brain. There are many things I can't do anymore, I want to concentrate on what I can do, and creativity is essential for that. It makes me feel like I can do something meaningful, that I belong. It's my anchor and my outlet. More than ever. Now I ask myself the question "Who am I now?" now that things are changing. If I could not create, I would end up behind the geraniums (meaning sitting on his backside) and then it would go downhill very quickly.

I am very grateful to the spheres for my creativity, conscious of the fact that I may do this. Allowing myself to do it. I sleep well again, after years of insomnia. Pure surrender. In retrospect, I think I was trying to control my body, keep it on course. I think I crossed my limit too often. When there is surrender then there is acceptance and from there you can look again at how you—with this situation—can stand in life.

I pray a lot, at least a form of prayer (that's where the New Age Monk comes in again) and focus on something bigger than we are. Call it the Soul, Spirit, Energy.

Everything that happens in our lives brings us something. It was the same after the passing of Youri. It has enriched us. It has brought infinite love. Everything has a purpose, Everything has meaning.

Who am I? Infinity Johan van Dinteren

4 What is Creativity?

I have received answers to three questions from 45 people. The questions are:

1. What is Creativity?
2. What is the importance of creativity (for the world)?
3. What are the positive benefits of creativity for you?

I have tried to bring together the answers to each question in a rhythm, to connect them so that one almost all-encompassing answer emerges. May this become a manifesto to fully integrate and (re)value creativity and art in the world, in every human being, big and small.

Art is a guarantee of sanity—Louise Bourgeois

Creativity is the ability to make something that was not there before. Very basically you can say: make something out of nothing. You come up with something that wasn't there before and then you implement it. That also includes solutions to problems. If you make something that was not there before, loose material takes on a different form. You have the courage to color outside the lines and go on a journey of discovery. You feel freedom in creating. You start looking differently, seeing something new.

It is the rich ability to think and do new things. When creativity flows, solutions arise naturally. Through creativity you make new connections in original, surprising, and astonishing ways. You create something new with your own energy, your own imagination, in your own space in complete freedom. It is free action without restrictions.

In the search and finding of solutions, speak the heart, the emotional life, and the imagination, and to a much lesser extent the ratio. This freedom resonates with a sense of self and individuality. You allow yourself to be with that which is. You tap into your spiritual source. There is something mysterious about it. Uncensored, you bring impulses into the world and embrace this art of living, the inspiration. You grow imperceptibly in your personal development and have a flexible attitude. You become aware of your own creative power. Creativity is magic. It is pure life force and "fairy dust" flowing through your veins. Even in non-religious terms, it is a god expressing your dreams and manifesting that through your body. It is a flowing, fluid, effervescent, gentle, and powerful energy. It is the work of the soul, connected to the source.

Creativity detaches you from judgment and connects color, movement, space, and music together so that you are touched and feel that everything is right. The impulses of creation arise from your living impulsive self, comes from the deepest part of your being, whatever presents itself and wants to come into being. Everyone has it in them.

For creativity, thinking outside the box is essential. With your expression in any form—2D/3D, audio, and/or video—you tickle and touch one or more senses. You surprise, amaze, challenge, fascinate, still, and enthuse yourself and others. It happens naturally because you follow, you listen, and you tune in. Through creativity

you express your life in connection—with being. I AM. You create the opportunity to make new connections. You perceive, you imagine, you feel, and you create. Without rules, frameworks, limitations, and judgments, you bring out what is inside you and give it form. You act from intuition and bring out an inner image (emotion) in form.

For creativity you need to be able to listen in the broad sense to the word. In a fluid way you bring out beauty or rawness in various forms. You express your personal message to your beloved ones and to all the others who want to hear or see your message. It's a language. It is communication in which you visualize your deepest feelings. You sense your power and your emotions. All created by hand and heart.

Creativity is equal to giving sense and meaning to your own life. You give shape and color to your life. You give shape to your imagination and you did not know that this was all in you.

Creativity is being busy with art, the art of living. Art is everywhere, in museums, at home, on the street and in the woods. Creativity is acting, doing. It is the expression of your essence, the expression of your being.

For everyone who creates, keep the fire burning.

For everyone who think (s)he is not creative: don't hesitate, go and act.

Creativity is your true nature.

BE INSPIRED, Ellis

5 A Bubble of Peace

Hetty was diagnosed with Parkinson's disease at 44 and also has the muscle disease HMSN (Hereditary motor sensory neuropathy). At the time of the interview, she is 58 years old. Creativity is vital to Hetty. I receive her in my studio for a nice, open, and inspiring conversation. I get to know Hetty as a woman with a zest for life and great resilience.

Hetty tells...

"Why is art so beautiful and I enjoy life so much? Here, in this studio, I would like to be every day."

I have had Parkinson's for 15 years now. Last year I had surgery [DBS] and as a result I no longer tremble and I can talk well. I am very happy that I had the operation, although I found it very frightening. To be honest, I didn't think I could have this surgery because I used to be depressed and took medication for that, Antidepressants. However, the Parkinson's medication worked on me more and more erratically. In the morning I was below my level and in the evening I was dancing while cooking—so incredibly overactive. I was taking seven tablets a day.

To my surprise, the doctor said that an operation was now possible for me. I waited for two years for it. Completely unexpectedly, I was called and two weeks later I was operated on. I knew: I must do this. It went very well. On the left side they had a little more trouble with placing the electrodes. I recovered well, though I felt some pressure on my brain. Within two days I was out of the hospital. After 2

weeks they started setting up the deep brain stimulation box. The tremors became milder and after a few months the setting was good and the tremors were gone. The medication was phased out. I can do much more again, walk; write. I have better control of my motor skills and my stomach and intestines just work much better.

Creativity is essential for me. My parents were both very creative. My mother as a craftswoman and front of house for the Rural Women. My father was a clockmaker. I had handicrafts in my school curriculum and art history.

I am now in several small groups with whom I paint, sculpt, and take care of Bonsai. I am the youngest there but am happy to go there. We work with soapstone. I paint with Kees Blom, a real fine painter. I learn a lot from him. With Ingrid I do more modern painting. I like to work colorfully. Kees had to get used to it. We inspire each other. When I'm sitting here in your studio, I get so happy, just from looking at art. I feel at home here.

When I create, I feel no pain. I stay in a bubble of peace. I see nothing, hear nothing, and am completely in myself. I would love to participate in an electro-encephalogram study—that they connect such a device when I am creating. What happens in the brain? Can we measure that? Why do I have no pain when I create? I feel like I'm in another world while creating. Before the surgery, I continued to paint. Right! I stopped working then and I did want to stay active and see people.

Sometimes, I painted well, sometimes not so well. Creating is of great value to me and has become of even greater value. On bad days I could also flip through a nice magazine and look at art. I could and do get a lot out of that too. Art watching. Through sculpting I also learned to let go. If a piece of my stone breaks, I learn to look again, to let go and then make another sculpture. Many more people should learn to do that: to let go. With a creative mind you learn to draw from new possibilities. I would like that a lot more people would learn that. People could go out and do more, make more. Boredom? I don't know what that means. When I create, I find myself.

You know, I have Parkinson's and HMSN, but otherwise I'm completely healthy. When I heard it, at 44, I was pretty upset. I cried for four days, worried about my parents, because they were worried, and then I thought, come on, I'm not going to die. It was just before Christmas that I got the diagnosis. In January, I was at a Parkinson's Association lecture and I offered my help. I come from a nursing background and was able to surrender to a walker or wheelchair quite easily. I have accepted Parkinson's and integrated it into my life. I am shocked when people are ashamed of Parkinson's or don't even dare to tell their children. I have a wonderful husband who thinks along and comes up with solutions. We love to travel. I can't go mountain hiking anymore, but with a cable car and a wheelchair I can go into the mountains. Two years ago, we went to Namibia and Botswana, we took a wheelchair and had a wonderful journey.

I want to make something of my life, not throw in the towel. That doesn't help you, nor does it help your partner. You deny yourself so much.

'What a life force and spirit you have, Hetty.'

"I hear that often," Hetty says with a smile. I thank her warmly. Her words resonate in me: "when I create, I reside in a bubble of Peace".

6 What is the Importance of Creativity?

Is vital importance too big a word? Because imagine a world without creativity, it is unlivable. Creativity is the engine that allows you to feel truly human. Your creative efforts give meaning to life. When you have created something and let your heart and soul flow into it, it reflects who you are and what you have seen. Leaving aside that we are not the only species that creates, it brings you very much in touch with your inner voice, with your identity. Creativity is important for mental wellbeing; it is freedom and you are free from a critical side that disturbs the process. It's pure enjoyment. It brings you into the Now, it makes you happy and it gives relaxation. Creativity provides solutions for complex and ill-defined problems. I can't live without it. I took antidepressants for 20 years, my brain became paralyzed, and the creativity disappeared completely. It is the basis to start doing something, that has proven to be very important after an illness. It is the emptying of the mind and the sublime experience of freedom. The way of life to the deepest fibers. Creativity helps you to discover your own strength, to dare to create something new, to let go and remain curious. It gives you the opportunity to express yourself as a whole person and to connect with others. Fixed patterns are broken through which renewal arises from other perspectives. The basis for transformation. You create with all your attention, so you can better let go. It stimulates the brain. You learn to deal with change. It is a feeling of freedom, an expansion of vision. You surrender to something greater. You touch the other straight from the heart and soul.

Creativity avoids the obvious which makes opportunities for development visible. It is the ability to think and act out of the box. With curiosity and astonishment, you give yourself free rein. Creativity is playing yourself free. You can express yourself without words, you recognize feelings in the work of others which makes you feel connected. Creativity creates balance between the left and right hemispheres. It enriches, energizes, and satisfies. You learn to express yourself and invent because it creates space in your head and heart.

You make contact with your deepest sources, with unconscious layers in yourself and thus it is essential to become who you are. Creativity is crucial to get out of my thought paths, break them and be delighted and surprised by the inspiration that has taken shape through my hands and before my eyes. When I can shape and color the movements from my surroundings and myself, I and others can grow through perception. It stimulates your mind and well-being. It helps you stay in your center, balanced and standing in interactions with people. It is of utmost importance to discover, see, feel, experience and therefore for your personal growth and happiness, both in smell and touch and odor, contemporary and made in a time that is behind us. Creativity helps me to stay positive and enjoy life. In creativity you discover yourself and the world, in all its beauty and rawness. It is essential for the world and the individual. Without creativity no development. The world would be boring without creativity, new ideas do not come, and we do not move forward. The importance of creativity lies in several areas. Being inspired and to inspire, feeling connection with others, other cultures, the world. Discovering, exploring, and manifesting new realities. Feeling bliss, wonder and admiration. It is the expression of

very deep layers within yourself and bringing them to expression so that mind and soul are cleansed. It is the path to self-knowledge, Archaeology of the Soul.

We need creativity to arrive at solutions to global issues. If we continue to think in boxes, we will not arrive at solutions. You discover new aspects of yourself as a human being and the world around you. The immense diversity and boundlessness of creativity makes it essential. It allows you to grow and develop, it allows you to feel the energy of everything and everyone, beyond your ego and brain. One-being in connection with EVERYTHING.

7 Finding My Wings

In the summer of 2020, Belgian Ann contacted me for an intake meeting. She was interested in the year-long training The Artist's Way. This intake interview will always stay with me. How powerfully she reshaped her life by using creativity as medicine. A healing journey that continues to deepen.

Ann tells..........

"I will outline my past in a nutshell." It took my former partner 17 years to acknowledge that he would rather be a woman than a man, with the necessary psychiatric hospitalizations. In the course of that period, our daughter made three suicide attempts, our youngest son had a depression and I had four very severe depressions. In order to keep our family going, I received outpatient help and took antidepressants and beta blockers for 20 years to avoid panic attacks. Our oldest son was already living in an apartment by then. Eventually, everyone in our family received psychological counseling. Some more than others.

After my first depression, I went to a psychologist who listened to me and always said: 'Ann, take good care of yourself.' And I could go back home. After 1.5 years I had had it. Take good care of myself? How could I do that? In the treatment there was no dynamic, no feedback, no interaction. I was left with a hunger. Meanwhile, my daughter had had her first suicide attempt and we ended up with another psychologist—for a span, it would turn out later, of 15 years.

My experience and images of 15 years of cognitive therapy are as follows....

My head was pure chaos, I picture it as a destroyed forest. I couldn't find a path or trail in it, not a single tree was straight. Disorder, chaos everywhere. Cognitive therapy brought order to the devastated forest. Trees became upright, a single path became visible.

If I compare it to an attic.... then the attic had been cleaned out.... Everything put in bins/boxes. And on the floor, a shelf always flopped up and a sphere appeared. That sphere came and went at the same time... but what did it say, what did it mean?

And sometimes I experienced my body as a boat...loaded with containers.... I felt so much discomfort, did not recognize myself in my own body... I could not do anything with it... what was that... I felt vague and not concrete about anything... couldn't find words for it.

I discussed my images and the associated issues with the psychologist, but she could not really do anything with it. For her, the therapy was therefore completed after 15 years... for me not....

At a certain moment I was in front of the class and had a lot of trouble with my balance. My eyesight diminished... I no longer knew my pupils by name... For me it was not okay..... For months I was unable to climb stairs, cook food, drive a car, or bike or anything else.... In order to have a definitive answer to my balance problems, I had to stop taking my medication. Over a period of a year, I tapered off my medication. I went through hell. After 20 years of medication my body was pretty much out of order. A very severe depression followed, my fourth one. I didn't get any help, didn't go to a doctor, didn't take any medication, I thought it was all part of withdrawal. I really sank below the surface. I was afraid of only one thing... not to go back to my exhaustion of my first depression where I could barely walk 50 meters, not read, not write... I tried very hard to look for a light somewhere.... and that light shone under that loose board. I looked my soul straight in the eye.

Later, the discomforts turned out to be side effects of the medication that brought other features of diseases to the fore. The advice: no medication and go back to a psychologist. But I didn't go back to the psychologist... there had to be something else where I could find more healing or salvation.

But what now? You'll have to do something else, I thought. I then took a two-year art exploration course at the academy, which I really enjoyed. After completing it, I started sculpting. With a piece of clay and a wire I could get to work. I thought I had created something beautiful. The next assignment was to enlarge my clay work. But how can you enlarge something that you have created from your deepest being and reason about it from your head? I didn't understand that... it didn't feel right. The teacher experienced me as difficult, not following, not listening. I felt absolutely not heard and definitely not comfortable in my skin.... I tried... with a lot of reluctance. With hammer and chisel I took the mold off... but the sculpture was never finished.

The following year I found another source of inspiration. At the little Tiki, I made my first contacts with my spiritual world. I received a lot of images from the past, felt like a fledgling shaman. I received some lessons from Johan, who I found such an inspiring, spiritual, wise man. I'll never forget him saying to me, 'Ann... good wine needs to mature.' I can still see myself standing in the hallway.

In the second year, I crashed through the exploration of the masculine and feminine in me. There was a very big trauma there for me that had to do with my former partner's gender choice.

Then I was assigned to haptotherapy to learn to feel again and I also ended up in creative therapy. I liked all of that.

So I share one of my assignments belonging to creative therapy. At the start of the day, we draw a card.... For example, a picture of a bird.... that you take with you the whole day, giving you support, something to hold on to, insight, etcetera. We do a visualization to music. In this visualization you spread your wings. Then, with your eyes closed, you work with the paint and your hands on the paper. When you fully open yourself to your assignment you can feel your deepest... you are touched, are touched... you come to your core... it is all allowed to be there... tears are allowed to flow, sounds you cry out,... your wounds are healed, you sink a layer deeper. In the afternoon, we move into refinement. Pure moments of happiness. Searching for and finding feathers as a metaphor for your delicacy. From coarse material to fine

material. My creative process exploded here. This is where I want to be, this is what I want to do. Here I leave a lot of energy and here I get new, different energy. I come to rest, I come to myself... in a safe bed.

In a vision or image that often comes back to me, I am standing on a platform. In front of me many women are calling to me: 'Thou canst set us free.' At some point it will become clear what is meant by this. That's how I started doing Aboriginal Art, portraying the women's lineage. I got back in touch with the Shaman in me and made a connection with nature, my foremothers.... Meanwhile I am following the learning path for family constellations... so many beautiful grateful elaborations of your experience... to get lighter, clear...that which is there, that which may be seen. It gives peace ... very nice! I am sure that in time my vision will become clear.

In one painting exercise I once got so overheated that I stood naked under an ice-cold shower for 20 minutes to come to myself. The tree I had painted turned out to have no roots... in other words I was not rooted, not grounded. In retrospect I understood that what I experienced at that moment was the same as in a depression, with the only difference that now I was not under the influence of medication and was able to express my feelings. After all, because of the medication, my emotions had been completely flattened. I could not get to the core. Emotions like anger, sadness, and pain were all suppressed by the medication. After 20 years my body was a chemical factory that didn't know what feeling was anymore... and now; ...now everything splashed out... so liberating!

I participated in a large study on the cognitive impact of medication in people with depression. They followed me for a year. Filling out a diary every day. Cognitive ability and resilience was tested. In my case, it turned out that my cognitive ability dropped more than half. But my resilience appears to be enormously strong. Thanks to my resilience, I get back on my feet every time.

Through body-aware therapy I learned what my triggers are. I experience being triggered a hundred times worse than withdrawal from medication. A trigger is there on an unconscious level. All at once there is pure chaos. All the symptoms then return. It's too high of an energy, too high for my heart. I'm looking to redirect the tension into relaxation.

Now, I also appear to have heart failure. I've had several infarctions that I didn't notice because of the long-term intake of medications, especially the beta blockers. My heart rhythm is not good. My heart muscle has become overloaded and is only working at 40 percent. Now suddenly I am a severe heart patient, I have never felt anything but the consequences of my past and of the medication. I went through all the emotions again without medication, through my creative therapy. The containers I felt before in my body are now quietly getting an anchorage, getting cleared. The content no longer has a heavy energy, it is transformed and that is only because I have lived through it in a creative way and have been able to express it. This is different than using words. Words are too limiting, people don't understand you. I do dare to express myself more than I used to. But visual language is more real, more lifelike, more universal. The moment you create you go from your head to your heart and your hands and it touches another part of your brain. There is no direction in it, you listen, tune in and make, create. That's why I like to work abstractly. I want

to connect my own story but also create space for the input of another. Painting takes me out of my head. It is a combination of meditation, concentration, focus and just doing.

Ellis quotes Yayoi Kusama. The queen of polka dots. Yayoi has voluntarily resided in a psychiatric clinic since 1973, her studio in close proximity. Art is her medication. Yayoi (92) is a famous artist. I also think of Louise Bourgeois' quote, Art is a guarantee of sanity.

The doctor wants me to take beta blockers again, this time for my heart. I tried it but don't want it anymore. I felt the flattening of my feelings again. With a regular doctor the conversation is very restrictive and one-sided, it is only about the heart, not about me as a feeling human being.

So I looked for a holistic doctor in the Netherlands. She looks at me as a total human being and under her guidance I started to lower the medication, step by step. I am at my minimum dose. I also work through body-oriented therapy, deep massage and on my breathing... the heart is now under control.

In the meantime, I have a bungalow on the river Waal, a relationship with a wonderful woman in Nijmegen, discovered the tower of Johan and so many beautiful things here in Nijmegen and I ended up at De Nieuwe Creatieven.

It is 'coincidental' and wonderful that during the first lesson of De Nieuwe Creatieven in 2020, we healed our wounds with gold glue. So metaphorical. My heart had become petrified. I tried to save my marriage because I had to. My wounds are there, but I've transformed them and coated them with gold. My heart is much more open now. My heart is back in my life.

I have healed my wounds with Gold.

Found connection with myself... with my soul... life wants me... and I want life!

Ann

8 Creativity is Freedom

Sanne has HMSN, hereditary motor and sensory neuropathy, an inherited disorder of the nerves. Sanne is the daughter of Hetty.

Sanne tells...

I was diagnosed with HMSN, a condition in which the longest nerves slowly die. My feet are paralyzed, I can't raise them and my calves don't work properly either. I walk with braces. The braces put my feet at a 90-degree angle, which allows me to walk. In the house I take off the braces and I shuffle a little bit, it's called a cocked gait. Now that I have new braces—it took me a long time to find the right ones—I walk almost 4 kilometers and hope to build this up even more. At age seven my mother identified something different about my walking, and first I got little soles, then semi orthopedic shoes, and then orthopedic shoes. When I was seventeen, I was referred to the St Maartens Clinic and had five operations on my feet. After the first two operations I did not rehabilitate and I turned out to have the muscle disease HMSN. My ankles were then fixed so that I fit into braces. I am very happy that I am still mobile in this way. I also see very different cases.

It's quite a process. Last year I was really fed up with the old braces. I am very happy with the new ones, and I see that I can do more. It is also a mental process. I have friends who love shoes very much, when they buy new shoes, it is sometimes painful. I walk in mountain shoes. I can never wear heels again. With the previous braces I had shoe size 45, with the new size 42/43. I also always wear long pants, so people don't see it. Mentally I still want to get over that. It's also very hot in the summer. For the first time I bought some wider pants, of thinner fabric.

I often take my wheelchair with me when we go for longer walks or on a city trip. Since half a year I have a little motor with my wheelchair and I am not so dependent on my partner, Martijn, anymore. He doesn't mind at all to push the wheelchair but now he can also walk beside me once in a while and I have a bit of self-control again.

I work as a psychologist in a trauma clinic in Boxmeer, where people stay internally for two weeks. I find myself very creative as a psychologist. With people with anxiety disorders where you do behavioral experiments, I think up special exercises. With a client who also wears braces I went to town with her in a dress and we showed off our braces with guts and courage. That gives self-confidence.

Creativity to me is freedom. I love to play theater. Right now, I'm working on four plays, a little hobby that got out of hand. I have my own theater group with four girls. We write, direct, and play the play ourselves. In Nijmegen I am in a group of physical theater, we do not use text. At the moment I play in two plays of my friend Danielle and, if necessary, I am her assistant director.

I notice that when I'm on stage I can always do more than I think. If you were to ask me to make a dash for it, I would have a lot of trouble doing so. However, when I'm on stage I can run across the stage quite a bit. There is adrenaline. I push my limits in that. My brain switches itself off, I think. I don't think in limitations anymore. I just go and do it, am then very active, quite busy. On stage I am less analytical towards myself. In the theater an impulse is very important. Following your impulse and associating comes from your creative brain, not from your mind. As soon as I start thinking about plays and characters it becomes boring. It's about feeling and acting. You get into a flow, an interaction with each other. Afterwards I wake up and think, wow what have we done together? Those are the best performances, when I'm really into it. Then I forget that I am a psychologist, where I live, there is no pain, there are no doubts. Creativity is very important to me, essential. A friend of mine is very musical, I myself cannot play an instrument, but I enjoy listening and sparring with him. Spontaneously I made an audio package with a theater group about love. It was fun to write lyrics for it, put soundscapes underneath it. Just to mess around with it, just to be busy with it. I do it primarily for myself. I can put a lot into the creative process.

Theater acting is often physically demanding for me but mentally I have recharged my batteries. I get strength from it, confidence too. Sometimes afterwards I am amazed at what I have done on stage. That also helps me in daily life.

Treating people with an illness could be more creative. Like in an exercise for me where I have to stand on one leg, that exercise is called star, toe, touch. I can't do that. My physical therapist gave me a small smooth disc for under my foot, now I can do the exercise.

When doctors tell me what I can't do anymore, I experience it as unpleasant. By the way, I know that myself. It is nicer to look at what I can do and to think of solutions, to look at possibilities.

With my mother I watched with amazement how her tremors changed when she started painting. She had great difficulty standing, two trembling hands but then when she painted it became quiet and she could paint the most exquisite details. Head still, hands still, it seems. Enormous focus. The surgery (a deep brain stimulation) has brought a lot to my mother. I have my mother back, it feels like that.

Creativity is freedom and everyone is creative. No child, no baby is born with a censor. That comes later and it is present in many areas. If you manage to reduce that censor through creativity in one area, it helps in other facets as well. I have a good brain and was always praised for it. On the rationale and the cognition. Creativity should be valued much more.

Creativity is freedom and groundbreaking.

Sanne

9 I Do Want to Try, to Create

Elly was diagnosed with Parkinson's disease seven years ago and Lewy Body dementia in the same year. I got to interview Elly, with the support of her husband Jos, in their beautiful apartment.

For years I have not seen Elly and Jos. Jos took sculpting lessons with me for about 10 years and I also met Elly at exhibitions and parties. Upon entering she recognizes me. A bit reserved at first, she loosens up more and more during the course of the conversation.

Elly tells:

"The beautician had written down after my visit to her: 'I suspect that Elly has Parkinson's.' I hadn't realized it myself yet. Six weeks later at the neurologist's, I found that I could not put one foot in front of the other. The diagnosis of Parkinson's was made. I was immediately put on medication, Levodopa, the replacement for dopamine. Despite the fairly low dosage, it immediately did something to me, to my sense of happiness. At first, I didn't mind that I had been diagnosed with Parkinson's. The medication made me calmer. In the beginning the Parkinson's wasn't too bad. What didn't work I tried to solve. When I played bridge, I took a sheet of notes with me to support myself. Jos reads a lot about Parkinson's and I liked that. Jos asked the question: 'Where does Parkinson's come from, what causes it?' We read a lot about the influence of pesticides. We talked for a while about agriculture, spraying poison, our food chain, and the food forest in Groesbeek, the crusade of Bas Bloem (neurologist and author of the book: *"De Parkinson Pandemie. En recept voor actie"*, 2021; English version: *"Ending Parkinson's disease. A prescription for action"*; 2021), the farmer's disease and about the quality of life.

I am not creative. As a child I loved to play outside, to be occupied with others."

I feel some tension and anxiety with Elly but certainly also curiosity. Elly asks questions, I see her relax more and more. Her enthusiasm grows.

"I can't play bridge anymore; the cards fall out of my hands and I feel uncomfortable." I can have a pleasant conversation with acquaintances but in a group, I fall silent, afraid of making mistakes.

I would love to develop my creativity and to come to the studio every week. I find it very exciting though. Will I be painting? Look, do you see those paintings? So incredibly beautiful, those colors. I'm always surrounded by art though; the house is full. Art makes me happy, it's beautiful.

We get into a conversation about a friend who fell off a wall, was in a coma, and had severe brain damage from the fall. She used to create. Now she doesn't. Elly and Jos would love it if I could stimulate and inspire her too. It makes me even more enthusiastic and aware that the need is great. I explain to Elly that it's not about whether you're "good" but that you enjoy it, being in your moment of happiness and that we would like to research what creativity does to the brain, more specifically what the influence is on the production or activation of the substance dopamine.

Elly tells us how she is doing now:
"I feel good physically." Every day I walk on the treadmill for half an hour. It's great. I really enjoy sitting with my grandchildren and chatting. Speech therapy helps me a lot, I can speak better and nicer talking. So great. At the moment, I am practicing with the speech therapist a speech that I want to recite to my daughter. When I read it aloud the tears immediately come. My emotions are on the surface.

We have visitors every day, physical therapy, housekeeping help, or a friend for coffee. Preferably only in the morning. In the afternoon, I rest for 1.5 hours, and I sleep very well. I don't drink alcohol anymore; I should have done that much earlier. I get up much fitter. By the way, it doesn't taste good anymore either.

Reading is bad. I received a magnifying glass with a light as a present, I'm going to practice with it.

I would like to try creating.

Elly's voice has become stronger and clearer. When I show her the photographs, she is very enthusiastic. This is where I would like to go. I would be proud if I could say that I create there. It is so palpable that Elly has become looser in conversation. Time and attention are of the essence.

It would be nice to bring Elly into the process of creating because she has never done anything in it. What effect will it have on her sense of happiness, her well-being and quality of life? Similarly, the friend with brain injury who used to draw and now does nothing at all. What would be touched in her if she started drawing again?

I am even more convinced of the need to see people, not with their limitations but with their talents, and to use creativity as a lubricant. There is a great need for meaning, belonging, and staying in it. To connection, activity, and fun.

The smile on Elly's face and the twinkle in her eye are a gift. I say goodbye and express my wish to receive her in my studio.

I do want to try, to create.
Elly

10 What are the Positive Benefits of Creativity for You?

The expression of my impressions makes visible and tangible who I am. Creativity is the source of life. Being who I am teaches me to embrace myself in love. It helps me to discover and enter new fields through which I am initiated into worlds that the mind does not know and cannot know. It is the bridge between these and other worlds, connecting us to our past and our future. Creativity gets you out of your head, brings you to the now, connected to your heart. It brings a sense of freedom and joy and thus an important counterbalance to the overvaluation of thinking, thoughts and limiting judgments. It allows my heart and hands to speak. I get to let go of my high bar and start playing again. I feel joy and experience flow.

The vast majority of my existence runs on my creative engine. Whether it's a garment, embroidery, photo, film or just the dinner of the day, creative power seeps into everything. I don't always have access to a vast ocean of ideas, some days more than others. But when I can let my head and heart blow a little, I can tap back into creative-life-force. It makes me happier from it, also from watching someone else's creativity. I recharge, feel free. Time and space do not exist, it gives me a lot of fulfillments. Creativity is meaning, it makes me active both mentally and physically. You can when you are in a flow put your head in a tree or make a tail that is exactly what you are missing. Anything is possible. It brings me into the NOW, in that time-lessness everything is perfect, and I experience myself as complete. That moment when everything else falls away is healing for body and mind. I dare to take risks. It brings life happiness, freedom, and inspiration—also for other things, it helps me focus and brings out an unprecedented energy in me. I forget everything around me. I feel calm, relaxed, happy and connected. It's the ultimate way of being in contact with my soul, my inner self. It makes me a better person. I get to know myself as I don't know myself yet. Unsuspected talents come to the surface and feelings of happiness and gratitude. It is essential for the preservation of this earth because it promotes tolerance towards us and the environment. Creativity is the language of the heart. I see and experience beauty in every detail and feel the space to play and fail. There is no performance pressure. It keeps my brain active, is relaxing and gives me self-confidence. My creativity inspires my colleagues, helps them to imagine other pathways. It gives me freedom, free from my ego and takes me beyond my thinking. In this way I feed my self-confidence from within. And that makes me happy. I am then totally myself. There is no stress, but pride and satisfaction, it makes my life interesting. From peace and quiet I get into a flow, the life stream can flow freely, fed from my soul. I gain insight into my processes in life. It heals, keeps me healthy and gives me confidence in the future. It gives recognition and offers comfort. Creativity is beneficial, it is a path, a sigh of relief, coming home. It doesn't just lead to development. It is the place where I am at home in myself, my home (maybe everyone's home?). The denial of creativity almost became my downfall. But there in the darkness turned out to be my strength at the same time. Now creativity has become a journey for me consisting of slowing down and listening to continue to nurture my creativity. A healing journey.

Art is not something you make........it is you!

11 Afterword

Looking back on these conversations, the answered questions, the experiences of my students and my own life path, I can say with all my heart, from a deep knowing and feeling, that creativity is essential for human well-being.

I wish for a holistic view and vision of life for all of us in which we connect art and science again, in which creativity in all its facets gets the (re)appreciation it deserves, that artists get a central position in society and their works will be shown and praised.

I wish we could inspire you to (re)discover your own creativity and that you dare to let it flow freely and show it in all aspects of your life. It will help you to turn limiting thoughts about yourself into unprecedented possibilities and talents. It will bring you closer to yourself, create a deeper awareness.

I wish that in every organization a space will be freed up where employees/employers can go, to connect with creativity, where the head goes out (or maybe better descent form head to heart and hands, into limbo) and the heart and hands go on. Such a wonderful space filled with materials to create, make music, or listen, become still and descent to a deeper dimension within yourself. That creates relaxation, health, less stress, better quality of life, less sick leave, happy people and so much more. You come back into connection, into contact with yourself so you can feel and say: I AM

Do everything with attention and love.

In love, Ellis

"I wish I could tell you that you have to do it a certain way, that you have to read a certain book, or take a certain trip. That you will be rewarded with a moment of beauty that changes your life, that unlocks the happiness inside of you, if you just do this or that. I wish I could tell you that you will heal in four months, or two weeks, or by next Monday if you really try. But I can't. I can't. For if there is anything I have learned about moving forward, about letting go, about becoming the person you want to become – it is that it happens in the quietest moments. Growth creeps into you, it burrows and it stretches, it cracks you open from the inside and one day you wake up and you really connect with the fact that you are happy to have opened your eyes. One day you wake up and all you feel is intense love; you almost don't know how to deal with all of the softness blooming from your fingertips. Hope pours out on you onto sidewalks, and into the arms of your lover, and into the words you write and the art you make and the depth of your laughter. You feel so damn lucky to be alive, and you dont't really know how it happened, or when it did. You don't really know where the shift occured, or what was responsible for it. But I don't think you ever will - because happiness was never something you were going to find. Instead, it was something you were going to become."

Bianca Sparacino

On my nightstand there is a pile of books, they are my source.

A selection:

The Artist's Way	Julia Cameron
Walking in this World	Julia Cameron
Heelmeesters	Richard Hoofs
Scheppend Leven	Hans Andeweg
Walk through Walls	Marina Abramovic
Leven en Lessen van de Sjamaan Joska Soos	Yurek Onzia
Intimate Geometries	Louise Bourgeois

Visual Representation of Bodily Sensations: The Taken-for-Granted and the Alienated Body: Bodily Self-Awareness

Barbara Graf

Body sensations only become explicit in conspicuous situations; it is as if I would not feel my body as long as no special sensual incident takes place. Bodily self-awareness either necessitates intense physical experiences or focused attention, which then lead into conscious reflections. Although the body is always physically present, it might often appear as though it is absent and, in a sense, reticent and tacit. Physical sensations are then particularly striking in specific situations; for example, when they have never been experienced before, when they appear unexpectedly, or when they are in strong contrast to what has been felt immediately before that very sensation. If these bodily sensations are both long-lasting and maintain a certain distance from the threshold of pain, they can be present and absent at the same time. Thus, they could be switched on and off by one's focused attention. When reflecting upon an immediately experienced body sensation, the perception alters and leads to a process of constant transformation. Corporeal sensations are rather immediate, which can render difficult grasping, describing or representing them. We react differently to physical sensations which are perceived as uncomfortable than to those regarded as pleasant sensations. If body sensations are enjoyable, we usually do not question these. As we surrender to pleasure, we are then less interested in reflecting on their meaning (Fig. 1).

In my current work[1] I investigate physical sensations and pose questions of possible ways of representing subjective perception. One of the results of my research

[1] This investigation is part of the Artistic Research PhD Project *Stitches and Sutures*, in progress since 2018 at the University of Applied Arts Vienna, Zentrum Fokus Forschung, Supervisor: Barbara Putz-Plecko, https://zentrumfokusforschung.uni-ak.ac.at/en/researchprojects/artistic-research-phd-projects/barbara-graf-stitches-and-sutures/. Accessed 16 April 2021.

B. Graf (✉)
Institute of Art Sciences and Art Education, University of Applied Arts Vienna, Vienna, Austria

© The Author(s), under exclusive license to Springer Nature Switzerland AG 2023
A. Richard et al. (eds.), *Art and Neurological Disorders*, Current Clinical Neurology, https://doi.org/10.1007/978-3-031-14724-1_12

Fig. 1 Barbara Graf, *Touching the Sole of the Foot*, 2017, photograph, 18 × 24 cm. This photograph is one of the first works I made on the altered perception of the body. The overlapping of bodily and textile tissues embodies the strange phenomenon of textile sensations. Touching the inside of the body with one's own hand—an impossible touch—indicates the foreign body sensation, but also means testing one's own bodily certainty (Photocredits © Barbara Graf)

is a catalogue of pencil drawings of corporeal sensations. These are divided into different categories, e.g. types of body sensations, ways of perception, conditions of perception or methods of drawing. Said forms of representation of sensations are based on my personal experiences, wherefore the chronic illness of multiple sclerosis (MS) makes this exploration quite explicit. Sensory disturbances are common for people affected by MS, and they can be of many different types, such as numbness, burning, stinging, crawling and tingling sensation, or pain, tension, hypersensitivity, but also the sensations of tightness and bandages around body parts, walking on cotton balls or sand, wearing gloves and socks and sensation of enlargement. They are often described in medical publications and by affected persons, but rarely visually represented.

However, these bodily sensations do not differ from those perceived under different conditions based on other disorders or, in fact, ordinary everyday corporeal experiences. Still, it certainly makes a major difference whether such physical sensations occur temporarily or permanently. This very point transfers into the complex question of the existence of a supposedly 'normal' bodily perception and the possibilities of integrating long-lasting or permanent disturbances into one's body awareness, whereby they are eventually no longer perceived as such.

The sensory disorder of paraesthesia, caused by MS, as well as other illnesses bringing about nervous disorders, are peculiar cases for reflecting body perception, as the sensations are not caused by external stimuli, but by lesions in the central nervous system and its disturbed transmission. Said nervous disturbances powerfully imitate real tactile perception. Related to this phenomenon, I ask myself how the inner images, which are assigned to such exceptional sensations, arise, or rather what they refer to. As an artist, I am not only trained in drawing but also as a

Fig. 2 Barbara Graf,
Drawing 202, 2019,
29.7 × 42 cm. Sensation of
kotted fibers (under the
feet and partially fused
with the feet) (Photocredits
© Barbara Graf)

Fig. 3 Barbara Graf,
Drawing 193, 2018,
29.7 × 42 cm. Sensation of
wearing sock-like layers
(Photocredits © Barbara
Graf)

recipient of such. While drawing sensations, the momentary action of doing so is connected to all of my drawing experiences through my hand and fingers as a tool, but also to an archive of observed drawing structures, e.g. Leonardo Da Vinci's depictions of smoke or flowing water, Raphael's drawings of hair or draperies or Bruegel's ways of visual representation of trees, leaves, roots and clouds.[2] (Fig. 2).

Many of the paraesthesia have a textile character, allusive to a sock (Fig. 3) or a glove (Fig. 4) feeling and referring to the everyday experiences of wearing clothes. Furthermore, my past and current artistic activity is deeply entwined with actual textiles, therefore supporting the imagination and visualisation of corporeal

[2] See Graf B, *Stitches and Sutures*. In: Damianisch A, Jahrmann M, editors. Envelope#3, yearly publications of the Artistic Research PhD Programme, Zentrum Fokus Forschung, University of Applied Arts Vienna; 2020. See Graf B, From Physical Sensations to Forms of Perception, Imagination and Representation. In: Damianisch A, Jahrmann M, editors. Envelope#4, yearly publications of the Artistic Research PhD Programme, Zentrum Fokus Forschung, University of Applied Arts Vienna; 2021.

Fig. 4 Barbara Graf,
Drawing 218, 2019,
29.7 × 42 cm. Sensation of
wearing a glove
(Photocredits © Barbara
Graf)

Fig. 5 Barbara Graf,
Cloth 7 – Suture, 2014,
photograph,
26.7 × 35.6 cm
(Photocredits © Barbara
Graf)

perception. Current sensations can evoke past experiences—adding to a kind of vocabulary collected throughout my life.

I call the project *Stitches and Sutures* as a metaphoric suturing of a wound, but also as an artistic procedure. The title refers not only to the technique of sewing and the medium of textile, but also to Jacques Lacan's concept of the *suture*. Lacan's term *point de capiton* (quilting point) signifies a process whereby the past is studded retroactively with stitches, as it were, as if by needle and thread, at larger and smaller intervals (Fig. 5). Many of them can constitute a *suture*.[3] The linkage they form is more or less stable: it results in the diachronic production of meaning. The past can be connected to the present by a partial similarity, even without belonging to the

[3] See Lacan J, Séminaire du Mercredi 6 Juin 1956 (later published as: Seminar III, Chap. XXI, transcribed and edited by Miller J-A). https://ecole-lacanienne.net/wp-content/uploads/2016/04/1956.06.06.pdf. Accessed 16 April 2021.

In English, Jacques Lacan's term *point de capiton* is variously translated as "quilting point," "anchoring point" or "upholstery button".

same context or content. Everyday experiences associate with sensory disturbances, or memories and stored images give language to the paresthesias.

To go deeper into the sensations, I choose a micro-phenomenological way of visual representation. The sensations represented by the object that could potentially trigger that sensation, however, does not show the sensation itself. To show exclusively the structure of the sensation, I isolate it from the body.

In order to represent both the characteristics and the intensity of sensations as accurately as possible, I have introduced a scale ranging from 1–5 of micro-phenomenological drawings (Figs. 6, 7 and 8). Not only does it differ from the common pain scale of 1–10 by the number of gradations, it also shows the interwovenness of quantity and quality through sections of varying pencil structures. I try to record quasi seismographically a sensation and to sense how it is in the most subtle

Fig. 6 Barbara Graf, *Drawing 228*, 2020, 11.7 × 27 cm. A fine Fibrous sensation transforms into fiber-clusters as tangle-like accumulations (Photocredits © Barbara Graf)

Fig. 7 Barbara Graf, *Drawing 223*, 2020, 11.7 × 27 cm. A whiff of a dot-shaped prickly sensation transforms into intensive stinging accumulations (Photocredits © Barbara Graf)

Fig. 8 Barbara Graf, *Drawing 232*, 2020, 11.7 × 27 cm. A slight and dull fibrous tension sensation develops into a muscle fiber-like tugging tension (Photocredits © Barbara Graf)

manifestation and how it develops before it becomes an excessive strong pain. For this purpose I use pencils with different degrees of hardness, as well as various sizes of pencil mines. The visual representations become not only progressively darker and denser, but also more pronounced in the specific structure.

Subsequently, the question arises to what extent such a sensation undergoes transformation in terms of its quality through intensity. The five sections classifying the intensity of sensations are marked by invisible pseudo-brackets. Preceding the first section, there would be an empty section, the blank white paper respectively, which denotes the inconspicuous body and is therefore not visually represented. Likewise, the other section not depicted would follow the fifth and thus most intense category. Here, the qualitative structures would start to collapse and dissolve by pushing the pain itself into the foreground, subsequently causing the loss of its distinct quality. Hereafter, reference to said gradations of the experience of paraesthesia and different descriptions of discomfort or pain is illustrated in more detail.

- The first field shows a whiff of sensation, merely perceptible, and the inconspicuousness already slightly broken, but there is still no clearly remarkable characteristic in quality.
- The second stage embodies an intensification as an irritation and a tentative orientation of the characteristics of the sensation.
- The third level of the scale defines the quality of a sensation more clearly and starts to be perceived as unpleasant.
- The fourth stage describes a discomforting up to a slight pain and its quality is even more clearly defined.
- In the last and fifth rubric, the sensation is well defined as quality and the pain is only so strong that it does not dominate the quality.

Fig. 9 Barbara Graf, *Drawing 189*, 2017, 29.7 × 42 cm. The banding or girdling sensation is also known as the MS hug, because the sensation of a tight (from irritaiting till painful) bandage is often around the chest, but it can be felt anywhere, especially around the ankles or wrists (Photocredits © Barbara Graf)

Consequently, the conscious perception of body sensations and their subsequent graphic description led me to the question whether almost every sensation would turn into pain when being perceived as extremely intense, e.g. if there is no longer a difference between burning and stinging due to the intensity.

Another part of my project is the artistic embodiment of the disturbed corporeal self-image and the (non-)acceptance of unpleasant sensations. Here, my focus is not on enormously intense physical sensations such as extreme pain. Rather, I look at different kinds of paraesthesia and the possibly resulting uncertainty regarding one's bodily confidence, the effect on the self and the relation between the taken-for-granted and the alienated body.

I feel as if textile-like materials would either touch parts of my body, are wrapped around (Fig. 9) or located inside it; a feeling as if the textile tissue is mutating into human tissue, and yet alien to me (Figs. 1 and 11). However, I understand the alienation also in a more general sense, the loss of the presupposed wholeness through the illness respectively. It may never have existed, but in the very moment of disturbance it becomes more obvious.

When working with drawings as a kind of micro-phenomenology, I approach physical sensations very closely, but also distance myself through the graphic recording. Almost the other way around—also in the process of an externalization—I proceed with an extremely enlarged foot out of medical gauze (Figs. 10 and 11). It is a kind of semi-transparent canvas. I shift threads until the contour and inner lines of the sole of a foot is formed, without removing or adding material. Thus, it is merely a reorganization of threads. In an over-identification with my alienated body part of the foot, I reappropriate matters of distance through proximity, transferred from a bodily tissue to a textile tissue and transformed to a textile membrane which could envelop the whole body. Formulating symptoms of a disease and transferring them into an artistic form allows me to feel healthy living with an illness.

In the field of medical humanities, there are more and more projects that follow the phenomenological approach in order to reach a different understanding of

Fig. 10 Barbara Graf, *Cloth 10 – Large Foot*, 2020/2021, medical gauze, 186 × 93 cm, and photographs (Photocredits © Barbara Graf)

Fig. 11 Barbara Graf, *Cloth 10 – Large Foot*, 2020/2021, photograph, 26.7 × 35.6 cm (Photocredits © Barbara Graf)

illness and also to become part of the therapy.[4] Thereby the experience of illness is in the foreground. Havi Carel known for her approach of medical phenomenology developed together with Jane Macnaughton a transdisciplinary approach in their projects *Life of Breath*. In this project, artistic forms of expression such as music and dance play an essential role.[5]

Jane Macnaughton emphasized in her keynote lecture at the *Conference Interactions between Medicine and the Arts* 2019 in Vienna that the approach of the critical medical humanities[6] is to incorporate knowledge from other disciplines such as art, humanities and social sciences, as well as their methods. The study of the human experience is of special importance and focuses on the dialogue with the patients. In the context of the project *Life of Breath* she describes their approach as: "One important theme has been that of investigating the difference between experience and sensation in relation to breathlessness and how this informs neuroscientific investigation".[7]

The Sociologist and filmmaker Christina Lammer highlights that the patient's voice is of particular importance, but not only their verbal articulation, but active participation leads to an interactive practice that can support a healing process. In artistic-scientific research projects Lammer has been investigating the body in the medical context for over 20 years. One of her important areas of research is embodied emotions and sensory interaction between patients and physicians. In close cooperation with patients she investigates concerns, needs, anxieties and decision-making processes of patients.[8]

This empathic approach is exemplified in the project *Features*, in which the patients (facially paralyzed children) took an active position. After nerve and

[4] Neither the implementation in clinical practice nor the establishment of Medical Humanities in the academic context is an easy matter, despite the increasing number of projects and researches.

[5] *Life of Breath* (2015-20, funded by the Wellcome Trust) was led by Jane Macnaughton Professor of Medical Humanities at Durham University and Havi Carel Professor of Philosophy at University of Bristol. Havi Carel is the author of the *Phenomenology of Illness*, University Press Oxford, 2016. https://lifeofbreath.org/, Accessed 9 October 2021.

[6] Critical medical humanities is not a new discipline compared to medical humanities, but widening the fields or intensify approaches, e.g. as the patient-clinician relationship, the implementation of the arts and various experimental approaches. See: William Viney, Felicity Callard, Angela Woods, Critical medical humanities: embracing entanglement, taking risks, *Medical Humanities*, 2015;41:2-7. https://mh.bmj.com/content/41/1/2, Accessed 9 October 2021.

[7] Jane Macnaughton, Critical medical humanities in action: symptom and sensation in breathlessness, in: Interactions between Medicine and the Arts, International Conference of the Medical University and Vienna and the Austrian Academy of Sciences. Wiener Klinische Wochenschrift, 132. Jahrgang 2020, Supplement 1, Wolfgang Schütz, Katrin Pilz (eds.), p.8, p.9. https://doi.org/10.1007/s00508-020-01706-w, Accessed 9 October 2021.

[8] In many of Christina Lammer's projects, I worked as an artistic collaborator. Currently I'm part of the artistic research project *Visceral Operations / Assemblage* (2019-23, founded by the FWF – Austrian Science Fund). http://www.corporealities.org/, Accessed 9 October 2021.

muscles transplants, patients had to do facial training. A special example is mentioned here: the children were not only filmed, but given a camera to take at home and film themselves. However, it was not limited only to the face, but movement of the whole body, helped the children to perceive themselves physically differently than only through the injured part of the body. The project leader Lammer, the children, the operating surgeon, physical therapists and a choreographer were in intensive contact and exchange, with the aim that the children could move their faces again.[9]

Similar to Carel's and Macnaughton's Project *Life of Breath*, artistic (in particular performative) methods are important parts of the therapy, can add to medical treatments, but it is also an exploration to gain different insights—the knowledge of lived experiences—through the approach of the critical medical humanities with artistic tools.

The transition or simultaneity of illness and health is posed anew. It is allowed to change sides, respectively, they are not so rigidly separated anymore. I can be a research artist, a patient and the subject of investigation at the same time, and speaking in the first person's perspective is part of the phenomenological investigation of lived experiences. In the case of MS, an MRI (*Magnetic Resonance Imaging)* as a medical visualization can show the locations and extent of damaged nerves in the spinal cord and brain. These allow conclusions about the disorders they evoke, but are not representing the specific qualities of the sensations. An artistic visual representation is also only a supporting vehicle, but it can evoke in the viewer a sensation that may be close to that one intended in the representation—functioning as a resonating image. Furthermore, artistic approaches have the potential, through the doing itself, to experience one's own body not only through the illness, but also to achieve a kind of wholeness again. They are an artistic tool of mediation and communication, especially when it comes to invisible symptoms—and perceptions are always invisible.

Barbara Graf was born in Switzerland and lives in Vienna, Austria. She is an artist and a Senior Lecturer at the University of Applied Arts Vienna. In her work she investigates forms of visual body representation and develops flexible sculptures as a second skin. Her main media are drawing, sculpture and photography. Since 2004 she has been working in various art research projects dealing with medical issues. She is currently developing her Artistic Research PhD Project *Stitches and Sutures* on the visualisation of body perception at the University of Applied Arts Vienna.

http://www.barbara-graf.at/
barbara.graf@uni-ak.ac.at
https://base.uni-ak.ac.at/cloud/index.php/s/CFq5I7fWsYeKulO

[9] *Features – Vienna Face Project* (2010-2014, funded by the FWF – Austrian Science Fund). Publication: Christina Lammer, Bewegende Gesichter – Moving Faces, Löcker, Vienna 2015.

The Artistic View with Parkinson's Disease: In Search of "Why"

Urs Bratschi

1 Urs Bratschi Swiss Pasta Artist

U. Bratschi (✉)
Urs Rainbow Art Pasta, Rheinfelden, Switzerland
e-mail: ursb@hangloose.net

2 This One Moment in Time

A good 7 years ago, my world collapsed with the diagnosis of Parkinson's disease. Questioning the meaning of life took on a completely new dimension. I thought, I already vaguely discovered what life was all about when suddenly it turned me inside out and it became completely impossible to find answers to questions which I still had. I desperately tried to find anyone and anything that would make it possible to get rid of this nightmare, I was suddenly stuck in. One feeling I knew with certainty, it was clear to me from the beginning without a hesitant doubt: nobody and nothing could help me or could change this fact, I have Parkinson's disease!

Life abruptly came to a halt and I no longer felt capable to do anything at all. Thoughts of taking my own life took a very strong overwhelming hold on me. However, I did not actually know, if I could even be capable of going through with ending my own life. I was panic-driven and completely stuck. Fortunately, these thoughts maneuvered me to visit the Cantonal Psychiatric Services where I reached out for help. I was so relieved to have found someone there who took on my case. Being guided through these dark moments of my life was a true blessing. Someone who managed to show me step by step with lots of care, that life does somehow go on, even if you do have Parkinson's disease? However, I still had a strong urge to search for reasoning as to "Why". This "why" do I have to be the one struck by this unlucky draw of getting Parkinson's disease?

3 The Parallel Path of the Artistic Journey

Almost 12 years ago, I bought a food processor with a mixer and a pasta roller. I had this idea in my head to make fresh homemade pasta. I was craving for a good plate but I honestly did not have a clue how to actually make it. That did not stop me from immediately going to work in my kitchen. I was just planning to wing it and try it out. Unfortunately, it did not work out well. When I was done, I only had this sticky lumpy piece of dough which defiantly could not be eaten nor called a fresh homemade pasta dish. I did however feel quite enriched by this experience, so I was determined not to give up and try it again. The second time around, I attempted it with tagliatelle and it turned out pretty tasty. I also went on for further rounds and made spaghetti, lasagna, ravioli, tortellini, farfalle and rigatoni. I was motivated at my best in my kitchen which became my playground.

Having mastered the basics of the pasta layer, I was faced with new challenges of coloring the dough. I did some research on how one could dye the pasta green. This is when I introduced spinach into my kitchen. Chlorophyll can be extracted from spinach through a relatively simple procedure but still entails a complex process (spinach mat). This creates grass-green pasta. It looked just amazing. A colleague at work at the time, mentioned to me (probably in a more joking manner) that I should try to make a rainbow-colored pasta. At first, I did not think it was possible, but I spent a lot of time thinking about how I could do it. The thought of it really intrigued me a lot. My mind was fascinatingly captured by this and I was

determined to figure out how it could be done. The main problem I still needed to overcome, was finding something which could dye the pasta blue. Food coloring from a tube was out of the question. This still remains unthinkable to this day since I only use natural bio products in all my dishes. I keep this as a general cooking rule in my kitchen. As if I got struck by lightning the idea suddenly hit me. I wondered why I did not think of it sooner. I suddenly remembered when washing dishes, if a small piece of red cabbage was stuck on a plate, it would turn it blue. So of course, that was my solution to blue. I attempted this with red cabbage and mixed in a little baking soda for this beautiful blue color. The first rainbow-colored ravioli dish made it on the plate. I thought the mix was kind of brilliant.

Soon it was no longer magic to make rainbow colored strip pasta, I somehow felt I wanted more. I tried to make colored patterns on ravioli as well. I wanted to create more and more, complex and really crazy abstract pasta patterns. It became almost like an addiction to strive for new patterns. At some point, my friends, who enjoyably ate the pasta dishes in-between my new attempts mentioned these creations had nothing to do with the dish being edible anymore. They went on to tell me the pasta dishes had taken on a form of art. It was also almost a shame to eat them. I remember my first thoughts at the time. I recall kind of holding in with it and after a long pause came out my shy "hmm"?

But yes, the more I thought of it, I kind of liked it and had to agree. It is in many ways some kind of unique and unconventional art! This of course put my pasta creations in a whole different shade of light and as colors inspire me. I had reached the limits of what could be achieved with just a plain pasta roller and rolling techniques. For some time already, I had been thinking how to get the patterns to be more complex. The idea evolved from flat pasta into a third dimension. Working patterns into three-dimensional dough blocks as well as cross-sectioning to expand the design possibilities was most defiantly the next level. It turned out that this concept actually worked. It immensely expanded the spectrum of design possibilities for my art. This technique is quite complex indeed. However, it has been a huge leap forward for my creations.

4 The Walls We Build or the Ladders We Climb

My Parkinson's disease has done quite a lot for me and also to me. Questioning: what should I do next in my life? Leaving me with only two options.

1: I could just resign, feel sorry for myself and do nothing at all with the rest of my life.
2: I could make the best of it, actively participate in life and still feel a sense of joy.

One should not let the disease affect you and drag you down to a point where you feel just chained. If you run these options through your mind, you can only come to one conclusion: The first option, is not a considerable or even serious choice at any given age or stage of anyone's life. To truly comprehend and somehow live to implement it as easily as it is worded, is of course easier said than done for most of us. Needless to say, it is the only chance you are given in situations such as these. But I am living proof that it is possible! I have learned so much from being exposed to this extreme situation at my age. Putting it into these words sounds strangely odd. It has thoroughly turned my whole self-image upside down. Today, I know so much more about myself. I view the world with different eyes since being diagnosed.

I have learned to talk openly about my problems with other people especially together with my friends and the people I share my time with. That was something unimaginable for me before falling ill. At some point, I reached a moment, where there was just no other way. I had to talk about what I was facing with those around me. It did me a lot of good. I learned to recognize what is important and let go of the things that do not matter.

Things that I want to do now, I do them without hesitation and with great determination. I no longer face moments of boredom as in times before I had Parkinson's. The most important thing for me today are my friends and my time with them. I always make time for them no matter what.

5 The Parkinson's Ingredient in My Art Formed My Artistic Spark

I believe without Parkinson's, I would still be making pasta today but probably not with this passionate drive and probably not in the form of art.

On the one hand, the meditative aspect of creating pasta has certainly helped me in difficult times to distract myself from the disease. On the other hand, it is even more important to me now, to achieve something in my life. I want to be the proof that this is possible even with Parkinson's disease and it really sparked my artistic touch. The impossible only exists if you believe that something is impossible, and you build these walls in your mind. Our own thoughts are powerful ingredients of the walls we build or the ladders we do climb. We are able to release unimaginable energies if we want and believe in it, even if you have Parkinson's disease.

I have learned so much and had so many positive experiences from having this disease. It is absurd to say but my life has changed for the better from that one moment which I first mentioned opening up this chapter. At first, when I often meet other individuals affected by Parkinson's and I tell them this, they cannot grasp or comprehend my thoughts and views. They most likely think; I am completely off my rocker and must have lost my mind in between the lines. Of course, Parkinson's disease is nothing pleasant for anyone including myself. If one could just flick it off like a switch and get rid of it, I certainly would also do so without the slightest hesitation. Truth be told, it has so many positive effects on me, it has taken away my fears despite me knowing what is still yet to come. The challenges I am bound to face is enough to scare the living daylights out of anyone, but I have found a calm with my fears possibly even through the meditative state while making pasta art. The disease has become a part of me. It now belongs to me and I belong to it, somehow that seems alright!

Often people are amazed at my never-ending creativity in coming up with new pasta dishes and patterns. I also have to admit; I do surprise myself at its best. Sometimes these ideas just bubble up in my mind. From time to time, I make sketches or geometric calculations to see if they could work out. It has happened a few times that I attempted something and failed miserably with my original plan. Plans are often made to change, so from the failed attempt something new turned out. Sometimes, something much better than I had originally anticipated. I also often realize that many people have no idea what it means to make these pasta dishes. They find my pasta beautiful but do not see behind the creation, behind the scene of the process involved in making it. Pasta dough has an impossible consistency. It is difficult to shape into any form and sometimes you have to use a lot of force to try to keep it as you want it. The dough remains a lump. If you cut it apart the separate pieces cannot be easily rejoined. These are difficulties that can only be countered with appropriate techniques. Techniques that sometimes require highly precise work, techniques that also require a lot of time to learn and need much practice. Somehow kind of like life.

6 Feeding the Spark Film Project

Late fall 2021 The Centre for Parkinson's and Movement Disorders at the University Clinic for Neurology in Bern Switzerland launched a short film by the name "Feeding The Spark" with the Bernese Filmmaker Bettina Rotzetter and the Neurologist Dr. med. Ines Debove. The film was subtitled in 11 languages to reach a wide variety of *Parkinsonian's* from all kinds of cultural backgrounds, to raise awareness and help others in their journey with this disease. It was the third-generation project for this film crew from Bern. Of course, I was honored and absolutely delighted to be the artist featured in it. It was also a great pleasure to not only host this film team in my kitchen for a day but also feed them a plate of my artistic pasta before they headed back out with their cameras and crew.

Dr. med. Ines Debove is a senior physician who initiated this ongoing project which first started in 2019. Portraying creative individuals suffering from Parkinson's disease and how they differently cope in everyday life is a mission the passionate doctor and filmmaker are dedicated to. Many Parkinsonians turning to art and creativity are shown in these short films which have captured a lot of attention even in the medical community. The team is archiving these projects which they intend to historically build up for further referencing. The balancing act between life's challenges and coping with the disease was and is the motivation behind these captured short films at the department led by Prof. Paul Krack at the Parkinson and Movement Disorder Center at the University Hospital Inselspital Bern.

"Feeding The Spark" was in particular also interesting, for the team invited additional two experts the Neuropsychologist also from the center Marie Maradan-Gachet and rounding up the expert group was Blanca T.M. Spee a researcher focusing on art, creativity, and Parkinson's disease at the RadboudUMC in the Netherlands and the University of Vienna. So there we were me as the pasta artist, a filmmaker, a round of highly qualified experts, and a kid who depicted the creative process. The team was joined by a youngster named Elia Tornarelli who is a bright young fella indeed. Capturing the perspective of a young person's thoughts and views while watching me create the dish in my kitchen with these experts unfolding it, was also a rich growing experience for all parties involved. Not only the social interaction with the film team but also the additional perspectives that came into the discussions while we enjoyed a plate of pasta at my dinner table thus influencing—delicately—the filmmaker in the dark editing room.

7 Still in Search of My "Why?"

Now the question "why" still remains unsolved. Why do I have to be the one? Why was this imposed on me and why do I have Parkinson's disease? During the film shooting of "Feeding the Spark" with the film set being hosted in my own kitchen, it suddenly dawned on me. I am beginning to understand even if my pace is somewhat slow to comprehend. I reason with it and maybe all good things do take time. This film crew would not be in my kitchen without it. Even more now, as I was asked to write this chapter of this book, there seems to be a little spark of light inside this dark again. If you have read the book this far and made it to MY chapter, you may have an idea what the answer could be. This book is the answer. The short film "Feeding the Spark" is also part of my personal answer. The conversations I have with others that suffer from Parkinson's is also part of the answer. It moves me tremendously to realize this. It also gives me a lot of energy to pursue my plans further into a brighter future. I live my dreams now even more intensified with Parkinson's!

Index

Printed in the United States
by Baker & Taylor Publisher Services